Engaging with Heritage and Historic Environment Policy

A comprehensive review of policy and practice in the historic environment, this book exposes the tensions, challenges and difficulties faced by the heritage sector at a time of political volatility.

This collection comes at a key moment for planning policy in the historic environment of England. The chapters reflect a wide range of views and experience in the practical environment of policy and implementation. Contributors give perspectives on both policy and practice from legal counsel to local authorities, from the country's largest NGO to the museums sector. Some conclusions are controversial, providing an important insight into the operation of national and local government.

The thrust of the volume is the need to close the gap between research and policy production. Written when the UK government's White Paper, *Planning for the Future* (August 2020), was in preparation, the chapters explore the implementation of policy, its unexpected and unanticipated outcomes and the enduring legacies of guidance and established practice. It highlights tensions within the sector and the need for collaboration and partnership. This book is the most recent and comprehensive review of how the heritage sector has evolved and draws special attention to the importance of the historic environment, not just in planning policy but for the country as a whole.

The chapters in this book were originally published in *The Historic Environment: Policy & Practice*.

Hana Morel is an archaeologist and heritage practitioner, currently working as Senior Policy Advisor (Climate Change) for Historic England. Previously, she worked as Research Associate at University College London where she led the AHRC-funded Heritage Priority Area project, 'Opening Pathways across Heritage Research, Policy and Practice', on the need to engage with government policy on regional, national and international levels and support the contribution which heritage research can make to public policy and heritage-related policy.

Michael Dawson is an archaeologist and heritage consultant, Director of Heritage at RPS. Author of several books including the recent *Heritage Under Pressure* (2019). His research interests lie in the application of conservation policy and he is editor of the journal *Historic Environment Policy and Practice* and a panel lecturer at the Oxford University Department of Continuing Education.

Engaging with Heritage and Historic Environment Policy

Agency, Interpretation and Implementation

Edited by
Hana Morel and Michael Dawson

LONDON AND NEW YORK

First published 2021
by Routledge
2 Park Square, Milton Park, Abingdon, Oxon OX14 4RN

and by Routledge
605 Third Avenue, New York, NY 10158

Routledge is an imprint of the Taylor & Francis Group, an informa business

© 2021 Taylor & Francis

All rights reserved. No part of this book may be reprinted or reproduced or utilised in any form or by any electronic, mechanical, or other means, now known or hereafter invented, including photocopying and recording, or in any information storage or retrieval system, without permission in writing from the publishers.

Trademark notice: Product or corporate names may be trademarks or registered trademarks, and are used only for identification and explanation without intent to infringe.

British Library Cataloguing in Publication Data
A catalogue record for this book is available from the British Library

ISBN13: 978-0-367-72564-8 (hbk)
ISBN13: 978-0-367-72575-4 (pbk)
ISBN13: 978-1-003-15538-6 (ebk)

Typeset in Myriad Pro
by Newgen Publishing UK

Publisher's Note
The publisher accepts responsibility for any inconsistencies that may have arisen during the conversion of this book from journal articles to book chapters, namely the inclusion of journal terminology.

Disclaimer
Every effort has been made to contact copyright holders for their permission to reprint material in this book. The publishers would be grateful to hear from any copyright holder who is not here acknowledged and will undertake to rectify any errors or omissions in future editions of this book.

Contents

Citation Information vii
Notes on Contributors x

Introduction: Engaging with Policy in England - Agency, Interpretation and Implementation 1
Hana Morel and Michael Dawson

1 Power of Place - Heritage Policy at the Start of the New Millennium 11
Kate Clark

2 Principles into Policy: Assessing the Impact of *Conservation Principles* in Local Planning Policy 38
Gill Chitty and Claire Smith

3 The Disconnect between Heritage Law and Policy: How Did We Get Here and Where are We Going? 56
Nigel Hewitson

4 Heritage Assets: Decision Making in the Real World 64
Peter Goatley and Nina Pindham

5 It's Not Mitigation! Policy and Practice in Development-Led Archaeology in England 84
Roger Thomas

6 Borderlands: Rethinking Archaeological Research Frameworks 101
Paul Belford

7 Archaeology, Conservation and Enhancement: The Role of Viability in the UK Planning System 124
Dan Phillips

8 For Everyone?: Finding a Clearer Role for Heritage in Public Policy-making 142
Georgina Holmes-Skelton

9 Always on the Receiving End? Reflections on Archaeology, Museums and Policy 159
 Gail Boyle

10 Historic Environment Policy: The View from a Planning Department 174
 Chris Patrick

11 The Heritage-creation Process and Attempts to Protect Buildings of the Recent Past: The Case of Birmingham Central Library 187
 Matt Belcher, Michael Short and Mark Tewdwr-Jones

12 Pathways to Engagement: The Natural and Historic Environment in England 210
 Hana Morel and Victoria Bankes Price

 Index 231

Citation Information

The following chapters were originally published in *The Historic Environment: Policy & Practice*, volume 10, issue 3–4 (January 2020). When citing this material, please use the original page numbering for each article, as follows:

Introduction
 Engaging with Policy in England - Agency, Interpretation and Implementation
 Hana Morel and Michael Dawson
 The Historic Environment: Policy & Practice, volume 10, issue 3–4 (January 2020)
 pp. 245–254

Chapter 1
 Power of Place - Heritage Policy at the Start of the New Millennium
 Kate Clark
 The Historic Environment: Policy & Practice, volume 10, issue 3–4 (January 2020)
 pp. 255–281

Chapter 2
 Principles into Policy: Assessing the Impact of Conservation Principles *in Local Planning Policy*
 Gill Chitty and Claire Smith
 The Historic Environment: Policy & Practice, volume 10, issue 3–4 (January 2020)
 pp. 282–299

Chapter 3
 The Disconnect between Heritage Law and Policy: How Did We Get Here and Where are We Going?
 Nigel Hewitson
 The Historic Environment: Policy & Practice, volume 10, issue 3–4 (January 2020)
 pp. 300–307

Chapter 4
Heritage Assets: Decision Making in the Real World
Peter Goatley and Nina Pindham
The Historic Environment: Policy & Practice, volume 10, issue 3–4 (January 2020) pp. 308–327

Chapter 5
It's Not Mitigation! Policy and Practice in Development-Led Archaeology in England
Roger Thomas
The Historic Environment: Policy & Practice, volume 10, issue 3–4 (January 2020) pp. 328–344

Chapter 7
Archaeology, Conservation and Enhancement: The Role of Viability in the UK Planning System
Dan Phillips
The Historic Environment: Policy & Practice, volume 10, issue 3–4 (January 2020) pp. 345–362

Chapter 8
For Everyone?: Finding a Clearer Role for Heritage in Public Policy-making
Georgina Holmes-Skelton
The Historic Environment: Policy & Practice, volume 10, issue 3–4 (January 2020) pp. 363–379

Chapter 9
Always on the Receiving End? Reflections on Archaeology, Museums and Policy
Gail Boyle
The Historic Environment: Policy & Practice, volume 10, issue 3–4 (January 2020) pp. 380–394

Chapter 10
Historic Environment Policy: The View from a Planning Department
Chris Patrick
The Historic Environment: Policy & Practice, volume 10, issue 3–4 (January 2020) pp. 395–407

Chapter 11
The Heritage-creation Process and Attempts to Protect Buildings of the Recent Past: The Case of Birmingham Central Library
Matt Belcher, Michael Short and Mark Tewdwr-Jones
The Historic Environment: Policy & Practice, volume 10, issue 3–4 (January 2020) pp. 408–430

Chapter 12
Pathways to Engagement: The Natural and Historic Environment in England
Hana Morel and Victoria Bankes Price
The Historic Environment: Policy & Practice, volume 10, issue 3–4 (January 2020) pp. 431–451

The following chapter was originally published in *The Historic Environment: Policy & Practice*, volume 11, issue 2–3 (August 2020). When citing this material, please use the original page numbering, as follows:

Chapter 6
Borderlands: Rethinking Archaeological Research Frameworks
Paul Belford
The Historic Environment: Policy & Practice, volume 11, issue 2–3 (August 2020) pp. 359–381

For any permission-related enquiries please visit:
www.tandfonline.com/page/help/permissions

Notes on Contributors

Victoria Bankes Price studied at Newcastle University. She is a chartered town planner who has previously worked in both the private sector and local government.

Matt Belcher is an interdisciplinary artist and creative director exploring new approaches – and responses – to interpretation and storytelling.

Paul Belford is the Director of the Clwyd-Powys Archaeological Trust. He is an archaeologist with diverse interests in late prehistoric, early mediaeval and post-medieval archaeology.

Gail Boyle has had a successful career as a museum archaeologist for over 30 years and is Senior Curator of Archaeology and World Cultures for Bristol Museums.

Gill Chitty is Director of Studies for Conservation in the Department of Archaeology, University of York and Associate Dean in its Faculty of Arts & Humanities.

Kate Clark is an industrial archaeologist, with a career in public policy and leadership across heritage and museums.

Michael Dawson is an archaeologist and heritage consultant, Director of Heritage at RPS (www.rpsgroup.com).

Peter Goatley was called to the Bar in 1992 having previously been a partner in a medium sized commercial solicitors practice. He acts for a wide range of clients including developers, retailers, construction companies, community groups, house builders, local authorities, and government agencies.

Nigel Hewitson was Legal Director at English Heritage between 2001 and 2006 and is the coauthor of *Listed Buildings and Other Heritage Assets* (Fifth Edition), 2017, Sweet & Maxwell.

Georgina Holmes-Skelton is Head of Government Affairs at the National Trust, where she leads on the National Trust's engagement with public policy, particularly focusing on heritage and culture.

Hana Morel is an archaeologist and heritage practitioner, currently working as Senior Policy Advisor (Climate Change) for Historic England. Previously, she worked as Research Associate at University College London.

Chris Patrick started his career as a field archaeologist employed on developer-funded commercial work and research projects for the field unit at Birmingham University and later for Worcestershire County Council.

Dan Phillips is an archaeology currently undertaking a Masters in Spatial Planning at the UCL Bartlett School of Planning. He is founder of drp archeology, ACIfA, member of Rescue Council and *Rescue eNews* editor.

Nina Pindham is a member of the Planning and Environment and Environmental Law groups at No5 Barristers' Chambers. She has appeared before the High Court, Court of Appeal, and the Aarhus Convention Compliance Committee.

Michael Short is Senior Teaching Fellow in Planning and Urban Conservation at the Bartlett School of Planning, University College London.

Claire Smith is undertaking a collaborative, AHRC-funded PhD researching statutory and nonstatutory heritage lists in England with the University of York and Historic England.

Mark Tewdwr-Jones is Professor of Town Planning at Newcastle University and an expert in urban and regional planning, historic and contemporary urban change, digital place engagement, and spatial governance.

Roger Thomas worked in a variety of archaeological roles at English Heritage (now Historic England) from 1984 to 2017, where he took a particular interest in development-led archaeology. He is an Honorary Research Associate in the School of Archaeology, University of Oxford.

Introduction

Engaging with Policy in England - Agency, Interpretation and Implementation

Scholars and practitioners alike in the historic environment have long felt the pressures of changing government agendas, shifts in funding, and changing global priorities. Over the past two years government reshuffles have seen changes in personnel at the UK Ministry for Culture, Communications and Creative Industries[1] and numerous consultations relating to the environment.[2] The new conservative government elected on 12th December 2019 promises further change. In 2019 alone, the Secretary of State for Housing, Communities and Local Government Robert Jenrick MP launched a new campaign to protect local heritage buildings in addition to a recent announcement of a £95 million fund to unlock the economic potential of 69 historic high streets. Yet at the same time the Heritage Alliance are continuing discussions with DCMS and the Home office on the proposed immigration system after potential EU Exit, including salary thresholds for heritage professionals applying for working visas and organisational preparedness for no-deal Brexit.[3] While Brexit seems to dominate most agendas, a collaborative and transparent historic environment community continues to support efforts to highlight relevant work as well as reshape research to understand further the scale of challenges faced by the sector and how to respond to them.

As part of that effort, the remit of this journal is both international in outlook and world-wide in scope, with members of the editorial board in both hemispheres with interests which span the complexities of the historic environment. Amongst the advantages of a global perspective is the level of engagement in contemporary debate, and in recent years the publication list of papers has included commentary on the principles of heritage practice and case studies illustrating how the apparatus of heritage conservation functions in a wide range of situations. Interpretation of policy in any administration is a key subject area with important implications for the implementation of conservation policy at local, regional and national levels. In some areas, national engagement and interpretation may have important implications for international practice.[4] In this age of globalisation the study of a particular administration's policy is an important aspect of public and academic interest, part of a discourse contributing to and informing the development of common definitions, themes, solutions and priorities.

This Special Issue of the journal was inspired by the AHRC Heritage/Rescue conference *'Engaging with Policy in the UK: Responding to Changes in Planning, Heritage and the Arts'*, held at the University College London, Institute of Archaeology on 27 October 2018. Its purpose was to promote further the dialogue between those involved with the historic environment and related fields, to draw on and bring together transdisciplinary and cross-sectoral perspectives on a range of critical changes in UK policy. Its objective was to provide a detailed case study of engagement with English policy in relation to the historic and natural environment and the role of governance.[5] The conference addressed challenges and

opportunities resulting from significant changes in the political landscape seen through increasing numbers of consultations and calls for evidence which have emerged in the past few years.[6] It aimed to engage with academics, civil servants, amenity societies, private and professional bodies to address three core areas: (1) building culture and protection of the natural and historic environment into the planning system; (2) planning for people by addressing the changing role of culture, museums and the arts; and (3) the need for evidence-based and practical strategies in responding to key issues and concerns.

The Conference is just one approach amongst many providing a forum aimed at the deployment of our collective resources and research capacity to improve the future of the historic environment. Invited speakers from a range of sectors, many of whom are featured in this volume, explored the mechanisms by which researchers and practitioners can provide relevant information and evidence which is urgently needed by government to enable progressive and informed decision making.

The Conference' focus on law, policy and practice in contemporary England reflects an increasing concern across the heritage, museum, arts and planning sectors that evidence-based policy is under threat. It is evident within the sector that contemporary practice can contribute to the emergence of policy by providing a clearer understanding of the scope and influence of heritage through an improved grasp of what constitutes value and significance. This can only be achieved by a more comprehensive use of the evidence base and by means of a theoretical understanding of contemporary practice.

Current practice within the sector can also contribute to greater historical awareness by engagement with a diversity of groups within society whose perspectives and understanding of cultural values may offer a more contested perspective on the role of policy. Engagement at this level can provide increased understanding between groups in relation to their own actions and how these might influence or be influenced by others. Such engagement runs contrary to the criticism that policy makers only have in mind the concerns of special interest groups. In an evident practical sense engagement by the sector can demonstrate the effectiveness of policy initiatives and promote practical reform. There is no doubt, too, that evidence-based publication aids the conservation sector's advocacy and agitation for practical reform and in monitoring objectively where policy is found to be inadequate, opaque or inappropriate. It is some 32 year since Robert Hewison in 'The Heritage Industry – Britain in a Climate of Decline'[7] argued for the establishment of a critical culture with respect to heritage and this publication may be seen as vindicating this important aspiration.

English Law and Policy

The protection offered by English law and the conservation policy instruments which underpin the framework of practice provide the focus for the papers which follow. They exemplify the wide range of personal, organisational and institutional agency, and the capacity of the sector to engage with the development of an evidence base for change and transformation affecting the historic environment. The political weight carried by policy is explicit in government statements and over the years, we have seen government propose a range of changes in policy supported by official consultations.[8] This enabling of democratic governance process is key to ensuring fair participation in policy production. In recent years consultation has been undertaken on, amongst other things, the 2012 and

2019 National Planning Policy Framework, the Neighbourhood Planning Bill, the Raynsford Review on Planning, the Museum Review, the call for evidence on how to build bridges within and between communities by the Select Committee on Citizenship and Civic Engagement, the Environment Bill, and recently the Treasure Act. The heritage sector has also seen, in what could be viewed as a positive gain, the creation of the 'Heritage Council', a cross-departmental group in Parliament indicative of Government's commitment to ensure greater coordination and a stronger voice for heritage.[9] At the time of its announcement, alongside the launch of the 2017 *Heritage Statement*, the then Minister for Arts, Heritage and Tourism John Glen MP, in setting out the government's priorities for the coming years wrote:

> *Our heritage requires careful protection and sympathetic conservation. But we need to focus our investment to protect, conserve and enhance our heritage where it delivers the greatest benefits today and in the future. We must ensure that our heritage helps to create great places to live, work, visit, and do business, as well as contributing to our economy, our wellbeing and the regeneration of our communities. We must aim to improve access to our heritage and extend opportunities to enjoy and learn about it to everyone in every community. And we must maximise the power of our heritage as an asset in our international outlook and use it to promote our country around the world.*[10]

In the 2018 *Heritage Statement – One Year On*, the Minister of Arts, Heritage and Tourism, Michael Ellis noted the success of that statement heralding the institution of a new place-marker scheme, an increase of £55 million allocated to the heritage sector to regenerate high streets.[11] Yet at the same time hard pressed local authorities were encouraged to make *'better use of volunteer resources in areas of fundraising, outreach, events staffing, and specialist conservation work, to governance roles and trusteeship'*.[12] Whilst it is not the role of this journal to engage in overt politicised debate, such policy is contested and has been challenged in the sector. Simon Aldous writing in the *Architect's Journal* on the London Imperial War Museum exhibition *'What Remains'* described how a country's cultural heritage is often deliberately targeted in conflict as evidenced by the recent destruction of Palmyra in Syria, the Bamiyan Buddhas of Afghanistan, the violation of the Hague Convention in Kosovo, or the Baedeker Raids during the Second World War, when German bombers used travel guides of Britain as a checklist of which buildings to set out to destroy.[13] Yet, Aldous continued, *'a latter-day foreign aggressor may be saved the effort by the UK government's cumulative funding cuts to its heritage protection body, Historic England. Adopting an interesting turn of phrase, Historic England says it has 'raised the bar' on the type of planning applications for which it will be offering advice. Which in practice seems to mean it will not be giving assistance to local authorities determining most planning applications affecting Grade II-listed buildings."*[14]

Policy affecting heritage and the historic and natural environment directly is a broad church, and such an exchange draws attention to capacity, one of the key issues in implementation. Simon Aldous' focus was the reduction in funding for Historic England, seen against a 27% cut in Historic England and English Heritage spending since 2014, and a 35% reduction in Local Authority Historic Environment staff since 2006.[15] Local authorities in England lost 27% of their spending power over five years from 2010 to 2015.[16] Some services, such as planning and 'supporting people' have seen cumulative cuts of 45%.[17] The Local Government Association highlighted almost half of all councils – 168 – will not receive any core central government funding by

2020, and that local councils will see central funding fall by 77% by that time.[18] Add to this a cut in overall historic environment advice of 32% since 2006, of which 26% is in archaeological advice (including Historic Environment Records Officers) and 35% in conservation advice.[19]

In recent times emphasis by the Chartered Institute for Archaeologists (CIfA), the sponsoring body of this journal, has been placed on the capacity of the profession to respond to ambitious policies such as that outlined by Ellis in 2017 in the context of Brexit. The current policy for the UK to leave the EU, with or without a deal, has led to a demand by CIfA, among other heritage organisations, that the *'government must put in place new systems that enable the right level of immigration to meet the UK's archaeological needs. It should also ensure that UK professionals can work in the EU. Provisions should ensure that UK universities maintain research and teaching excellence and attract top students.'*[20] Such a plea is made not only as there is currently a high demand for archaeological services due to infrastructure and house building but in light of the current make-up of the archaeological workforce. Presently some 13% of archaeologists working in the UK come from EEA and the Institute has made common cause with the construction sector in voicing concern over the potential impact that post-Brexit migration restrictions might have on the capacity of the profession to respond in the context of housing policy.[21]

Such engagement with policy notionally outside the narrower remit of historic environment conservation, is consistent with the need for a wider engagement with policy generally. Many heritage organisations, such as CIfA, The Heritage Alliance, the Council of British Archaeology, and RESCUE, aim to develop networks through which to influence policy when opportunities or threats arise in relation the historic environment providing authoritative advice to ministers, parliamentarians, civil servants and agencies or NGOs. They seek to influence policy not only in areas of heritage practice, but in related fields of employment, licencing and regulation. Specific initiatives related to England include the successful implementation of the 2017 Cultural Property (Armed Conflicts) Act and the implementation of the Hague Convention, ratification of the UNESCO Convention on Underwater Heritage in collaboration with the Joint Nautical Archaeology Policy Committee (JNAPC) and the maritime Archaeology Group. Whilst the country is still a member of the EU CIfA, for example, continues to work towards the creation of an EU Directive on the historic environment.[22]

While many heritage organisations work towards improving the standards of conservation and enhancement of the environment as well as standards of employment for practitioners, the limited capacity of organisations acts to deter them from more extensive engagement. Recognition of this limitation has led to the re-emergence of The Archaeology Forum (TAF), with members from lead national (or wider) bodies supporting the archaeological discipline with an interest in policy, in which their strategic actions aim to shape the future of the discipline by enabling information sharing on advocacy, campaigns, research and wider activities with the potential of alignment of initiatives and unified messages.[23]

Engaging with Policy, the inspiration for this edition of the journal, is one of many attempts to promote knowledge exchange among a range of representative heritage organisations. The objective, through the agency of individual and group action is to improve the implementation of policy, inform the evidence base of policy formulation,

review its interpretation and to look ahead towards the sort of research which is needed to address the long-term future of our sector.

Agency

The first paper of the volume is Clark's important paper *'Power of Place – heritage policy at the start of the new millennium'* which sets the tone by introducing the *'wide-ranging engagement process involving the private sector, natural and cultural heritage organisations and others'*. The extent of consultation is a valuable counterpoint to the exponents of the AHD. The paper is both empowering and a valuable contribution to understanding the strength of personal agency. It provides detail and context to many of the discussions that follow in this volume. *Power of Place-the future of the historic environment*, although no longer available online unless specifically requested, envisioned many of the challenges faced by contemporary heritage. From concerns of wealth distribution and the impact of climate change, it looked to a new vision for heritage.

Chitty and Smith's paper *'Principles into Policy: assessing the impact of Conservation Principles in local planning policy'* provides a key insight examining and reflecting on the unquestionable influence and impact of the 2008 English Heritage *Conservation Principles* in local policy formation. This is despite the document never having formal public policy status in England's planning system. The paper draws on the role of agency through understanding the context of policy transfer and influence across networks, it demonstrates how principles and documents can have a lasting impact on practice regardless of support (or not) from Government.

Interpretation

The broader interpretation of heritage policy and practice, from the definition of terms to explaining principles, is riddled with inconsistencies in practice. Key to greater clarity is how policy is interpreted and applied in law.

Nigel Hewitson provides a clear and straightforward examination of the compatibility between legislation and policy highlighting *'The Disconnect Between Heritage Law and Policy: How did we get here and where are we going?'* Exploring how we came to categorise and protect different classes of heritage assets Hewitson specifically focuses on substantial or less than substantial harm in relation to designated and non-designated heritage assets.

Decision Making in the Real World, co-authored by barristers Peter Goatley and Nina Pindham, considers the interpretation of heritage legislation and policy at inquiry and by UK courts. Drawing on specific cases they emphasise the precision of language. Of particular interest to those of us who deal with setting is their conclusion that, despite Barnwell, it may not be necessary for an authority to state that they have given 'special regard to the desirability of preserving the building or its setting' where this is explicit in the text of a report or assessment.

These two 'legal' papers provide insight into the dynamic between formal policy, its interpretation in law and its subsequent use in policy decisions. Roger Thomas' paper *'It's Not Mitigation! Policy and Practice in Development-Led Archaeology in England'* provides a much needed examination of terminology in custom and practice. Many of us are familiar with terms such as rescue archaeology', 'developer-funded archaeology',

'preservation by record', 'preventive archaeology' and 'mitigation'. However, Roger questions the application of what have become 'archaeological traditions' and whether these correctly reflect the application of policy. The paper is a clear analysis of the interpretation of policy and how this has been applied in practice.

The final paper in this section is a warning to the sector from Rescue, one of our more important amenity societies. Dan Phillips, on behalf of Rescue, explores the concept and role of viability, now prominent in the UK planning process. This is an important development about which the historic environment sector should be fully conversant. Philips highlights how viability can influence the conservation and enhancement of the historic environment, and provides an essential explanation of viability, its role and assessment in the planning process. He shows how the financial costs of developments are calculated and, in certain circumstances, how viability expressed in financial terms can upstage conditions related to the historic environment.[24]

Implementation

The third section concludes with five papers discussing the application and implementation of policy. At the heart of this section is the extent to which policy depends on the social, political and economic landscape of the time. The capacity to implement policy is clearly based on the availability of resources, whether financial, expert or a supportive environment.

Boyle in her paper *'Always on the receiving end? Reflections on archaeology, museums and policy'* provides a clear example of the unintended consequences of a lack of consultation, illustrating how one of the most celebrated policy statements for the sector, PPG 16, resulted in significant problems for archaeology museums. PPG 16, noteworthy for establishing the historic environment as a material consideration within the UK planning system has for over 20 years heaped pressure on archaeology museums to deal with the fallout resulting from the omission of any requirement to 'preserve the archaeological record as a result of development-led archaeology'. The pressures on storage space is now critical, with ongoing conflict as to who should pick up the bill for archiving and storage.

The issue of capacity is further explored in Patrick's paper, '… *the view from a planning department'* in which he lays out the reality of funding cuts to local government across the country based on his experience in the West Midlands as a senior conservation officer. This candid paper raises concern by detailing the role of advice provided by specialist archaeologists to planning officers, and the consequences of funding cuts on those arrangements over the last ten years. More urgently, Patrick questions *'the mantra of doing "more with less"'* and reveals how the national picture actually obscures' the impact of cuts across England's less well-resourced regions. The knowledge and insight lost as a result of policy, Patrick adds, has yet to be replaced.

Holmes-Skelton in her paper *'For everyone? Finding a clearer role for heritage in public policy-making'* delves into the relationship between spending and the long-term environmental impacts of policy decisions through Capital Valuation. Triggered by the challenge of finding a new role for heritage and facing the complexities of contested heritage, she argues, using an approach to assess the economic value of cultural resources recently put forward by the Natural Capital Valuation committee may well demonstrate that *'public*

money spent on protecting and enhancing the environment is not merely money spent without return'. Such protection can generate significant returns on investment.

Belcher, Short and Tewdwr-Jones continue the exploration of implementation. *'The heritage-creation process ...* is an excellent example of evidence-based analysis (via semi-structured interviews) of practice, based on the case of the former Birmingham City Library. The article is an important reflection on *'the values that we ascribe to particular structures and landscapes'* and how these values underpin *'conflicts inherent within the conservation'* of heritage. Their call for a more holistic, interdisciplinary understanding of heritage issues using post-war buildings and their survival as an example, should be welcome to all.

Morel and Bankes Price address the divide between the historic and natural environment in *'Pathways to engagement: the natural and historic environment in England'*. Exploring the complex relationship – and forced separation- of nature and culture in international and national documents, they explore the recent revision of the National Planning Policy Framework and the Woodland Trust's Campaign in support of the Environment Bill through Parliament. Both the natural and historic environment sectors have been strongly active in advocating the conservation and enhancement of the two environments, but have rarely worked together in their campaigns. The co-authorship is in itself an effort to bridge both the divide and to join with academia and NGOs, in finding common ground.

Lastly Matt Thompson's review, *'Who Owns England? How We Lost Our Green & Pleasant Land & How To Take It Back'* by Guy Shrubsole reminds us that much of Britain's heritage assets are privately owned, and credits Shrubsole's activism in seeking to explore the angles (and secrecy) of land ownership. While referencing style may be an issue, Thompson continues, the book itself is of importance to those involved with the historic environment. Shrubsole, whose role as environmental campaigner for Friends of the Earth and research calling into question the myths around land ownership, align well with this volume's aim to be mindful of how seemingly disconnected law and policy impact the historic environment.

Overall, this Special Issue is part of the initiative to reflect on issues of importance to the historic environment across the planning, arts and museum sectors. Its objective has been to overcome limitations due to resources, capacity or experience and to celebrate cross-sectoral and interdisciplinary approaches and to recognise the value of agency, interpretation and implementation in policy and practice.

Notes

1. The Parliamentary Under-Secretary of State for the Arts, Tourism and Heritage was John Glen (June 2017 – Jan 2018), then Michael Ellis (Jan 2018 – May 2019), Rebecca Pow (May – Sept 2019) and Helen Whately MP from 10 September 2019.
2. This includes, for example, the Ministry of Housing, Communities, Local Government consultation *Delivering the 25 Year Environment Plan for the historic and natural environments*; and consultations in relation to *The Environment Bill; Planning reform: supporting the high street and increasing the delivery of new homes; Scrutiny of the draft Environment (Principles and Governance) Bill Inquiry; Improving our Management of Water in the Environment; Conservation Covenants*, and the *Revising the definition of treasure in the Treasure Act*.

3. https://www.theheritagealliance.org.uk/update/no-deal-brexit-how-will-it-affect-the-heritage-sector/ accessed 11/11/19.
4. Dolowitz and Medearis, "Considerations of the Obstacles and Opportunities," 684–97.
5. *Engaging with Policy in the UK: Responding to Changes in Planning, Heritage and the Arts*, UCL Conference 28 September 2018.
6. See Endnote 2 for 2019 consultations, earlier consultations include: the *Treasury Committee VAT inquiry*; the *revised National Planning Policy Framework*; the *Environment Bill*, the *Fisheries Bill*; the *Planning Appeal Inquires Review call for evidence questionnaire*, and the *Landscapes Review Call for Evidence.* .
7. Hewison, *The Heritage Industry*, 10.
8. Civilservice.blog.gov.uk 2016 'Consultations – What's New and Why They Are so Important – Civil Service'.
9. 'Heritage Council', https://www.gov.uk/government/groups/heritage-council.
10. *Heritage Statement 2017*, DCMS .
11. Sutherland, Potton, 18 December 2018; '£40 Million Government Funding To Improve Historic High Streets', 2018 Historic England.
12. Heritage Statement – A Year On 2018, DCMS, 11.
13. Aldous, July 2019; for Palmyra see UNESCO World Heritage Centre, "Director-General of UNESCO Irina Bokova Firmly Condemns the Destruction of Palmyra's Ancient Temple of Baalshamin, Syria," UNESCO World Heritage Centre, for the Bamiyan Buddhas, see "Ten Years on – Remembering the Tragic Destruction of the Giant Buddha Statues of Bamiyan (Afghanistan)," UNESCO World Heritage Centre; for Kosovo, see Herscher and Riedlmayer, "Monument and Crime," 109–22.
14. *Architects Journal* 6 July 2019.
15. English Heritage, ALGAO, and IHBC, "A Sixth Report on Local Authority Staff Resources, Historic England."
16. National Audit Office, "Financial Sustainability of Local Authorities," 14.
17. Historic England, "Heritage Counts 2016: Heritage and Place Branding," 6; JRF, 10 March 2015, 3.
18. "Council Funding to Be Further Cut in Half over next Two Years – LGA Warns," 2019 www.local.gov.uk.
19. Historic England, 2014.
20. CIfA Position Statement Briefing – Archaeology and Immigration May 2019.
21. Migration in the UK Construction and Built Environment Sector, IFF repprt for CITB 2018.
22. From CIfA Advocacy Objectives 2018/19.
23. Personal notes from TAF meeting, May 2019; EP: Town & Country Planning Services, "Cutting the Red Tape of Planning?" *Ethical Partnership* (blog), 20 April 2012.
24. EP: Town & Country Planning Services, "Cutting the Red Tape of Planning?" *Ethical Partnership* (blog), 20 April 2012.

Acknowledgments

Special thanks to the *AHRC Heritage Priority Area* and *Rescue: The British Archaeology Trust* for funding *Engaging with Policy in the UK: Responding to Changes in Planning, Heritage and the Arts*. Special thanks also to the Editorial board of *The Historic Environment: Policy and Practice* for encouraging this Special Issue.

Bibliography

Aldous, S. 2019. "Heritage Fails to Make the Grade." *Architects Journal*, July 6. Accessed July 27, 2019. https://www.architectsjournal.co.uk/opinion/weekend-roundup-built-heritage-fails-to-make-the-grade/10043479.article

Bulmer, S., D. Dolowitz, P. Humphreys, and S. Padgett. 2007. *Policy Transfer in European Union Governance : Regulating the Utilities*. London: Routledge. doi:10.4324/9780203964743.
CIfA. *Advocacy Objectives 2018/19*. Accessed July 27, 2019. https://www.archaeologists.net/advocacy
CIFA. 2019. "Position Statement Briefing - Archaeology and Immigration." May. Accessed July 27, 2019. https://www.archaeologists.net/sites/default/files/CIfA%20policy%20position%20on%20archaeology%20and%20immigration%20post-Brexit.pdf
"Consultations - What's New and Why They are so Important - Civil Service." Accessed August 14, 2019. https://civilservice.blog.gov.uk/2016/01/15/consultations-whats-new-and-why-they-are-so-important/
Dept for Digital, Culture, Media & Sport. 2019. "Revising the Definition of Treasure in the Treasure Act 1996 and Revising the Related Codes of Practice." Accessed December 2019 https://www.gov.uk/government/consultations/revising-the-definition-of-treasure-in-the-treasure-act-1996-and-revising-the-related-codes-of-practice
Dept for Digital, Culture, Media & Sport. *Heritage Statement 2017*. London:DCMS.
Dept for Environment, Food & Rural Affairs. 2018. "Delivering the 25 Year Environment Plan for the Historic and Natural Environments." London:Dept for Environment, Food & Rural Affairs.
Dept for Environment, Food & Rural Affairs. 2018. "Consultation Outcome Sustainable Fisheries for Future Generations: Consultation Document." Accessed December 1, 2019. https://www.gov.uk/government/consultations/fisheries-white-paper-sustainable-fisheries-for-future-generations/sustainable-fisheries-for-future-generations-consultation-document
Dept for Environment, Food & Rural Affairs. 2018. "Landscapes Review Team Panel Landscapes Review: Call for Evidence." October. Accessed December 1, 2019. https://consult.defra.gov.uk/land-use/landscapes-review-call-for-evidence/supporting_documents/landscapesrevieweviden cedocument.pdf
Dept for Environment, Food & Rural Affairs. 2019. "Improving Our Management of Water in the Environment Summary of Responses and Government Response." July. Accessed December 1, 2019. https://assets.publishing.service.gov.uk/government/uploads/system/uploads/attach ment_data/file/819372/floods-water-consult-sum-resp.pdf
Dept for Environment, Food & Rural Affairs. 2019. "Conservation Covenants. Consultation Outcome Summary of Responses and Government Response." Updated July 23. Accessed December 1, 2019. https://www.gov.uk/government/consultations/conservation-covenants/outcome/sum mary-of-responses-and-government-response
Dept for Environment, Food & Rural Affairs. "The Environment Bill Policy Paper, Documents Related to the 2019 Environment Bill." London:Dept for Environment, Food & Rural Affairs.
Dolowitz, D. P., and D. Medearis. "Considerations of the Obstacles and Opportunities to Formalizing Cross-National Policy Transfer to the United States: A Case Study of the Transfer of Urban Environmental and Planning Policies from Germany." *Environment and Planning C: Government and Policy* 27, no. 4 August 1 (2009): 684–697. doi:10.1068/c0865j.
EP: Town & Country Planning Services. 2012. "'cutting the Red Tape of Planning?', 2012 Ethical Partnership (Blog)." April 20. Accessed March 1, 2019. http://www.ethicalpartnership.co.uk/2012/04/20/cutting-the-red-tape-of-planning/
Hastings, A., N. Bailey, G. Bramley, M. Gannon, and D. Watkins. 2015. "The Cost of the Cuts: The Impact on Local Government and Poorer Communities." *Joseph Rowntree Foundation, Report*, March 10. https://www.jrf.org.uk/report/cost-cuts-impact-local-government-and-poorer-communities
Herscher, A., and A. Riedlmayer. "Monument and Crime: The Destruction of Historic Architecture in Kosovo." *Grey Room*, no. 1 (2000): 109–122.
Hewison, R. *The Heritage Industry - Britain in a Climate of Decline*. Methuen: London, 1987.
Historic England. October 30, 2018. Accessed December 1, 2019. https://historicengland.org.uk/whats-new/news/40-million-pounds-govt-funding-historic-high-streets/
Historic England. *Heritage at Risk*. London: Historic England, 2018.
Historic England. "Heritage Counts 2016: Heritage and Place Branding." Accessed August 14, 2019. http://historicengland.org.uk/research/heritage-counts/2016-heritage-and-place-branding/

Historic England, ALGAO, IHBC. 2019. "A Sixth Report on Local Authority Staff Resources." Accessed August 14, 2019. http://historicengland.org.uk/images-books/publications/sixth-report-la-staff-resources/

IFF Research. 2018. "Migration in the UK: The View from Employers, Recruiters and non-UK Workers in 2018." *Full Report*. London: ConstructionIndustry Training Board. Accessed July 27, 2019. https://www.citb.co.uk/about-citb/construction-industry-research-reports/search-our-construction-industry-research-reports/mobility-and-migration/migration-uk-construction-built-environment/

Local Government Association. 2017. "Council Funding to Be Further Cut in Half over Next Two Years - LGA Warns." Accessed August 14, 2019. https://www.local.gov.uk/about/news/council-funding-be-further-cut-half-over-next-two-years-lga-warns.

Ministry of Housing, Communities & Local Government. 2018. "Consultation Outcome Draft Revised National Planning Policy Framework." London: Ministry of Housing, Communities & Local Government. Accessed December 1, 2019. https://www.gov.uk/government/consultations/draft-revised-national-planning-policy-framework

Ministry of Housing, Communities & Local Government and HM Treasury. 2019. "Government Response to Consultation on Planning Reform: Supporting the High Street and Increasing the Delivery of New Homes. A Summary of Responses to the Consultation and the Government's Response." London: Ministry of Housing, Communities & Local Government.

Ministry of Housing, Communities and Local Government. 2018. "Independent Review of Planning Appeal Inquiries." https://assets.publishing.service.gov.uk/government/uploads/system/uploads/attachment_data/file/777823/Independent_Review_of_Planning_Appeal_Inquiries_Main_Report.pdf

National Audit Office. 2018. "Financial Sustainability of Local Authorities." London: NAO. Accessed August 14, 2019. https://www.nao.org.uk/wp-content/uploads/2018/03/Financial-sustainabilty-of-local-authorites-2018.pdf

"Scrutiny of the Draft Environment (Principles and Governance) Bill Inquiry." 2019. Accessed March 1, 2019. https://www.parliament.uk/business/committees/committees-a-z/commons-select/environment-food-and-rural-affairs-committee/inquiries/parliament-2017/scrutiny-of-the-draft-environment-bill-17-19/

Sutherland, N., and E. Potton. 2018. "House of Commons Library: Town Centre Heritage Action Zones." *Town Centre Heritage Action Zones*, December 18. https://researchbriefings.parliament.uk/ResearchBriefing/Summary/CDP-2018-0279

"Treasury Committee VAT Inquiry." 2017. *Treasury Committee*. https://www.parliament.uk/business/committees/committees-a-z/commons-select/treasury-committee/inquiries1/parliament-2017/vat-17-19/

UNESCO World Heritage Centre. "Director-General of UNESCO Irina Bokova Firmly Condemns the Destruction of Palmyra's Ancient Temple of Baalshamin, Syria." *UNESCO World Heritage Centre*. Accessed August 14, 2019. https://whc.unesco.org/en/news/1339/

UNESCO World Heritage Centre. "Ten Years on – Remembering the Tragic Destruction of the Giant Buddha Statues of Bamiyan (Afghanistan)." *UNESCO World Heritage Centre*. Accessed August 14, 2019. https://whc.unesco.org/en/news/718/

Hana Morel

Michael Dawson

Power of Place - Heritage Policy at the Start of the New Millennium

Kate Clark

ABSTRACT

In 2000 the (then) English Heritage was asked to lead on a review of policies relating to the historic environment in England. Rather than simply draft something in isolation, English Heritage launched a wide-ranging and inclusive engagement process involving the private sector, natural and cultural heritage organisations, faith groups and many others supported by a MORI survey of peoples' attitudes to the historic environment and the value they placed on it.

The resulting document, *Power of Place – the future of the historic environment*, anticipated many issues that have subsequently become mainstream elements of policy and practice including conservation-led regeneration, tackling heritage at risk, reviewing public parks and publishing regular state of the historic environment reports. Other recommendations still remain challenging in policy terms – including encouraging better maintenance, promoting craft skills, putting heritage at the heart of education, understanding what people value and why, enabling more participation, managing change, making the regulatory system work better and supporting local leaders.

This article simply sets out to raise awareness of that initiative, as a contribution to the history of heritage policyin England.

Introduction

In the late 1990s a group of people working in heritage in England set out to revolutionise our understanding of heritage and the way it was talked about and cared for. Perhaps like every generation of heritage practitioners before and since, they were chafing at what they saw as the limitations of the then language, policy and legislation. They were frustrated by the narrow constraints of designation, enmeshed in concepts of place rather than dots on maps, excited by the philosophy of sustainable development, and beginning to get to grips with the wider social, environmental and economic dimensions to heritage. Many had worked with the strong voluntary sector in the UK and so recognised that different people had different perceptions of heritage, and that what could be achieved within a public sector organisation related to only a tiny part of what most people saw as their heritage. The disciplinary boundaries between archaeology and buildings, or landscapes and built heritage, nature and culture were also breaking down.

The opportunity came in 2000 when the then Department for Culture, Media and Sport (DCMS) and the Department for Transport, Local Government and the Regions (DTLR) wrote to English Heritage asking for a major review of policies for heritage, following the sixth report from the Culture, Media and Sport Committee Session 1998–99 on DCMS and its quangos.[1]

Although that review raised some important and powerful ideas about heritage, it was to some extent overtaken by proposals to reform designation that culminated in the draft 2008 heritage bill. As a result, many of the policy implications of the review were never fully worked through.

Protecting Our Heritage

Less than four years before DCMS and DTLR wrote to English Heritage, the Department of National Heritage (DNH) published a 'green' (or consultation) paper entitled *'Protecting our Heritage: A consultation document on the built heritage of England and Wales'*.[2]

The core issues raised in the green paper are reflected in the cover design which juxtaposed two buildings – the Grade1 listed Willis Corroon buildings (1973–5) and Tintern Abbey – a monument in guardianship in Wales. The purpose of the consultation was to address some of the controversy that had arisen over the listing of inter- and post-war buildings.[3] The consultation proposed that more modern buildings from the 1950s and beyond should be listed on a different basis to older buildings. Although there were other proposals relating to the operation of the legislation, the primary focus was on designation – the identification of heritage for protection.

The context for *Protecting our Heritage* was that the management of the historic environment was not seen as problematic – the rate of loss of historic buildings had dramatically slowed, the financial support available for heritage was growing and the launch of the National Lottery had created new opportunities to support heritage assets such as urban parks, as well as additional support for voluntary groups – but there were concerns about the way the system of protection worked.

Power of Place

By January 2000 heritage policy was in a very different place. The Department of National Heritage had been renamed the Department for Culture, Media and Sport (DCMS) and the government had embarked on a series of ambitious reviews to look at the problems of poor neighbourhoods, one of which was PAT 10 (Policy Action Plan 10) which examined the role of arts and museums and social inclusion.[4] Following the 1992 *Rio Declaration on Environment and Development*, the sustainable development agenda was building up, recognising the links between diversity, quality of life, and the need to integrate development and conservation – thinking that was beginning to find its way from the natural environment into cultural heritage practice and the government had published its own sustainable development strategy.[5]

English Heritage was the arms-length 'quango' (quasi-autonomous non-government organisation) set up in 1983 to take on heritage functions previously done by government departments including designation, providing grants, advice, policy and casework, as well as the 'guardianship' of properties in the care of the state. In 1991 an internal re-organisation

of the side of English Heritage that dealt with heritage in the land-use planning system had broken down the professional silos that divided architects, planners, historic buildings professionals and archaeologists, who were now working together in multi-disciplinary regional or place-based teams.

From a policy perspective, English Heritage was beginning to mirror some of the language and approaches of sustainable development and the environmental movement. The most notable change was that the organisation was starting to take a more place-based approach to heritage, seeing it as 'historic environment' rather than a series of individual sites and monuments, reflected in the principal policy document covering heritage in the land-use planning system – *Planning Policy Guidance 15: Planning and the Historic Environment*. Linked to this, there was a new emphasis on understanding patterns of loss through the surveys of first buildings at risk and later monuments at risk. And in a move that signalled a much closer link between economic policy and heritage conservation, English Heritage was positioning itself very much as a regeneration agency.[6] The table at Appendix One sets out a list of contemporary policy topics in 2000.

It was against this background of internal and external policy thinking that the Department for Culture Media and Sport and the Department for Transport, Environment and the Regions commissioned a review of policies for the historic environment. The fact that the review was commissioned across two government departments signalled a recognition of the relevance of heritage/the historic environment to wider economic and environmental policy agendas.

In response – and mindful of a perception that the heritage sector was fragmented – English Heritage wrote to around 250 organisations and individuals including academics and practitioners, inviting them to participate in the review.[7] Drawing on those responses, English Heritage set up a steering group, five working groups (each with around 25 external members) and a smaller internal group drawn from the many different departments of the organisation, including properties-in-care, statutory casework, education, designation and regional management.

For its time, this was a very diverse and inclusive approach to heritage, bringing together people whose interest in heritage went well beyond the responsibilities of English Heritage. Participants in the review included representatives from faith groups, black heritage networks, museums, natural heritage, design, property interests, disability advocates, community groups, rural and urban planning, tourism and visitor attractions as well as academic and professional disciplines such as archaeology and architecture. The organisations spanned the public, private and voluntary sectors, local government, businesses and academia. The steering group was made up of twenty senior representatives from tourism, local government, natural heritage, rural heritage, voluntary organisations, the private sector, architecture, churches, archaeology, property interests, the black environment network, national museums and archives of black culture.

As most of the people or organisations involved in the review were active in caring for heritage, but did not necessarily represent the general public, English Heritage also commissioned a MORI poll to find out what people in England thought about the historic environment. The exercise involved opinion polls, focus groups and background research.[8]

The review was seen as a once in a generation opportunity to – in the words of the coordinator Graham Fairclough – 'think big, think basics, think new'. The aim was not to try to fine-tune essentially 19th century methods of protection as,

> 'not everyone consulted believes that the present system, even if streamlined is capable of delivering everything that society now expects, and there is good will to find a new approach and philosophy'.[9]

A new approach might take ten or twenty years so the review adopted twin timescales of a 25 year longer term vision and shorter term actions. The starting point for the review was the emerging cultural version of sustainable development – a philosophy that was,

> 'more socially inclusive, better able to celebrate multi-cultural society, find a constructive reconciliation between old and new, promote sustainable use of the history environment and ensure that we pass on an environment within which history could be appreciated'.[10]

and the key issues identified in the early stages were:

- subsidiarity (of definition and of decision-making)
- citizenship and culture
- democratic decisions about the environment
- social inclusion
- sustainable development[11]

The review used a continually evolving neutral definition of the historic environment that excluded nothing from the past, recognised that heritage was created (those parts we wish to keep or which one or more communities see as special), and provided a holistic approach to decision making.

The issue of heritage values emerged early on. Steering group papers recognised that the identification of value depends on the valuer's perspective and circumstances at the moment of valuing, and noted that few values are absolute. The was also an admission that heritage has not been inclusive and it was hoped that the review would find ways to broaden it by for example expanding official definitions to incorporate ethnic, class, age and regional/local geographic values; re-examining conventional heritage through new eyes; strengthening values attached to place and local-ness; building new approaches based on narrative-led heritage; accepting that not all of the historic environment carries positive messages and acknowledging that there is no single official narrative about the past.

In July 2000 English Heritage went out to consultation on the findings of the working groups. A simple white folder contained a booklet with twenty big questions and five discussion papers, one from each of the working groups. Because the five discussion papers were intended to provoke wider involvement in the review, they presented quite radical challenges to established ways of thinking about heritage. These were not necessarily English Heritage papers – the introduction made clear that the English Heritage facilitators had been there to collate responses rather than shape direction and that:

'Not every statement in the Papers is endorsed by all members of a Group, nor by the organisations that members work for or represent, nor indeed by English Heritage. The papers are intended to seek advice, ideas and information, and to explore new ideas and new solutions; they often set out opposing viewpoints'.[12]

The titles of the five papers – 'Understanding', 'Belonging', Experiencing', 'Enriching' and 'CarinG' (sic) – in themselves reflect the move away from the traditional heritage language of protecting and preserving, as did the simple block-colour look and feel of the design.

Understanding

Discussion paper 1 looked at the historic environment in terms of its condition, trends and future contexts.[13] The group started with a new definition of historic environment as

'all of the physical evidence for past human activity and its associations that people can see, understand and feel in the present world'.[14]

that was

'Many-faceted, relying on engagement with physical remains but also on emotional and aesthetic responses and on the power of memory, history and association'.[15]

The group recognised that the historic environment was contested territory to be argued about and debated, not simply accepted as a given, passed down from above or by our predecessors and noted that,

'People constantly remake and reinvent perceptions and interpretations of the historic environment to meet their own needs, ideas and aspirations'.[16]

The paper anticipated many of the debates that are now commonplace in heritage. It is explicit in wishing to

'Avoid giving the impression that our view of what matters in the historic environment is fixed by vested interests, unchangeable and beyond challenge. "Establishment" definitions can have the result of concealing or denying some people's pasts; officially-endorsed values can separate many people from their past'.[17]

It talks about actively seeking out challenging and conflicting interpretations of the historic environment, and the need to develop policies that recognise the existence of opposing viewpoints.

The paper embeds heritage practice in the narrative of change – looking forward to future scenarios including the impact of climate change, of changing demographics and wealth distribution, changing ideas of significance and the importance of minority cultures, and changing approaches to decision-making and subsidiarity.

It also anticipates future threats – not just physical threats but the loss of heritage because of the assumption that the past is known. It highlights the threat of loss of unwritten and minority values – many of which have yet to be understood acknowledged, as well as risks to commonplace items.

That other papers looked at the implications of that broader concept of heritage and historic environment for other aspects of public heritage practice including public involvement and access, tourism, protection and regulation, and broader policymaking.

Belonging

The group behind the second discussion paper[18] looked at public involvement and access to heritage as well as the links to cultural identity, social inclusion and citizenship, quality of life and conservation, regeneration and sustainability.[19]

The paper begins with an exploration of participation including cultural rights and identity, social inclusion, cultural diversity and citizenship and quality of life. It goes on to explore the different ways in which people participate in the historic environment now, from everyday life through to lifelong learning, tourism and the planning process and then goes on to tackle future participation. The group started with the idea that everyone in England should have the opportunity to use, delight in and draw meaning from the historic environment, and participate in its identification understanding, use and conservation. It describes a stake in the historic environment as a citizen's right.[20]

In relation to heritage values, the paper identifies one of the core challenges of heritage protection as lying in the contrast between

> 'The recognition of the wider values of the whole historic environment and the more restrictive definition that underlies national designation and the powers of local authorities – a contrast that lies at the root of many access issues'.[21]

In addition to setting a broad, ambitious and inclusive vision for participation, the paper tackles some of the practical policy challenges of widening participation – such as the operation of the planning system and the perception that planning is not inclusive, as well as gaps between professional and popular judgements on what is important. While talking about positive engagement through local activity, it also recognises that where people do not feel safe or happy, the local environment can take on a negative significance.

In terms of future policy changes, the group made the case for understanding more about why people engage and how, and the wishes and needs of those who do not participate. It talks about the importance of investing in projects that are locally relevant or community based, and argues that current institutions need better skills in order to transform policy into results. The group talked about replacing experts with involved facilitators,[22] better able to support minority and community groups, with a better understanding of different viewpoints. The group also reconsidered established ideas of heritage and changing the language around values away from academic and elitist towards one that explores alternative narratives, as well as the importance of multicultural history and heritage.

For the future, the group look towards the social and economic benefits associated with the historic environment, and taking more account of the ways historic fabric works on individual consciousness, affects feelings and behaviour, as well as how best to find a balance between academic, professional and community needs, and how best to support smaller organisations.

Experiencing

Working Group 3 looked at tourism and the historic environment.[23] The focus for the paper was not tourism itself, but

'How the historic environment can be used to create sustainable tourism and how ... to get the most from the complex and valuable interaction between tourism and the historic environment'.[24]

It looks at the complexity of heritage tourism – noting the wide range of faith bodies, private owners, museums and others who care for and open historic places to the public.

The paper sets a vision of becoming world leaders in the promotion, presentation and sustainable care of the historic environment with goals relating to involvement and partnership, greater accessibility, education and customer service, all underpinned by good conservation.[25]

It looks forward to finding new ways to present existing sites, and anticipates the idea of new sites that might become sought after in the future. It talks about alternative interpretations and more inclusive approaches. It explores reasons for exclusion and barriers to access such as lack of transport, and flags the need to pay more attention to physical access following the 1995 Disability Discrimination Act, and the potential implications for Human Rights. The downward trend in education visits, is noted.[26]

In terms of tourism trends – at the time growth was levelling, affected by the strong pound sterling, poor summers and overseas competition. Finally it notes inequities in mechanisms for support and identifies a series of future challenges around the need for better research, benchmarking performance, sustainability in tourism, the gap between revenue from tourism and the cost of maintaining heritage assets and the need for greater dialogue with bodies within and outside government which are not normally regarded as having close links to tourism but which can affect it considerably.[27]

Caring

Working Group 4 looked at regulation, procedures, protection and characterisation tackling head-on the question of what a broad vision for the historic environment set out by group 1 (Understanding) might mean in relation to the practical issues of how we identify, value, manage and use it.[28] They saw the biggest challenge as

'That we may be over-preserving some aspects of the historic environment, whilst undervaluing the general character of the whole'.[29]

As a result they felt that,

' ... (we) are in danger of passing on to the future a few well-preserved gems without any meaningful setting or background, while the great diversity and local distinctiveness of the historic environment, which is one of its chief glories, is allowed to decline'.[30]

Central to the paper was the effectiveness of existing regulatory systems which for some were slow and an impediment to development whilst for others simply needed better implementation, against a background demand for greater transparency, democratic participation and scrutiny.

The group noted that the policy implications went well beyond extending designation or streamlining procedures (the issues that had been addressed in the 1996 green paper). Instead they talked about the role of the historic environment in stimulating local economies, fostering social inclusion, enhancing the

quality of life by strengthening the sense of identity and place, promoting citizenship by empowering people and reinforcing cultural identity.

With regard to the specific legal and policy challenges of a broader definition, three concerns – how to identify and treat character, how to measure the value we place on the past (significance) and how to ensure appropriate conservation in a way that maintains character and enhances significance.[31]

The second part of the paper debates values – asking 'whose values' and exploring ways of assessing the values that underpin both designation and management, including the two main approaches - characterisation and designation.[32] This paper also notes the limitations of designation in excluding certain types of sites and values, noting that the current designation process was poor at recognising the ordinary, typical and local.[33]

Ironically, they note that districts that fell below the threshold of significance for designation as conservation areas are often those where the very fabric has a greater role to play in supporting community regeneration. They also argued that if local communities are expected to care for assets of national significance, it is surely right, conversely, that local significance should be recognised at a local level.

Looking forward, the group set a vision for responsible stewardship, and a system that is transparent, effective and sustainable which ensures that assets contribute socially, culturally and economically to the creation of strong communities and a vibrant healthy nation. It notes there is still no widely shared explicit framework for managing the built environment, but points to countries such as Australia that at the time had made significant progress in attempting to integrate the more intangible and controversial issues relating to alternative value systems and cultural property rights.[34]

It points to the need for better information and skills as critical factors in effectively managing the historic environment, and the need to understand value in decision-making. In the light of emerging technology, the paper anticipates the transfer of data to GIS systems and talks about good information management for decision-making about individual places.

It directly addresses the public interest question – the *quid pro quo* between the restrictions of designation places on private owners in the interests of society as a whole, and the role of the public purse in supporting those owners, whilst also noting that designation (eg Conservation Areas) can actually increase property values. It talks about how best to balance the non-material weirder community benefits obtained from heritage assets versus the costs to owners of maintaining those assets, and potential options for ameliorating them such as VAT reductions or direct grants.[35]

Ultimately, discussion paper 4 looks forward in the long term to a heritage management system that reflects a holistic approach to the historic environment – asking whether a radical overhaul is needed, in addition to short term measures that balance individual property rights with community interests. It looks forward to a future where it would be possible to delegate decisions to the lowest appropriate level of local government – and more say for communities – and better mechanisms for genuine debate and inclusion in local plan processes.

Enriching

Working group 5 looked at sustainability, economic and social growth,[36] following on from the government's strategy for sustainable development.[37] It starts with the question of whether the care of the historic environment is a narrow elitist interest, or something that should go beyond the sector to form part of mainstream government policy?'[38]

The move away from individual heritage assets to the wider idea of the historic environment, and the vision for conservation as a dynamic process of managing change highlighted in earlier papers, were starting points for an exploration of the social and economic benefits of the historic environment.

In relation to social benefits it looks at the role of heritage in the quality of life, and in regeneration – particularly of deprived neighbourhoods. The paper also makes the argument for conservation as a source of creativity, rather than the enemy of good new design. It notes the 'green' benefits of older neighbourhood and argues for a 'constructive dialogue between the design and conservation professions'.[39] Given the role of place in identity, the paper makes the case for the importance of taking a culturally diverse approach to place – particularly in light of new concepts of cultural rights and the impact of the Stephen Lawrence inquiry.[40] The agenda on cultural diversity then being promoted through DCMS and PAT 10 was a window of opportunity to demonstrate the relevance of heritage to everyone, through recognising and respecting community values for places.

In terms of the economic role of conservation, the paper points to the economic advantage of conservation in towns such as Cambridge and other less obvious towns like Brighton, and the relevance of conservation to the health of the property market, noting that today's controversial heritage decisions might become tomorrow's market advantage. It explores the dichotomy between the costs that fall on individual owners of older buildings and makes the case for fiscal incentives for heritage, such as equalising VAT on new build and repairs.[41] It also anticipates the case for the environmental benefits of retaining older buildings on the grounds that they contain embodied energy.

The paper argues that in light of the social and economic benefits of heritage conservation and its relevance to wider policy areas such as sustainable development, place-making, regeneration, town centre renewal, and creativity, there is a case for responsibility to be spread across more than one government department.[42]

But changes are also needed in the sector – given the social relevance of heritage, it anticipates that new skills mediation or working with community groups may become as important as technical skills or knowing about historic building materials for conservators of the future, and that we need to consider whether heritage organisations are adequately equipped with the staff or attitudes to tackle diversity. It also talks about a model vision for conservation, requiring new ways of working with professionals working across disciplines.

Additionally, it talks about the importance of better understanding of the state of the historic environment, a stronger role for the voluntary sector, and a better link to intangible heritage – all of which is needed if,

> conservation of the historic environment is to play a more constructive role in economic and social life.[43]

 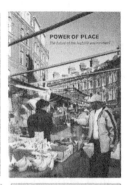

Power of Place

As part of the attempt to widen out the debate about the role of the past in contemporary society, the folder of five discussion papers was sent to around 3500 organisations and individuals – who went well beyond conservation and heritage interests. Six hundred written responses were received, and those responses, the original papers and the results of the MORI survey of public attitudes to heritage and the value they place on it from a

representative sample of 3000 people, collectively informed English Heritage's final review, published in December 2000.

Entitled *Power of Place – the future of the Historic Environment*, the look and feel was very different to the DNH's *Protecting our Heritage*. It used a sans serif font, the cover featured people in a historic setting (the market at Electric Avenue Brixton, an urban conservation area) and images of industrial and urban places, modern design in historic places and second world war remains. There are almost no people in *Protecting our Heritage* whereas *Power of Place* includes images of a diverse range of people doing or taking part in heritage activities, or in historic places.[44]

Although the introduction makes clear that this too is not an English Heritage report,[45] the radicalism of the policy papers has been tempered by the need to engage the more pragmatic levers of policy. The concept of historic environment – what it is, why it matters and what that means for the future – drives the recommendations for policy and practice that follow. Historic environment or place is described as,

> 'what generations of people have made the places in which they lived ... most of our towns and cities and all of our countryside, are made up of layer upon layer of human activity. Each generation has made its mark'.[46]

People experience it in different ways, as a place to live, to enjoy or to work. But it is not static – places have to evolve, react and grow. The second key point is about change. Whilst people value their historic environment, this does not represent resistance to change – indeed most people see change as necessary and desirable. In terms of place,

> 'good new building, high quality design, thoughtful planning, intelligent land use are objectives in their own right'.

And yet the paper recognises the complex dynamic around change and loss:

> 'The future is not secure. In the past 50 years much development simply ignored or trampled through its context in city, town or countryside'.

It talks about the impact of agricultural policy, traffic, and poor design on places and thus the quality of life, quoting Kim Wilkie who said that

> 'A sense of continuity does not have to stop new ideas – just the opposite. The deeper the root, the greater the range of nutrients'[47]

In this context, it is clear that places need to evolve, react and grow, but decisions need to be based on understanding and information, and

> 'largely rest upon value judgements which must be consistent, transparent and never arbitrary. They need to be widely accepted. This means that they need to be understood. They must be made openly, tested and refined by continuing debate. This debate must not be exclusive; everyone should be able to participate'[48]

The core issues defined by the paper are around unlocking the value of conservation-led renewal; the idea of reinvestment and the wealth created by caring for the historic environment and the value of maintenance. Section 2.4 about people and place is about reflecting the wider values of the historic environment, recognising the people want to take part in decision, but many feel powerless and excluded, their personal

heritage does not seem to be taken into account by those who take decisions and notes that

> 'If the barriers to involvement can be overcome, the historic environment has the potential to strengthen the sense of community and provide a solid basis for neighbourhood renewal. This is the power of place.'[49]

Section 5 is about managing change and enhancing character, section 2.6 about the value of knowledge and 2.7 leadership. Finally there are actions for government, for the heritage sector, local authorities and regional bodies, and owners.

But where *Protecting our Heritage* sought to improve the selection of sites for designation, *Power of Place* barely mentions designation. Instead most of the policy recommendations are grounded in the environment, design, place and land-use planning system operated by local authorities or other government departments dealing with issues such as agriculture, transport or regeneration. Here the policy levers are things like the regional regeneration agenda, economic policy, land-use planning policies, and decision making, operated by local authorities and other government departments or agencies such as the environment, transport, agriculture or the new regional bodies. Even when talking about the value of heritage, ideas about character – what makes places distinctive – rather than 'national importance' predominate. *Power of Place* is also less strong on other areas of English Heritage's remit at the time – e.g. opening sites to the public, education, or interpretation.

This reflects the nature of the original commission – DCMS working with DTLR – so there is less engagement across DCMS areas of remit, but greater engagement between the two. DTLR were responsible for local authorities, the environment and the then emerging regional planning agenda, so it is likely that the writers of *Power of Place* took the opportunity to position heritage in what are core areas of interest for that ministry.

A Force for Our Future

In response, DCMS and DTLR issued a joint statement entitled '*A Force for our Future*'.[50] This represented clear government commitment to the historic environment, seeing the heritage sector as

> something of a sleeping giant both in cultural and economic terms. We need to find new ways of reaching and empowering excluded individuals and communities. We need to develop new policies to realise economic and educational potential through modernised structures and improved service delivery.[51]

It also talks about going beyond legislation to use the many different policy instruments including funding, policy guidance delivery mechanisms, reprioritisation and partnership working and sets an ambitious vision to deliver on the historic environment's contribution to contemporary life:

> more attractive towns and cities, a prosperous and sustainable countryside; world class tourism attractions; new jobs; and learning, vibrant and self-confident communities.[52]

There is a new vision of the historic environment as a totality, the imprint of history on the environment shaped by collective memory and a layering of experiences, with local

distinctiveness and identity, and it describes the interplay between the different ways that people experience the historic environment – learning, as a visitor, as a place of work or home, or a contributor to overall quality of life. It talks about the complexity of interests involved with individuals, communities, visitors owners, the voluntary sector, business, local and central government.

This is a policy for the whole of government, embedding the historic environment not only within DCMS and DTLR, but in the work of the Department for Environment, Food and Rural Affairs (DEFRA). It is genuinely a cross-Whitehall approach – but with an explicit link to the remit of Green Ministers.[53]

A Force for our Future also uses the broader definition of the historic environment, going beyond designated assets to see it as something which all sections of the community can identify with and take pride in, rather than something valued only by narrow specialist interests.

The idea of the historic environment as an educational resource has much greater prominence, perhaps reflecting the strategic priorities that the Secretary of State had set for DCMS as a whole following the PAT 10 review asking them to enhance access to a fuller cultural and sporting life for children and young people, open up institutions to the wider community, maximise the contribution of tourism, creative and leisure industries to the economy and modernise delivery by ensuring that sponsored bodies are set and meet targets that put the customer first.[54] The original PAT 10 work had looked at the role of arts and sports in social inclusion, and there was an intention to follow up on heritage.

Notably, within *A Force for our Future*, inclusion is,

> not simply about going to people and telling them what they ought to know; it is about listening to them and discovering what they themselves are interested in and regard as important.[55]

One of the case studies was the Hackney Building Exploratory set up in one of the poorest boroughs in London to explore the local area, and *A Force for our Future* acclaimed it as a place where professionals can learn from the experience of local residents. The section on including and involving people goes beyond conventional discussions about physical access, to address the need to respond to people who feel that aspects of the past to which they themselves attach importance have been overlooked or under-valued. In the recommendations, English Heritage is asked to get more involved in Creative Partnerships, the Attingham Trust work on learning[56] as well as professional skills – craft skills and skills in heritage interpretation and managemen. The paper also anticipates a futurepolicy document that would explore the role the historic environment might play in combatting social exclusion through life-long learning, volunteering and regeneration.

Legacy

It is beyond the scope of this paper to document the full impact of either *Power of Place* or *A Force for our Future* on heritage policy and practice over the past 20 years. As the coordinator Graham Fairclough presciently noted, this was a 25 year project. And even if it were possible to trace the impact of the fifty-four recommendations in *A Force for our Future*, this would overlook the bigger point that the whole exercise, including the

discussion papers and *Power of Place* itself, simply provides a snapshot of thinking about heritage practice in England at a particular moment in time.

That snapshot captures what were, at the time, the big philosophical issues in heritage practice – the move from heritage as a set of individual protected assets to wider concepts of place and identity, more inclusive approaches to value, a more strategic understanding of what was happening to the historic environment, and the drive to position cultural heritage more firmly in wider economic, social and indeed environmental agendas through understanding value.

Many of those philosophical issues had their roots in practices that had developed over the previous thirty years, are still developing today. This can be illustrated through three examples of policy themes that emerged from *Power of Place* and *A Force for our Future* – the collection of data and reporting on the historic environment as a whole (including patterns of loss); the move to place-based thinking and economic regeneration, and the drive for more transparent, informed decision-making in heritage.

Data and Reporting on the Historic Environment

Both *Power of Place* and *A Force for our Future* made specific recommendations about the need for better data and reporting on the historic environment, to inform policy. In response, English Heritage produced the first State of the Historic Environment Report in 2002. Known later as 'Heritage Counts', the initial aim was to quantify historic environment assets of all kinds – whether designated or not – and report on what was happening to them through a series of indicators, reflecting similar loss-based reporting in the natural environment. In practice, the reports went beyond loss from the outset, presenting wider data on the historic environment including economic benefits delivered through tourism, employment, regeneration and sustainable development, and information on the social benefits including outreach, knowledge and access as well as public attitudes to the historic environment and data relating to direct involvement of the public in protecting the historic environment. Part 4 of the 2002 *Heritage Counts* report for example, included data on national, regional and local government administration, resourcing and employment in an attempt to capture the scale of the sector. Since then *Heritage Counts* has been published every year – initially divided in to regional reports (to mirror the then regional agencies and devolved administrations) and later nationally, albeit with annual themes.[57]

As with the other ideas in *Power of Place*, this was not new. *Heritage Counts* replaced *The Heritage Monitor* which contained data about the performance of heritage attractions and had been published by the English Tourism Council over the previous 25 years[58]. The voluntary campaigning body SAVE had long been targeting buildings at risk, publishing an annual catalogue from the early 1990s and had a dedicated buildings at risk officer.[59] During the 1990s English Heritage had also been systematically analysing patterns of loss; in 1990–1 it set out to survey some 43,000 listed buildings to understand their condition but also to gain wider insight into the character of listed buildings as a whole and their location. A new strategy targeted resources at buildings at risk[60], whilst a systematic survey of Monuments at Risk in 1995 was published in 1998.[61]

Place-based Thinking

A second major philosophical trend was around the move from the idea of heritage as a series of individual protected buildings and monuments to a wider place-based/whole historic environment approach which explicitly challenges the model of heritage as individual designated assets. Character or place-based thinking had its origins in the creation of conservation areas in the 1960s, enshrined in the Civic Amenities Act of 1967. But this move towards place was also apparent across other fields of heritage practice; landscape management plans were often based on character areas, whilst English Heritage was using archaeological characterisation as an alternative approach to designation. Tourism practitioners were adopting 'Destination Management' approaches to place, whilst in architecture and urban design, 'Placemaking' was emerging as a theme.

In policy terms, this place-based thinking played out through building a stronger alliance between heritage and urban regeneration.

In 1997 the government had created Regional Development Agencies (RDAs) to tackle social and physical regeneration in the regions with the aim of attracting inward investment, raising skills, improving derelict land and supporting new businesses in rural communities. By 1998 English Heritage had positioned itself as a national regeneration agency showing how investing in heritage could deliver the economic benefits that the government was looking for launching the new Heritage Economic Regeneration schemes.[62] English Heritage published its first *Heritage Dividend* report in 1999, capturing the impact of heritage regeneration; the second report in 2002 made a strong case for investing in heritage in order to drive regeneration, and in later years the report was published on a regional basis in order to align more closely with the work of the RDAs.[63] English Heritage, the Heritage Lottery Fund (now the National Lottery Heritage Fund) and the RDAs joined forces to capitalise on the regeneration of conservation investment in more deprived areas, where other forms of investment are not necessarily forthcoming and where heritage investment can lead the way, acting as a catalyst for other partners.

Transparent Decision-making

A third trend that emerged in the years after the publication of *Power of Place*, was the move towards a more open, transparent and inclusive decision-making framework for heritage, particularly as it played out in the land-use planning system, which was a core recommendation in *Power of Place*. In relation to English Heritage policies, the intellectual successor to the ideas in *Power of Place* were the *Conservation Principles* and the wider Constructive Conservation approach.[64]

As noted elsewhere in this volume[65] the *Principles* are not about selecting *what* to protect, but more about how to make decisions about and manage things that are important. They break down the divisions between buildings and sites, avoid the terms 'listed buildings' or 'scheduled monuments' – using 'place' as a proxy for any part of the historic environment including under the ground or sea, 'that people perceive as having a distinct identity'.[66] They also stretch other established definitions such as fabric.

Like *Power of Place*, they ground historic environment conservation in the language of sustainability noting that

> each generation should therefore shape and sustain the historic environment in ways that allow people to use, enjoy and benefit from it, without compromising the ability of future generations to do the same.[67]

They set out a transparent approach to decision-making based on understanding the values that represent a public interest in places, regardless of ownership, arguing that it is this public interest which justifies the use of law, public policy, and public (although not necessarily private) investment. A more nuanced exploration of significance in heritage decision-making distinguishes the values that underpin designation from the wider range of values that are relevant to day to day management,[68] noting the importance of engaging with owners, communities as well as specialists, and acknowledging that different people and communities attach different weight to the value of places.[69]

The *Principles*, and indeed *Power of Place*, underpin what became the English Heritage (now Historic England) concept of 'constructive conservation' and the virtuous circle that placed understanding and value at the heart of conservation.

A Tale of Two Policies

In retrospect, 2008 was a momentous year for heritage policy in England marked by two major initiatives.

In the same year that the *Conservation Principles* document was published, the UK government issued a draft Heritage Protection Bill.[70] Just two years after the publication of *Force for our Future*, the Secretary of State had announced a review of the heritage protection legislation and issued suggestions for reforming the legislation in the consultation document *'Protecting our historic environment: Making the system work better'*.[71] The subsequent *Review of Heritage Protection: The Way Forward* recommended a single register of historic sites and buildings to be set out in new legislation.[72] That draft bill was in effect the policy successor to the pre-*Power of Place* 1996 document, *Protecting our Heritage*.

The draft bill took forward the idea of a single heritage register that would merge listed, buildings, ancient monuments, heritage open spaces and perhaps historic landscapes into one form of designation; the bill also contained proposals for a unified consent regime known as 'heritage asset consent'. In relation to post-designation management, there were proposals for heritage partnership agreements or management agreements for complex assets, reforms to class consents, and a new duty on local authorities to hold Historic Environment records. There was provision of protecting assets of special local interest and new powers for English Heritage in relation to listing. In the end it was not possible to find parliamentary time for the new Bill.

Although the *Principles* and the *Bill* were written to fit together (the *Conservation Principles* anticipate a single heritage register for example) they emerged from two very different streams in heritage thinking.

The *Principles* were grounded in the challenging of managing development in and around important sites and places, where there are always conflicting values and different approaches, where the distinctions between building, place and site break down, and

where so-called experts were often at odds with communities. It is a space of multiple players – local authorities, businesses, community groups, owners – as well as multiple disciplines – biodiversity, planning, architecture, new design – that spilled out beyond the limits of what was formally protected, to engage with all of the debates about placemaking.

In contrast, the draft bill and the consultations that preceded were primarily about designation – the process of selecting assets for protection – and the implications that changing that might have for the operation of the subsequent consent regime, inspired by the debates that raged around modern movement listing, and also the move towards a more integrated approach to heritage.

But as well as covering different issues, behind each is a very different approach to value. The values that underpin conservation decisions as set out in the *Principles* are essentially about the wider public interest in place as it plays out in the planning system – which does not always fit easily into the narrow range of values used in designation in the Bill, where the aim is to select the best and most outstanding examples of a genre for protection.

In the end, there was no legislative time to take the bill forward. Although this was seen as a major set-back at the time, looking back a decade later, Rob Lennox argues that the financial crisis of 2007–8 was more important. In his overview of heritage policy development during this period, he notes that the political and economic shifts that followed the 2008 economic crash had a more significant impact on heritage policy than is often realised. After 2008, some parts of the sector questioned those earlier approaches, and many of the attempts to create a more inclusive approach to heritage within the land-use planning system at least, fell by the wayside.[73]

The National Lottery Heritage Fund

In a way, the real legacy of the inclusivity of *Power of Place* lies in the work of the National Lottery Heritage Fund (formerly the Heritage Lottery Fund). Founded in 1994, the Fund had a much broader remit than English Heritage, covering Scotland, Wales, Northern Ireland and England, with a broad definition of heritage that encompassed built and natural environment, collections and intangible heritage (and thus the work of a wide range of other natural and cultural heritage agencies including museums). The Fund has no regulatory role in land-use planning or the environment, and so has been freer support heritage that has not been designated but where those heritage assets contribute to the character and overall heritage value of an area.

The 2002 *Strategic Plan* set funding priorities that were (and still are in subsequent strategic plans) very much on the same lines as *Power of Place*, based on a very broad concept of what heritage is, a recognition of the importance of the widest possible audiences for heritage and a drive to increase active public involvement in heritage.[74] The plan widens out the definition of heritage used by the Fund to include biodiversity – in other words both cultural and natural heritage. In a first for the UK it is also explicitly able to fund projects that involve intangible heritage. Recognising that many applicants for HLF funding are community groups, there is more support for training and project development. This reflects the

strength of the voluntary sector in the UK. The fund had also just launched the pioneering Young Roots programme, that brought together youth organisations and heritage groups to deliver projects, pushing a new degree of partnership and cross sector working – again very much in the partnership tradition of *Power of Place* and *A Force for our Future*.

Conclusion

It is well beyond the scope of this paper to provide a comprehensive assessment of the impact and legacy of *Power of Place*, in part because there are so many different policy threads to trace – from place-making and data, to values and decision-making, and indeed to core concepts of heritage. It is also not straightforward, as some impacts will be quite visible – for example the influence of *Power of Place* (or at least the heritage thinking that lay behind it) can be seen in the 2005 Council of Europe *Faro Convention on the Value of Cultural Heritage for Society*, with its emphasis on the relationship between heritage human rights and democracy, a wider definition of heritage, and the core role of meaning and value in heritage. But other impacts will be harder to trace – such as the personal impact that the experience of being part of the whole exercise has had on the heritage practice of the individuals involved.[75]

Instead, the purpose of the paper is to draw attention to the process of making public heritage policy. The UK Civil Service *Policy Profession Standards* describe the skills and knowledge required by policy professionals at all stages of their career. They note that policy-creation involves a complex interplay between evidence, delivery and politics, and that the art of policy-making is to navigate those three often opposing points of the triangle.[76] It is often easy to assume that evidence or ideas alone are sufficient to drive policy change – the history of *Power of Place* shows that this is self-evidently not the case.

Policy-making is usually anonymous activity; it is rarely possible to write the biography of a policy, tracing its genesis from inception to delivery, through evaluation to quiet demise and its replacement by something else. The publications relating to the *Power of Place* initiative – from the five steering group papers, through the report to DCMS, the government response and some of the subsequent policy initiatives – provide a rare insight into the policy-making journey.

Amongst other things, those working papers show clearly that policy ideas evolve. Many of the ideas that informed *Power of Place* – such as the move in heritage practice from the focus on site to wider concepts of place and character – can be traced back to policy thinking from the 1960s and earlier. It reminds us that *Power of Place* was not, in and of itself, original, but instead a snapshot in time – a rare moment at which a set of policy ideas that had been evolving over decades of heritage practice were set down.

The five working group papers behind *Power of Place* are also a forceful reminder that our contemporary concerns, are not new. Those who work within public heritage policy or practice, responsible to democratically elected ministers or local authorities, are often criticised for narrow, elitist, expert views of heritage. The discussion papers show that the heritage practitioners behind *Power of Place* in the late 1990s were equally frustrated; they were committed to moving away from what felt to them like a creaky and outdated system, including what *they* saw as narrow and elitist views of the past.

The two initiatives together – *Power of Place* and the 2008 *Bill* – also show that in practice, the process of developing policies around what to protect and why – in effect articulating a public interest in property regardless of ownership – is not a simple problem of academic elitism (however that is defined). The draft 2008 *Bill* did indeed take on board expert ideas about how best to select what to preserve – but this was in the light of controversy around attempts to push the boundaries of what was then seen as heritage by protecting twentieth century modern movement architecture. It was also put forward in the context of the acknowledgement that many of the heritage silos created by individual academic disciplines such as archaeology, architecture and landscapes, have little meaning when dealing with places that encompass all of these. And as *Power of Place* shows, that articulation of what to protect and how best to do so (and indeed the wider articulation of value), also sits beside, and responds to, broader policy issues such as place-making, regeneration, inclusive working, involvement, working with young people and broader narratives about both heritage and value.

In conclusion, this paper has simply tried to draw attention to an important and often overlooked, historical heritage policy initiative, that set out to create a wider and more inclusive approach to heritage, that challenged perceptions of value and concepts of heritage, and that sought to connect heritage to wider social, economic and even environmental agendas. If nothing else, the story of *Power of Place* shows that it is one thing to have a clear and even collective vision of how heritage ought to be But a vision is not enough. In reality, the juggling act of policy development goes well beyond ideas. As the policy standards note, it involves keeping all three balls in the air at once – evidence, delivery and politics. And it is that – rather than great ideas – which makes policy so interesting.

Notes

1. House of Commons Culture, Media and Sport Committee, *Sixth report*.
2. Department of National Heritage and the Welsh Office. *Protecting Our Heritage*.
3. Requests from members of the public had led to the first post-war buildings being listed in 1987 and from 1992 English Heritage had begun a more thematic survey of post-war buildings. A series of events and publications including two travelling exhibitions demonstrated the richness of Britain's building stock from the 1950s and early 1960s, and since 1995 member of the public had been invited to comment on specific recommendations for listing. English Heritage, *Something worth keeping?*
4. Cabinet Office, *Bringing Britain together*; and Cabinet Office, *Policy action team audit*.
5. United Nations Conference on Environment and Development, *Rio Declaration*; English Heritage, *Sustaining the historic environment*; and Department of the Environment, Transport and the Regions, *A better quality of life*.
6. Department of the Environment, *Planning Policy Guidance 15*; English Heritage, *Buildings at risk*; English Heritage, *Monuments at risk*; and English Heritage, *Conservation-led regeneration*.
7. Government's Review of Policies Relating to the Historic Environment: An Invitation to Participate. Letter requesting views on the review and the working groups issued by English Heritage on 1 February 2000.*Our questions for you. Discussion paper 1.* **Understanding**. *The historic environment: condition, trends and future contexts. Discussion paper 2.* **Belonging**. *The historic environment: public involvement and access. Discussion paper 3.* **Experiencing**. *Tourism and the historic environment. Discussion paper 4.* **CarinG**. *The*

historic environment: regulation, procedures, protection and characterisation. Discussion paper 5. **Enriching**. The historic environment: sustainability and economic and social growth.
8. Ipsos MORI, *What does heritage mean.*
9. Internal working note.
10. Ibid.
11. Tabled notes from an internal Steering Group Meeting, 25 April 2000.
12. English Heritage, *Review – Our questions for you*, 5.
13. The group was chaired by Jane Grenville of the University of York and facilitated by Martin Cherry. Twenty three external members worked with ten English Heritage staff and two DCMS observers. Members included academics, voluntary sector, local authorities and government with knowledge of museums, natural heritage, parks, maritime heritage, archaeology, arts, culture and buildings.
14. English Heritage, *Review – Understanding*, 5.
15. Ibid., 5.
16. Ibid., 5.
17. Ibid., 7.
18. Chaired by Dr Kate Pretty – an educator who had played a pioneering role in involving young people in archaeology – and facilitated by Anna Eavis, the 22 external members included voluntary campaign bodies such as Common Ground, museums, gardens and local authorities.
19. English Heritage, *Review – Belonging*.
20. Something that was later reflected in the Council of Europe *Faro Convention*.
21. English Heritage, *Review – Belonging*, 5.
22. Ibid., 11.
23. Chaired by Michael Elliot of the Heart of England Tourist Board, and facilitated by regional properties director Chris Young. The 22 external members included tourism organisations, local authorities, groups such as the Sensory Trust, national parks and independent museums.
24. English Heritage, *Review – Experiencing*, 5.
25. Ibid, 7.
26. Ibid., 8.
27. Ibid., 11.
28. Chaired by David Holgate QC and facilitated by(then) historic buildings inspector Carol Pyrah with 34 external members covering legal, planning, conservation, civic engagement, design, landscape in the voluntary, public and private sectors.
29. English Heritage, *Review – CarinG* (sic), 5.
30. Ibid., 5.
31. Ibid., 6.
32. Ibid., 7.
33. Ibid., 8.
34. Ibid., 9.
35. Ibid., 10.
36. Working Group 5 was chaired by Tony Burton (then at the Council for the Protection of Rural England) with 27 external members including faith groups, design, property, regeneration, voluntary sector, and others. The author of this paper was the internal English Heritage facilitator.
37. Department of the Environment, Transport and the Regions, *A better quality of life*.
38. English Heritage, *Review – Enriching*, 5.
39. Ibid., 7.
40. The Stephen Lawrence Inquiry followed the murder of a black British student in 1993, raised issues of institutional racism. https://www.gov.uk/government/publications/the-stephen-lawrence-inquiry.
41. English Heritage, *Review – Enriching*, 10,11.
42. Ibid., 14.

43. Ibid., 16.
44. English Heritage, *Power of Place*.
45. Ibid., 1.
46. Ibid., 4.
47. Ibid., 5.
48. Ibid., 4.
49. Ibid., 23.
50. Department for Culture, Media and Sport and Department for Transport, Local Government and the Regions. *A force for our future*.
51. Ibid., 4.
52. Ibid., 5.
53. Ibid., 12.
54. The original PAT 10 report is not available on line, but the progress report from February 2001 can be found at https://webarchive.nationalarchives.gov.uk/+/http:/www.culture.gov.uk/PDF/social_inclusion.pdf.
55. Department for Culture, Media and Sport and Department for Transport, Local Government and the Regions. *A force for our future*, 30.
56. Waterfield, *Opening Doors*.
57. English Heritage *Heritage Counts*, These are annual reports first published in 2002 as *State of the Historic Environment*.
58. English Tourism Council, *The Heritage Monitor*.
59. SAVE, "Buildings at Risk Register".
60. English Heritage, *Buildings at risk*.
61. English Heritage, *Monuments at risk survey*.
62. English Heritage, *Conservation led regeneration, Heritage dividend*. Again this was not new – the roots can be raced back to the Conservation Areas Partnerships scheme of 1995, designed to prioritise support to the 8000 or so conservation areas across England, putting the onus on local authorities to work together with owners.
63. English Heritage, *Heritage Dividend*.
64. English Heritage, *Conservation Principles; Constructive conservation*.
65. Chitty and Smith, "Principles into Policy".
66. English Heritage, *Conservation Principles*, 13.
67. Ibid., 19.
68. Ibid., 31.
69. Ibid., 67.
70. House of Commons, *Draft heritage protection bill*.
71. Department for Culture, Media and Sport, *Making the system work better*.
72. Department for Culture, Media and Sport, *Review of heritage protection*.
73. Lennox, *Heritage and Politics*, 239.
74. Heritage Lottery Fund, *Broadening the horizons of heritage*.
75. Council of Europe, *Convention on the value of cultural heritage*.
76. Policy Profession, *Standards 2019*.

Disclosure statement

Note that the author was involved in the review as a working group facilitator.

Bibliography

Cabinet Office. *Bringing Britain Together: A National Strategy for Neighbourhood Renewal*. Report by the Social Exclusion Unit. London: HMSO, 1998.

Cabinet Office. *National Strategy for Neighbourhood Renewal: Policy Action Team Audit*. Report by the Social Exclusion Unit. London: HMSO, 2001.

Chitty, G., and C. Smith. "Principles into Policy: Assessing the Impact of *Conservation Principles* in Local Planning Policy." *The Historic Environment: Policy & Practice* (2019). doi:10.1080/17567505.2019.1652401.

Civic Amenities Act, 1967. https://www.legislation.gov.uk/ukpga/1967/69/contents.

Council of Europe. *Convention on the Value of Cultural Heritage for Society*. Brussels: Council of Europe, 2005. https://www.coe.int/en/web/culture-and-heritage/faro-convention.

Department for Culture, Media and Sport. *Building on PAT10. Progress Report on Social Inclusion*. London: DCMS, 2001. https://webarchive.nationalarchives.gov.uk/+/http:/www.culture.gov.uk/PDF/social_inclusion.pdf.

Department for Culture, Media and Sport. *Protecting Our Historic Environment: Making the System Work Better*. London: HMSO, 2003.

Department for Culture, Media and Sport. *Review of Heritage Protection: The Way Forward*. London: HMSO, 2004.

Department for Culture, Media and Sport. *Heritage Protection for the 21st Century*. London: HMSO, 2007. https://www.gov.uk/government/publications/heritage-protection-for-the-21st-century-white-paper.

Department for Culture, Media and Sport and Department for Transport, Local Government and the Regions. *The Historic Environment: A Force for Our Future*. London: HMSO, 2001. https://webarchive.nationalarchives.gov.uk/±/http://www.culture.gov.uk/reference_library/publications/4667.aspx.

Department of National Heritage and the Welsh Office. *Protecting Our Heritage: A Consultation Document on the Built heritage of England and Wales*. London: HMSO, 1996.

Department of the Environment. *Planning Policy Guidance 15: Planning and the Historic Environment*. London: HMSO, 1994. https://www.periodproperty.co.uk/pdf/Planning_Policy_Guidance_15_Sept_1994.pdf.

Department of the Environment, Transport and the Regions. *Building a Better Quality of Life - a Strategy for Sustainable Development for the United Kingdom*. London: Stationery Office, 1999.

English Heritage. *Conservation Area Partnerships*. London: English Heritage, 1995.

English Heritage. *Something Worth Keeping? Post-War Architecture in England - Churches, Civilc Buildings, Bridges, buildings for Health Care, Higher Education*. London: English Heritage, 1996.

English Heritage. *Sustaining the Historic Environment*. London: English Heritage, 1997.

English Heritage. *Buildings at Risk: A New Strategy*. London: English Heritage, 1997.

English Heritage. *The Monuments at Risk Survey of England 1995*. London: English Heritage, 1998.

English Heritage. *Conservation-led Regeneration - the Work of English Heritage*. London: English Heritage, 1998.

English Heritage. *The Heritage Dividend*. London: English Heritage, 1999.

English Heritage. *Review of Policies Relating to the Historic Environment: We Want Your View Point*. London: English Heritage, 2000.

English Heritage. *Power of Place: The Future of the Historic Environment*. London: English Heritage, 2000.

English Heritage. *State of the Historic Environment Report 2002 - Supporting Evidence*. (Later Published as Heritage Counts). London: English Heritage, 2002.

English Heritage. *The Heritage Dividend*. London: English Heritage, 2002.

English Heritage. *Conservation Principles*. London: English Heritage, 2008. https://historicengland.org.uk/images-books/publications/conservation-principles-sustainable-management-historic-environment/.

English Heritage. "Constructive Conservation." Historic England. 2008b. Accessed September 9, 2019. https://historicengland.org.uk/advice/constructive-conservation/

English Tourism Council (previously English Tourism Board). *The Heritage Monitor, 2000-1*. London: English Tourism Council, 2001.

Heritage Lottery Fund. *Broadening the Horizons of Heritage. The heritage Lottery Fund Strategic Plan 2002-2007*. London: Heritage Lottery Fund, 2002.

House of Commons Culture, Media and Sport Committee. *Sixth Report: DCMS and Its Quangos. Session 1998-9*. London: HMSO, 1999. https://publications.parliament.uk/pa/cm199899/cmselect/cmcumeds/506/50602.htm

House of Commons Culture, Media and Sport Committee. *Draft Heritage Protection Bill*. CM 7349. Norwich: OPSI, 2008. https://www.gov.uk/government/publications/draft-heritage-protection-bill

Ipsos MORI. "What Does Heritage Mean to You?" 2000. https://www.ipsos.com/ipsos-mori/en-uk/what-does-heritage-mean-you

IUCN, UNEP, WWF. *Caring for the Earth: A Strategy for Sustainable Living*. Switzerland: Gland, 1991.

Lennox, R. "Heritage and Politics in the Public Value Era: an analysis of the historic environment sector, the public, and the state in England since 1997." PhD Thesis, University of York, Archaeology, 2016.

Office of the Deputy Prime Minister. *Sustainable Communities: Building for the Future*. London: Office of the Deputy Prime Minister, 2003. https://webarchive.nationalarchives.gov.uk/20060502112859/http://www.odpm.gov.uk/index.asp?id=1139873

Policy Action Team (PAT). *National Strategy for Neighbourhood Renewal: Policy Action Team Audit*. London: Cabinet Office, 1999. https://dera.ioe.ac.uk/9947/1/National_strategy_for_neighbourhood_renewal_-_Policy_Action_Team_audit.pdf'

Policy Profession. "Policy Profession Standards 2019 - a Framework for Professional Development." https://civilservicelearning.civilservice.gov.uk/sites/default/files/2016-12-21_policy_profession_standards_v3.3.pdf

SAVE. "Buildings at Risk Register." https://www.savebritainsheritage.org/buildings-at-risk/

United Nations Conference on Environment and Development. *The Rio Declaration on Environment and Development*. 1992. www.unesco.org/education/pdf/RIO_E.PDF

Waterfield, G. *Opening Doors: Learning and the Historic Environment*. London: Attingham Trust, 2004.

Appendix

FREE CONSERVATION LEAFLETS PRODUCED BY ENGLISH HERITAGE

This list provides a snapshot of key policy issues for English Heritage in 2000, as a context for understanding the heritage policy context in 2000. The list is based on an internal typescript 'List of free conservation leaflets currently held by interactive/customer services, January 2000', which lists the leaflets in alphabetical order without publication dates. The table below is based on that list, supplemented with additional publications from an earlier 'Catalogue of Free Conservation Publication:The work of English Heritage', published in March 1997. The table below uses the dates given in that catalogue, and leaflets have been grouped into the categories used in the catalogue. Items in italics are consultation documents rather than published policies or guidance.

Category	Title	Date
Work of English Heritage	Listing buildings	1997
	Scheduling monuments	1997
	Protecting archaeological sites	1997
	Looking after places of worship	1997
	Looking after historic buildings	1997
	Looking after conservation areas	1997
	Monuments protection programme: introduction	1997
	Monuments protection programme 1986-96 in retrospect	1996
	Register of parks & gardens: an introduction	1992
	Battlefields: the proposed register of historic battlefields	1994
	Work on historic churches: the role of English Heritage	1994
	Conservation-led regeneration: The work of English Heritage	1998
Archaeology	Archaeometallurgy in archaeological projects	1995
	Ancient monuments in the countryside	nd
	Archaeology of stone	
	Archaeology Review: an annual review of English Heritage's archaeological activities	Annual
	Conserving the inheritance of industry: English Heritage grants for industrial archaeology	1995
	Development plan policies for archaeology	1992
	England's coastal heritage: a statement on the management of coastal archaeology	1996
	Exploring our past	1991
	Frameworks for our past: a review of research frameworks, strategies and perceptions	1996
	Geophysical survey in archaeological field evaluation	1995
	Guidelines for the care of waterlogged archaeological leather	1995
	Identifying & protecting palaeolithic remains	1998
	Industrial archaeology: a policy statement by English Heritage	1995
	Management of archaeological projects 2nd edition	1991
	Medieval ceramics studies in England	1994
	Planning for the past volume 1: a review of archaeological assessment procedures in England 1982-91	1995
	Protecting archaeological sites	
	Reconstructing the past	1995
	Rescue excavations 1938 to 1972	1994
	Rescue archaeology funding: a policy statement	1991
	Scheduled monuments: a guide for owners and occupiers	1996
	Users of metal detectors: advice about scheduled ancient monuments and protected archaeological areas	1985
	Waterlogged wood: guidelines on the recording, sampling, conservation and curation of waterlogged wood	1996

(*Continued*)

(Continued).

Category	Title	Date
Conservation areas and historic towns	Conservation area appraisals: defining the special architectural or historic interest of Conservation Areas	1997
	Conservation area character appraisals: consultation draft	1996
	Conservation area partnership scheme: a consultation paper	1993
	Development in the historic environment	1995
	Enabling development and the conservation of heritage assets: policy statement	2000
	Conservation Area practice	1995
	Shopping in historic towns: a policy statement	1990
	Street improvements in historic areas	1994
	Conservation area partnerships schemes: leaflets 1-7	1994-7
Grants	Acquisition grants to local authorities to underwrite repairs notices	
	Repair grants: a guide to repair grants from English Heritage	1994
	Historic buildings and monuments grants: notes for applicants	1992
	Repair work and grants from English Heritage: types of work which may qualify	1994
	Survey grants for presentation purposes	1994
	Repair works and buildings at risk grants	1995
	English Heritage grants for buildings at risk (a set of three)	1995
	A technical guide to repair work and grants from English Heritage	1997
	Joint grant scheme for churches & other places of worship: notes for applicants and technical guide (with Heritage Lottery Fund)	1996
	Claiming payment of English Heritage grant	1995
	Grants to local authorities to underwrite Urgent Works Notices	
	Guidance notes for applicants: English Heritage grants for the repair and conservation of historic buildings, monuments, parks and gardens 1999-2002	1999
	Grants 1984-92. A list of repair grants offered by English Heritage to buildings and monuments of outstanding national importance	1994
Fire Safety	Timber panelled doors & fire	1997
	The use of intumescent products in historic buildings	1997
Fire Safety in Cathedrals	Fire safety management in cathedrals	1997
	Evacuation of visitors from cathedrals in the event of fire	1997
	Prevention of loss or damage by fire in cathedrals	1997
	Smoke detection systems for cathedrals	1997
London	Mansard roofs	1989
	Archaeology & planning in London: archaeology and planning advice in London and the Greater London Sites and Monuments Record	1993
	Capital archaeology	
	Dormer windows	1991
	Georgian joinery 1660-1840	1993
	London terrace houses 1660-1860: a guide to alterations and extensions	1996
	Twentieth century war memorials in central London	
	On the trail of Prince Albert (education leaflet)	1995
Landscape & gardens	Tree management system	1995
	After the storms	
	Golf course proposals in historic landscapes	nd

(*Continued*)

(Continued).

Category	Title	Date
Historic buildings	Anthrax & historic plaster	
	Bats in churches	
	Buildings at risk: a new strategy	
	Buildings at risk: a sample survey	1992
	Cathedral fabric records: a report of the joint working group on records and recording of cathedral fabric	1995
	Churches needs survey: August 1998	
	Conversion of historic farm buildings: an English Heritage statement	1993
	Dendrochronology	
	Easy access to historic properties	1995
	Framing opinions 1-7 (energy savings, door and window furniture etc)	1994-7
	Graffiti on historic buildings & monuments	
	Guidelines for the conservation of textiles	1996
	Historic court buildings	1998
	Historic prison buildings : guidelines for alterations	1995
	Hybrid mortar mixes	
	Insuring your historic building: churches & chapels	1996
	Insuring your historic building: houses and commercial	1997
	Investigative work on historic buildings	1995
	Lead roofs on historic buildings	
	New work in historic churches: an English Heritage statement	
	Office floor loading in historic buildings	1994
	Ornamental ironwork: gates and railings	1993
	Picture palaces: new life for old cinemas	
	Pointing of brickwork	1994
	Presentation of historic building survey in CAD	
	Principles of repair*	1993
	Roofs of England: a celebration of England's stone slate roofing traditions	
	Scaffolding & temporary works for historic buildings	1995
	Stone slate roofing: technical advice note	1998
	Stopping the rot	
	Thatch & thatching: a guidance note	2000
	Theatres: A guide to theatre conservation from English Heritage	1995
	Theft of architectural features*	1987
	Underside lead corrosion*	1997
	Window comparisons	
Listing	Understanding listing: pubs	1994
	Understanding listing: Manchester mills	1995
	Understanding listing: East Anglian farms	1997
	Understanding listing: historic buildings in Sheffield	1995
	Something worth keeping? Post-war architecture in England	1996
	Something worth keeping? Post-war architecture in England: churches, civic buildings, bridges, buildings for healthcare, higher education	1996
	Something worth keeping? Post-war architecture in England: entertainment, planned town centres, new town housing, rural housing	1996
	Developing guidelines for the management of listed buildings	1996

(Continued)

(Continued).

Category	Title	Date
Historic Environment	Sustaining the historic environment: new perspectives on the future. An English Heritage discussion document	1997
	The heritage dividend	
	Development in the historic environment: An English Heritage guide to policy, procedure and good practice	1995
General	Catalogue of free conservation publications	
	Catalogue of priced conservation publications	
	English Heritage annual report	Annual
	Conservation Bulletin	

Principles into Policy: Assessing the Impact of *Conservation Principles* in Local Planning Policy

Gill Chitty and Claire Smith

ABSTRACT
The arc of policy change in heritage conservation in England – from the 1967 Civic Amenities Act to the National Planning Policy Framework 2018 – spans significant shifts in the underpinning principles supporting conservation policies. While national policies can be interpreted as inflections of changing policy frameworks enacted in international and European arenas, the interplay is complex and causal relationships may be impossible to demonstrate conclusively. This paper takes the instance of English Heritage (now Historic England)'s *Conservation Principles, Policies and Guidance for the sustainable management of the historic environment* (2008) and considers its international hinterland and legacy. While it has no formal status in the heritage protection or planning system in England, this research examines its sustained presence in local heritage planning policy. An examination of local heritage strategy documents shows that *Conservation Principles*, and the body of early 21st-century European and international thought that it reflects, are embedded in current practice in local authority policy-making. This impact is notable in the context of an English statutory planning and heritage protection system largely unchanged for 30 years, and attests to the agency of innovative international conservation principles despite the inertia of national heritage reform.

Introduction

In this paper we engage with the relationship between policy and practice for managing heritage through the planning system in England as it has played out in the first decades of the 21st century. We present a brief retrospective context for current practice, reflecting on the arc of policy change from the 1960s, and a detailed analysis of the ways in which evolution of heritage policy – national and international – is evidenced and embedded in practice in contemporary local planning. As observed at the 2018 AHRC Heritage/Rescue conference that stimulated this volume, much of our practice in the cultural and heritage sectors operates within a system based on policy rather than governed by statutory legislation. Such policies may be national, as set out by Government departments and promoted by government agencies; regionally evolved in local government, within frames set by national bodies; or independently devised to

support institutional strategies. In the UK heritage sector, for example, the policies of the National Trust and the National Lottery Heritage Fund have notably played a formative role in shaping policy on public engagement, and for the wider public benefit of working and place-making in heritage, with powerful social and economic outcomes. The global context in which these national policy spheres are situated includes broader currents of policy formation on international platforms notably through UNESCO, the European Union and the Council of Europe. These contextualising frameworks for new principles can be attributed a formative role in policy-making but they also emerge iteratively out of consensus on progressive new thinking aggregated from individual and shared acts of innovative practice and research through, for example, EU Framework programmes like Horizon 2020.

Understanding how the relationship between policy formation and progressive change in practice is enacted in these entangled, iterative and plural relationships is challenging but a critical engagement through case studies, as offered here, can provide a meaningful way to think forward to future approaches. What strategies for policy enactment can we say make effective, lasting and impactful change in local practice? This paper chose the instance of English Heritage (now Historic England)'s *Conservation Principles, Policies and Guidance for the sustainable management of the historic environment* (2008) as a case study. It is of particular interest because it represented, in the early 2000s, a radical platform for introducing international thinking about understanding heritage and its value for society into a landscape of English heritage policy and legislation that was focused narrowly on protection. It is unique in shaping local heritage practice in this respect and yet has no formal status as policy in statutory heritage protection or the planning system in England. This research examines its presence as a sustained influence in local heritage planning and considers its international hinterland and legacy.

Diffusionist models for policy transfer into practice are clearly over-simplistic. While national policies can sometimes be interpreted as inflections of changing policy frameworks evolved in international and European arenas, the interplay is so much more complex. Direct, causal relationships may occasionally be acknowledged or evident, but more often they are impossible to demonstrate conclusively or may be simply not exist. For example, one might look for evidence of policy transfer between the *Venice Charter* (1964),[1] an internationally adopted canon of 'principles guiding the preservation and restoration of ancient buildings', and the introduction in England and Wales three years later of Circular 53/67. This was national government's policy on the implementation of the 1967 Civic Amenities Act 'for the protection and improvement of buildings of architectural or historic interest'. Delafons, a contemporary biographer of British preservation politics in the civil service through the 1960s – 1980s, attributes this with introducing a significant 'shift of emphasis from negative control to creative planning for preservation',[2] but he makes no reference to the *Venice Charter*, suggesting that the drivers lay in the personal interests of Conservative politicians and the model of French *zones protégéés*.[3]

By contrast, Delafons' narrative of early 1970s heritage policy in England indicates that it directly reflected European thinking and a proactive conservation response to the Council of Europe's Architectural Heritage Year (1975). Government policy Circulars encouraged local authorities to prepare 'townscape and conservation studies, measures

to reduce traffic and parking in architecturally sensitive areas [and] restoration of old buildings' to contribute 'to enhancing the national architectural heritage'.[4] The adoption of the European Charter of Architectural Heritage later that year signalled two significant policy shifts in the UK: firstly towards 'integrated conservation' – the idea of heritage as 'a capital of spiritual, cultural, social and economic value' integrated in 'the context of people's lives'.[5] Secondly, and essential to its success, was the principle of 'the cooperation of all': citizens being 'entitled to participate in decisions affecting their environment' and heritage as a common property for which all are responsible. These phrases prefigure, and indeed ultimately paved the way for, the Council of Europe's framing of the 2005 (Faro) *Convention on the Value of Cultural Heritage for Society* thirty years later.[6] The intervening period saw increasing socially-centred valorisation of heritage develop in the values-based approaches that characterised a millennial shift in conservation practice. Emanating from Australia and the USA, in the work of James Semple Kerr (1982 onwards), the ICOMOS Australia *Burra Charter* (1999), and the research of the Getty Conservation Institute (2000), new discourses of value have become central to internationally established conservation practice.[7]

Contexts for understanding these shifts in international policy and their expression in national and local policy direction are well-researched, theorised and critiqued[8] and, interestingly for this study, also self-documented by the actors of heritage policy change themselves. Fairclough describes the consultative process for English Heritage's review of government policies in 2000,[9] the drivers behind the wide-ranging, participative project that resulted in the sector's *Power of Place*, and the Government's responding policy document in *Historic Environment: a force for our future* (2001).[10] Clark provides an insightful overview of the adoption of values-based approaches to conservation in the UK from an insider perspective, in first the Heritage Lottery Fund and then English Heritage, mapping the incremental sequence of change in policy and practice.[11] Drury accounts for the process of developing *Conservation Principles* in terms of 'the need for a consistent and coherent framework for making decisions about managing heritage values' in English Heritage without resort to 'ICOMOS Australia's *Burra Charter* to fill a perceived gap'.[12] The international lineage of *Conservation Principles* is openly acknowledged and was, it is said, explicitly designed to follow the 'general pattern of the *Burra Charter* and *Conservation Plan* documents ... and the definition of authenticity borrowed from *Nara [Document]*'.[13] The self-conscious choice of internationally framed, socially inclusive and values-centred approaches is clearly evident.

Planned statutory reform for heritage in England, with the draft Heritage Protection Bill in 2008, might have embedded some of these changes in approach in new legislation but, while that was not taken forward, *Conservation Principles* remained in place. It was never adopted as public policy, however, and still has no formal status in the planning system in England. As a guidance document it lacks official weight in policy - or decision-making for local authorities and yet, as this research into local planning strategies aims to demonstrate, *Conservation Principles* is embedded in current local policy formation. It would appear to have made a lasting and impactful change in practice, evidenced over ten years since its publication, without support from national Government policy, from the short-lived Planning Policy Statement 5 (2010) through to the *National Planning Policy Framework* (*NPPF*) in its 2012 and current 2018 iterations.

Looking more closely at the context of drafting *Conservation Principles*, the messages from the 2008 document about its intentions and purpose are somewhat mixed. The introduction states that it was intended as internal advice for English Heritage staff and to ensure a consistent approach in their casework and policy development, rather than aimed at local planning authorities. This conflicts with aspiration elsewhere for the document to be read and used widely by various actors in the heritage sector,[14] and with Lord Bruce-Lockhart's foreword which reveals a longer-term hope that *Conservation Principles* would become a formative component of a 'progressive framework for managing change in the historic environment', its success resting on its wider take-up in the sector.[15] How far either of these goals has been achieved has never been evaluated and, after a decade of use and consultation on a revised *Conservation Principles* document at the end of 2017, it is timely to consider the legacy of *Conservation Principles* in practice and in particular its relationship to local planning policy.

Method: Examining Heritage Strategies

Conservation Principles has been a popular subject for review in critical heritage studies that, inter alia, highlight its intertextual relationship with many other national and international policy documents and the complexity of interwoven discourses in each fresh policy iteration.[16] Accepting the slipperiness of this intertextual complexity, but looking beyond it to find a meaningful index for evaluating the adoption and impact of this particular document, one approach at the most basic level of analysis would be to enumerate instances of direct references to the document in local planning policies. However, given that it has no formal place in local authority policy or decision-making, this kind of raw quantification would be unlikely to represent its actual impact: local authorities have no need to refer to it. More recent formal guidance covering similar topics, such as Historic England's *Good Practice Advice Note 2: Managing Significance in Decision-Taking in the Historic Environment*, would more likely warrant direct reference on the basis of alignment with the *NPPF* introduced in 2012.

For this research, therefore, the rationale has been to focus on examining how the 'principles' section of *Conservation Principles*, the six key themes providing 'a comprehensive framework for the sustainable management of the historic environment',[17] has become embedded in local authority practice. The links sought here are tricky to evidence to the exclusion of other influences, given the intertextual relationships at play and that it was by no means alone in articulating more inclusive, participatory and values-based approaches in UK heritage management.[18] The approach has therefore been to use textual analysis to identify explicit policy positions or verbatim references from which a relationship can be inferred with the *Conservation Principles* 2008 text. To do this, a sample of heritage strategies from across England was selected for detailed analysis. Heritage strategies are defined in this study as documents produced for, or by, local planning authorities to set out their approach to heritage considerations in their work. Some local authorities (e.g. Isles of Scilly 2004, Stockport 2008 and Torbay 2004 updated 2011) adopted strategies prior to 2012, but the majority were produced in response to the government's request for local authorities to set out 'a positive strategy for the conservation and enjoyment of the historic environment' in the 2012 publication of the *NPPF*.[19] Most were adopted in the last five years and the sample includes both

drafts and formally adopted documents which have weight in supporting a local plan policy, or as a supplementary planning document.[20] Using heritage strategies allows the researcher to interrogate data without involvement in its production, negating potential bias. Strategies, both draft and adopted, give agency to local authorities as organisations, representing the collective and authorised view on heritage from a local management level: its definition, how the management role is perceived, the involvement of other parties and priorities for conservation.

The total pool of local authorities with standalone heritage strategies (i.e. not integrated with a cultural or other strategy) available for sampling was 46 out of 326 local planning authorities (14%). The figure rose to 91 strategies if those combining heritage within a cultural strategy are counted.[21] A sample of 12 was selected from the pool of 46 for in-depth coding using heterogeneity 'group characteristics' sampling[22] where characteristics of the local authority area are used to capture variety in local planning authorities, and thereby study the breadth of the national picture. The characteristics used were: geographic location, local authority type (e.g. London borough, district, or unitary); urban to rural as categorised by DEFRA[23]; quality of life, indicated by Indices of Deprivation[24]; and numbers of heritage assets and listed building consents in 2018.[25]

The sampled heritage strategies were examined for direct references, quotes or summaries of *Conservation Principles*. They were then coded for the first four of the six *Conservation Principles*:

- The historic environment is a shared resource
- Everyone should be able to participate in sustaining the historic environment
- Understanding the significance of places is vital
- Significant places should be managed to sustain their values[26]

The last two of the six principles – 'Decisions about change must be reasonable, transparent and consistent' and 'Documenting and learning from decisions is essential' – are fairly generic ones that could be considered basic good practice in local authority planning and these were therefore excluded from the coding. Finally, other features of *Conservation Principles* were selected from the heritage strategies in an inductive manner, illuminating phrases and processes which were derived from the 2008 guidance. The variety in the strength of links with *Conservation Principles*, seemingly without a geographic or chronological rationale, prompted a further investigation into the 46 standalone heritage strategies using text searches for key phrases, retrieving the context of the searches and checking the meaning and relevance of the result. The text searches looked for direct references to *Conservation Principles* but also matched key phrases from the document to explore how embedded the guidance may or may not have become within local planning practice.

Findings

Local Authorities' Definitions of Heritage

Analysis of the Heritage Counts[27] data for the 46 local planning authorities with standalone heritage strategies revealed two aspects of interest. Firstly, authorities with

both high and low numbers of statutorily-designated heritage assets and listed building consent (LBC) cases produce heritage strategies. Secondly, the rationale for creation of a heritage strategy is not led primarily by the need for management of statutorily designated assets, nor is the council's role in and definition of heritage limited to national designation, as the results below show. A full range of local authorities is represented in the 46, slightly weighted towards those with the lower numbers of designated assets and LBC applications: 15 of the local authorities with strategies had twenty LBC applications or less in 2018; 11 authorities had over 150.[28] This is an important counter to the argument that heritage strategies will tend to be produced by those authorities who have high numbers of designated assets or high levels of development on designated sites. Local authorities with locally designated heritage or non-designated heritage are motivated to create heritage strategies too. Blackpool City Council has only 47 listed buildings,[29] but over 250 heritage assets on the local list,[30] and its heritage strategy seeks to manage local heritage as much as nationally and internationally recognised heritage. This broader interpretation of heritage is entirely consistent with the *Conservation Principles* approach, which avoids the terms of designation and speaks instead of 'the heritage significance of a place', an inclusive concept relevant to all heritage – whether designated or not. In this regard, local planning practice is in closer alignment with *Conservation Principles* than with the *NPPF* which is bound by statutory limitations.

Broader definitions of heritage found in local strategies also support the view that they are not designed solely for managing built or material assets. Nottingham's heritage strategy encompasses social history, myths and legends, traditions and customs[31] and recognises: 'Much of Nottingham's heritage is intangible'.[32] Sources for definitions vary. Stroud's heritage strategy quotes *Conservation Principles*'s definition of heritage: 'all inherited resources which people value for reasons beyond mere utility'; it also quotes the *International Cultural Tourism Charter*, beginning, 'Heritage is a broad concept and includes the natural as well as the cultural environment.'[33]; Fylde's resorts to a dictionary definition.[34] What is apparent is that the source is not UK legislation or policy, which does not offer a definition unbound by designation criteria. While some heritage strategies, such as Fylde's, recognise a broader definition of heritage but explicitly choose to confine the strategy to the built environment in alignment with their statutory planning duties,[35] others are, to varying extents, seeking applicability to a more inclusive, locally-defined meaning of heritage.

Conservation Principles in Heritage Strategies

In the sample of 46 strategies examined, 12 mentioned *Conservation Principles* directly, as highlighted in blue in Figure 1. However, 39 of these were published after *Conservation Principles*, meaning 31 percent of the strategies that could have possibly mentioned it, did so: a surprisingly high proportion given that four of those mentioning *Conservation Principles* were written in 2018 or later – ten years after the publication of *Conservation Principles*.

It is also notable that heritage strategies which did not directly mention *Conservation Principles* can be shown to adopt some of its ideas. These are marked in yellow in Figure 1. For example, the phrase 'shared resource' from the first principle appeared in five heritage

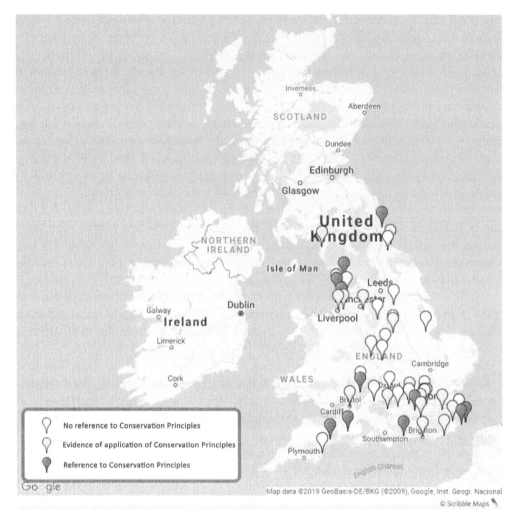

Figure 1. Distribution map showing the sample of 46 local planning authorities with stand-alone heritage strategies with those referencing *Conservation Principles*, and those analysed in depth that show some evidence of its application, highlighted.

strategies, either referring to heritage or the historic environment. Of these five, Brighton and Hove, Knowsley and Tower Hamlets did not reference *Conservation Principles*, yet the concept and phrase seems precise enough to assume that *Conservation Principles* is the source, whether consciously or otherwise. From the in-depth coding, it was noted that Allerdale and Nottingham, neither of which reference *Conservation Principles*, use multiple phrases that align closely with the principles. For example, Nottingham's strategy includes, 'ensuring that people from all generations and communities can contribute to, share in and enjoy a common cultural heritage'; and 'To manage it effectively we now need to understand its significance'.[36] It is possible, of course, that heritage practitioners have adopted the lexicon and discourse of *Conservation Principles* without necessarily applying them directly

in the local policies. Further in-depth analysis is likely to demonstrate more of this intertextual influence.

Understanding Significance

Understanding significance, the third of the principles, appeared in half of the heritage strategies – 23 of the 46 – always in relation, or as a precursor, to successful management. A proximity search, where 'understanding' and 'significance' appear within five words of each other, was used to capture all relevant phrases; for example, 'understanding the significance' or 'understanding the local heritage significance'. Applying contextual analysis to the text searches for 'understanding significance' shows that the idea is often prioritised in heritage strategies, being found as an aim, objective or theme of the heritage strategy and therefore the weight attributed to it should be greater than its numerical count. For example, the first of the five objectives of Stroud's heritage strategy is understanding; it is also the first key point in the aim of Elmbridge's document. While there appears to be a strong connection between the third principle and practice, 'understanding significance' is a theme that developed through several documents prior to the publication of *Conservation Principles*, and has been advocated in other documents since 2008. It is at the core of Clark's 2001 publication, *Informed Conservation*, where the aim of understanding heritage is to define its significance in preparation for managing change.[37] Clark's guidance document for English Heritage is focused on detailing a management process suitable for working on heritage sites or in development management, and in this practical respect was a forerunner of *Conservation Principles*.[38] While it may have other antecedents, 'understanding significance' is not a phrase used in the *NPPF* (2018): paragraph 190 requires local authorities to assess the significance of heritage assets affected by planning applications but provides nothing on the process. Neither does *Good Practice Advice Note 2: Managing Significance in Decision-Taking in the Historic Environment* explain a process for understanding significance, but refers to two sources to provide a method: the first is *Conservation Principles* and the second is *British Standard 7913: 2013 Guide to the Conservation of Historic Buildings*. Of these two documents that provide the practical route to assessment of significance, the financial cost of the British Standard document can act as a barrier for some heritage professionals[39] while *Conservation Principles* is open access and still freely available as a PDF online. Evidencing its widespread use, *Conservation Principles* is still the third most frequently downloaded document of Historic England's advice and guidance suite.[40] *Conservation Principles* is set apart from the *Good Practice Advice Note* and the *NPPF* in that it offers a practical process for assessing significance, guiding the practitioner through the rationale for understanding significance and then how to achieve sufficient understanding to underpin management decisions. This process can be found within heritage strategies. Bristol's heritage strategy, for example, which, again, does not directly reference *Conservation Principles*, articulates the process of understanding significance and then 'demonstrating' or explaining the significance following the *Conservation Principles* model.[41] This methodology, whether developed directly from *Conservation Principles*, or through the stream of intertextual exchanges that have foregrounded understanding, found in texts like *Informed Conservation*, is evidently a useful and practical one which still works well in a

local authority context. While in the next section we examine the use of the values terms from *Conservation Principles*, it is perhaps the methodology of understanding significance as a precursor to managing change at heritage sites that is the most vital legacy flowing from *Conservation Principles* and its precursors.

Conservation Principles Values

As noted earlier, values-centred heritage management practice was already well-established in many of the approaches that informed *Conservation Principles*. In order to identify its distinctive contribution to a values-led approach, analysis focused on the four value groups defined in *Conservation Principles*: aesthetic, historical, evidential and communal. These differ from the terminology of current legislation, which uses architectural or historic 'interest' to define values in listed buildings;[42] and are different again from the *NPPF* which lists archaeological, architectural, artistic or historic interest as components of significance.[43] They also differ from the *Burra Charter*'s definition of cultural significance with its grouping of aesthetic, historic, scientific, social or spiritual values. Interestingly, these were cited in two local strategies,[44] with Chichester's strategy defining cultural significance as per the *Burra Charter* in its glossary but also separately defining each of *Conservation Principles*' four values.[45]

Setting aside 'historical value' temporarily, due to the many related forms of the word historic or historical, Table 1 shows that, where used, the values terms are often found as a set. This is often in a summary of the four values. The more interesting findings are from the three local authorities where one or two terms are used. In Medway's strategy, the lexicon of *Conservation Principles* has been adopted into general criteria for assessing significance for local designation, with 'communal value' alongside aesthetic interest, archaeological interest and historic association as possible criteria for local listing. This suggests an intention to provide local recognition for heritage sites with communal value which would otherwise not be afforded protection through the narrower scope of national designation. Boston uses the phrase 'aesthetic value' but none of the other value terms,[46] and Hartlepool, which uses 'evidential' and 'communal value', does not use 'aesthetic'.[47] These instances might indicate that terms from *Conservation Principles* are entering common use in the lexicon of conservation practice but equally this may simply be a generic usage, since neither strategy summarises the *Conservation Principles* values.

Table 1. Local planning authorities' use of the values terms from *Conservation Principles*. Note that this only counts instances where the word 'value' is included.

LPA	Aesthetic value	Evidential value	Communal value
Ashford	✓	✓	✓
Boston	✓		
Chichester	✓	✓	✓
Dover	✓	✓	✓
East Devon	✓	✓	✓
Folkestone and Hythe	✓	✓	✓
Fylde	✓	✓	✓
Hartlepool		✓	✓
Lancaster	✓	✓	✓
Medway			✓
South Somerset	✓	✓	✓

There is similar ambivalence in establishing a clear link between usage of 'historical value' and *Conservation Principles* because the words historic or historical are, as can be expected, commonly used in heritage strategies, and because definitions of significance, from the *NPPF* or *Burra Charter* for example, also include 'historic' or 'historical'. However, for the sake of completeness, the graph below (Figure 2) shows the numbers of local authorities using particular phrases including 'historical value' as per *Conservation Principles* and 'historic interest' as per the *Planning (Listed Buildings and Conservation Areas) Act* and *NPPF*.

Comparison with NPPF Terms

In order to provide a comparative set of data for the value terms, the same method of analysis was applied to the *NPPF*'s equivalent phrases. It was expected that in strategies published after 2012, the *NPPF*'s terms would be used much more frequently as adopted strategies would be in alignment with national policy. The 34 strategies that use the phrase 'historic interest' (shown in Figure 3) includes a significant increase due to legislative quotations and by its general usage. In the summarising table (Table 2), the problematic 'historical/historic value/interest' phrases have again been left out as they confuse the analytical picture. 'Archaeological interest' and 'architectural interest' were used in 13 and 14 strategies respectively, as shown in Figure 3 – a comparable figure to those using *Conservation Principles*' phrases – but none of the heritage strategies used the phrase 'artistic interest' on its own. The seven strategies, depicted in Figure 4, list all the interests in the same order as they appear in the *NPPF*, and are the only ones to use 'artistic'. This suggests a prioritising of the 'interests' with some being seen as less useful or appropriate than others. Conversely, *Conservation Principles* values are often used equally or as a set.

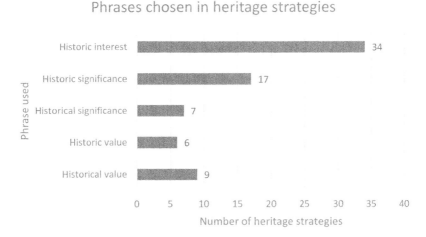

Figure 2. Graph showing the number of heritage strategies using specific terms which are equivalent to 'historical value' in *Conservation Principles*.

Table 2. Local planning authorities' chosen terms.

LPA	Aesthetic value	Evidential value	Communal value	Archaeological interest	Architectural interest	Artistic interest	Social value
Ashford	✓	✓	✓	✓	✓		✓
Boston	✓						
Chichester	✓	✓	✓	✓	✓		✓
Dover	✓	✓	✓		✓		
East Devon	✓	✓	✓	✓			
Folkestone and Hythe	✓	✓	✓	✓	✓		
Fylde	✓	✓	✓		✓		
Hartlepool		✓	✓	✓	✓		
Lancaster	✓	✓	✓		✓		
Medway			✓	✓			
South Somerset	✓	✓	✓		✓		
Blackpool				✓			
Elmbridge				✓			
Enfield				✓			
Isles of Scilly				✓			
Merton					✓		
North Tyneside					✓		
Reigate and Banstead				✓	✓		
Stroud				✓	✓		
Tower Hamlets					✓		
West Berkshire				✓			
Allerdale							✓

Figure 3. Distribution maps showing the local planning authorities using the terms 'archaeological interest' (green), 'architectural interest' (pink) and 'historic interest' (blue).

The 2017 Revision of Conservation Principles

The redraft of *Conservation Principles* which went out to consultation at the end of 2017 battled with the differences between terms in the *NPPF* and *Conservation Principles*, with 'interests' (*NPPF*) being chosen over 'values' (*Conservation Principles*) and the description components for articulating significance also being aligned with the *NPPF*: archaeological, architectural, artistic or historic. While the draft moved towards the *NPPF*'s terms, it stated that these were just one way of articulating significance keeping the 2008 *Conservation Principles* words as part of 'the palette

Figure 4. Distribution map showing the seven local authorities that list the four *NPPF* terms as a set: Ashford, Chichester, East Devon, Elmbridge, Fylde, South Somerset and Stroud.

of terms which may be used',[48] corresponding with the approach of *Good Practice Advice Note 2: Managing significance in decision-taking in the historic environment*.[49] The 'palette' approach is reflected in local practice, as the overlap in local authorities using both *Conservation Principles* and *NPPF* terms shows – it is not considered to be a binary choice. However, this research indicates that practice in local planning is to employ the value groupings from *Conservation Principles* 2008 as often as those from the *NPPF*: surprising given expectation that current national planning policy would have greater weight in informing contemporary local policy than a guidance document from 2008. When strategies utilise the *NPPF*'s terms, they do so on a selective basis with 'artistic interest' never being used on its own. The redraft of *Conservation Principles* recognised this weakness in the *NPPF* terms and grouped architectural and artistic interest together. Arguably the most significant difference with the suggested move from *Conservation Principles* 'values' to the *NPPF*'s 'interests', however, is that there is no equivalent for 'communal value'.

Interestingly three local heritage strategies use the term, 'social value', even though this does not appear in English legislation, policy or guidance.[50] This suggests that at least some local authorities are engaged with recent critiques of heritage values,[51] seeking more relevant meanings of heritage than those provided in national policy,

and filling the gap by turning to established international frameworks, just as Drury stated in 2008.[52] Finally, it is worth noting that in 24 of the 46 heritage strategies, these terms did not appear at all: either alternative phrases were used (such as 'aesthetic significance') or suggesting that local authorities were not communicating elements of significance in their heritage strategies.

Participation: A Wider Agenda

The final principle considered was 'Everyone should be able to participate in sustaining the historic environment'. The words 'participate' or 'participation' alone were not considered to correlate meaningfully to *Conservation Principles* as participation in heritage has been a theme in many earlier international heritage conservation texts, from the 1975 onwards[53], through to the production of *Power of Place* in England in 2000 which emphasised that debate about the historic environment, 'must not be exclusive; everyone should be able to participate easily';[54] and continuing with a series of government policies documents where a cross-over with social inclusion and community agendas make participation a recurring theme.[55] At the same time, outside public policy, the Heritage Lottery Fund (now the National Lottery Heritage Fund) and National Trust have enacted successful policies promoting inclusive participation in the historic environment through grant-giving programmes and volunteering. Recent decades have therefore seen a prevalence of participatory discussion which makes a distinctive discourse from *Conservation Principles* difficult to discern. For example, an objective from Merton's heritage strategy is; 'Enabling everyone, alone or collectively, to benefit from Merton's cultural heritage, contribute towards its enrichment, and participate in decisions about its future.'[56] While this is close to the ethos of *Conservation Principles*, it is not undoubtedly derived from the document.

Conclusion

This research aims to provide insights into the usage of *Conservation Principles*, as a point of reference and an actively used instrument in local planning policy, in order to understand better what makes impactful and lasting change in heritage practice. It is not about the proportion of local planning authorities in England who have included a reference to *Conservation Principles* within a local heritage strategy, but about the effective use of the document within local planning policy. What is striking about the findings is that *Conservation Principles* can, and does, have a quantifiable presence in local policy strategies at all, regardless of the number of instances in which it appears. Given that there is no onus on local planning authorities to draw on *Conservation Principles*, its existential effect in local planning policy is a remarkable statement of its influence and the weight given to it in heritage conservation practice. While its presence is evident from this analysis of heritage strategy texts, the influence of *Conservation Principles*' methodology could be expected to extend further into the daily practice of development planning and management. Further research, for example, examining conservation officer correspondence and interviews with heritage professionals, might illuminate the extent of its influence in development management practice.

Why is *Conservation Principles* found as underpinning in heritage strategies at all? When asked to identify the key changes in heritage protection over the past ten years, one conservation officer's comment sums it up as: 'Conservation Principles. I find that useful.'[57] *Conservation Principles* gives heritage practitioners good overarching principles and backs them up with a practical method for assessing significance and a structure for how to manage change. It provides a process that works in practice to guide from a first encounter with a site of unknown heritage significance, to an understanding of how to manage change at that site in an informed and transparent way. That process is arguably the most vital part of its influence, although *Conservation Principles* is not the sole proponent of those ideas.[58]

The research also investigated the values terms used by *Conservation Principles* and provided a comparison with the terms to describe 'interests' in the *NPPF*. Findings indicate both are used in roughly equal measure in local policy, and it is questionable why the current national planning policy terms have not overridden the guidance from 2008 and in fact are used with reasonably equivalent frequency. It appears that *Conservation Principles* endures in use while national policy has changed around it, which potentially points to the need to better understand how it is used in practice and its potential as a model to build on to underpin future public policy.

How and why has *Conservation Principles* remained resiliently relevant alongside the changing the national policy surrounding it? Part of the answer evidently lies in its usefulness for local practice in heritage management. The other part of the answer appears to be that it is supported by ideologies and an ethos that have developed, been endorsed and sustained over the last three decades, while the English statutory planning and heritage protection system has remained largely unchanged. It attests to the agency of innovative international conservation principles despite the inertia of national heritage reform. *Conservation Principles* shares, 'text semantics and thematic continuity'[59] not only with locally produced policy documents but with the international forebears from which is derives its inspiration, as Waterton, Smith and Campbell discuss in relation to the *Burra*, *Athens* and *Venice* charters. In doing so, *Conservation Principles* not only connects international thinking directly with English conservation guidance, but allows local authority policy makers to 'leap the gap' – to draw upon stable, internationally supported canons and principles in heritage decision-making which are lacking in English national planning policy. The fact that local heritage strategies are still strongly engaged with *Conservation Principles* for this role, and that it has yet to be superseded by effective further guidance, shows the success of the document: the 'perceived gap' in intellectual underpinning for conservation practice that the *Burra Charter* was filling before 2008 might still exist if *Conservation Principles* were not fulfiling it.[60]

Notes

1. ICOMOS, The Venice Charter.
2. Delafons, *Politics and* Preservation, 100, quoting Ministry of Housing and Local Government Circular 53/67.
3. Delafons, *op cit*, 95–96.
4. Delafons, *op cit*, 111.
5. Council of Europe, European Charter of the Architectural Heritage.

6. Council of Europe, Convention on the Value of Cultural Heritage for Society (Faro Convention).
7. Australia ICOMOS, Burra Charter; Kerr, The Conservation Plan; Avrami, Mason, and De la Torre, Values and Heritage Conservation; De la Torre, Values in Heritage Conservation: A project of the Getty Conservation Institute.
8. Pendlebury, "Conservation values, the authorised heritage discourse and the conservation-planning assemblage"; Orbasli, "Conservation theory in the twenty-first century: slow evolution or a paradigm shift?", Waterton, *Politics, Policy and the Discourses of Heritage in Britain*; Waterton, Smith and Campbell, "Utility of Discourse Analysis," 155.
9. Fairclough, Graham, "Roots of England's culture."
10. English Heritage, Power of Place; DCMS, A Force for our Future.
11. Clark, "Value-based Heritage Management and the Heritage Lottery Fund in the UK."
12. Drury, "A Sense of Value," 8.
13. Emerick, Conserving and Managing Ancient Monuments, 186.
14. Historic England, *Conservation Principles*, 13.
15. Historic England, *Conservation Principles*, foreword.
16. See for example Pendlebury, "Conservation values, the authorised heritage discourse and the conservation-planning assemblage"; Waterton, *Politics, Policy and the Discourses of Heritage in Britain*.
17. Historic England, *Conservation Principles*, 7.
18. See, for example, Heritage Lottery Fund policies.
19. DCLG, *National Planning Policy Framework*, 30.
20. Only heritage strategies available online are included and, given standard local government practice to put documents online for consultation and accessibility, it is expected that the sample captures most current strategies.
21. This excludes the City of London heritage strategy and others which act as umbrella strategies for several local planning authorities.
22. Patton, *Qualitative research*, 266.
23. DEFRA, 2011 Urban-rural classification.
24. MHCLG, English indices of deprivation.
25. Historic England, *Heritage Counts*.
26. See note 17 above.
27. See note 25 above.
28. Additionally, the average number of listed buildings for the 326 local planning authorities in England in 2018 was 1161 while the average for those with heritage strategies was 943.
29. See note 25 above.
30. Blackpool Council, *Built Heritage Strategy*, 3.
31. Nottingham City Council, *Nottingham Heritage Strategy*, 2.
32. Ibid., 9.
33. Stroud District Council, *Stroud's Heritage Strategy*, 1.
34. Fylde Council, *Built Heritage Strategy*, 7.
35. Ibid., 7.
36. Nottingham City Council, *Nottingham Heritage Strategy*, 9, 18.
37. Clark, *Informed Conservation*, 7; 8; 12.
38. Clark, *Informed Conservation*, 23.
39. Anonymous, *pers. comm.* 18 February 2019.
40. Historic England, *Popular Advice and Guidance*.
41. Bristol City Council, *Our Inherited City*, 34.
42. Planning Act 1990.
43. DCLG, *National Planning Policy Framework*, 71.
44. Australia ICOMOS, *Burra Charter*; cited by Chichester and Liverpool.
45. Chichester District Council, *Chichester Historic Environment Strategy*, 46.
46. Boston Borough Council, *Heritage Strategy*, 9.
47. Hartlepool Borough Council, *Strategy for Historic Environment*, 21.

48. Historic England, *Conservation Principles draught*, 1.
49. Historic England, *GPA Note 2*, 4.
50. Heritage strategies of Allerdale Borough Council, Ashford Borough Council and Chichester District Council.
51. See Jones; "Wresting with the social value of heritage: problems, dilemmas and opportunities."
52. Drury, "A Sense of Value," 8.
53. Council of Europe, Architectural Heritage Charter.
54. English Heritage, *Power of Place*, 4.
55. DCMS, The Historic Environment: a force for our future (2001), People and places: a social inclusion policy for the historic environment (2002) and Heritage Protection for the Twenty-first Century (2007).
56. Merton Council, *Merton Heritage Strategy*, 10.
57. Anonymous, comment contributed as part of a focus group for PhD research.
58. Clark, *Informed Conservation*.
59. Waterton, Smith and Campbell, "Utility of Discourse Analysis," 344.
60. Drury, "A Sense of Value," 8.

Disclosure statement

No potential conflict of interest was reported by the authors.

ORCID

Gill Chitty http://orcid.org/0000-0001-6521-3785
Claire Smith http://orcid.org/0000-0002-2397-062X

Bibliography

Australia ICOMOS. *The Burra Charter: the Australia ICOMOS Charter for Places of Cultural Significance*. Burwood: Australia ICOMOS, 2013.
Avrami, E., R. Mason, and M. de la Torre. *Values and Heritage Conservation*. Los Angeles: The Getty Conservation Institute, 2000.
Blackpool Council. "Built Heritage Strategy 2016 – 2020: a Future for the Past." Blackpool Council, 2013. https://www.blackpool.gov.uk/Your-Council/The-Council/Documents/Built-Heritage-Strategy-October-2016.pdf
Boston Borough Council. "Heritage Strategy for the Borough of Boston." Boston Borough Council, 2017. https://moderngov.boston.gov.uk/documents/s5489/Appendix%20A%20-%20Heritage%20Strategy%20for%20the%20Borough%20of%20Boston.pdf

Bristol City Council. "Our Inherited City: Bristol Heritage Framework 2015 – 2018". Bristol City Council, 2015. https://www.bristol.gov.uk/documents/20182/0/Our+Inherited+City+-+Bristol+Heritage+Framework/d429a15b-ce0f-4048-92a0-da30a9ba9536

Chichester District Council. "Historic Environment Strategy and Action Plan." Accessed June 7, 2019. http://www.chichester.gov.uk/CHttpHandler.ashx?id=27915&p=0

Clark, K. *Informed Conservation: Understanding Historic Buildings and Their Landscapes for Conservation.* London: English Heritage, 2001.

Clark, K. "Values-Based Heritage Management and the Heritage Lottery Fund in the UK." *APT Bulletin: the Journal of Preservation Technology* 45, no. 2/3 (2014): 65–71.

Council of Europe. 1975. *European Charter of the Architectural Heritage.* Accessed 10 June 2019. https://www.icomos.org/en/charters-and-texts/179-articles-en-francais/ressources/charters-and-standards/170-european-charter-of-the-architectural-heritage

Council of Europe. 2005. *Convention on the Value of Cultural Heritage for Society (faro Convention).* Accessed 10 June 2019. https://www.coe.int/en/web/culture-and-heritage/faro-convention

DCLG. *National Planning Policy Framework.* London: HMS, 2012, 2018.

De la Torre, M. "Values in Heritage Conservation: A Project of the Getty Conservation Institute." *APT Bulletin: the Journal of Preservation Technology* 45, no. 2/3 (2014): 19–24.

DEFRA. 2014. "2011 Rural-Urban Classification of Local Authorities and other geographies" Accessed 3 June 2019. https://www.gov.uk/government/statistics/2011-rural-urban-classification-of-local-authority-and-other-higher-level-geographies-for-statistical-purposes

Drury, P. "A Sense of Value." *Conservation Bulletin* 60, no. Spring (2009): 7–10.

East Devon District Council. 2019. East Devon Heritage Strategy 2019-2031. Accessed 4 June 2019. http://eastdevon.gov.uk/planning/planning-policy/heritage-strategy-and-draft-local-list-guide/

Emerick, K. *Conserving and Managing Ancient Monuments: Heritage, Democracy, and Inclusion.* Newcastle: Boydell & Brewer, 2014.

English Heritage. *Power of Place.* London: English Heritage, 2000.

English Heritage. *Conservation Principles - Policies and Guidance for the Sustainable Management of the Historic Environment.* London: English Heritage, 2008.

Fairclough, G. "The Roots of England's Culture." *Conservation Bulletin* 37, no. March (2000): 24–25.

Fylde Council. "Built Heritage Strategy for Fylde: 2015 to 2032." Fylde Council, 2015. http://www4.fylde.gov.uk/heritage-strategy.pdf

Hartlepool Borough Council. "Strategy for the Historic Environment." Hartlepool Borough Council, 2016. https://www.hartlepool.gov.uk/download/downloads/id/2939/hlp03_21_strategy_for_the_historic_environment_dec_2016pdf.pdf

Historic England. *Good Practice Advice Note 2: Managing Significance in Decision-making in the Historic Environment.* London: Historic England, 2015.

Historic England. 2018. "Heritage Counts" Accessed 30 May 2019 https://historicengland.org.uk/research/heritage-counts/indicator-data/

Historic England. 2018. "Most Popular Advice and Guidance Documents." Historic England. Accessed 18 May 2019. https://historicengland.org.uk/advice/find/most-popular/

HM Government. *Planning (listed Buildings and Conservation Areas) Act.* London: HMSO, 1990.

ICOMOS. *International Charter for the Conservation and Restoration of Monuments and Sites (the Venice Charter).* Paris: ICOMOS, 1964.

Jones, S. "Wrestling with the Social Value of Heritage: Problems, Dilemmas and Opportunities." *Journal of Community Archaeology & Heritage* 4, no. 1 (2017): 21–37. doi:10.1080/20518196.2016.1193996.

Merton Council. "Merton Heritage Strategy 2015 – 2020." Merton Council, 2015. https://www2.merton.gov.uk/merton_heritage_strategy_2015_-_2020.pdf

MHCLG. 2015. "English Indices of Deprivation 2015" Accessed 3 June 2019. https://www.gov.uk/government/statistics/english-indices-of-deprivation-2015

Nottingham City Council. "Nottingham Heritage Strategy: a Future Heritage for the City." Nottingham City Council, 2015. http://locusconsulting.co.uk/wp-content/uploads/2015/06/Nottingham-Heritage-Strategy.pdf

Orbaşli, A. "Conservation Theory in the Twenty-First Century: Slow Evolution or a Paradigm Shift?" *Journal of Architectural Conservation* 23, no. 3 (2017): 157–170. doi:10.1080/13556207.2017.1368187.

Patton, M. *Qualitative Research and Evaluation Methods*. 4 ed. London: Sage, 2015. Accessed 29 August 2018. https://www.vlebooks.com/vleweb/Product/Index/952318

Pendlebury, J. "Conservation Values, the Authorised Heritage Discourse and the Conservation-Planning Assemblage." *International Journal of Heritage Studies* 19, no. 7 (2013): 709–727. doi:10.1080/13527258.2012.700282.

Stroud District Council. "A Heritage Strategy for Stroud District: Valuing Our Historic Environment and Assets." Stroud District Council, 2018. https://www.stroud.gov.uk/environment/planning-and-building-control/conservation-listed-buildings-trees-and-hedgerows/a-heritage-strategy-for-stroud-district

Waterton, E., L. Smith, and G. Campbell. "The Utility of Discourse Analysis to Heritage Studies: the Burra Charter and Social Inclusion." *International Journal of Heritage Studies* 12, no. 4 (2006): 339–355. doi:10.1080/13527250600727000.

Waterton, E. *Politics, Policy and the Discourses of Heritage in Britain*. London: Palgrave Macmillan, 2010.

The Disconnect between Heritage Law and Policy: How Did We Get Here and Where are We Going?

Nigel Hewitson

ABSTRACT
There is an apparent disconnect between the terminology used in heritage protection legislation on the one hand and that used in national heritage protection policy in the National Planning Policy Framework on the other. Nigel Hewitson explains how this disparate terminology came about, describes the correct approach to development management decisions involving heritage assets and provides a useful update on how the courts have approached the issues.

The Disconnect

One of the first things that one notices on comparing UK law and policy relating to what we have come in recent years to call the 'historic built environment' is that there is an apparent disconnect between the two. There are significant differences in both the terminology used and the range of what is protected.

The law, as it stands, only protects very specific elements of the historic built environment. The Planning (Listed Buildings and Conservation Areas) Act 1990 protects the 'special architectural or historic interest' of listed buildings and the 'character' of conservation areas. The Ancient Monuments and Archaeological Areas Act 1979 protects monuments which are of 'national importance'. Beyond that, Historic England has a power under s.8C of the Historic Buildings and Ancient Monuments Act 1953 to compile a register of parks and gardens in England 'appearing to them to be of special historic interest'. The Welsh Ministers have a duty to compile a similar register of historic 'parks, gardens, ornamental landscapes, places of recreation and other designated grounds' in Wales which appear to them to be of special historic interest. However, in neither case do any specific legal controls flow from inclusion in the register.[1]

By contrast the National Planning Policy Framework (NPPF) protects the 'significance' of a range of 'heritage assets', some statutorily 'designated' and others not. The NPPF defines 'heritage asset' very widely:

> **Heritage asset**: A building, monument, site, place, area or landscape identified as having a degree of significance meriting consideration in planning decisions, because of its heritage interest. It includes designated heritage assets and assets identified by the local planning authority (including local listing).[2]

And 'designated heritage asset' is defined as:

Designated heritage asset: A World Heritage Site, Scheduled Monument, Listed Building, Protected Wreck Site, Registered Park and Garden, Registered Battlefield or Conservation Area designated under the relevant legislation.[3]

It will immediately be seen firstly that 'heritage asset' includes 'assets identified by the local planning authority', including locally listed buildings and other assets identified in the local plan as worthy of protection. Secondly, 'designated heritage assets' goes beyond those assets which enjoy legal protection as such. Neither World Heritage Sites nor protected battlefields (another register kept on a non-statutory basis by Historic England) enjoy any legal protection as such. As we have seen, although the register of parks and gardens has a statutory basis, no specific legal protections flow from inclusion on it.,[4]

In the same way that there are differences between what is protected by law and policy, there are apparent differences in terms of what it is about the heritage asset that is protected. The Planning (Listed Buildings and Conservation Areas) Act 1990 prohibits works of alteration or extension which affect the character of a listed building as one of special architectural or historic interest.[5] When considering whether to grant listed building consent for any works the planning authority has a duty to have 'special regard to the desirability of preserving the building or its setting or any features of special architectural or historic interest which it possesses'.[6] There is a similar duty in s.66 of the 1990 Act when deciding planning applications which affect a listed building or its setting. In conservation areas there is a duty on the planning authority as follows:

In the exercise, with respect to any buildings or other land in a conservation area, of any functions under or by virtue of [the Planning Acts] special attention shall be paid to the desirability of preserving or enhancing the character or appearance of that area.[7]

The Ancient Monuments and Archaeological Areas Act 1979 prohibits almost any works to a scheduled monument – viz:

(a) any works resulting in the demolition or destruction of or any damage to a scheduled monument;

(b) any works for the purpose of removing or repairing a scheduled monument or any part of it or of making any alterations or additions thereto; and

(c) any flooding or tipping operations on land in, on or under which there is a scheduled monument.[8]

By contrast, the NPPF seeks to protect the 'significance' of heritage assets. Significance is defined in the following terms:

Significance (for heritage policy): The value of a heritage asset to this and future generations because of its heritage interest. The interest may be archaeological, architectural, artistic or historic. Significance derives not only from a heritage asset's physical presence, but also from its setting. For World Heritage Sites, the cultural value described within each site's Statement of Outstanding Universal Value forms part of its significance.[9]

The NPPF states that planning authorities should:

... identify and assess the particular significance of any heritage asset that may be affected by a proposal (including by development affecting the setting of a heritage asset) taking account of the available evidence and any necessary expertise. They should take this into account when considering the impact of a proposal on a heritage asset, to avoid or minimise any conflict between the heritage asset's conservation and any aspect of the proposal.[10]

Note that this definition of significance imports the concept of setting to heritage assets generally. The only heritage assets that, as a matter of law, enjoy protection for their setting are listed buildings. At a stroke the NPPF seems to have extended protection, as a matter of policy, at least, to the setting of all heritage assets. As we will see this has led to the Courts making decisions to some extent on the basis of impact on the setting of heritage assets, the protection of which, as previously noted, was never intended by Parliament – see in particular *Barnwell Manor Wind Energy Ltd v East Northants DC & Others [2014] EWCA Civ 137* where the impact was, at least in part, on the setting of a scheduled monument and a registered park and garden.

How Did the Disconnect Come About?

So how did we get here? Why is it that law and policy protect different (albeit significantly overlapping) classes of asset? And why the different terminology when it comes to describing what it is about the asset that is worthy of protection?

To answer that question we must look back to the turn of the century. In quick succession English Heritage (as it then was) published 'Power of Place' (2000) and 'Historic Environment: A Force for our Future' (2001). The central idea in these publications was that what people value, and therefore what ought to be protected, are 'places' in the sense of wider localities rather than individual buildings or areas. English Heritage, supported by the Department for Culture, Media, and Sport (DCMS) (as it then was), began to contemplate a more holistic approach to the protection of the historic built environment.

This led on to a draft Heritage Protection Bill being published for consultation in April 2008. The Bill proposed bringing together statutorily protected buildings and monuments plus 'heritage open spaces' (e.g. registered parks, gardens and battlefields), World Heritage Sites and marine monuments (e.g. protected wrecks) into a single class to be collectively known as 'heritage assets' and introduce a single 'heritage consent' covering listed building consent, conservation area consent and scheduled monument consent.

The draft Bill's timing turned out to be against it. Its publication date was, of course, a matter of a few months before the global financial crisis led to the government having much bigger fish to fry. Unfortunately, possibly in part because the financial crisis but also, the writer cannot help but conclude from personal experience, because heritage is in any event perennially low in the priority lists of governments of all stripes, the Bill never found Parliamentary time and was shelved indefinitely. Undeterred, English Heritage and DCMS nevertheless ploughed ahead with what remained in their control: the associated policy statement. Thus when old PPGs 15 and 16, which had provided guidance on the protection respectively of listed buildings, conservation areas, ancient monuments and archaeology, were replaced by PPS5, the terminology which would have matched the Heritage Protection legislation had it ever been passed was utilised throughout. Thus in policy terms, 'heritage assets' and 'significance' replaced the

statutory terminology. The PPS5 terminology was then carried forward into the NPPF and its recent reiterations.

The NPPF Approach

The NPPF sets out in some detail the approach decision-makers should take when heritage assets are affected by development proposals. It begins by emphasising the importance to be attached to the conservation of heritage assets:

> *When considering the impact of a proposed development on the significance of a designated heritage asset, great weight should be given to the asset's conservation (and the more important the asset, the greater the weight should be).*[11]

It goes on to state that any harm to, or loss of significance:

> *… should require clear and convincing justification. Substantial harm to or loss of:*
>
> *(a) grade II listed buildings, or grade II registered parks or gardens, should be exceptional;*
>
> *(b) assets of the highest significance, notably scheduled monuments, protected wreck sites, registered battlefields, grade I and II* listed buildings, grade I and II* registered parks and gardens, and World Heritage Sites, should be wholly exceptional.*[12]

It then prescribes a different approach depending on whether the heritage asset is designated or not and, in the case of designated heritage assets, whether the harm is substantial or less than substantial. This latter distinction is key. Unfortunately the terms are not defined and the NPPF provides no guidance as to how to determine whether harm is substantial or less than substantial. It is obviously a question of subjective professional judgement. In some cases it will be clear whether harm is substantial or less than substantial. Other cases, obviously, might be less clear-cut and it is entirely possible (indeed likely) that one respected professional might legitimately take the view that the harm is substantial while another equally respected professional might, equally legitimately, take the view that it is less than substantial. As it happens, in the cases that have so far come before the courts there appears to be substantial agreement between the parties on this point so the Courts have provided no guidance either. There is a school of thought that harm to setting can only ever be less than substantial. There is no case law support for this view other than the fact that in the various cases that have come to court on setting following the publication of the NPPF there has been agreement between the parties that there is less than substantial harm involved in terms of the impact on the setting of the heritage asset concerned (see, for example *Barnwell Manor Wind Energy Ltd v East Northants DC & Others [2014] EWCA* and *Mordue v SosCLG [2015] EWHC 539 (Admin)*). This does not, of course, justify a hard and fast view that impact on setting will always be less than substantial. Further, it does not necessarily follow that every intrusion into the fabric of a heritage asset will be substantial.

The following approaches are prescribed in the NPPF:

Designated Heritage Asset/Substantial Harm

Paragraph 195 applies:

> Where a proposed development will lead to substantial harm to (or total loss of significance of) a designated heritage asset, local planning authorities should refuse consent, unless it can be demonstrated that the substantial harm or total loss is necessary to achieve substantial public benefits that outweigh that harm or loss, or all of the following apply:
>
> (a) the nature of the heritage asset prevents all reasonable uses of the site; and
>
> (b) no viable use of the heritage asset itself can be found in the medium term through appropriate marketing that will enable its conservation; and
>
> (c) conservation by grant-funding or some form of not for profit, charitable or public ownership is demonstrably not possible; and
>
> (d) the harm or loss is outweighed by the benefit of bringing the site back into use.

It will be seen that this approach comes close to a presumption against development which causes substantial harm to a designated heritage asset.

Designated Heritage Asset/Less than Substantial Harm

Paragraph 196 applies:

> *Where a development proposal will lead to less than substantial harm to the significance of a designated heritage asset, this harm should be weighed against the public benefits of the proposal including, where appropriate, securing its optimum viable use.*

As we will see, this paragraph has been the cause of confusion in the minds of more than one decision maker, leading them to believe that, where harm to a listed building or conservation area is less than substantial, a straightforward planning balance is appropriate. As a result they have failed to apply the rather greater weight to heritage interests that is required by the law in the case of listed buildings and conservation areas. It cannot be emphasised too strongly that where a decision maker is considering less than substantial harm to a listed building, its setting or a conservation area, the s16, s.66 and/or s.72 duty (as appropriate) described above must be applied alongside paragraph 196.

Non-Designated Heritage Asset

Paragraph 197 applies:

> *The effect of an application on the significance of a non-designated heritage asset should be taken into account in determining the application. In weighing applications that directly or indirectly affect non-designated heritage assets, a balanced judgement will be required having regard to the scale of any harm or loss and the significance of the heritage asset.*

The fact of non-designated heritage asset status is just one factor in the normal planning balance. As this will typically only apply to locally identified assets this is probably the correct approach.

Squaring the Circle

The good news is that, despite their apparent differences, the approaches taken by law and policy are not incompatible. As we have seen the intention of the proposed legislation was to simply pull together everything that is currently statutorily protected into a single protection system. In doing so existing terminology was extensively used. For example, a close examination of the definition of 'significance' shows that it has pulled in the terms 'architectural interest' and 'historic interest' from the 1990 Act and simply added 'archaeological interest' and 'artistic interest' which had long been used as policy criteria for scheduled monuments.

Since the first NPPF was introduced in 2012 the Courts have considered the correct approach in a number of cases, which has hopefully provided some clarity.

How Have the Courts Dealt with the Disconnect?

There has been a string of cases dealing with the correct approach to decision-making on applications involving heritage assets (which I propose to briefly summarise):

In *Barnwell Manor Wind Energy Ltd v East Northants DC & Others [2014] EWCA Civ 137 the Court of Appeal (Lord Justice Maurice Kay, Lord Justice Sullivan and Lady Justice Rafferty)* there was a challenge to the decision of the Secretary of State to grant planning permission for a four-turbine wind farm. The Inspector concluded that there would be harm to the setting of various heritage assets particularly Lyveden Old Bield (Grade 1 listed building; scheduled monument and Grade 1 on the Register of Historic Parks and Gardens). He decided that that harm would be less than substantial 'and reduced by its temporary (25 year) nature'. He balanced that harm against the positive contribution to renewable energy needs and targets the development would make and concluded the harm was outweighed by the benefits.

On the balancing exercise point, Sullivan LJ commented:

> [The Inspector] appears to have treated the less than substantial harm to the setting of the listed buildings ... as a less than substantial objection to the grant of planning permission.

The Inspector may have been misled by what is now paragraph 196 of the NPPF which, as discussed above, appears to advocate a straightforward balancing exercise where the harm to a designated heritage asset is less than substantial. In fact, as noted above, the s.66 duty still falls to be applied in the case of the setting of a listed building whether the harm is substantial or less than substantial.

A case where the Inspector expressly fell into the paragraph 196 trap, so to speak, is *North Norfolk DC v Secretary of State and Mack [2014] EWHC 279 (Admin)*. North Norfolk applied to quash the decision of the Inspector appointed by the Secretary of State to allow an appeal for a wind turbine at Pond Farm, Bodham in Norfolk. The grounds of the application included an allegation that the Inspector had failed to properly apply the s.66 duty.

The proposed turbine had an impact on the setting of a number of listed buildings in the area, including Barnigham Hall and Baconsthorpe Castle (both grade I) and a number of Grade II* churches. Addressing the impact on those settings, the Inspector's decision letter had concluded:

> ... I agree with the officer's opinion in their (sic) report to committee that [the development] would lead to less than substantial harm, engaging paragraph 134 [now 196] of the NPPF. The harm will be weighed against the public benefits of the proposal in the final issue.

Robin Purchas QC sitting as a Deputy High Court Judge concluded that the Inspector has thus misdirected himself, concluding that:

> ... the Inspector's approach seems to me at this level to have balanced the relative harm and benefit as a matter of straightforward planning judgement without that special regard required under the statute. Thus he treated the balance under paragraph 134 [now 196] of the NPPF as the same exercise as that in respect of the landscape effects.

The decision was quashed as a result.

Another case where the decision maker got it (in that case quite spectacularly!) wrong was *Gerber v Wiltshire Council. Unreported Case Number: CO/3930/2014*. Dove J quashed planning permission for a 22 hectare solar farm at Broughton Gifford. The claimant only became aware of the development when the photovoltaic arrays were being installed. Despite the solar farm operator standing to lose some £12 million, permission was quashed on three grounds:

- the council should have consulted the claimant and had breached his 'legitimate expectation' that he would be notified of a development proposal of this sort.
- as the council had considered that the solar farm development would have an effect on listed buildings in the area and a conservation area, English Heritage should have been consulted.
- the council had failed in its duty to have 'special regard' to the desirability of preserving the setting of listed buildings and had carried out a 'flawed' assessment of environmental issues.

With admirable understatement, Dove J commented:

> The status of Gifford Hall as a Grade II* listed building and the failure to give its interests a proper and lawful consideration attracts in my view very significant weight in the overall balance of considerations.

The final case to mention is *Mordue v SosCLG [2015] EWHC 539 (Admin)*. This was another proposed wind turbine which would have had an impact on a number of listed buildings including particularly the Church of St Mary in Wappenham. In the case at first instance (it was appealed to the Court of Appeal on other grounds), John Howell QC offered the following useful and very eloquent advice to decision makers:

> In my judgment, a decision-maker who follows the guidance given in paragraphs 132 and 134 [now 193 and 196] of the NPPF (when dealing with a case in which the proposed development will result in less than substantial harm to the value of a listed building (for example by development within its setting)) will comply with the obligation imposed by section 66(1) of the Listed Buildings Act as interpreted by the Court of Appeal in the [Barnwell Manor] case. When a proposed development will result in harm to the value of a listed building (for example by development within its setting) but that harm is less than substantial, however, then a decision maker following the guidance will give 'great weight' to any such harm. Giving any such weight to any such harm must at least involve giving 'considerable weight' to it.

Further, as the policy itself illustrates, it cannot be inferred from the fact that the decision-maker considers that the proposed development will cause less than substantial harm that he or she necessarily regards such harm as having less than 'considerable weight'.

Conclusions

Although there are clear differences between law and policy, as we have seen, these are explicable once one understands the history of how the policy came about. The Courts have considered the policy and found that the two are not incompatible. When considering applications which affect heritage assets decision-makers need to bear in mind any applicable statutory duties and the overall policy in paragraph 193 of the NPPF that 'great weight' should be given to the conservation of heritage assets and that the more important the asset, the greater the weight that should be given. Provided they do so, they will not go far wrong.

Notes

1. The Protection of Wrecks Act 1973 also provides protection for the remains of vessels which have sunk but the marine environment is beyond the scope of this paper.
2. MHCLG, "National Planning Policy Framework." Glossary.
3. Ibid.
4. It is, though, the case that most, if not all, UK World Heritage Sites enjoy protection because they have another designation. For example, Stonehenge is a scheduled monument and Blenheim Palace is a Grade I listed building.
5. Planning (Listed Buildings and Conservation Areas Act 1990 s.7.
6. Planning (Listed Buildings and Conservation Areas) Act 1990 s.16.
7. Planning (Listed Buildings and Conservation Areas) Act 1990 s.72.
8. Ancient Monuments and Archaeological Areas Act 1979 s.2(2).
9. MHCLG.Glossary.
10. Ibid. para 190.
11. Ibid.para 193.
12. Ibid.para 194.

Disclosure statement

No potential conflict of interest was reported by the author.

Bibliography

MHCLG. "National Planning Policy Framework." edited by Communities & Local Government Ministry of Housing. London, UK: The Crown, 2019.

Heritage Assets: Decision Making in the Real World

Peter Goatley and Nina Pindham

ABSTRACT
This article aims to analyse and provide some insight into how practitioners can provide pragmatic advice to their clients in dealing with planning decision-making involving heritage assets. It also aims to provide some insight into how decision-making relating to heritage assets is likely to play in the real world so as to enable a more predictive approach to be taken by practitioners. In doing so, it sets out the relationship between legislation and policy and details how this framework has been applied in the courts, planning inquiries and at local plan examinations.

Introduction and Context

'Designated heritage assets' is the term now used to encompass land and buildings identified by the planning system as being in need of special recognition and protection. In respect of listed buildings, these have been the subject of statutory protection since 1947. Conservation Areas came later in 1967.[1] The protection of both is now enshrined within the Planning (Listed Building and Conservation Areas) Act 1990 (as amended) ('the 1990 Act'). There are also other designated heritage assets to which varying degrees of protection are applied including scheduled ancient monuments, World Heritage Sites, registered parks and gardens, protected wreck sites (restricted and prohibited areas), protected military remains and registered battlefields. There is also policy protection, in the National Planning Policy Framework (NPPF), Planning Practice Guidance (PPG), and potentially in local plans, for some of the above-listed assets as well as for heritage assets which do not warrant formal designation, referred to as 'non-designated heritage assets'. A 'heritage asset' is very broadly defined in the NPPF as:

> A building, monument, site, place, area or landscape identified as having a degree of significance meriting consideration in planning decisions, because of its heritage interest. Heritage asset includes designated heritage assets and assets identified by the local planning authority (including local listing). (Annex 2: Glossary, National Planning Policy Framework)

The protection of listed buildings in a legal sense is underpinned by a range of potentially quite severe penalties in respect of demolition, destruction or alteration. Legal culpability, subject to some highly limited exceptions, amounts to strict liability.[2] In other words, the intention of the person carrying out the works is irrelevant. Penalties for heritage crime can be severe: there is the capacity to impose an unlimited fine and/or a term of imprisonment by both magistrates' courts and the Crown Court.[3]

Listed Buildings

Listed Buildings are buildings of special architectural or historic interest. They appear on lists compiled or approved by the Secretary of State under section 1 of the 1990 Act. The term 'listed building' incorporates both the building (the principal building); any object or structure fixed to the principal building; and any object or structure within the curtilage of the principal building that although not fixed to the principal building has formed part of the land since before 1 July 1948 (by section 1(5) of the 1990 Act).

The Principles of Selection for Listed Buildings[4] set out the general principles the Secretary of State or Historic England[5] will apply when deciding whether a building is of special architectural or historic interest. Buildings may be considered of special architectural interest for their architectural design, decoration, plan form or craftsmanship. To have historic interest a building must illustrate important aspects of England's social, economic, cultural or military history and/or have close historical associations with nationally important people and it will normally have some quality of interest in its physical fabric. When listing a building, the Secretary of State may also take into account a building's group value.

The listed building consent regime is the responsibility of local planning authorities and the Department of Communities and Local Government, with Historic England as statutory consultee on many applications (particularly those affecting Grade I and II* listed buildings). Historic England also has specific powers as regards the determination of listed building consent applications in Greater London. The designation also ensures that special regard is given to the desirability of preserving the building or its setting or any features of special architectural or historic interest that it possesses when decisions are made on planning applications (by s.66 of the 1990 Act). Listing protection applies to the whole building: both interior and exterior.

In each instance, there are a series of judgement-sensitive decisions to be made by decision-makers as to whether the importance of statutory listing is to apply. Subject to potential scrutiny by the courts, pursuant to *Wednesbury* unreasonableness[6] or other public law grounds of challenge, any such decision is not one otherwise amenable to determination by the courts.

Case law has clarified the scope of what is meant by 'listed building'. *Dill v Secretary of State for Communities and Local Government* [2018] EWCA Civ 2619 concerned two early eighteenth-century limestone piers surmounted by a lead urn of the same era which were moved to Idlicote House, a Grade II listed building, in 1973. Subsequently in 1986, each of the piers and urns was separately Grade II listed. In 2009, Mr Dill sold the objects at auction. He did not know the name of the purchaser and did not know where the objects went. He challenged the refusal to grant retrospective listed building consent and a subsequent enforcement notice requiring their return on the basis that the objects were not a 'listed building'. As a point of principle, Hickinbottom LJ agreed with the judge below that a decision-maker in that context (i.e. not considering an application to de-list the building) could not consider or determine whether something on the list was a building. As Hickinbottom LJ said: ' ... being on the list is determinative of the status of the subject matter as a listed building, the protection given by the Act deriving from that status'.[7] The inclusion on the list at the relevant time is also determinative of whether the object or structure in question amounted to a listed building.[8]

Conservation Areas

Conservation areas are designated areas of special architectural or historic interest the character or appearance of which it is desirable to preserve or enhance (sections 69 and 70 of the 1990 Act). They are usually designated by local planning authorities. However, Historic England can designate conservation areas in London in consultation with the relevant London Borough Council and with the consent of the Secretary of State. The Secretary of State can also designate in exceptional circumstances, usually where an area is of more than local interest.

The purpose of the designation is to provide a broader form of protection beyond protection for an individual building. It recognises that historic buildings and architecturally interesting buildings do not exist in a vacuum but are part of an urban or rural context providing a setting for them, which may itself have a special character or appearance.[9] Conservation areas may be areas with a high number of nationally designated heritage assets, a variety of architectural styles and historic associations, linked to a particular individual, industry, custom or pastime with a particular local interest, where an earlier, historically significant, layout is visible in the modern street pattern, where a particular style of architecture or traditional building materials predominate, or because of the quality of the public realm or a spatial element, such as a design form or settlement pattern, green spaces which are an essential component of a wider historic area, and historic parks and gardens and other designed landscapes.[10]

The most significant effect of the designation of a conservation area is to remove certain permitted development rights granted under the Town and Country Planning (General Permitted Development) (England) Order 2015.[11] It also restricts the works which may be carried out to trees without consent.

In exercising its planning functions including the determination of planning applications, local planning authorities are under a duty to pay special attention to the desirability of preserving or enhancing the character or appearance of a conservation area (by s.72 of the 1990 Act).

The consent regime is the responsibility of local planning authorities and the Department of Housing, Communities and Local Government.

Decision Making: Sections 66 and 72

Leaving aside infractions of planning and listed building control which are otherwise dealt with by the enforcement process, the vast majority of decisions that come to be made relate to new development involving such buildings or conservation areas either directly or indirectly through a change to their settings.

The relevant statutory provisions to which this article is principally directed are those relating to such judgements that arise under the operations of sections 66 and 72 of the 1990 Act.

Section 66 provides:

General duty as respects listed buildings in exercise of planning functions.

(1) In considering whether to grant planning permission or permission in principle for development which affects a listed building or its setting, the local planning authority or,

as the case may be, the Secretary of State shall have special regard to the desirability of preserving the building or its setting or any features of special architectural or historic interest which it possesses.

(2) Without prejudice to section 72, in the exercise of the powers of appropriation, disposal and development (including redevelopment) conferred by the provisions of sections 232, 233 and 235(1) of the principal Act, a local authority shall have regard to the desirability of preserving features of special architectural or historic interest, and in particular, listed buildings.

(3) The reference in subsection (2) to a local authority includes a reference to a joint planning board.

Section 72 provides:

General duty as respects conservation areas in exercise of planning functions.

(1) In the exercise, with respect to any buildings or other land in a conservation area, of any [functions under or by virtue of any of the provisions mentioned in subsection (2), special attention shall be paid to the desirability of preserving or enhancing the character or appearance of that area.

(2) The provisions referred to in subsection (1) are the planning Acts and Part I of the Historic Buildings and Ancient Monuments Act 1953 and sections 70 and 73 of the Leasehold Reform, Housing and Urban Development Act 1993.

(3) In subsection (2), references to provisions of the Leasehold Reform, Housing and Urban Development Act 1993 include references to those provisions as they have effect by virtue of section 118(1) of the Housing Act 1996.

(4) Nothing in this section applies in relation to neighbourhood development orders.

Again, these are judgement-infused decisions as to whether there will be any effect on a listed building or conservation area or their setting and if so whether that effect is harmful, positive or neutral. It is only the first of these that should give rise to an adverse outcome though, perhaps predictably, the decision-making process is more labyrinthine than that.

Any planning decisions have to be made having regard not only to the statutory duties set out above under the 1990 Act but also the decision-making requirements of section 38(6) of the Planning and Compulsory Purchase Act 2004. This provides:

If regard is to be had to the development plan for the purpose of any determination to be made under the planning Acts the determination must be made in accordance with the plan unless material considerations indicate otherwise.

Development plan policies may have been established at various times and during periods where different fashions of the imposition of restriction were in play. Hence, it was not uncommon for development plan policies formulated during the 1990s to be expressed in relatively stark and binary terms to the effect that 'no development shall be permitted which will have an adverse effect upon the character, appearance or setting of a listed building or conservation area'. Such a formulation was intended to in some way replicate the statutory tests but self-evidently such formulations are vastly more restrictive than that which was required by those tests.

Finally, whilst the NPPF does not have the force of statute, being a national planning policy, it will always be a weighty material consideration. Coincidentally, at about the time that the first iteration of the NPPF was published in 2012, the Supreme Court dealt with an appeal regarding Scottish planning law in the case of *Tesco Stores Ltd v Dundee City Council* [2012] UKSC 13. This case resolved what had been something of an unresolved issue in public law.

That is whether the correct interpretation of policy by a decision-maker was (1) a matter for the reasonable determination of the decision-maker (subject only to the review of the courts if it strayed outside the bounds of reasonable decision-making) or (2) it was a matter for interpretation by the courts, purely as a matter of law. In *Tesco v Dundee* the courts finally came down firmly in favour of the latter. This is crucially important. What it means is that it is now for the courts to decide (as a matter of law) what policy means. It is no longer for a decision-maker to say what it means (and perhaps decide, on some other occasion, that it 'means' something else). Whilst it will remain for the decision-maker to *apply* policy (in any given case), the decision-maker must, in approaching any decision, correctly interpret the policy. If he or she does not do so then the decision will be susceptible to challenge in the courts. It also behoves those who are seeking to draft policy to exercise particular care to ensure that the terms of the policy are appropriately directed to achieving the requisite policy intention.

It was then perhaps unsurprising if, with the advent of the NPPF, it was necessary to specifically examine whether decision-makers have properly understood the scope and effect of planning policy.

The relevant paragraphs in the current version of the NPPF (now from February 2019) are as follows:

193. When considering the impact of a proposed development on the significance of a designated heritage asset, great weight should be given to the asset's conservation (and the more important the asset, the greater the weight should be). This is irrespective of whether any potential harm amounts to substantial harm, total loss or less than substantial harm to its significance.

194. Any harm to, or loss of, the significance of a designated heritage asset (from its alteration or destruction, or from development within its setting), should require clear and convincing justification. Substantial harm to or loss of:

(a) grade II listed buildings, or grade II registered parks or gardens, should be exceptional;

(b) assets of the highest significance, notably scheduled monuments, protected wreck sites, registered battlefields, grade I and II* listed buildings, grade I and II* registered parks and gardens, and World Heritage Sites, should be wholly exceptional[63]. [63: Non-designated heritage assets of archaeological interest, which are demonstrably of equivalent significance to scheduled monuments, should be considered subject to the policies for designated heritage assets.]

195. Where a proposed development will lead to substantial harm to (or total loss of significance of) a designated heritage asset, local planning authorities should refuse consent, unless it can be demonstrated that the substantial harm or total loss is necessary to achieve substantial public benefits that outweigh that harm or loss, or all of the following apply:

(a) the nature of the heritage asset prevents all reasonable uses of the site; and

(b) no viable use of the heritage asset itself can be found in the medium term through appropriate marketing that will enable its conservation; and

(c) conservation by grant-funding or some form of not for profit, charitable or public ownership is demonstrably not possible; and
(d) the harm or loss is outweighed by the benefit of bringing the site back into use.

196. Where a development proposal will lead to less than substantial harm to the significance of a designated heritage asset, this harm should be weighed against the public benefits of the proposal including, where appropriate, securing its optimum viable use.

197. The effect of an application on the significance of a non-designated heritage asset should be taken into account in determining the application. In weighing applications that directly or indirectly affect non-designated heritage assets, a balanced judgement will be required having regard to the scale of any harm or loss and the significance of the heritage asset.

One of the most vexed questions in decisions affecting heritage assets, particularly listed buildings, is the question of setting. There is no statutory definition of setting, even though it is given statutory protection in the context of listed buildings by s. 66(1) of the 1990 Act. This means the definition set out in the NPPF is effectively used for this purpose. This states that a 'setting' comprises:

> The surroundings in which a heritage asset is experienced. Its extent is not fixed and may change as the asset and its surroundings evolve. Elements of a setting may make a positive or negative contribution to the significance of an asset, may affect the ability to appreciate that significance or may be neutral.

Explanation of the Courts' Interpretation of the Statutory Tests

The most noteworthy cases are the Court of Appeal judgements of Sullivan LJ, with whom Kay and Rafferty LJJ agreed, in *East Northamptonshire District Council v Secretary of State for Communities and Local Government* [2015] 1 WLR 45 (also known as the 'Barnwell Manor case'), particularly paragraphs 16–29; the judgement of Sales LJ, with whom Richards and Floyd LJJ agreed, in *Mordue v Secretary of State for Communities and Local Government* [2015] EWCA Civ 1243, particularly paragraphs 26–29, and Lindblom LJ, with whom McFarlane and Asplin LJJ agreed, in *Steer and Historic England v Secretary of State for Communities and Local Government and Catesby Estates* [2018] EWCA Civ 1697, particularly paragraphs 26–29. These and related cases will be examined in turn.

No doubt practitioners are well aware of the decision in *East Northamptonshire*. Familiarity, however, has not led to compliance. Decision-makers continue to make errors of law when considering the impact of development on heritage assets. Most recently, a decision of Liverpool City Council[12] was quashed in the High Court because the officer's report to the Council's Planning Committee said '.impacts on heritage are considered to be outweighed by the public benefits identified within the report'. It was successfully argued that this indicated the Council had failed to afford 'great weight' to the desirability of preserving the setting of the affected listed building.

The assessment of harm is, and always has been, a matter of planning judgement. However, as Sullivan LJ in *East Northamptonshire* confirmed (at paragraphs 22, 24 and 29), a finding of harm – whether less than substantial or substantial – to the setting of a listed

building or its setting is a consideration to which the decision-maker must give 'considerable importance and weight'. In other words, a decision-maker is not then free to give that harm such weight as they see fit when carrying out the balancing exercise. Also, worth noting is Sullivan LJ's comment that once harm is identified, this creates a 'strong presumption' against the grant of planning permission (paragraph 23).

Sullivan LJ went on to say that where harm is properly assessed as less than substantial, 'it does not follow that the "strong presumption" against the grant of planning permission has been entirely removed' (paragraphs 28 and 29).

Reiterating the approach set out above in the context of a conservation area, in *R (Hughes) v South Lakeland DC* [2014] EWHC 3979 (Admin) HHJ Waksman QC (sitting as a Judge of the High Court) stated (at paragraph 53, referring to paragraphs in the former NPPF):

> As is made clear in paragraph 45 of *Forge Field*, [discussed further below] even if the harm would be less than substantial so that paragraph 133 did not apply but paragraph 134 did, the harm must still be given considerable importance and weight. That of course is doing no more than following the injunction laid down in s72(1). The presumption therein needs to be 'demonstrably applied' – see paragraph 49 of *Forge Field*. Put another way, in a paragraph 134 case, the fact of harm to a heritage asset is still to be given more weight than if it were simply a factor to be taken into account along with all other material considerations, and paragraph 134 needs to be read in that way. By way of contrast, where non-designated heritage assets are being considered, the potential harm should simply be 'taken into account' in a 'balanced judgment' – see paragraph 135. It follows that paragraph 134 is something of a trap for the unwary if read – and applied – in isolation.

Therefore, in striking the planning balance when considering harm to a listed building or its setting, the question is not whether the advantages of the scheme outweigh the harm, but whether the advantages sufficiently outweigh the harm to rebut the strong presumption against causing any harm.

It should be noted that there is not, as such, an obligation for decision-makers to carry out a detailed assessment of the significance of the heritage asset in question. Whilst paragraph 197 of the NPPF advises that when decision-makers are assessing 'the effect of an application on the significance of a non-designated heritage asset should be taken into account', this only means the designation of the asset is to be taken into account. Kerr J in *R (Simon Shimbles) v City of Bradford Metropolitan District Council v Endless Energy Limited, The National Trust* [2018] EWHC 195 (Admin) (at paragraph 89) considered that '[there is] no need for the LPA to make a further finding whether it is a "high grade I" on the spectrum, a "low grade I", or somewhere in between. That would introduce unnecessary complexity'. Nor is there a need to specify where on the spectrum of 'substantial' or 'less than substantial' harm the development's impact sits (*Shimbles*, paragraph 87). Per Kerr J at paragraph 90: '[t]he two categories of harm are adequate to enable the weighted balancing exercise to be carried out'.

However, that approach might appear somewhat surprising unless one appreciates its context: namely whether there was a need for a decision-maker to specify (as a matter of law) where any identified harm lay on the spectrum of harm from less than substantial to substantial. It would remain open to a decision-maker to adopt such an approach and it would seem most surprising if the courts would seek to try and constrain or preclude such an approach. Indeed, as Lindblom J (as he then was) noted in *R (The Forge Field Society & Others) v Sevenoaks District Council and West Kent Housing Association* [2014] EWHC 1895 (Admin), at

paragraph 49 (in dealing with properly carrying out the planning balance of harm and benefits where the statutory presumption is engaged):

> This does not mean that an authority's assessment of likely harm to the setting of a listed building or to a conservation area is other than a matter for its own planning judgment. It does not mean that the weight the authority should give to harm which it considers would be limited or less than substantial must be the same as the weight it might give to harm which would be substantial. But it is to recognize, as the Court of Appeal emphasized in *Barnwell*, that a finding of harm to the setting of a listed building or to a conservation area gives rise to a strong presumption against planning permission being granted. The presumption is a statutory one. It is not irrebuttable. It can be outweighed by material considerations powerful enough to do so. But an authority can only properly strike the balance between harm to a heritage asset on the one hand and planning benefits on the other if it is conscious of the statutory presumption in favour of preservation and if it demonstrably applies that presumption to the proposal it is considering.

Perhaps of more pertinence in the litigation-conscious world that planning and conservation officers inhabit is Kerr J's lament in *Shimbles* at paragraph 93 that:

> I observe with some regret that in this case there is strong evidence of defensive drafting This is ... a sorry consequence of a litigious culture in which planning decisions are, rightly, subject to scrutiny to ensure they are lawfully made. The repetitious allusions to the need for considerable weight to be given to the harm to the setting of the Hall would, perhaps, have been better replaced by saying more about the nature of that harm.

In terms of when to weigh in the presumption against causing harm, care should be taken not to factor it into the planning balance several times. There is a risk of this occurring in decisions concerning less than substantial harm under paragraph 196 of the NPPF, for the decision-maker is to consider whether the harm caused is outweighed by the public benefits of the scheme, including securing its optimum viable use. If, applying the internal planning balance in paragraph 196, and giving considerable importance and weight to the less than substantial harm that would be caused, the decision-maker concludes that the public benefits outweigh that harm, then it would be double-counting if the presumption was to be factored back into the planning balance again when considering the overall balance. This is not to say that the harm ought to be ignored when striking the overall planning balance: it remains a factor to take into account, but in considering it in the overall balance the decision-maker must bear in mind that they have already given it considerable importance and weight and applied the presumption against causing harm in the internal paragraph 196 balance.

Further clarification on this point was given by the Court of Appeal in *Palmer v Herefordshire Council* [2016] EWCA Civ 1061. Lewison LJ concluded that it was lawful for the decision-maker to have found that the harmful aspect of the development could be balanced against the proposed mitigation, in effect cancelling each other out. At paragraph 29:

> ... where a proposed development would affect a listed building or its settings in different ways, some positive and some negative, the decision maker may legitimately conclude that [though] each of the effects has an impact, taken together there is no overall effect on the listed building or its setting ... the duty to accord "considerable weight" to the desirability of avoiding harm does not mean that any harm, however slight, must outweigh any benefit, however great, or that all harms must be treated as having equal weight.

The judgement in *East Northamptonshire* was followed by Lindblom J (as he then was) in *Forge Field* (above). Lindblom J (at paragraph 45) further considered the approach to take when any harm has been identified:

> Mr Strachan submitted that in determining the second application the Council failed – as it had in determining the first – to comply with its duties under sections 66 and 72 of the Listed Buildings Act. Its error was similar to the one made by the inspector in Barnwell. Having 'special regard' to the desirability of preserving the setting of a listed building under section 66, and paying 'special attention' to the desirability of preserving or enhancing the character and appearance of a conservation area under section 72, involves more than merely giving weight to those matters in the planning balance. 'Preserving' in both contexts means doing no harm (see the speech of Lord Bridge of *Harwich in South Lakeland District Council v Secretary of State for the Environment* [1992] 2 A.C. 141, at p.150 A-G). There is a statutory presumption, and a strong one, against granting planning permission for any development which would fail to preserve the setting of a listed building or the character or appearance of a conservation area. The officer acknowledged in his report, and the members clearly accepted, that the proposed development would harm both the setting of Forge Garage as a listed building and the Penshurst Conservation Area. Even if this was only 'limited' or 'less than substantial harm' – harm of the kind referred to in paragraph 134 of the NPPF – the Council should have given it considerable importance and weight. It did not do that. It applied the presumption in favour of granting planning permission in Policy SP4(c) of the core strategy, balancing the harm to the heritage assets against the benefit of providing affordable housing and concluding that the harm was not 'overriding'. This was a false approach. Its effect was to reverse the statutory presumption against approval.

As noted above, this had to be considered in the context of Lindblom J's observations on the basis for assessing harm and attributing weight set out at paragraph 49 of the judgement.

Sullivan LJ's reference in Barnwell to the need to 'expressly acknowledge the need ... to give considerable weight to the desirability of preserving the setting of those buildings' in paragraph 29 of *East Northamptonshire*, and Lindblom J's reference to the need to 'demonstrably appl[y] that presumption' in *Forge Field* was subsequently interpreted as requiring express text in the decision to that effect, as though it could be used as some sort of mantra to avoid legal challenge. However, this effectively reversed the burden of proof in any legal challenge as the assumption then became that the decision-maker hadn't complied with the statutory duty in the absence of any such mantra. The issue was finally resolved by the Court of Appeal in *Aidan Jones v Jane Margaret Mordue, Secretary of State for Communities and Local Government, South Northamptonshire Council* [2015] EWCA Civ 1243. This is the case where Sales LJ famously introduced the planning world to 'fasciculus' (a bundle of structures, such as nerve or muscle fibres or conducting vessels in plants, or, evidently, a set of heritage policies in national planning policy).

In the High Court decision in *Mordue*, the claimant (the chairperson of a local group of objectors) successfully made an application under section 288 of the Town and Country Planning Act 1990 ('the 1990 Act') to quash the grant of permission for the erection of a single freestanding wind turbine. John Howell QC, sitting as a deputy judge of the High Court, held that the Inspector had failed to *demonstrate* in the reasons he gave that he had complied with his duty under s.66(1) to have special regard to the desirability of preserving the setting of listed buildings by giving considerable weight to the desirability of preserving their setting (paragraph 48). The deputy judge considered that he was bound to reach his conclusion by the decision in *East Northamptonshire* (in particular at paragraph 29) (quoted above).

The deputy judge, however, also gave what Sales LJ said in *Mordue* were 'excellent reasons' for thinking that this result would be out of line with the House of Lords case of *Save Britain's Heritage v Number 1 Poultry Limited* [1991] 1 WLR 153. In that case, Lord Bridge of Harwich (giving the leading speech) had said at pages 167C-168E:

> Whatever may be the position in any other legislative context, under the planning legislation, when it comes to deciding in any particular case whether the reasons given are deficient, the question is not to be answered in vacuo. The alleged deficiency will only afford a ground for quashing the decision if the court is satisfied that the interests of the applicant have been substantially prejudiced by it. This reinforces the view I have already expressed that the adequacy of reasons is not to be judged by reference to some abstract standard. There are in truth not two separate questions: (1) were the reasons adequate? (2) if not, were the interests of the applicant substantially prejudiced thereby? The single indivisible question, in my opinion, which the court must ask itself whenever a planning decision is challenged on the ground of a failure to give reasons is whether the interests of the applicant have been substantially prejudiced by the deficiency of the reasons given. Here again, I disclaim any intention to put a gloss on the statutory provisions by attempting to define or delimit the circumstances in which deficiency of reasons will be capable of causing substantial prejudice, but I should expect that normally such prejudice will arise from one of three causes. First, there will be substantial prejudice to a developer whose application for permission has been refused or to an opponent of development when permission has been granted where the reasons for the decision are so inadequately or obscurely expressed as to raise a substantial doubt whether the decision was taken within the powers of the Act. Secondly, a developer whose application for permission is refused may be substantially prejudiced where the planning considerations on which the decision is based are not explained sufficiently clearly to enable him reasonably to assess the prospects of succeeding in an application for some alternative form of development. Thirdly, an opponent of development, whether the local planning authority or some unofficial body like Save, may be substantially prejudiced by a decision to grant permission in which the planning considerations on which the decision is based, particularly if they relate to planning policy, are not explained sufficiently clearly to indicate what, if any, impact they may have in relation to the decision of future applications.

> Here again, I regret to find myself in disagreement with Woolf L.J. who said, 60 P. & C.R. 539, 557:

> Once it is accepted that the reasoning is not adequate, then in a case of this sort it seems to me that, apart from the exceptional case where it can be said with confidence that the inadequacy in the reasons given could not conceal a flaw in the decision-making process, it is not possible to say that a party who is entitled to apply to the court under section 245 has not been substantially prejudiced.

> The flaw in this reasoning, it seems to me, is that it assumes an abstract standard of adequacy determined by the court and then asserts, in effect, that a failure by the decision-maker to attain that standard will give rise to a presumption of substantial prejudice which can only be rebutted if the court is satisfied that the inadequacy 'could not conceal a flaw in the decision-making process.' But this reverses the burden of proof which the statute places on the applicant to satisfy the court that he has been substantially prejudiced by the failure to give reasons. When the complaint is not of an absence of reasons but of the inadequacy of the reasons given, I do not see how that burden can be discharged in the way that Woolf L.J. suggests unless the applicant satisfies the court that the shortcoming in the stated reasons is of such a nature that it may well conceal a flaw in the reasoning of a kind which would have laid the decision open to challenge under the other limb of section 245. If it was necessary to the decision to resolve an issue of law and the reasons do not disclose how the issue was resolved, that will suffice. If the decision depended on a disputed issue of fact and the reasons do not show how that issue was decided, that may suffice. But in the absence of any such defined issue of law or fact left

unresolved and when the decision was essentially an exercise of discretion, I think that it is for the applicant to satisfy the court that the lacuna in the stated reasons is such as to raise a substantial doubt as to whether the decision was based on relevant grounds and was otherwise free from any flaw in the decision-making process which would afford a ground for quashing the decision.

The guidance in *Save Britain's Heritage* was followed by Lord Brown of Eaton-under-Heywood in his speech in *South Bucks District Council v Porter (No. 2)* [2004] UKHL 33 leading to his very familiar summary of the relevant principles concerning the standard of reasons at paragraph 36:

> The reasons for a decision must be intelligible and they must be adequate. They must enable the reader to understand why the matter was decided as it was and what conclusions were reached on the 'principal important controversial issues', disclosing how any issue of law or fact was resolved. Reasons can be briefly stated, the degree of particularity required depending entirely on the nature of the issues falling for decision. The reasoning must not give rise to a substantial doubt as to whether the decision-maker erred in law, for example by misunderstanding some relevant policy or some other important matter or by failing to reach a rational decision on relevant grounds. But such adverse inference will not readily be drawn. The reasons need refer only to the main issues in the dispute, not to every material consideration. They should enable disappointed developers to assess their prospects of obtaining some alternative development permission, or, as the case may be, their unsuccessful opponents to understand how the policy or approach underlying the grant of permission may impact upon future such applications. Decision letters must be read in a straightforward manner, recognising that they are addressed to parties well aware of the issues involved and the arguments advanced. A reasons challenge will only succeed if the party aggrieved can satisfy the court that he has genuinely been substantially prejudiced by the failure to provide an adequately reasoned decision.

The deputy judge in *Mordue* had treated what Sullivan LJ had said in paragraph 29 of *East Northamptonshire* as authority for the proposition that there is an onus on a decision-maker positively to demonstrate by the reasons given that considerable weight has been given to the desirability of preserving the setting of relevant listed buildings. John Howell QC went on to say that this appeared contrary to the general position in *Save Britain's Heritage* and *South Bucks DC v Porter (No. 2)*. He concluded that 'the normal burden of proof is reversed in respect of the requirement to give considerable weight to any harm to a listed building or its setting which section 66(1) of the Listed Buildings Act is taken to impose' (paragraphs 65 and 73). The deputy judge also drew support for this conclusion from Lindblom J's decision in *Forge Field*.

Given the inconsistency in approach advocated by the two lines of cases, the Court of Appeal in *Mordue* was obliged to consider whether the deputy judge was right to interpret Sullivan LJ's judgement in *East Northamptonshire* in the way he did. They held that he was not (unsurprisingly, as Sullivan LJ himself granted permission to appeal on the basis that the deputy judge was wrong to interpret his own judgement in *East Northamptonshire* in the way he did).

Sales LJ stated in his judgement for the Court (at paragraph 26) that:

> Sullivan LJ's comments in para. [29] were made in the context of a decision letter which positively gave the impression that the inspector had not given the requisite considerable weight to the desirability of preserving the setting of the relevant listed buildings, where as a result it would have required a positive statement by the inspector referring to the proper test under section 66(1) to dispel that impression. In my judgment, the relevant standard to

be applied in assessing the adequacy of the reasons given in the present case is indeed the usual approach explained in *Save Britain's Heritage and South Bucks DC v Porter (No. 2)*, which is what the deputy judge correctly thought it ought to be.

In support of his decision Sales LJ found it notable that the decisions in *Forge Field* and *Hughes* had contained *positive* indications that the decision-maker had failed to comply with the s.66(1) duty, and so this indication would have had to have been dispelled by a countervailing positive reference to the relevant duty in the reasoning in order to avoid the otherwise inevitable conclusion that the decision-maker had erred when applying the test (paragraph 27).

Of particular significance, both in terms of the scope of reasons that need to be given and decision-makers and the approach to compliance with both the statutory tests and national policy is set out by Sales LJ at paragraph 28 of his judgement:

> [it] cannot be said that the reasoning of the Inspector gives rise to any substantial doubt as to whether he erred in law. On the contrary, the express references by the Inspector to both Policy EV12 and paragraph 134 of the NPPF are strong indications that he in fact had the relevant legal duty according to section 66(1) of the Listed Buildings Act in mind and complied with it. Policy EV12 reflects that duty, and the textual commentary on it reminds the reader of that provision. Paragraph 134 of the NPPF appears as part of a fasciculus of paragraphs, set out above[13], which lay down an approach which corresponds with the duty in section 66(1) . Generally, a decision-maker who works through those paragraphs in accordance with their terms will have complied with the section 66(1) duty. When an expert planning inspector refers to a paragraph within that grouping of provisions (as the Inspector referred to paragraph 134 of the NPPF in the Decision Letter in this case) then – absent some positive contrary indication in other parts of the text of his reasons – the appropriate inference is that he has taken properly into account all those provisions, not that he has forgotten about all the other paragraphs apart from the specific one he has mentioned. Working through these paragraphs, a decision-maker who had properly directed himself by reference to them would indeed have arrived at the conclusion that the case fell within paragraph 134, as the Inspector did.

To conclude on the position post-*Mordue*, no mantra is required. So long as the decision-maker has worked through the relevant paragraphs in the NPPF (and absent any reasons indicating the contrary), they will be taken to have complied with the statutory duty. This said, the Court of Appeal decision in *R (Williams) v Powys CC v Bagley* [2017] EWCA Civ 427 (discussed further below) must be borne in mind when considering how 'explicit' that consideration of the ss.66/72 duty/NPPF needs to be when potential impact on a designated heritage asset has been raised as an issue but subsequently discounted on closer analysis.

Setting

One of the core planning principles in the NPPF is the need to conserve heritage assets in a manner appropriate to their significance so that they can be enjoyed for their contribution to the quality of life of this and future generations. Significance in terms of heritage policy is defined in the Glossary of the NPPF as

> [t]he value of a heritage asset to this and future generations because of its heritage interest. That interest may be archaeological, architectural, artistic or historic. Significance derives not only from a heritage asset's physical presence, but also from its setting(emphasis added).

Any assessment of the significance of a heritage asset should, therefore, include an analysis of the contribution of its setting.[14]

It is clear from the above definition that setting is not a heritage asset in itself nor is it a heritage designation, though the setting of a listed building is given express statutory protection in its own right by s.66(1). Its importance lies in what it contributes to the significance of a heritage asset. The key question is whether and to what extent elements of the setting of a heritage asset contribute to the asset's significance. The next question is then whether any change in that setting arising from the proposed development would affect the significance of the asset. It should be noted that change alone does not automatically constitute an effect on significance.

When an asset is likely to be affected, significance must be assessed in its entirety. This involves looking at the heritage asset (both its fabric and its setting) 'in the round'. Particular views may be more important (for example, if they were designed or convey more relevant heritage information than other views). But an assessment should not be restricted merely to views upon which a development may have an effect if there is a historic, social or economic connection which brings a site into the setting of a listed building and warrants equivalent consideration to views (*Steer v SSCLG* [2017] EWHC 1456 (Admin), confirmed as the correct approach in the Court of Appeal at [2018] EWCA Civ 1697). Historic England joined as a party to the litigation in *Steer* due to its desire for clarification on the approach to setting.

In *R (Friends of Hethel Ltd v South Norfolk DC* [2010] EWCA Civ 894 Sullivan LJ (with whom Sedley and Lloyd L.JJ. agreed) observed (at paragraph 32) that 'the question whether a proposed development affects, or would affect, the setting of a listed building is very much a matter of planning judgment for the local planning authority'. This is still very much the case, however, if the interpretation of policy and/or the approach taken when answering that question are wrong then it is very much a matter of law.

The Court of Appeal case of *Williams* considered the same issue (insofar as relevant to this paper) as *Steer*, specifically whether the decision-maker erred in failing to perform the duty in s.66(1) to have special regard to the desirability of preserving the setting of a listed building.

In *Williams* neither the officer's reports to committee nor the Council's decision notice indicated that the Council had in fact performed the duty in s.66(1). If the duty ought to have been engaged but was not an error of law would have been demonstrated. The judge below, noted Lindblom LJ with approval (at paragraph 47), accepted that the s.66(1) duty 'arises from the existence of the listed building, not from what anybody says about it'. So, the absence of any objection about the effect of the development on the setting of the grade II* listed church at Llanbedr was not in itself decisive.

However, the judge below did not accept that the existence of a view in which one could see both the church and the turbine was in itself enough to engage the s.66(1) duty (paragraph 21 of the decision of the High Court in *Williams*). Rather, it would have to be shown that 'the part of the view containing the turbine was to be regarded as the setting of the [listed] building' (citing Hickinbottom J, (as he then was), at paragraph 89 in *R (Miller) v North Yorkshire County Council* [2009] EWHC 2172 (Admin)).

Lindblom LJ said:

> 53 As the case law shows, the circumstances in which the section 66(1) duty has to be performed where the setting of a listed building is concerned will vary considerably, and with

a number of factors. What are those factors? Typically, I think, they will include the nature, scale and siting of the development proposed, its proximity and likely visual relationship to the listed building, the architectural and historic characteristics of the listed building itself, local topography, and the presence of other features both natural and man-made in the surrounding landscape or townscape. There may be other considerations too. Ultimately, the question of whether the section 66(1) duty is engaged will always depend on the particular facts and circumstances of the case in hand. ... 56 The setting of a listed building is not a concept that lends itself to an exact definition, applicable in every case. This is apparent, I think, from the deliberately broad definitions of the setting of an historic or heritage asset in Cadw's document and in the NPPF [see above]. I would not wish to lay down some universal principle for ascertaining the extent of the setting of a listed building. And in my view it would be impossible to do so. Clearly, however, if a proposed development is to affect the setting of a listed building there must be a distinct visual relationship of some kind between the two a visual relationship which is more than remote or ephemeral, and which in some way bears on one's experience of the listed building in its surrounding landscape or townscape. This will often require the site of the proposed development and the listed building to be reasonably close to each other, but that will not be so in every case. Physical proximity is not always essential. This case illustrates the possible relevance of mutual visibility or

'intervisibility', as the judge described it and also of more distant views from places in which the listed building and the proposed development can be seen together 'co-visibility', as it was described in submissions before us. But this does not mean that the mere possibility of seeing both listed building and development at the same time establishes that the development will affect the setting of the listed building.

Now the eagle-eyed will have noticed that what Lindblom LJ said (*"setting' ... is a matter of judgment to be determined in visual terms ... Clearly ... if a proposed development is to affect the setting of a listed building there must be a distinct visual relationship of some kind between the two [,] a visual relationship which is more than remote or ephemeral, and which in some way bears on one's experience of the listed building in its surrounding landscape or townscape'*) is directly contrary to the decision of Lang J in *Steer*, who concluded that a visual connection was not determinative to the question of setting, which can consist solely of a historic, social and/or economic connection. The decision in *Williams* was only published a few days after the hearing in *Steer* and so neither decision had regard to the other.

The introduction of the potential need for a 'visual' element by a judge of the Court of Appeal gave rise to the appeal to the Court of Appeal in *Steer*. Because the appeal in *Steer* was listed before the same judge who decided *Williams*, unsurprisingly, he confirmed that his understanding of what was said in *Williams* was correct (though he accepted the principle that a visual link was not always required). He then found that the Inspector was perfectly correct in *Steer* and allowed the appeal.

Less than Substantial Harm V Substantial Harm

The NPPF does not clearly draw a line between 'substantial harm' and 'less than substantial harm'. However, the PPG makes plain that the threshold to constitute 'substantial harm' is a high one (see 18a-017-20140306).

Helpfully, case law has clarified the distinction. In *Bedford Borough Council v SSCLG and Nuon UK Ltd* [2013] EWHC 2847 (Admin) Jay J observed that (at paragraph 25):

... in the context of physical harm, [substantial harm] would apply in the case of demolition or destruction, being a case of total loss. It would also apply to a case of serious damage to the structure of the building. In the context of non-physical or indirect harm, the yardstick was effectively the same. One was looking for an impact which would have such a serious impact on the significance of the asset that its significance was either vitiated altogether or very much reduced.

It is worth taking into account Historic England's view (which it sought to circularise, though not formally publish, after *Bedford and following the advent of the PPG*):

> The question on what constitutes substantial harm has bounced around the courts since the advent of the NPPF. An early High Court case was the *Bedford* example (*Bedford Borough Council v Secretary of State for Communities and Local Government*) where the High Court judge suggested that substantial harm would arise if 'very much, if not all, of the significance was drained away.' This wording is still referenced by certain planning consultants, in our view incorrectly.
>
> This decision pre-dated the Planning Practice Guidance we saw earlier in which government gave a clearer indication of what substantial harm is. It is at odds with that guidance and with the government's approach to the setting impacts of wind and solar farms. ...
>
> Bedford is also starkly at odds with the way the government guidance in relation to substantial harm and conservation areas, which also post-dated Bedford. ...
>
> So Bedford appears to set too high a bar for substantial harm.[15]

Therefore, whilst *Bedford* remains the law, this must be read in light of the subsequent PPG. The relevant paragraph in the PPG provides:

> How to assess if there is substantial harm?
>
> What matters in assessing if a proposal causes substantial harm is the impact on the significance of the heritage asset. As the National Planning Policy Framework makes clear, significance derives not only from a heritage asset's physical presence, but also from its setting.
>
> Whether a proposal causes substantial harm will be a judgment for the decision taker, having regard to the circumstances of the case and the policy in the National Planning Policy Framework. In general terms, substantial harm is a high test, so it may not arise in many cases. For example, in determining whether works to a listed building constitute substantial harm, an important consideration would be whether the adverse impact seriously affects a key element of its special architectural or historic interest. It is the degree of harm to the asset's significance rather than the scale of the development that is to be assessed. The harm may arise from works to the asset or from development within its setting.
>
> While the impact of total destruction is obvious, partial destruction is likely to have a considerable impact but, depending on the circumstances, it may still be less than substantial harm or conceivably not harmful at all, for example, when removing later inappropriate additions to historic buildings which harm their significance. Similarly, works that are moderate or minor in scale are likely to cause less than substantial harm or no harm at all. However, even minor works have the potential to cause substantial harm.
>
> Policy on substantial harm to designated heritage assets is set out in paragraphs 132 and 133 to the National Planning Policy Framework.[16]

Ultimately, as the PPG provides, whether a proposal causes substantial harm will be a judgement for the decision taker, having regard to the circumstances of the case and the NPPF.

Historic England Guidance

The government's advisers, Historic England produce a series of guidance documents as to how to approach matters such as setting and views as well as other physical interventions arising from development.[17]

Historic England (and its predecessor English Heritage) have from time to time sought to flex their muscles when such guidance documents were published. The purpose would appear to be in order to have these documents considered by the Secretary of State (in various decision-making contexts) so that they could be considered as having received some form of endorsement by the Secretary of State. Whilst Historic England are an adviser to the government, they do not make policy: that is the exclusive preserve of government itself. There have been instances where Historic England/English Heritage have sought to make initiatives and their policy formulation has simply gone wrong.

One example relates to an appeal regarding Scraptoft Hall in Leicestershire.[18] The application was called in by the Secretary of State at the behest of English Heritage who had recently formulated and published a new 'policy' on enabling development in a document that it had published entitled 'Enabling Development and the Conservation of Significant Places (EDCSP) 2008'.[19] The policy stated that enabling development that would secure the future of a significant place, but contravene other planning policy objectives, should be unacceptable unless: (a) it will not materially harm the heritage values of a place or its setting. There also then followed a number of other criteria.

However (and perversely), the interaction of the opening sentence and criterion (a) gave rise to a circular 'catch 22' argument: if proposals would fall foul of the development plan by way of harm, then they could not accord with criterion (a).

In short, the 'policy' formulation adopted by English Heritage specifically frustrated the very objective of enabling development which national policy recognised as an appropriate consideration in the context of schemes for the preservation of vulnerable heritage assets. The result of the public inquiry was that planning permission and listed building consent granted and costs were awarded against English Heritage. The latter organisation also had to hastily rewrite their 'policy' in order to bring it into line with national policy.

Conclusions on the Approach to the Assessment of Harm to Designated Heritage Assets

Although the assessment of likely harm to a listed building, its setting, or a conservation area is entirely a matter for the decision-maker's own planning judgement there is a statutory presumption against granting planning permission for development which would harm a designated heritage asset. If harm is to a non-designated heritage asset (howsoever considered short of irrationality), this is a matter to be considered in the planning balance absent the weighted presumption against harm.

Therefore, even if the identified harm is less than substantial it should still be given considerable importance and weight in the decision. Both positive and negative impacts

may be balanced against each other in a holistic assessment to decide what the overall impact on the asset would be. Cases of substantial harm are limited to impacts that would seriously affect a key element of its special architectural or historic interest or where there are direct impacts to the asset (such as partial or total demolition). It is the degree of harm to the asset's significance, rather than the scale of the development, that is to be assessed. Substantial harm may arise from works to the asset or from development within its setting.

If any harm, whether substantial or not, to a designated heritage asset is found to exist, then it is to be given more weight in the decision than if it were simply a factor to be taken into account along with all other material considerations. This need not be expressly stated (though it is a good practice to do so). If there is harm, so long as the decision-maker has properly worked their way through the sequential paragraphs in the NPPF they will have complied with their statutory duty. Where the s.66/s.72 duties are engaged, even hypothetically, the duty must be expressly considered by the decision-maker in their decision.

Discussion on the Interaction of Policy and Law

The interaction between law and policy in the construction and subsequent application of policy decisions can be a somewhat curious and perhaps lead to a rather quixotic and self-reinforcing process.

The consequence of this can be an excessive overemphasis of the importance to be attached not only to the preservation of heritage assets but also their settings. As set out earlier in this paper, the term 'setting', whilst contained in statute, is itself undefined and it is left to decision-makers to establish what the setting of the building is in any given circumstances.

The statutory tests in respect of settings of listed buildings and conservation areas require 'special regard/special attention' to be accorded to their preservation or enhancement. The authorities that have considered the term 'special regard' in this context require that 'considerable importance and weight' is attributed to the purpose of achieving such preservation or enhancement such that there is a statutory presumption, albeit a rebuttable one, in favour of preservation.

Since 1991 there has also been a statutory presumption in decision-making in favour of the development plan (and its policies). A number of development plans, certainly those that predate the NPPF 2012, still contain policies to the effect of 'no development shall take place/permission will be refused for any development which affects the setting or appearance of a listed building/conservation area'.

The consequence of such a formulation is that statutory tests (contained in the 1990 Act) which seek to ensure that, in taking decisions special regard/attention is had to the preservation and enhancement of listed buildings and/or conservation areas, if there is any adverse impact then permission must be refused. In and of itself it excludes any other balancing factors.

In short, the originating statutory provisions in the 1990 Act mutated into a substantially more rigorous provision when enshrined in policy, a policy which then fell to be interpreted pursuant to what is now section 38(6) of the Planning and Compulsory Purchase Act 2004.

That rather absurd state of affairs has, to a degree, now been ameliorated with the advent of the NPPF, first in 2012, subsequently in 2018, and now the February 2019 version. Firstly, national policy is an 'other material consideration', in planning decision-

making. However, the litigation recited earlier between the decisions and *Barnwell Manor* and *Mordue* identify there was a query as to whether national policy sufficiently reflected the statutory tests in the 1990 Act. In other words, even if there was said to be compliance with national policy in the NPPF would a decision still fall to be criticised and indeed potentially quashed because of a failure to correctly identify, cite and apply the 1990 Act's statutory tests? Ultimately, the judgement of Sales LJ (as he then was) in *Mordue*, in most circumstances, represents a comprehensive end-to-end approach for the purposes of planning and heritage decision-making. Indeed, readers are invited to consider whether if the Court of Appeal's guidance in *Mordue* had been available at the time Barnwell Manor came to be considered at first instance that a different judgement may have been formed as to whether the reasoning of the Inspector was sufficient to demonstrate compliance with the statutory and policy tests.

What is clear from recent history is the difficulty in seeking to advance policy formulations which are intended to part emulate (but in fact add a gloss to) recognised legal principles. Any such proposed formulations must be approached with considerable circumspection and care.

The NPPF's approach has, for the present, probably been satisfactorily resolved by the Court of Appeal's judgement in *Mordue*. The 2019 version of the NPPF is not materially different in substance to the 2012 version the subject of deliberation in *Mordue*.

The example of English Heritage (as it then was) seeking to recapitulate the test for the consideration of enabling development, derived from *R. v. Westminster City Council Ex p. Monahan [1989] J.P.L. 3* (and thence contained in PPG 15/PPS 15) was shown to come to grief in an inadvertent 'Catch-22' formulation, the effect of which meant that by becoming enabling development one would fall out with the very policy intended to foster it. To be clear, this is not an instance of seeking to lampoon those who, in good faith, are seeking to draft and provide clear and workable policy formulations. However, it is an important caveat that such a task has to be approached with considerable care, lest results turn out to be the exact opposite of that which was originally intended.

Notes

1. By the Civic Amenities Act 1967.
2. For information on the range of sentences available to the courts and the principles the courts are invited to apply when sentencing offenders for heritage crime, see Historic England's Guidance for Sentencers, published 1 February 2017. Available at https://historicengland.org.uk/images-books/publications/heritage-crime-guidance-sentencers/.
3. For offences taking place after 12 March 2015 (the date section 85(1) of the Legal Aid, Sentencing and Punishment of Offenders Act 2012 entered into force) upon summary conviction the magistrates' court may impose a term of imprisonment not exceeding six months or an unlimited fine (for offences committed prior to 12 March 2015 the fine is capped at £20,000), or both; on conviction on indictment the Crown Court may order imprisonment for a term not exceeding two years, or a fine (unlimited), or both.
4. Published by the Department for Digital, Culture, Media and Sport. The final decision on listing a building, scheduling a monument or protecting a wreck site is taken by the Secretary of State for Digital, Culture, Media and Sport. The final decision on registering a park, garden or battlefield the decision is taken by Historic England. Historic England has also published supplementary guidance on the listing process: there are 44 separate selection guides, https://historicengland.org.uk/listing/selection-criteria/listing-selection/and https://historicengland.org.uk/listing/selection-criteria/scheduling-selection/.

5. The decision to designate gardens or battlefields is taken by Historic England.
6. A reasoning or decision is Wednesbury unreasonable (or irrational) if it is so unreasonable that no reasonable person acting reasonably could have made it (Associated Provincial Picture Houses Ltd v Wednesbury Corporation (1948) 1 KB 223).
7. *Dill*, paragraph 33.
8. Ibid. 48.
9. Section 69 of the Planning (Listed Buildings and Conservation Areas) Act 1990: '[e]very local planning authority…(a) shall from time to time determine which parts of their area are areas of special architectural or historic interest the character or appearance of which it is desirable to preserve or enhance…[and designate those areas as a conservation area]'.
10. Historic England Advice Note 1 (Second Edition) (8 February 2019), paragraph 73.
11. Designation also provides support for the use of article 4 directions under the Town and Country Planning (General Permitted Development) (England) Order 2015 to further restrict permitted development rights.
12. (R *(Liverpool Open and Green Spaces Community Interest Co) v Liverpool City Council* [2019] EWHC 55 (Admin).
13. Now found in modified form in section 16 of the NPPF (February 2019).
14. see PPG at 18a-009-20140306 and 18a-013-20140306 and Historic England's guidance on setting in the December 2017 edition of its Good Practice Advice 3.
15. Memo to members of IHBC following the publication of the Bedford case.
16. NPPG *Paragraph: 017 Reference ID: 18a-017-20140306.*
17. Covering a wide range of topics from Post Modern Architecture to 3D Laser Scanning for Heritage. Full list available at: https://historicengland.org.uk/images-books/publications/advice-guidance-new-backlist/heag000-advice-guidance/Last accessed 8 June 2019.
18. APP/F2415/V/09/2105762 & APP/F2415/V/09/2105763.
19. Rebranded 2015, https://historicengland.org.uk/images-books/publications/enabling-development-and-the-conservation-of-significant-places/enablingwebv220080915124334/ accessed 6/8/19.

Disclosure statement

No potential conflict of interest was reported by the authors.

Table of Cases

Aidan Jones v Jane Margaret Mordue, Secretary of State for Communities and Local Government, South Northamptonshire Council [2015] EWCA Civ 1243.
Associated Provincial Picture Houses Ltd v Wednesbury Corporation (1948) 1 KB 223
Bedford Borough Council v SSCLG and Nuon UK Ltd [2013] EWHC 2847 (Admin)
Dill v Secretary of State for Communities and Local Government [2018] EWCA Civ 2619
East Northamptonshire District Council v Secretary of State for Communities and Local Government [2015] 1 WLR 45
Harwich in South Lakeland District Council v Secretary of State for the Environment [1992] 2 A.C. 141, at p.150 A-G)
Mordue v Secretary of State for Communities and Local Government [2015] EWCA Civ 1243
Palmer v Herefordshire Council [2016] EWCA Civ 1061.
R (Friends of Hethel Ltd v South Norfolk DC [2010] EWCA Civ 894
R (Hughes) v South Lakeland DC [2014] EWHC 3979
R (Liverpool Open and Green Spaces Community Interest Co) v Liverpool City Council [2019] EWHC 55 (Admin)
R (Miller) v North Yorkshire County Council [2009] EWHC 2172 (Admin)
R (Simon Shimbles) v City of Bradford Metropolitan District Council v Endless Energy Limited, The National Trust [2018] EWHC 195 (Admin)
R (The Forge Field Society & Others) v Sevenoaks District Council and West Kent Housing Association [2014] EWHC 1895 (Admin)
R (Williams) v Powys CC v Bagley [2017] EWCA Civ 427
R. v. Westminster City Council Ex p. Monahan [1989] J.P.L. 3
Save Britain's Heritage and South Bucks DC v Porter (No. 2).
Save Britain's Heritage v Number 1 Poultry Limited [1991] 1 WLR 153.
South Bucks District Council v Porter (No. 2) [2004] UKHL 33
Steer and Historic England v Secretary of State for Communities and Local Government and Catesby Estates [2018] EWCA Civ 1697
Tesco Stores Ltd v Dundee City Council [2012] UKSC 13.

Bibliography

Gov.UK, National Planning Policy Framework. Ministry of Housing, Communities & Local Government, February 2019
Historic England. *The Setting of Heritage Assets, Historic Environment Good Practice Advice in Planning: 3*. 2nded. London:Historic England December 22, 2017.
Historic England. *Historic England, Guidance for Sentencers*. London: Heritage Crime. February 1, 2017.
Historic England. *Conservation Area Appraisal, Designation and Management, Historic England Advice Note 1*. 2nded. London:Historic England February 8, 2019.

It's Not Mitigation! Policy and Practice in Development-Led Archaeology in England

Roger Thomas

ABSTRACT

In 2010, a significant change was made to the policy for development-led archaeology in England. This paper considers how far the revised policy wording has been reflected in changes in archaeological practice. It concludes that, to a considerable degree, practice remains rooted in the terminology and concepts of the previous policy regime, which saw development-led work as 'mitigation' (or 'preservation by record') rather than as a form of offsetting, in which advances in understanding offset the loss of physical remains. Some suggestions for future improvements are offered.

Introduction

Despite a substantial change in the wording and the apparent intent of government policy for development-led archaeology in England in 2010, professional terminology and practice in this area remain largely rooted in the previous policy regime. This paper examines the conceptual and legal basis of policy in this area. It also highlights how a more wholehearted embrace of concepts contained in the current National Planning Policy Framework (NPPF) for England could pay significant dividends. In particular, it could help to dispel some current concerns about the efficacy and 'value for money' of current approaches to development-led archaeology.

Background

Development-led archaeology in England (that is, archaeology carried out as part of land-use planning and development consent systems) has its origins in a government policy document published in 1990 and known as PPG 16 – Planning Policy Guidance Note 16, *Archaeology and Planning*.[1] Prior to that, the regime was one of 'rescue archaeology', in which planning permissions were generally granted without regard to archaeological impacts. State funding was then used to 'rescue' the threatened sites before construction took place.[2]

PPG 16 very much reflected the concerns and responses of its time: the European Economic Community's promulgation, in 1985, of a Directive on environmental impact assessment,[3] with its 'polluter pays' principle; and a growing interest in

sustainability, which featured large at the Earth Summit held in Rio de Janeiro in 1992.[4]

PPG 16 revolved around five key principles:

(1) Archaeological remains are a finite and non-renewable resource.
(2) Archaeology is a material planning consideration.
(3) The archaeological implications of proposed developments should be properly assessed before a decision on planning permission is taken.
(4) Important archaeological remains should be preserved *in situ* if possible.
(5) Where preservation *in situ* is not possible, then appropriate and satisfactory provision for excavation and recording should be made, before planning permission is granted.

Where archaeological work was needed, whether before a planning decision (3 above) or as a consequence of one (5 above), then it was to be the developer who arranged this and paid for it, rather than (as was the case before 1990), the state. For this reason, the activity became known as 'developer-funded' archaeology (in contra-distinction to the previous norm of state funding), although the term 'development-led archaeology' is now in general usage in England.

This paper will concentrate on (5) above: that is, on work undertaken to 'excavate and record' archaeological remains which are not, for whatever reason, going to be preserved *in situ* in the face of a proposed development. This has been a major area of activity in English archaeology since 1990, with a huge number of investigations undertaken throughout the country, some of them on an enormous scale, and with an extraordinary wealth of new information gained.[5]

'Preservation by Record'

The phrase which, above all others, was embraced by the archaeological profession to describe this work, and to encapsulate the philosophy behind it was, was 'preservation by record'. Those words appear in PPG 16, but only, in fact, in a paragraph heading; the words used in the main text are 'excavation and recording'.[6] The phrase 'preservation by record' was introduced well before PPG 16. It actually appears to have originated as a means of enabling the UK government to spend money on 'rescue archaeology', when it had no specific statutory power to do so.[7] The government had the power to spend money on preserving monuments; if a monument could not be preserved physically (e.g. because it was threatened by development) then it could be 'preserved by record', by excavating and recording it. As the government's Chief Inspector of Ancient Monuments and Historic Buildings said in 1983: 'The Department's brief is limited to preservation and it must direct rescue archaeology funds to the recording of threatened sites as just one of the options open ... for preserving sites for future study'.[8] This stance may, among other things, have led to a perception that 'rescue excavation' and 'research excavation' were different forms of activity.

Objections to 'Preservation by Record'

The phrase 'preservation by record', and the thinking behind it, has long been seen as problematic. There is a fundamental, and ultimately irresolvable, tension in destructive archaeological fieldwork: to what extent should the aim be to make a neutral record of the evidence which one encounters, and to what extent should it be to record, selectively, only that evidence which bears on particular research questions or hypotheses defined by the excavator? The dilemma is a sharp one. If the aim is to make a neutral record, the result is actually necessarily selective (as no record of archaeological deposits can be 'complete'), and probably without a very clear justification of why some things have been recorded and others not (beyond the fact that they were there). On the other hand, if a recording strategy is driven simply by questions or hypotheses set in advance, there is a risk that information which might well have been of interest to others, had it been recorded, is discarded.

This problem emerges in a particularly acute form in the context of development-led archaeology. There, the locations to be excavated are determined primarily by non-archaeological factors, and any evidence which is not recorded at the time is liable to be destroyed by the development and thus lost forever.

There are no easy answers to this problem, which is rooted in philosophy and debates about the philosophy of science: objectivity versus subjectivity, and inductive (or empiricist) versus problem-oriented or hypothetico-deductive approaches, for example.[9] This is a long-standing debate; in the 1970s, for example, a paper with the provocative title 'Rescue archaeology: research or rubbish collection' was published in the journal *Antiquity*.[10] It is also an international issue. In some European countries, notably France, the term used is 'preventive archaeology' (*l'archéologie preventive*). Presumably, the thing being prevented is the unrecorded destruction of archaeological remains. The English-language description of preventive archaeology on the web-site of the national agency INRAP suggests a slightly uneasy compromise between neutral recording and investigation: 'Preventive archaeology … preserves the soil archives by means of scientific investigation'.[11]

In this author's view, the only solution is to steer a course between the two poles. Excavators must reflect continuously on both their research questions and their recording strategies. They must then make adjustments to either (or both) in the light of what emerges as work proceeds, taking account of an archaeologist's ethical responsibilities. Those responsibilities include both ensuring that important archaeological evidence is not thoughtlessly destroyed, and ensuring that the human and material resources devoted to archaeological work are used wisely. 'Good' archaeology is, in this author's view, archaeology which successfully steers this middle course, achieving a proper balance between the need to record evidence neutrally and faithfully and the need to produce worthwhile contributions to knowledge by seeking to answer defined questions or to address specific hypotheses. This view reflects the character of archaeology, as being a subject in which there is a continuous, critical engagement between our knowledge, ideas and perceptions and the physical archaeological material which we encounter.[12]

It is also the case that some individual archaeologists will incline more towards recording archaeological remains, others more towards interpretation and the asking of questions, as a matter of personal orientation.[13] Differences may also be seen between different

archaeological traditions. In some contexts and times, the main focus of archaeological endeavour has been on recording and classification, in others there has been more emphasis on creating narratives of the past. It should be emphasised, though, that archaeology always involves a mixture of both record and interpretation. The issue is simply one of where the balance lies.

In any event, the phrase 'preservation by record' is very unhelpful, because it misrepresents what a destructive archaeological investigation does and what it achieves.

PPG 16 in Practice

PPG 16 was enormously successful and influential; by the time it was replaced in 2010, it was one of the most long-enduring pieces of government planning guidance in England. By embedding archaeology firmly in the planning process, it resulted in systematic consideration of archaeological issues in planning decisions, the preservation *in situ* of many important remains, and the excavation of many more in advance of their destruction by development. By making developers responsible for archaeological work on their developments, it also laid the foundation of the present-day archaeological profession in the United Kingdom. It led to the appearance of a series of clearly defined and complementary professional roles: curators (local authority archaeologists giving advice and monitoring work within the planning system), contractors (archaeological organisations carrying out fieldwork on a commercial basis for developers), consultants (giving independent professional advice to developers and instructing contractors) and clients (the developers themselves). PPG 16 also led a huge increase in archaeological knowledge. Both the number and the scale of archaeological investigations increased dramatically, with work taking place in geographical locations which had previously been neglected, as well as in areas already well-known for their archaeological potential.[14]

There were also, inevitably, concerns about the operation of PPG 16. In the years immediately after its introduction, there was considerable anxiety about the introduction of a commercial and competitive model of funding, in a situation where previously publicly-funded organisations had enjoyed local or regional monopolies of archaeological work.[15] Concerns focussed especially on questions of standards, and the Chartered Institute for Archaeologists (as it now is) did much work on this, producing a range of 'Standards and Guidance' documents covering different aspects of the development-led archaeological process.[16]

Another area of concern was the adoption by curators of formulaic or prescriptive requirements for how investigations should be undertaken. This was seen particularly in requirements for fixed percentages of excavation, such as 10% of the length of all linear features or 50% of discrete features like pits. Such prescriptions were seen as a way of creating a fair baseline for competitive tenders, and of ensuring a common approach, but they also had the potential (if applied inflexibly) to prevent excavation strategies from responding intelligently to the emerging character of the remains being investigated.

More generally, especially towards the end of the PPG 16 era, concern began to grow that ever-increasing amounts of site information were being recorded, not always in very thoughtful ways, with some work being done by rote, rather than as a result of investigation strategies tailored to the specifics of individual sites.[17] This, combined with a realisation that archaeological remains were far more abundant than previously

thought, led to concerns about 'redundancy' (or repetitiveness) in the information being recovered: the same kinds of archaeological remains being investigated in the same ways, producing the same kinds of information. This opened up the possibility of public or political opinion moving against archaeology, on the grounds that it was a costly activity which did not produce public benefit in proportion to the expense and inconvenience involved.[18]

It's Not Mitigation!

Perhaps because of concerns about the phrase 'preservation by record', the term 'mitigation' began to be used to describe archaeological investigations carried out, under PPG 16, to deal with the 'post-planning permission' archaeological impacts of new developments. The word 'mitigation' is familiar in the field of environmental impact assessment, which may have made it seem a logical choice for describing this kind of archaeological work. It is used archaeologically to describe measures to reduce the physical impact of development on remains, for instance by foundation design.[19] This is a correct usage. It is also widely used to describe archaeological excavation ahead of development. This, however, is semantically incorrect and therefore misleading. 'Mitigation' means the reduction of harm, but when *in situ* archaeological remains are destroyed (whether with or without prior excavation and recording) the harm is total. It cannot be mitigated, as the remains, with their potential for future investigation, will have gone forever. Some documents even refer to archaeological investigation ahead of development as 'fully mitigating' the destructive impacts of the development. This is clearly wrong.

Unfortunately, the terms 'preservation by record' and 'mitigation' both allow development-led archaeological work to be seen as an essentially mechanical exercise in 'recording' – the application of standardised techniques to archaeological remains. This is clearly aligned with the 'neutral recording' view of the archaeological process discussed above. In such a view, the role of the excavator is to 'record the facts'; it is for others, later, to interpret them. This can also foster a view that the more 'recording' is done, the better. Certainly, most of the debates between planning authority archaeologists and developers are quantitative ones, about the size of the area to be excavated or the intensity of sampling. That in turn can have implications for resourcing and procurement, as the question may become: who can 'record' a defined quantity of remains at the lowest cost?

Rethinking PPG 16

Concerns of these kinds led to a reconsideration of the policy basis for development-led archaeology in England.[20] This involved a greater emphasis on producing contributions to knowledge, rather than simply records, as a form of public benefit. Rather than seeing this activity as a form of 'mitigation' (a problematic word, as discussed above) it was suggested that development-led investigation should be seen as 'off-setting'.[21] This is a word which occurs in the European Union's environmental impact assessment Directive, which envisages 'measures to avoid, reduce and, if possible, offset' the adverse impacts of development on the environment.[22] There is a clear sequence here. The first

objective should be to avoid impacts altogether. If that is not possible, the aim should be to reduce their severity (in other words, to mitigate them, in the proper sense of that word). Finally, to the extent that it is not possible to avoid or reduce impacts, there should be offsetting (which might also be termed 'compensating'). To take a non-archaeological example, if a development unavoidably involves the felling of trees, this harm could be offset by planting an equivalent number of trees somewhere else. The original trees are lost, but new ones are provided. In an archaeological context, we can see the loss of the archaeological deposits themselves as being offset by the acquisition of new public knowledge and understanding about the past. The physical deposits are permanently lost (and, unlike trees, cannot be replaced), but in their place a public good of a different kind is provided: an expanded knowledge of the past.

This approach was seen as bringing a number of benefits.[23] First, it makes explicit that the purpose of development-led archaeological work is to make useful contributions to knowledge, as a form of public benefit.

Second, it aligns the test of whether proposed development-led work is adequate with that for whether 'research' excavations on unthreatened sites should be permitted. In each case, the test is the same: will the anticipated gain in knowledge be enough to make up for the loss of the deposits themselves? This is a coherent and logical position.

Third, an emphasis on producing knowledge and understanding should place a premium on academic insight, innovation and elegance in research design. Under PPG 16, competition tended to be on the basis of who could 'record' a given body of deposits at the lowest cost. If the aim was actually to increase understanding, rather than to create records, the question should be: who can secure the optimum balance between the resources spent and the results (in terms of increased understanding) obtained? This could result in greater increases in understanding being obtained for the same level of expenditure. In some cases, it might even result in lower costs for developers, through investigations being more sharply focussed. In all cases, continuous critical review of resource allocations in relation to emerging results would be needed throughout every stage of the work.

Finally, it aligns development-led archaeology with the concepts and language of environmental impact assessment more generally. In that sphere, impacts which cannot be reduced any further are known as 'residual' impacts: in other words, those which remain after all possible steps to avoid harm or to reduce it (that is, to mitigate it) have been taken. Residual impacts can be offset; by definition, they cannot be reduced.

This approach is also consistent, I would argue, with the Council of Europe's Valletta (or Malta) Convention of 1992. This states that: 'the archaeological heritage is essential to a knowledge of the history of mankind' and that: 'the archaeological heritage [is] a source of the European collective memory and . an instrument for historical and scientific study.'[24] Archaeological remains are a source of evidence for the past. We preserve some remains so that they can be investigated, in order to add to knowledge, in the future. When those investigations are carried out, they are of course properly recorded (and the records and finds are available for future study, beyond the scope of the research aims of the original work). Where remains cannot be preserved, we investigate them now. In essence, we realise their potential for contributing to knowledge immediately, rather

than deferring it to the future; in doing so, we still leave an archive of records and finds for further study in the future.

Planning Policy Statement 5 (2010) and the National Planning Policy Framework (2012)

In 2010, PPG 16 on *Archaeology and Planning* and PPG 15 on *Planning and the Historic Environment*[25] were replaced by a single document, Planning Policy Statement 5 (PPS 5), *Planning for the Historic Environment*.[26] This sought to bring policy on all aspects of the historic environment together in a single document, in order to support new integrated heritage legislation. In the event, the planned Heritage Bill never passed into law, but PPS 5 remained in place as a statement of the government's approach.

For our purposes, the key change between PPG 16 and PPS 5 was contained in Policy HE12, Policy Principles Guiding the Recording of Information Related to Heritage Assets. This policy is reproduced in full as Appendix 1. The key phrase was contained in 12.3: 'Where the loss of the whole or a material part of heritage asset's significance is justified, local planning authorities should require the developer to record and **advance understanding** of the significance of the heritage asset before it is lost' [emphasis added].

The text of PPS 5 was very clear and explicit about the reason for this wording. The section of PPS 5 which is headed 'The Government's Objectives' states:

> "The Government's overarching aim is that the historic environment and its heritage assets should be conserved and enjoyed for the quality of life they bring to this and future generations. To achieve this, the Government's objectives for planning for the historic environment are:
>
> ...
>
> - to contribute to our knowledge and understanding of the past by ensuring that opportunities are taken to capture evidence from the historic environment and to make this publicly available, particularly where a heritage asset is to be lost."

In short, the new policy aim was to contribute to knowledge and understanding now, not to 'preserve sites for future study'. A definition of the phrase 'archaeological interest' also emphasised the role of investigation, without undermining the primacy of preservation *in situ* as the most desirable aim. The current version of NPPF (see below) defines archaeological interest as follows:

> There will be archaeological interest in a heritage asset if it holds, or potentially holds, evidence of past human activity worthy of expert investigation at some point.[27]

This is different from seeing archaeological remains as something which can simply be 'recorded' for later study. By placing the emphasis on 'evidence', the issue becomes: when is it right that (destructive) investigation should take place?

In March 2012, PPS 5 and a number of other planning policy documents were replaced by the National Planning Policy Framework (NPPF),[28] which sought to condense, and bring together in one place, a wide range of planning policy and guidance. One section of NPPF was devoted to 'Conserving the Historic Environment' and the wording of PPS 5 policy 12.3 was carried largely unchanged into paragraph 141 of NPPF.

Revised versions of NPPF were published in July 2018 and February 2019, but the wording has remained; it is now found in paragraph 199 of the 2019 version.[29]

The overall aim of PPS 5 (and then NPPF) in this area was to ensure greater public benefit from development-led investigations. The historic environment sector responded to PPS 5 by producing the Southport Report, *Realising the Benefits of Planning-Led Investigation in the Historic Environment*, in 2011.[30] This set out a vision and wide range of recommendations, including:

> 4.1.3 The vision is that planning-led research into the historic environment should ... be focused on interpretation, understanding and significance, not record alone.

The publication of PPS 5 and then NPPF, and the profession's response in the form of the Southport report, marked an important break with the era of PPG 16 and its emphasis on 'preservation by record'.

2010 to 2019 – PPS 5 and NPPF in Practice

With nearly ten years' experience of working under the changed policy objective of 'advancing understanding', how has the new (or not-so-new) wording affected practice and thinking in development-led archaeology in England?[31]

There have been some positive results. There is a much greater awareness of the need for development-led work to produce identifiable public benefit, not simply archaeological records and technical reports. This is manifested in various ways, for instance by media coverage, publications and exhibitions on development-led projects. A particularly clear example is the widespread publicity given to discoveries made on the new Crossrail London underground railway line.[32] Similarly, a publication by Historic England in 2015 sought to highlight, for non-specialist audiences, the huge advances in understanding gained from twenty-five years of development-led work since 1990.[33]

At the level of working practices, however, it seems that rather less has changed; the scope which PPS 5 and then NPPF presented for refreshing our professional archaeological approaches seems not, for the most part, to have been taken up in earnest. A report published in 2017 which reviewed progress on the Southport recommendations commented:

> In the development and planning sectors, historic environment work is still more likely to be approached as risk mitigation than as value-adding. ... There appears to be a disconnect between policy and implementation – especially practical implementation in the field.[34]

This is seen particularly in the language used in the documents which lie at the heart of the process: the briefs, produced by local authority archaeologists to outline what they wish to see happen on particular sites, and the Written Schemes of Investigation (WSIs) produced by archaeological organisations which tender to do the work under a commercial contract with the developer. The term 'mitigation' is still used very frequently, and may appear in Local Plans. For example, the policy for archaeology included one Local Plan which is at a late stage of preparation states that 'harm should be minimised and mitigated by a programme of archaeological investigation'.[35] The emphasis tends to be very much on the 'recording' component of the work, rather than on the 'advancing understanding' element. In some instances, reference is still made to

'preservation by record', even though it is almost ten years since this phrase disappeared from planning policy in England.

This seems regrettable, and to be missing an opportunity. It is important, though, to try and understand the reasons for this lack of change. The overlapping issues of time and resources appear to be two of the main roots of the problem. Access to the right kinds of information, and the availability of the right kinds of expertise, are also factors.

There is almost always a degree of time pressure on a development scheme: the need to get planning permission as quickly as possible, the need to start construction, the need to get planning conditions discharged by the local authority. This inevitably feeds through into the archaeological process. In particular, WSIs may have to be produced on a short timescale, and fieldwork teams mobilised and deployed very rapidly. There may well not be time to undertake background research, consultation with experts and so forth, all of which could result in better WSIs.

Resourcing is also a potential issue, especially if a WSI is being written as part of competitive tender. No commercial organisation will want to sink more resources than necessary into a tendering process for work which it may not win, especially when the tender is likely to be judged more on price than on the quality of research design.

Producing a WSI which really responds to the particular characteristics of a site and its research potential requires a number of things. It is obviously very dependent on the extent and quality of field evaluation results (such as geophysical surveys and trial trenching). To understand significance and potential, though, also requires knowledge both of the local, regional and national (and maybe even international) context, and of current research directions for the period and type of site involved. Both may be difficult to acquire quickly. For many sites, there will already be a desk-based assessment of the site and its surrounding area. Unfortunately, these are too often little more than a rehearsal of the contents of the Historic Environment Record for the area, with little attempt to distil a wider picture out of the data. More positively, the 'resource assessments' parts of Regional Research Frameworks[36] can present an overview of current knowledge and understanding in an area (although they are often quite high level, and can also go out of date quite quickly, especially in areas of intensive development). Other forms of synthetic reviews, such as Urban Archaeological Assessments,[37] Extensive Urban Surveys,[38] Aggregates Levy reviews,[39] and various regional or topic-based syntheses can also assist.

In terms of developing a full appreciation of the research potential of a site, and how this should shape the WSI, advice from period or topic specialists may be invaluable. Most commercial archaeologists tend, necessarily, to be generalists rather than specialists (although some have very high levels of knowledge of particular topics). The specialist expertise which may be needed for a WSI is often scarce, and may be possessed by individuals (especially academics) who may be a long way away, and who are likely to have other priorities and calls on their time.[40]

Heathrow Terminal 5

One project which did attempt to adopt a different approach was at Terminal 5 (Heathrow Airport, London).[41] This actually took place in the late 1990s and early 2000s, before the publication of PPS 5. Here, the client (BAA plc) was committed to developing innovative

ways of working with its contractors on the construction project. The aim was to reduce costs and timescales by finding more streamlined approaches. For the archaeological work, this manifested itself in two main ways. First, there was substantial investment at the outset in developing a research design, and also in the creation of an IT infrastructure for the fieldwork. The IT was designed to allow rapid feedback of emerging results from the field into an evolving excavation strategy. Second, the field team was fully engaged with the evolving research focus of the work, and excavation strategy was continuously reviewed and modified as the work progressed and results were obtained. This meant that unproductive lines of investigation could be curtailed, and resources concentrated on things which would yield the greatest increases in knowledge. This approach to excavation resulted in a substantial savings at the post-excavation stage;[42] an internal cost-comparison exercise carried out at the time also indicated that the Terminal 5 approach resulted in lower overall costs (per unit area excavated) than conventional 'preservation by record' approaches.[43] The Terminal 5 project was innovative, and widely discussed at the time, but – for reasons which are not clear – the approach it espoused has not been taken up more widely. Conservatism in the archaeological profession, and non-availability of funds for 'up-front' investment in projects, are two of the possible reasons.

The Research Cycle and the Need for Synthesis

Research does not proceed simply by the accumulation of more data. To be fair, the 'preservation by record' approach did not assert that it does; it said that records of threatened sites should be made so that there was a resource for future study. Archaeological research operates in an essentially circular manner (Figure 1). The starting point is existing knowledge and understanding. From this, new questions and new research directions are generated (some of them possibly stimulated by things like an interest in an area which is about to see much new development). New work then takes place, collecting evidence relevant to those research questions. This evidence is then subjected to analysis and synthesis. This will result in changed knowledge and understanding, and the cycle begins again.

A recognised problem with PPG 16 and its successors is that the rate of recovery of new evidence has outstripped traditional mechanisms of synthesis. This creates the risk of that more and more of the same kinds of evidence will be accumulated, gathered within an increasingly out-of-date framework of knowledge and understanding. Partly to address this issue, a number of projects aimed at synthesising development-led results have been undertaken. At a national level, there is Bradley's *Prehistory of Britain and Ireland*, Rippon and colleagues' *Fields of Britannia*, Fulford and colleagues' *Roman Rural Settlement* and Blair's *Building Anglo-Saxon England*.[44] There is also a wide variety of local and regional syntheses, as well as ones dealing with particular topics or categories of material. Such work is extremely valuable. The challenge now is to ensure that the insights generated from it are fed into the design of future development-led projects.[45]

Another form of synthesis is the regional (and other) research frameworks promoted by Historic England since the 1990s.[46] The 'resource assessment' element of these can provide a useful summary and starting point for the archaeology of an area or topic; they are essentially accounts of the current state of knowledge and understanding. As such, they serve a valuable purpose, by enabling practitioners to get a reasonably up-to-date

Figure 1. The archaeological research cycle.

overview of the archaeology of an area quite readily. Rather less satisfactory is the practice of taking very generic objectives from the 'research agenda' section and inserting these into WSIs, without a closer consideration of how that objective relates to the particularities of the site in question. The regional frameworks also cover large areas (a group of English counties) and are therefore quite general documents, although they do also provide a way into the archaeological literature for a region for anyone needing more detail.

Possible Future Improvements

This article has been mostly concerned with analysing how policy has been translated into practice, and identifying some problems in this area. It is not a main purpose of the article to try and suggest solutions, but some comments may be offered. There is a number of areas in which changes of approach could help.

It ought to be simple and uncontroversial to adopt a change in the language used in working documents, so that the overall purpose of the work is made clear. Every WSI (or other document concerned with a requirement for development-led work) should say, at the outset, that the objective of the work is to 'record and advance understanding'. At present, the objective is often stated as being to 'mitigate' the impacts of the development (see discussion above). Such a change in usage would bring the description of the activity into line with current policy wording. Equally importantly, the simple act of stating that 'advancing understanding' was a key aim would immediately raise the question: *how* (or in what ways) will understanding be advanced? In this way, attention would be forced onto addressing that issue in the WSI.

This might lead towards a second desirable outcome: increasing the level of investment in background work and research design in the opening stages of a project. This could include both an altered approach to desk-based assessments (with less emphasis on simply reproducing HER point data; more focus on what that information means more broadly in terms of the archaeological potential of an area; and more investment in considering current models and ideas about the area and periods thought to be present).[47]

Greater investment in background research (along with the evidence from any prospection: geophysical surveys, evaluation trenching, boreholes and so on), would provide a good starting point for a more considered approach to producing WSIs. These are often rather generic documents; they should be more closely tailored to the specifics of the site, matching archaeological potential to current research agendas in more detail than is often done at present. Compared to what may later be spent on excavation and the resultant post-excavation work, the costs of committing slightly more time and resources to the design stage (i.e. to developing the WSI) are small. This could pay significant dividends.[48]

There is also a continuing need for more synthesis projects, of the kind discussed above.[49] These need resources, and large national projects can be expensive, but the costs are relatively small compared to the many hundreds of millions of pounds spent on the development-led archaeological work which generates the material requiring synthesis.

It would be particularly desirable to undertake syntheses of work carried out to date in areas which have already seen a great deal of development-led investigation, and where more can be expected in the future. Much development is concentrated in particular locations (such as growth areas identified in local authority development plans). Syntheses in those areas could provide an excellent starting point for taking a more strategic approach, rather than a site by site one, to future archaeological work.

Experience to date shows that one of the biggest costs in any synthesis project is simply assembling and cleaning the data. This is partly a legacy problem, but some very basic measures – like requiring excavation plans to be supplied in GIS-ready formats, so that the plans of multiple excavations in an area could simply be amalgamated into one, comprehensive, GIS layer – would make the task immeasurably easier, quicker and cheaper.[50]

This would open the way for research frameworks which covered much smaller areas than the Regional Research Frameworks, and which – by being much more spatially specific – could feed much more directly and pertinently into assessments of the archaeological potential of an area, and into the identification of research questions for future projects.

Another valuable step (which could flow from synthesis) would be to develop a better understanding of the overall quantity, character and distribution of archaeological remains in the landscape. PPG 16 and its successors have shown us that archaeological remains are far more abundant than previously realised. This is especially true of the smaller or less susbstantial types, such as isolated prehistoric pits, small settlements of later prehistoric or Roman date, field systems and the like. This abundance has very substantial implications, which have barely begun to be worked through, for

assessments of significance, decisions about protection and preservation, and strategies for sampling and investigation.

In the end, however, the most effective argument for a revised approach to development-led archaeology is likely to be an economic one. I argue above that more investment in background research, thought and research design at the start of a project should produce better value for money (in terms of understanding gained *versus* expenditure incurred). This is because the work would be better focussed. It might even turn out, in some cases, that a more focussed approach could save the developer money, by avoiding unnecessary work which adds little to the sum of knowledge. If this could be demonstrated through real-world examples, then there would be an immediate incentive for developers to organise their timescales and finances in a way which facilitated 'front-loaded' spending on preparation, in the clear expectation of benefits (and possibly even financial savings) later. Finding ways of substantiating this argument seems a high priority today.

Conclusions

This paper contends that current practice in development-led archaeology in England has its policy roots in problematical concepts of achieving 'preservation by record' or 'mitigation' (reduction of harm), before remains are destroyed. Both phrases, it is argued, misrepresent the true nature of archaeological investigations carried out ahead of development, and have unhelpful consequences in terms of how this work is thought about and carried out.

A policy change in 2010 moved the emphasis from making records to advancing understanding and providing public benefit. In this view, development-led investigation of remains before their destruction is seen as 'offsetting' (a benefit of one kind, increased understanding, replaces a loss of another kind, the destruction of *in situ* deposits). This policy change has not, however, resulted in significant changes to professional practice in the sphere of development-led archaeology. This appears to be the result of either choice or inertia on the part of the archaeological profession, attributable to a variety of factors.

It is argued that a greater investment of time and expertise in background work, thinking and research design in the early stages of projects – i.e. seeing development-led archaeology as a process of enquiry, not one of recording – could pay considerable dividends. It should result in greater advances in understanding for the resources expended, and might even produce some cost saving, by avoidng doing work which contributed little in the way of new understanding.

A number of measures, notably connected with the need to synthesise existing information, could help to support this approach, which in effect spends more up-front in order to get better results, and possibly even to save cost, later. If it was possible to demonstrate to developers that this pattern of resourcing could produce better results, there would be an obvious incentive for them to adopt such an approach.

Perhaps most importantly, the archaeological profession should embrace more wholeheartedly the view that the purpose of development-led archaeology is to advance understanding (which is the policy position). This would make it clear that

this activity is driven by curiosity, by a desire to expand our knowledge of the past, and by a wish to impart that knowledge to the public. This could make development-led archaeology more satisfying in professional terms, and ensure that it is demonstrably fully worthwhile in terms of producing public benefit commensurate with its cost.

Notes

1. DoE, *Archaeology and Planning* (PPG 16).
2. Thomas, "English Heritage Funding,", 180–88.
3. EEC, *Council Directive 85/337*.
4. UNCED, *Rio Declaration*.
5. Darvill et al., *PPG 16 Era*.
6. DoE, PPG 16, paragraph 24.
7. Thomas, "Nothing new under the sun," 294.
8. Ibid.
9. E.g. Hodder, *Archaeological Process*, Chap. 2.
10. Thompson, "Research or Rubbish Collection?"
11. INRAP, "What is Preventive archaeology? [The French language version reads: 'L'archéologie préventive … permet de « sauvegarder par l'étude » les archives du sol' – or 'save by study']."
12. Hodder, *Archaeological Process*, Chap. 3.
13. See e.g. Carver, "Digging for data," 47.
14. See note 5 above.
15. Swain, *Competitive Tendering*.
16. CIfA, "CIfA regulations, standards and guidelines."
17. E.g. Southport Group, *Realising the Benefits*, 5–7.
18. Thomas, "Making the most," 16.
19. Historic England, *Preserving Archaeological Remains*, 2.
20. Thomas, "Rethinking PPG 16."
21. Ibid.
22. EEC, *Council Directive 85/337* (as amended), Art. 9 and Annexe IV, 5.
23. See note 20 above.
24. CoE, *Valletta Convention*, Preamble and Art. 1.1.
25. DoE, *Planning and the Historic Environment* (PPG 15).
26. DCLG, *Planning for the Historic Environment* (PPS 5).
27. MHCLG, *Planning Framework* (NPPF), 2019 version, Annexe 2: Glossary.
28. DCLG, *Planning Framework* (NPPF), 2012 version.
29. MHCLG, *Planning Framework* (NPPF), 2019 version, paragraph 199.
30. Southport Group, *Realising the Benefits*.
31. A forthcoming report, provisionally titled *Archaeology and Planning Case Studies*, by Jan Wills and Stewart Bryant, will also examine this issue. It is due to be published in late 2019.
32. Crossrail, "Uncovering a Layer Cake."; Keily, *Tunnel: Archaeology of Crossrail*.
33. Historic England, *Building the Future*.
34. Nixon, *What about Southport?*, 2.
35. Vale of White Horse District Council, *Local Plan 2031, Part 2*, 127, Development Policy 39.
36. Historic England, "Research Frameworks."
37. E.g. Baker et al., *Bristol archaeological assessment*.
38. Historic England, "Extensive Urban Survey."
39. English Heritage, "Aggregates Levy Sustainability Fund."
40. Society of Antiquaries, *Future of Archaeology in England*, para. 3.5.
41. Andrews et al., "Interpretation not record"; Framework Archaeology, *Landscape Evolution*.
42. Andrews et al., "Interpretation not record," 530.
43. Gill Andrews, pers. comm.

44. Bradley, *Prehistory*; Rippon et al., *Fields of Britannia* and Blair, *Building*.
45. See e.g. Cotswold Archaeology, "Approaches to Investigation."
46. Olivier, *Frameworks for our Past*; Historic England, "Research Frameworks."
47. CIfA, "Whats going wrong?"
48. Cf. Andrews et al., "Interpretation not record," 530; see also Rippon, "Contextualisation."
49. Wills, *21st Century Challenges*, 32–35.
50. Morrison et al., "Laying Bare," 2 – Methodology.

Acknowledgments

I am grateful to Mike Dawson, editor, for accepting this paper for publication. Mike Dawson, Pete Hinton and Jan Wills provided helpful comments on a draft. Gill Andrews commented on the Heathrow Terminal 5 project. I am most thankful for all of this help. Responsibility for the views expressed in the paper is, however, mine alone.

Disclosure statement

No potential conflict of interest was reported by the author.

Bibliography

Andrews, G., J. C. Barrett, and J. S. C. Lewis. "Interpretation Not Record: The Practice of Archaeology." *Antiquity* 74, (2000): 525–530. doi:10.1017/S0003598X00059871.

Baker, N., J. Brett, and R. Jones. *Bristol, a Worshipful Town and Famous City: An Archaeological Assessment*. Oxford: Oxbow Books, 2018.

Blair, J. *Building Anglo-Saxon England*. Princeton: Princeton University Press, 2018.

Bradley, R. *The Prehistory of Britain and Ireland*. Cambridge: Cambridge University Press, 2007.

Carver, M. O. H. "Digging for Data: Archaeological Approaches to Data Definition, Acquisition and Analysis." In *Lo Scavo Archeologico: Dalla Diagnosi All'edizione*, edited by R. Franconvich and D. Manacorda, 45–120. Florence: Edizioni all'Insegna del Giglio, 1990.

Chartered Institute for Archaeologists [CIfA]. "CIfA Regulations, Standards and Guidelines." Accessed July 12, 2019. https://www.archaeologists.net/codes/cifa

Chartered Institute for Archaeologists [CIfA]. "What's Going Wrong with Desk-based Assessments?" Accessed July 16, 2019. https://www.archaeologists.net/news/what%E2%80%99s-going-wrong-desk-based-assessments-1562930429

Cotswold Archaeology. "Approaches to the Investigation, Analysis and Dissemination of Work on Roman Rural Settlements and Landscapes in Britain." Accessed July 16, 2019. https://cotswoldarchaeology.co.uk/community/discover-the-past/developer-funded-roman-archaeology-in-britain/methodology-study/

Council of Europe [CoE]. *Convention for the Protection of the Archaeological Heritage of Europe (revised)*.Valletta, 1992. Accessed July 12, 2019. https://www.coe.int/en/web/culture-and-heritage/valletta-convention

Crossrail. "Uncovering a Layer Cake of London's History". Accessed August 17, 2019. http://www.crossrail.co.uk/sustainability/archaeology/

Darvill, T., K. Barrass, V. Constant, E. Milner, and B. Russell. *Archaeology in the PPG 16 Era. Investigations in England 1990 – 2010*. Oxford: Oxbow Books, 2019.

Department for Communities and Local Government [DCLG]. *Planning for the Historic Environment*. Planning Policy Statement 5 [PPS 5]. London: The Stationery Office, 2010. Accessed July 16, 2019. https://webarchive.nationalarchives.gov.uk/20120919201742/http://www.communities.gov.uk/archived/publications/planningandbuilding/pps5

Department for Communities and Local Government [DCLG]. *National Planning Policy Framework*. [NPPF]. 2012. Accessed July 16, 2019. https://webarchive.nationalarchives.gov.uk/20180608213715/https://www.gov.uk/guidance/national-planning-policy-framework

Department of the Environment [DoE]. *Archaeology and Planning*. Planning Policy Guidance note 16 [PPG 16]. London: HMSO, 1990. Accessed July 16, 2019. https://webarchive.nationalarchives.gov.uk/20100304225912/http://www.communities.gov.uk/publications/planningandbuilding/ppg16

Department of the Environment [DoE]. *Planning and the Historic Environment*. Planning Policy Guidance note 15 [PPG 15]. London: HMSO, 1990. doi:10.1099/00221287-136-2-327.

English Heritage. "Aggregates Levy Sustainability Fund." 2006. Accessed July 16, 2019. https://archaeologydataservice.ac.uk/archives/view/alsf/

European Economic Community [EEC]. *Council Directive 85/337/EEC of 27 June 1985 on the Assessment of the Effects of Certain Public and Private Projects on the Environment [as Amended]*. Accessed July 16, 2016. http://ec.europa.eu/environment/eia/eia-legalcontext.htm

Framework Archaeology. *Landscape Evolution in the Middle Thames Valley. Heathrow Terminal 5 Excavations Volume 2*. Oxford: Framework Archaeology, 2010.

Historic England. *Building the Future, Transforming Our Past. Celebrating Development-led Archaeology in England, 1990-2015*. 2015. Accessed July 16, 2019. https://historicengland.org.uk/images-books/publications/building-the-future-transforming-our-past/

Historic England. *Preserving Archaeological Remains – Decision-making for Sites under Development*. Swindon: Historic England, 2016. https://historicengland.org.uk/images-books/publications/preserving-archaeological-remains/

Historic England. "Extensive Urban Survey." Accessed July 16, 2019. https://archaeologydataservice.ac.uk/archives/view/EUS/

Historic England. "Research Frameworks." Accessed July 16, 2019. https://historicengland.org.uk/research/support-and-collaboration/research-frameworks-typologies/research-frameworks/

Hodder, I. *The Archaeological Process: An Introduction*. Oxford: Blackwell, 1999.

Institut National de Recherches Archéologiques Préventives [INRAP]. "What Is Preventive Archaeology." Accessed July 15, 2019. https://www.inrap.fr/en/what-preventive-archaeology-12006

Kiely, J. *Tunnel: The Archaeology of Crossrail*. London: Crossrail Ltd, 2017.

Ministry of Housing, Communities and Local Government [MHCLG]. *National Planning Policy Framework*. (Revised) [NPPF] 2019. Accessed July 16, 2019. https://www.gov.uk/government/publications/national-planning-policy-framework–2

Morrison, W., R. M. Thomas, and C. Gosden. "Laying Bare the Landscape: Commercial Archaeology and the Potential of Digital Spatial Data." *Internet Archaeology* 36, (2014). doi:10.11141/ia.36.9.

Nixon, T. *What about Southport? A report to CIfA on progress against the vision and recommendations of the Southport Report (2011)*, undertaken as part of 21st-century challenges in archaeology project. 2017. Accessed July 16, 2019. https://www.archaeologists.net/21st-century-challenges-archaeology

Olivier, A. *Frameworks for Our Past. A Review of Research Strategies, Frameworks and Perceptions*. London: English Heritage, 1996.

Rippon, S. "Paper 2 – The Contextualisation of Results". Accessed July 16, 2019. https://cotswoldarchaeology.co.uk/community/discover-the-past/developer-funded-roman-archaeology-in-britain/methodology-study/

Rippon, S., C. Smart, and B. Pears. *The Fields of Britannia*. Oxford: Oxford University Press, 2015.

Smith, A. T., M. Allen, T. Brindle, and M. Fulford. *New Visions of the Countryside of Roman Britain. Volume 1, the Rural Settlement of Roman Britain.* London: Society for Promotion of Roman Studies, 2016.

Society of Antiquaries. *The Future of Archaeology in England. A Discussion Paper from the Society of Antiquaries of London.* 2019.

Southport Group. *Realising the Benefits of Planning-Led Investigation of the Historic Environment.* 2012. Accessed July 16, 2019. https://www.archaeologists.net/southport

Swain, H., ed. *Competitive Tendering in Archaeology: Papers Presented at a One Day Conference in June 1990,* Hertford: Rescue, 1991.

Thomas, R. M. "English Heritage Funding Policies and Their Impact on Research Strategy." In *Archaeological Resource Management in the UK: An Introduction,* 2nd ed. edited by J. Hunter and I. Ralston, 179–193. Stroud: Sutton Publishing Ltd, 2006.

Thomas, R. M. "Rethinking PPG 16." *The Archaeologist* 73, (2009): 6–7. https://www.archaeologists.net/publications/archaeologist

Thomas, R. M. "Making the Most of Development-led Archaeology." *The Archaeologist* 89, (2013): 12–16. https://www.archaeologists.net/publications/archaeologist

Thomas, R. M. "Nothing New under the Sun: E.C. Curwen's Excavations at Whitehawk Camp, Brighton." *Sussex Archaeological Collections* 154, (2016): 291–295. doi:10.5284/1000334.

Thompson, F. H. "Rescue Archaeology: Research or Rubbish Collection?" *Antiquity* 49, (1975): 43–45. doi:10.1017/S0003598X00063249.

United Nations Conference on Environment and Development [UNCED]. *Rio Declaration on Environment and Development.* Accessed July 15, 2019. https://web.archive.org/web/20030402153036/http://habitat.igc.org/agenda21/rio-dec.htm

Vale of White Horse District Council. *Local Plan 2031, Part 2. Detailed Policies and Additional Site.* 2017. Accessed July 16, 2019. http://www.whitehorsedc.gov.uk/services-and-advice/planning-and-building/planning-policy/local-plan-2031-part-2

Wills, J. *The World after PPG 16: 21st Century Challenges for Archaeology.* 2018. Accessed July 16, 2019. https://www.archaeologists.net/21st-century-challenges-archaeology

Appendix 1. Planning Policy Statement 5, Planning for the Historic Environment (2010), Policy HE12

POLICY HE12: POLICY PRINCIPLES GUIDING THE RECORDING Of INFORMATION RELATED TO HERITAGE ASSETS

HE12.1 A documentary record of our past is not as valuable as retaining the heritage asset, and therefore the ability to record evidence of our past should not be a factor in deciding whether a proposal that would result in a heritage asset's destruction should be given consent.

HE12.2 The process of investigating the significance of the historic environment, as part of plan-making or development management, should add to the evidence base for future planning and further the understanding of our past. Local planning authorities should make this information publicly available, including through the relevant historic environment record.

HE12.3 Where the loss of the whole or a material part of a heritage asset's significance is justified, local planning authorities should require the developer to record and advance understanding of the significance of the heritage asset before it is lost, using planning conditions or obligations as appropriate. The extent of the requirement should be proportionate to the nature and level of the asset's significance. Developers should publish this evidence and deposit copies of the reports with the relevant historic environment record. Local planning authorities should require any archive generated to be deposited with a local museum or other public depository willing to receive it. Local planning authorities should impose planning conditions or obligations to ensure such work is carried out in a timely manner and that the completion of the exercise is properly secured.

Borderlands: Rethinking Archaeological Research Frameworks

Paul Belford

ABSTRACT
Research frameworks for archaeology in the UK have a long history. Since the 1990s research frameworks have been developed in formal programmes initially driven by state heritage bodies. These were intended to facilitate better decision-making in development-driven archaeological projects, and to provide an interface between archaeologists. However the effectiveness of such frameworks is limited by a number of constraints. These include 'internal' boundaries created by historic environment professionals: chronological borders; professional borders; disciplinary borders; and borders limiting access and regulating control. There are also boundaries created by others, which include institutional and resourcing constraints as well as the geographical limits of modern administrative boundaries. This paper discusses these issues through the prism of the border region between England and Wales, a borderland zone with long histories of conflict and co-operation. Some suggestions are offered for future changes.

Introduction

Archaeology and 'the historic environment' in the United Kingdom (UK) became embedded in the policy and practice of spatial planning in the early 1990s. This was a politically-driven change, which to some extent reflected broader international trends in applying so-called 'polluter pays' principles to archaeology and cultural heritage. The merits of both the process and the ways in which it was delivered have been discussed extensively elsewhere.[1] There were variations within the UK in the adoption of this kind of developer-funded planning-based archaeology; variations which owed something to pre-existing arrangements for dealing with cultural heritage in Wales, Scotland, Northern Ireland and England. The consequence was that the 1990s saw two simultaneous and related trends: first an acceleration in the quantity of archaeology being undertaken; second an increased diversity in the archaeology and historic environment disciplines. This diversity brought welcome opportunities for some, and fearful fragmentation for others. By the mid-1990s it had become clear that the volume of work, together with the increasing separation of different strands of professional practice, had the potential to create silos. This in turn reduced the accessibility of data through ignorance or misunderstanding, and so reduced the potential for public benefit to be derived from the system.

Rationale for, and Development of, Archaeological Research Frameworks

These potential gaps were recognised at an early stage, and research frameworks were identified as a way of overcoming them and building bridges between the silos.[2] In Wales, Scotland and England at least it was clear that archaeological advisors within the spatial planning system (in contemporary jargon the 'curators' of the archaeological resource) could not be aware of all the research questions for all periods and types of archaeology. The same was true of other actors in the increasingly complex 'biosphere' of archaeological endeavour. Consequently programmes to develop archaeological research frameworks emerged. This approach had first been advocated in the 1940s, and had been developed on an *ad hoc* basis during the 1980s.[3] In England, the reinvigorated research frameworks programme of the late-1990s was initially driven by the state heritage body, then known as English Heritage. This programme adopted a regional model in England, a template which was adapted as the basis for research frameworks in other parts of the UK. The intention was to create a tool to facilitate better planning and decision-making in development-driven archaeological projects, and to provide an interface between academic, professional and public archaeologists. Usually co-ordinated and funded by state heritage bodies or their proxies, such frameworks sought to engage academics, professionals and specialists, and to integrate work on archaeological sites, landscapes and historic buildings.[4]

The template for producing regional research frameworks was envisaged as a three-stage process:

- Resource Assessment: overview of the current state of knowledge and understanding
- Research Agenda: recognition of the potential of the resource, identifying gaps in knowledge and research topics.
- Research Strategy: a prioritised list of research objectives, furthered by implementing specific Research Projects.

All three elements – but particularly the Research Strategy – were intended to be regularly reviewed and priorities adjusted in the light of new information. The logic of the process meant that gaps identified would be filled and new research questions would emerge: therefore the whole process needed to be iterative and flexible.[5]

The first English region to undertake this process was 'Eastern England', an area comprising the historic counties of Bedfordshire, Cambridgeshire, Essex, Hertfordshire Norfolk and Suffolk (Figure 1). The resource assessment was published in 1997 and was followed three years later by a combined research agenda and strategy; later, a ten-year review led to further revisions.[6] Resource assessments were produced in the East Midlands during 1998–2000, with an overview and strategy published in 2006; in the north-west of England from 2001–2003, with an assessment published in 2007; and in the West Midlands from 1999–2003, with an overview assessment and agenda published in 2011.[7] Other regions, including London, developed similar initiatives at different times. The timing and thoroughness of subsequent stages varied across the English regions; some stages in the process were amalgamated and some were never fully completed.[8] A similar process began in Wales in 2001. Initially funded by the state heritage body Cadw,

Figure 1. Map showing the United Kingdom (shaded) and its principal administrative divisions. The main focus of this paper is England and Wales, so internal divisions in Northern Ireland and Scotland are not shown (see note 2 in text). The regional subdivisions of England used for the archaeological research frameworks are depicted in this drawing; for clarity relevant county and regional divisions of Wales are shown in Figure 3, the extent of which is indicated by the dark-bordered rectangle. Drawing © Paul Belford.

this was based on the four 'regions' defined by the territories of the Welsh Archaeological Trusts, and the first resource assessments were published in 2004.[9] Subsequent 'refresh' sessions took place periodically. As in England, the timing and consistency of the process has been mixed; some of the specific issues are discussed below. In Northern Ireland development-driven archaeology was largely centrally controlled until 2015, although the sector is characterised by much cross-border co-operation – including on research frameworks.[10]

The Scottish experience of research frameworks has been rather more positive than in England and Wales. Here the process was conducted in a much more orderly and consistent manner, and at the same time involved a much wider proportion of the (archaeological) population. The process of creating the Scottish Archaeological Research Framework (ScARF) has eschewed the production of a descriptive narrative for each period or region; instead producing an over-arching national narrative and a series of overview period-based site lists.[11] The result is a 'freely available, wholly online open-access resource for anyone who wishes to learn about Scottish archaeological research'.[12] Scotland was early to recognise the value of developing research frameworks for urban areas: what later became the Scottish Urban Archaeological Trust (SUAT) was formed in

1978 and over subsequent decades developed a rich and nuanced understanding of urban archaeology in Scotland through synthesis of results from development-driven rescue archaeology.[13] The work of SUAT was later echoed in England by a series of urban archaeological characterisation projects, which eventually covered over 700 settlements on a regional basis and over 30 larger towns and cities in substantial detail.[14] England also developed a programme of county-based 'Historic Landscape Characterisation' projects.[15] However both urban and landscape projects were never satisfactorily integrated with each other nor with the regional frameworks. Nothing on the same scale has ever been attempted in Wales.

These essentially state-sponsored regional or national research frameworks have also been accompanied by wide range of less formal ones. Some of these are very localised: for example many have related to World Heritage Sites (WHS), where they may comprise part of the formal structures supporting WHS Conservation Plans; although again with much variation in the emphasis given to different components of the historic environment.[16] Other frameworks have concerned specialist interests, resulting in multi-period research frameworks for subjects as diverse as urban archaeology, archaeometallurgy and maritime archaeology – produced independently but with a degree of support from state heritage bodies.[17] Yet others have been produced by societies or other groups specifically concerned with the archaeology of particular periods.[18] Some have even focused on particular landscape types in particular periods.[19] More recently there have been period-based synthetic studies based on data exclusively from developer-funded projects.[20]

Some General Constraints on the Effectiveness of Research Frameworks

As might be expected, the plethora of research frameworks, the different ways in which they have been funded and developed, and the multiplicity of overlapping timetables, has created a number of issues. Criticism of the research framework processes and outcomes crystallised in the 2011 'Southport' report, and its recommendation for a review was subsequently undertaken.[21] It is important to record that the 'Southport' report itself was firmly Anglocentric, and the subsequent review dealt only with research frameworks in England.[22] Wide variation in completeness, coverage and participation was noted. Since then work on refreshing regional frameworks has been inconsistent; period-specific or specialist national frameworks have been updated even more sporadically and in many cases not at all. It is convenient to suggest that these inconsistencies and irregularities are largely or entirely the result of limited resources. Certainly there is no question that funding for these projects has dwindled over time, and outside Scotland there has been more limited leadership from state heritage bodies – particularly in Wales. However this is only part of the answer. The failure of the research frameworks to deliver their potential public benefit has been for systemic reasons rather than financial ones. Although the frameworks programme was intended to overcome some of these obstacles, in many cases it has ended up reinforcing them.

Other than time and funding, perhaps the most obvious external constraints are modern administrative boundaries. These may be counties, regions or countries. Whatever claims may be made about the antiquity of the United Kingdom, the reality is that it has only existed in its current form since 1922, and most of its internal borders date from two periods of local government re-organisation in the 1970s and 1990s. Of course

some parts of present-day county and country borders can be traced back much further, but rarely convincingly before c.AD 1100. Consequently regional archaeological research frameworks were defined by administrative convenience not archaeological coherence. Terms such as 'Roman Worcestershire' or 'Mesolithic Wales' are ultimately meaningless and indeed counter-productive. This is not to say that there is no cross-border or inter-sectoral communication, and indeed one of the original objectives of the research frameworks programme was to facilitate such communication.[23] Nevertheless archaeologists operate within these structures. An employee of the state heritage body for England will not be actively working in Wales; equally the planning archaeologist for Herefordshire will not be dealing with developments in Shropshire. They will be aware of developments outside their own geographical area – not least due to the work of the Association of Local Government Archaeological Officers (ALGAO) – but the extent of this awareness and understanding depends on personalities and workload. Archaeologists in the private sector, who work across several administrative regions, may be better-placed to see emerging archaeological patterns; however they are constrained by commercial imperatives and are not always able to reflect on their work in this way. Academics – who it might be supposed are best-placed to produce synthesis – are also much more time-pressured and target-driven than they were in the 1990s.

The crux of the problem is the complexity of the systems within which UK archaeologists operate. To some extent these are external constructs: the UK version of the 'polluter pays' system is the result of political decisions made by non-archaeologists. Nevertheless 'polluter pays' or development-driven approaches have been adopted in other parts of Europe as a consequence of international agreement expressed in the Valetta Convention; yet these other countries have created systems that are less adversarial and confrontational, and less reliant on a type of private-sector 'entrepreneurship' that in reality is the consequence of a failed or forced market.[24] The fragmented nature of the archaeology and historic environment sector in the UK has made finding a unified voice very difficult. This fragmentation is sometimes characterised as a binary opposition between academic and commercial archaeologists. However reality is inevitably more complex. Commercial archaeologists are part of a wider group of professionals which includes public servants working for national and local government, as much as it includes those working for large multinational multidisciplinary consultancies: both are ultimately working for the public. Finally there are many borders that are created entirely by historic environment professionals: temporal borders between periods of archaeological chronology; disciplinary borders between 'below-ground' archaeology and standing buildings; and borders limiting access and regulating control.

The complexity of the archaeological structures in the UK are analogous to a series of 'ecosystems' which together make up a 'biosphere'. The relationships between these groups are key to enabling positive change in the future. In essence the archaeological 'biosphere' in England, Wales and Scotland can be distilled into five 'ecosystems' (Figure 2):

- Non-professionals. Arguably the oldest 'ecosystem', with its origins in post-Enlightenment antiquarianism, this sector continues in local societies and less formal groups – usually focussed on a particular geographical area which may be as large as

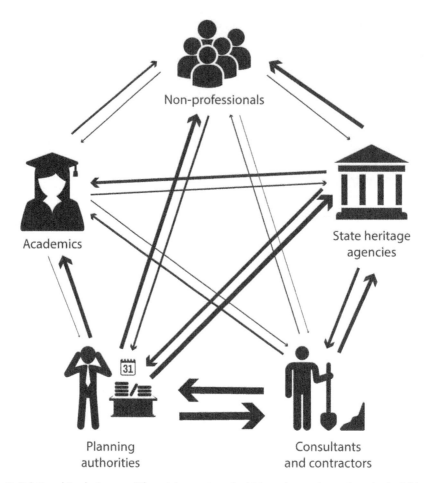

Figure 2. Relationships between different 'ecosystems' which make up the archaeological 'biosphere' in England and Wales (and to some extent Scotland and Northern Ireland). The directions of the arrows show the flow of information and their thickness reflects the degree of information exchange and the strength of relationships. Drawing © Paul Belford.

Wales or as small as a single field. Individuals tend to enjoy fieldwork and may be highly skilled and knowledgeable, but can be insular and wary of authority.
- Academics. Primarily motivated by research and teaching, many UK-based academics do not study the archaeology of the UK. They often have closer relations with other academics than with the local communities within which their institution is situated, although there are some notable exceptions. As individuals they are generally unconstrained in expressing political views.
- State heritage bodies. Arrangements differ markedly between the different parts of the UK. Wales effectively has three actors in the system, England has two and Scotland just one. They may be more or less 'arm's length' but need to observe political sensitivities in their actions and announcements, particularly during periods of political change.
- Planning authorities. These are one side of the coin of the development-driven system. Archaeological work in the spatial planning system is generally done at

county level, with some exceptions such as London (where is done by Historic England), Wales (where it is done by the Welsh Archaeological Trusts) and Northern Ireland (where is done by district councils). As with colleagues in state heritage bodies there may be explicit or implicit constraints on political engagement.
- Consultants and contractors come in a variety of sizes and institutional structures. Some are non-profit charitable educational trusts, some are private for-profit companies; others are semi-detached parts of local authorities or even universities (much less so now than formerly). Many are sole traders. Standards of work are enforced through the planning system, and regulated through accreditation (of individuals and organisations) by the Chartered Institute for Archaeologists (CIfA).

There are differences of detail between the different countries, and those specifically between England and Wales are discussed later. Nevertheless some generalities are constant. Links are strongest between the two sides of the development-driven process: they both closely engage with the Historic Environment Records (HERs) to inform their work, and their work adds data to the HERs. Planning archaeologists tend to have good links with their colleagues in the state heritage bodies. Those in the state heritage bodies are usually well-connected politically, but not always directly with archaeologists 'on the ground' or with local communities. Academics tend to engage less frequently with commercial archaeologists, planning archaeologists and HERs. Non-professionals tend to engage most closely with local authority archaeologists or the Welsh Archaeological Trusts; many academics also involve local volunteers on their project and engage with the more formally-constituted societies through lectures and publications.

There are of course further divisions within the different 'ecosystems' which both amplify and cut across this 'biosphere' of archaeological practice. Academics tend to find common ground more easily with colleagues studying the same field – medieval urbanisation, for example, or Iron Age metalworking. They will construct networks of shared interests that may have broad international scope but limited range in terms of period or archaeological material. Knowledge will tend to be shared through the medium of peer-reviewed academic journals and international conferences. Stepping outside those narrow confines is fraught with danger: 'people who are fully aware of debates in their own area' may be tempted to summarise the situation elsewhere 'on the basis of reading a single article'.[25] Professional archaeologists are if anything an even more fragmented 'ecosystem'. Some will specialise in particular methods or processes, such as geophysical survey or field evaluation. The maintenance of HERs requires specific skills in Geographical Information Systems, which are themselves not standardised. There remains considerable variation in fieldwork and reporting standards. CIfA's ability to enforce its own standards and guidance is hampered by a lack of resources. The sharing of information is also constrained by structural borders. Peer-reviewed journals sit behind institutional paywalls and are inaccessible for commercial archaeologists working for private- or third-sector organisations. Equally the extensive grey literature in the HERs is not consulted as readily as it might be by academics, who – for reasons related to formal and unspoken structures for funding and career progression in the higher education sector – tend to favour production of peer-reviewed articles over grey literature reports.

Of course these and other issues were part of the rationale for the creation of regional and national archaeological research frameworks. However the frameworks process has

largely failed to overcome these barriers. The rest of this paper assesses this failure using the case of the border region between England and Wales. This is a landscape whose cultural cohesion is not always reflected in the divergences of its present-day administrative arrangements, therefore it puts many of these general issues into a particularly sharp focus.

The England and Wales Borderland and Its Archaeological 'Biosphere'

The zone described here as the 'England and Wales borderland' is not a fixed or universally agreed entity; it has had many definitions at different times. The most persistent synonym is the 'march': an ancient word meaning 'borderland' – present in Farsi (*marz*), Latin (*margo*), Old Irish (*mruig*), Old Norse (*mörk*), Frankish (*marka*), and Old English (*mearc*). The name of one of the early medieval kingdoms whose western border defined this region – 'Mercia' – derives from the same root; there were numerous contemporary continental parallels.[26] Etymologically the term 'Welsh Marches' should therefore encompass lands on both sides of the border, however its modern usage tends to refer to those English counties which lie along the border.[27] Certainly the borderland was an area of contestation and conflict from c.800 AD to c.1400 AD, but only intermittently during that period and considerably less violently since then. It is also a zone with a high degree of cultural coherence as a borderland. Nevertheless its extent and margins are difficult to define, but the core of any borderland is naturally the border itself – although here there is an element of fuzziness. On the one hand there is the culturally-significant but administratively short-lived Offa's Dyke, usually identified as a ninth-century Mercian project.[28] On the other hand there is the modern border defined in 1536: administratively significant but less culturally resonant than the Dyke. On either side are England and Wales, with pockets of one in the other and a great deal of economic activity between the two. The 'Welsh Marches' has developed its own cultural identity. There are numerous books which explore the borderlands through literary, artistic, culinary and travel genres, making the point that this part of the world is both simultaneously partly England and partly Wales, and yet neither England nor Wales.

Topographically the borderland is a zone between the lowlands to the east and the uplands to the west; earlier cultural implications of this topographical division for prehistoric populations are no longer tenable.[29] Three key rivers have their origins in the west and flow to the east: from north to south the Dee, the Severn and the Wye. Controlling these rivers, their catchments and tributaries, seems to have influenced the location of Bronze Age and Iron Age agriculture, settlement and enclosures. Topography also defined the extent of Roman occupation. The rump of the third-century province of *Britannia Prima* survived to an extent into the medieval period, offering the basis for Welsh resistance to post-Roman Anglo-Saxon administrations.[30] Thus we come back to early-medieval Mercia and to Offa's Dyke, followed by the supremacy of Wessex over Mercia, and the Norman Conquest. The Norman objective was to subdue the Welsh, a long process which was never entirely achieved. After Edward I's defeat of Wales and its independent principalities in the late-thirteenth century, Wales became legally and administratively part of England. However the territory along the border was governed indirectly through a series of 'Marcher Lordships'. These lordships had particular characteristics: as well as being relatively small they were also autonomous – both from each

other and from the King. They had particular powers to create new towns and markets, raise taxes, maintain law and order, and build castles – powers that in England were solely those of the King.[31] Notwithstanding the rationale for their creation, their continued existence required (Anglo-Norman) Marcher Lords to secure political alliances with the Welsh through intermarriage.

Wales was fully incorporated into the English legal system in 1535–42, when Marcher Lordships were formally abolished – although in practice many had already passed into the hands of the crown. The territories were absorbed into English counties or formed the basis of new ones in the Principality of Wales, and the modern border was defined.[32] Wales' legal status as part of England was further fixed in 1746, but the industrial revolution gave Wales increased economic clout and so let to a resurgence in Welsh cultural, literary and historic identity. Official reversal of the subordination of Wales began in the late 1800s and continued through the twentieth century until formal devolution in 1997, since when the Welsh Government has acquired further powers. There has been an understandable tendency to assert 'Welshness' as distinct from what in some quarters is perceived as English colonialism. This has manifested itself in policy and practice for cultural heritage and archaeology.[33] Such divergence does not necessarily serve the geographical margins well.

The separate evolution of archaeological systems in England and Wales was partly a consequence of the appropriation of heritage for place-making and nation-building, although the current system in Wales was created long before formal devolution. This is based around a tripod of institutions that administer archaeology and cultural heritage on behalf of the state.[34] These are Cadw (established in 1983, and effectively the state heritage agency for Wales), the Royal Commission on the Ancient and Historical Monuments of Wales (RCAHMW, a semi-detached state body established in 1908) and the Welsh Archaeological Trusts – four independent charitable Trusts established in the mid-1970s. In contrast, England did not develop a regional system comparable to the Welsh Archaeological Trusts, and so responsibility for the management of archaeology and cultural heritage remained with the national body and local authorities. The national body was the Ministry of Works, until historic environment responsibilities were devolved in 1984 to English Heritage: a semi-detached agency, formally a commission. A separate Royal Commission on the Historical Monuments of England (RCHME) had also been established in the early twentieth century, but was absorbed into English Heritage in 1991. English Heritage both looked after the 'properties in care' (ie. sites and monuments owned by the state) and acted as a regulatory and 'curatorial' body for the wider sector. Finally in 2016 these two functions were split into 'English Heritage' and 'Historic England' respectively.

As well as these four bodies dealing with archaeology and cultural heritage on both sides of the border, other bodies also have a voice in these matters (Figure 3). On the English side there are four local authorities with direct responsibility for archaeology in the spatial planning system. They also have wider cultural heritage remits – managing public spaces outdoors (including historic landscapes and heritage 'assets') and indoors (including museums, galleries and libraries) – as do their counterparts in Wales: there are five local authorities on the Welsh side of the border. There are other public bodies too. For example there are 13 National Parks in England and Wales, which exist in their own right as planning authorities, together with 38 'Areas of Outstanding Natural Beauty'

Figure 3. The border region between England and Wales. National and county administrative boundaries are shown with dashed lines (thicker for the England-Wales border); regional archaeological framework areas are shaded (England: North-West, West Midlands and South-West; Wales: Clwyd-Powys and Glamorgan Gwent). The map also shows principal rivers and the early medieval linear earthworks of Offa's Dyke and Wat's Dyke (dark grey). Drawing © Paul Belford.

(AONBs). The AONBs protect the landscape in similar ways to National Parks but are not themselves planning authorities. Four of the AONBs are in Wales, 33 are in England, and one (the Wye Valley) is in both countries. Three AONBs are in the 'borderland'. As a result the borderland is covered by five regional research frameworks: three from England (the South-West, the North-West and the West Midlands), and two from Wales (the Clwyd-Powys region and the Glamorgan-Gwent region).

Some Specific Issues with Research Frameworks in the Borderlands

The generally problematic concept of using modern administrative boundaries to frame archaeological research gives rise to some very particular issues in the borderland. Awareness of at least some of these issues is not new.[35] For example the review of the Neolithic period in Wales postulated an 'east/west divide in Wales' and argued for more research in mid-Wales to determine whether the east of Wales was 'more connected to England' during this period – although of course neither England nor Wales existed in the Neolithic.[36] Similarly the most recent overview of Palaeolithic and Mesolithic archaeology in Wales rightly advocates that future work should 'continue to locate the Research Agenda for Wales within wider British and European contexts'.[37] Yet such admirable advocacy is not followed through. Thus the same document highlights how understanding of human activity in the Mesolithic would be improved with more work in inland locations, and specifically through 'investigation of river and lakesides' to identify 'possible focal points or areas for Mesolithic exploitation'.[38] However it completely ignores an example of exactly this sort of Mesolithic exploitation that was taking place literally a stone's throw from the modern Welsh border, the subject of a long-term community-based research project at Poulton. Indeed it is only an accident of medieval land ownership that places Poulton in Cheshire; in topographical terms – certainly from a Mesolithic point of view – it is in Wales, since it is on the west side of the River Dee. The relevant part of the framework for the North-West England notes the significance of the prehistoric finds at Poulton, which included 275 flint tools, with 'marked occurrence of diagnostically Early Mesolithic items, suggesting that this may have been the site of a temporary or seasonal camp'.[39]

This sort of situation is paralleled for other periods. For example the transition from Bronze Age to Iron Age unsurprisingly shows a similar pattern in Wales and England. The change from a settled agricultural economy with dispersed and undefended settlements, to a more nucleated and defensive system of competition for resources, appears largely to have been driven by climate change, and resulted in similar landscapes.[40] Yet although work on each side of the border acknowledges the importance of comparators on the other, the constraints imposed by the frameworks process means that they stop short of offering a cross-border synthesis of the situation (Figure 4).[41] Whilst hillfort studies have tended to overlook modern administrative boundaries – often quite literally as these sites are intervisible – the same is less true of other evidence.[42] Trans-border connections should be particularly apparent during the Roman period, when the whole of England and Wales were subject to the military occupation of an imperial power. In many ways the authors of the Roman period frameworks have been more aware of cross-border issues. For instance the Welsh frameworks note the similar rural settlement patterns in north-east Wales and Cheshire.[43] On the English side the long-term strategic importance of the Welsh borderlands in military terms has been acknowledged: the Roman Army's need to

Figure 4. A border landscape. View from the Breidden (an Iron Age hillfort) looking north. The border between England and Wales runs up the middle of this picture; England is on the right, Wales on the left. The cloud-darkened hill in the middle distance is Llanymynych: site of another Iron Age hillfort, Roman mining and post-medieval limeworking; the border runs down the high street of the eponymous village. The meandering and shifting loops of the Severn and Vrynwy converge here; the lines marked by their now-lost sixteenth-century loops define the modern border. Photograph © Paul Belford.

procure supplies of all sorts – from metals to meat – would also have given cohesion to the borderlands as a 'resource procurement' region.[44]

The early medieval period – that is, from the early-fifth century to the mid-eleventh century – would seem the most logical time-frame for a real difference in archaeological evidence between England and Wales. After all, this period marked the beginning of the emergence of the two medieval and post-medieval nations. Yet in fact precisely because of this process there was much more in common on either side of what later became the border. For example north-east Herefordshire had been absorbed into Mercia by the late-seventh century, but the south-western part of that county remained as a 'British' enclave of Archenfield until the late-tenth century.[45] Resources were procured from both sides; alliances were reshaped as strategies and tactics for maintaining power through kinship groups were developed.[46] The emergence of modern boundaries was the result of a series of contested processes: as noted above the material remains of those expressions of power – earthen castles and princely courts – are similar across both sides of the modern border. Ultimately the balance of power came to rest on the English side. Consequently there are manifestations of resistance to that power as relative administrative autonomy gave way to the centralising tendencies of the English state from the sixteenth century onwards. This cycle of domination and resistance may not be easily detectable, but this

does not excuse its conspicuous absence as a research question in existing research frameworks. Finally the post-medieval and industrial periods cannot be considered in national – or even regional – isolation. The industrial landscapes of extraction, processing, infrastructure and settlement were part of global networks.

The borders created by archaeology's chronological and geographical specialisms are further complicated by other specialist boundaries and areas of interest. Inconsistencies in specialist approaches – as well as very different approaches to the creation and management of data – have resulted in research frameworks that are at best patchy and at worst very difficult to use meaningfully in the day-to-day arena of the spatial planning system. Palaeoenvironmental evidence is treated very differently in different parts of the borderlands. The resource assessment and research agenda for south-west England provides a detailed analysis of the environmental evidence for each period.[47] Such stand-alone analysis is completely absent from north-west England, for example, and only appears in the west midlands for the early prehistoric and early post-medieval periods.[48] Wales on the other hand has an entirely separate research assessment for the whole country.[49] Similarly Wales treats maritime and coastal archaeology as a research theme in its own right, but this is not paralleled anywhere else – perhaps surprisingly for south-west and north-west England. Buildings archaeology has generally been neglected: only for north-west England has a separate resource assessment has been undertaken for historic buildings and designed landscapes.[50]

As if the straightjackets that archaeologists have imposed upon themselves were not enough, archaeologists often forget the existence of other fields of historical enquiry. Historical geographers look at landscapes, historians look at people and places, linguists see shifting patterns of population and influence.[51] In addition there is that fifth 'ecosystem' which has largely been ignored in the construction of archaeological research frameworks: the public. For instance the period in which the research frameworks have been in use has seen an increase in the reporting of metal detecting finds through the Portable Antiquities Scheme (PAS), introduced in England and Wales in 1996. The PAS relies on the goodwill of 'responsible' metal-detectorists to report finds to local Finds Liaison Officers (FLOs). Some research frameworks have made use of PAS data to try and identify new patterns of human activity, again welcoming that fact that the PAS 'has greatly increased the number of artefacts in general to be studied'.[52] However the evidence gleaned from the PAS doesn't feature prominently in the English research frameworks and does not appear at all in Wales.[53] Although this is not the place to discuss ethical, moral and legal questions around metal detecting and archaeology, two aspects are germane here. First, the borderlands region is poorly served by the PAS mechanisms, which are chronically under-funded. Anecdotal and quantitative data suggests that a large number of metal detectorists from England cross the border into Wales, and to a lesser extent this works the other way.[54] Second, numbers of detectorists are much higher, and rates of reporting much lower, than hitherto assumed. There may be up to 2,000 metal detectorists active in the border region, with less than 4% of finds being reported.[55] The role of the PAS needs to be considered going forward, and the reliability of the data it provides questioned.

Finally it is worth returning to some of the structural issues in archaeology itself, as reflected in the frameworks process. A simple analysis of the production of two regional frameworks is revealing. In the mid-2000s the English West Midlands and Wales contained

an estimated 467 and 422 paid archaeologists respectively; representing approximately 7% and 6% of all UK archaeologists.[56] The West Midlands framework involved 53 authors and Wales 43, or roughly 10% of the total archaeological populations of these regions. Many authors contributed more than one paper. There were 84 research papers produced for the West Midlands framework in 2002–03, of which 73 – an astonishing 87% – were written by men. In the first iteration of the Welsh framework in 2004 80% of the papers were written by men. This is in contrast to Scotland, where the 2012 assessment involved over 350 contributors.[57] However numbers of contributors only tell part of the story; equally important are the structures which enabled contribution. This is evident when the profile of research frameworks authors in those two regions is compared with the profile of the profession as a whole (Figure 5). Although more than 50% of the archaeological population work in the private sector, the production of the research frameworks was dominated by academic and 'curatorial' archaeologists. Some of the issues around access generally – and synthesis and reporting to the HER by academics in particular – were explicitly addressed in the research strategy for south-west England.[58] Nevertheless the top-down nature of the process – particularly in Wales where repeated calls for more open and inclusive approaches have not been well-received – hinders a genuinely engaging and iterative process which would better serve the public archaeology of the borderlands.

An Archaeological Research Framework for the Borderlands

It is clear then that the archaeology of the borderlands is poorly served by those research frameworks which cover its geographical area. Existing structures and systems on both sides of the border have either stalled or failed entirely, resulting in a static and out-of-date body of work which is no longer fit for the purpose for which it was intended. A review of one of the printed framework volumes notes that it 'suffers from a significant lack of recent analysis and updated revisions of the archaeological evidence'.[59] Similar critiques could be made of the others. Consequently, references made to the existing research frameworks by time-pressed archaeological contractors and historic environment advisors are often formulaic. Academic input is dependent on the interests and enthusiasms of individual researchers. Their work transcends administrative boundaries, but it often fails to permeate some of the boundaries between 'ecosystems' which make up the archaeological 'biosphere'. There is no feedback loop: information flow tends to be one way. The research frameworks provide useful soundbites to support particular research projects, funding applications or approaches to developer-funded projects; however the outcomes of such projects do not feed back to the frameworks process in the way was originally envisaged. Given these failings, it is necessary to consider where to go next. The development of any new research framework needs to address two key issues: coherence and accessibility.

Coherence refers mainly to geographical coherence, although it is also important to try and develop and deliver some sense of narrative coherence that spans different time periods and different disciplinary approaches. To turn first to the ways in which the archaeological territory may be defined. Helpfully for this particular area there is already a well-developed identity which is both historical and present in modern culture. There is also an increased recognition of borderlands as cultural landscapes in their own right. Conventional discourse in border theory has tended to concern the boundaries of nation-states, but archaeological and anthropological approaches have recognised that borders relate not only to polities, but

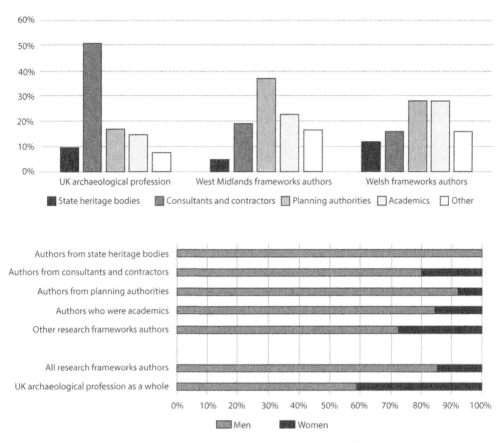

Figure 5. Representativeness of research frameworks in England and Wales. The three charts at the top show the relative sizes of professional 'ecosystems' – for the profession as a whole (left) and for research frameworks authors in the West Midlands (centre) and Wales (right). The bottom chart shows the gender balance within the authorship of the West Midlands and Wales research frameworks (categorised by 'ecosystem') and again compared with the profile of the profession as a whole. Drawn by the author using national data from Aitchison and Edwards *Profiling the Profession* and regional data from the respective research frameworks' papers (see also notes 9, 36, 37, 43, 44, 45, 48, 49, 52 and 64 in text).

also to physical and emotional states of being, and human and non-human interactions.[60] On a physical level borderlands themselves are spaces created by people in particular political circumstances, which bring people and cultures together.[61] Moreover the construction of borders – and their associated territories – are socially- and historically-constructed, and of course highly dynamic across time and space. Borders and borderlands are seen differently by different people, and are continually restructured and reshaped by human action and interaction.[62] Recognising the Welsh Marches in these terms is not intellectually problematic; the problem comes in translating this into meaningful action to enhance the public benefit that is delivered through the spatial planning system.

If modern administrative boundaries are rejected, then topographic features come to the fore. Apart from the hills and mountains, perhaps the most striking feature of this border region are its rivers. Of course all three rivers, and some of their major tributaries,

have demarcated different borders along their length. The Dee was traditionally the boundary of the Welsh kingdom of Gwynedd; it also marks much of the modern border between Flintshire (Wales) and Cheshire (England). Two tributaries of the Severn also form part of the modern border: the River Vrnwy from Llanymynech to its confluence with the Severn; and the River Wye from Hay again to the confluence – from which point the Severn itself forms the border. However for the most part the borders are not defined by the rivers; instead these rivers have formed a focus for communication, linking communities on either side and along them. It seems sensible therefore to define an area based on topographical features which have connected people, whether literally or in terms of lifestyle. In this case some sort of definition based on a transition zone between the lowlands and uplands, with reference to the catchments of the major river systems, would seem to provide useful common ground for archaeological research questions that could be addressed to all periods.

Such an approach would echo that taken by pan-regional archaeological synthesis projects elsewhere in Europe. One recent example, which sits under the umbrella of a much larger regeneration scheme, is the Iron-Age-Danube project. This is a partnership project looking at broader landscapes in nine micro-regions over five countries: Austria, Croatia, Hungary, Slovakia and Slovenia. Although focussed primarily on the 'monumental archaeological landscapes' of the early Iron Age – notably hillforts and funerary complexes – the broader aim is to develop joint approaches for researching and managing the historic environment, linking research agendas with public events and new visitor programme to deliver sustainable tourism.[63] By structuring the project around the Danube some of the anachronisms of contemporary administrative boundaries and borders are overcome. Defining a geographical territory is a familiar activity for archaeologists. There may be discussions about where the line should be drawn, but a line can be drawn that makes some sense of the archaeology for some of the time. This gives rise to the question about whether the same line would be drawn for different periods. Intellectually it would be difficult to justify such a position: an 'Iron Age borderland' would occupy a different space than an early medieval one. However this would bring the problems of period silos back to the fore in a way that would be problematic to administer practically, and so perhaps 'fuzzy boundaries' would provide a useful compromise.

The second issue is arguably more problematic: finding structures which enable the most inclusive and participatory approach to developing archaeological research frameworks. For many years it has been recognised that the audience for the frameworks is ostensibly a professional one, but that they also have a wider public audience. Consequently the 'idea that archaeological information and particularly understanding is uniquely ours' is no longer tenable, although a shift of position relies on the greatest accessibility of data and analysis.[64] Research outputs need to be socially relevant and to deliver public benefit – both as part of the spatial planning system and as a coherent 'biosphere' of knowledge production. This gives rise to two further issues that are familiar concerns for archaeologists: resources and power. Resourcing for an archaeological research framework that cuts across national and local administrative boundaries may initially seem problematic. However resourcing research frameworks at all has been increasingly problematic. In fact a multi-agency cross-border approach could result in more funding available for a more joined-up approach. The Iron-Age-Danube project cited above is one example, the Roman Limes network is another. Closer to home the pan-

Irish approach cited earlier is inspirational, particularly since the political changes provoked by the UK referendum on EU membership in 2016.[65] More locally still an *Offa's Dyke Conservation Management Plan* has been produced with funding from Cadw and Historic England that was channelled through a third-sector charitable body, the Offa's Dyke Association. Another advantage of this sort of approach is the de-politicisation of the process.

However the allocation of resources raises the issue of power. As noted above, this is one of the key flaws in the existing research frameworks structures. The model of authoritative narratives produced by period and region from the data held in local or regional HERs was probably the only possible approach in the mid-1990s. However in an era of crowd-sourcing, open-source software and citizen science this seems very old fashioned. Some of the English research frameworks have experimented with a 'wiki' style approach, in which contributors update articles on an *ad hoc* basis as results come in, with mixed technical success.[66] Such technical issues are resolvable, and although some degree of moderation would be necessary, a 'wiki' approach would make the framework process politically neutral and much more accessible and iterative. People other than those with time and institutional support to prepare papers and travel to meetings could contribute; the framework would be continually revised in line with the latest findings. Importantly, such an approach would reach out beyond the archaeological community: historians, linguists and members of the public would all be able to contribute. With appropriate support from Cadw, Historic England and the archaeological 'curators' at regional and county level on both sides of the border, such a framework would have a meaningful impact on the delivery of archaeological public benefit.

Conclusions

Archaeologists are, on the whole, prepared to put their own time and effort into initiatives which they perceive will give greater value in the long term. The research frameworks programmes, for all their flaws, have generally been embraced by the archaeological community. Although the processes to create archaeological research frameworks a troubled by limited resources and competing interests, positive outcomes have emerged. There has been much greater inter-sectoral awareness, some very exciting cross-disciplinary engagement, and considerable advances in archaeological understanding and the protection of the resource. However public archaeology could be much better served by research frameworks, and particularly so in border areas which by their very nature fall on the margins of existing administrative structures. The cultural, archaeological and landscape coherence of the Anglo-Welsh borderland is not in question; however existing structures only serve to emphasise differences to the detriment of archaeological understanding. Moreover political trends suggest increasing divergence and a greater potential for archaeology and cultural heritage to be deployed in support of national identities. Therefore there is not a moment to lose. A multi-agency cross-border 'bottom up' approach, served by a moderated 'wiki' connected to regional HERs, would reinvigorate the process in a way which has real resonance with the modern cultural coherence (and ambiguity) of the borderlands. It would provide a mechanism which would unite archaeology and cultural heritage to provide public benefit across borders.

Notes

1. Aitchison, "Global Financial Crisis"; Allen, "Legal Principles," 240–46; Belford, "Historical Archaeology," 27–32; and Belford, "Some More Equal," 27–32.
2. This paper focusses mainly on England and Wales. Scotland and Northern Ireland are discussed where relevant but are generally better served across and between administrations than England and Wales.
3. Hawkes and Piggott, *A Survey and Policy*; and Olivier, *Frameworks for Our Past*.
4. English Heritage, *Exploring Our Past*; Olivier, *Frameworks for Our Past*; and Tait, *Review of Research Frameworks*.
5. Olivier, *Frameworks for Our Past*.
6. Glazebrook, "Research and Archaeology," 1; Brown and Glazebrook, "Research and Archaeology," 2; and Medlycott, "Research and Archaeology Revisited."
7. Cooper, *The Archaeology of the East Midlands*; and Brennand, *The Archaeology of North West England*; and Watt, *The Archaeology of the West Midlands*.
8. Tait, *Review of Research Frameworks*, 68–87.
9. White, "Towards a Strategy."
10. Williams, "Archaeology in Northern Ireland," 14; and RIA, *Archaeology 2025*, 17–22.
11. Mann, "Developing Regional Research Frameworks," 9.
12. Gilmour and Riordan, "Enhancing Understanding," 5–6.
13. Murray, "Scottish Burgh Survey," 2–5; Rains and Hall, *Excavations in St Andrews*, 10–19; and Bowler, *Perth: The Archaeology and Development*, 7–15.
14. Dalwood, "Small Towns in Worcestershire," 216–18; Thomas, "Mapping the Towns," 68–74; and Belford, "Some More Equal," 30–35.
15. Fairclough, *Historic Landscape Characterisation*; and Aldred and Fairclough, *Historic Landscape Characterisation*.
16. Darvill, "'Research Frameworks for World Heritage Sites," 438–42.
17. Perring, *Town and Country in England*; Bayley, Crossley and Ponting, *Metals and Metalworking*; and Ransley et al., *People and the Sea*.
18. James and Millet, *Britons and Romans*; Blinkhorn and Milner, *Developing a Mesolithic Research and Conservation Framework*; Blinkhorn and Milner, *Developing a Mesolithic Research and Conservation Framework*.
19. Christie and Stamper, *Medieval Rural Settlement*.
20. Bradley, "Bridging Two Cultures," 9–11; Fulford, "Impact of Commercial Archaeology," 34–49; and Fulford and Holbrook, "Contribution of Commercial Archaeology," 329–38.
21. Southport Group, *Planning-led Investigation*; and Tait, *Review of Research Frameworks*.
22. Marvell, "Wales," 10.
23. See note 5 above.
24. Stefánsdóttir, "Development-led Archaeology in Europe."
25. Woolf, "Deaf and Dumb," 13–15.
26. Lieberman, "Medieval Marches," 1361–69.
27. Stanford, *The Archaeology of the Welsh Marches*, 35–47.
28. Fox, *Offa's Dyke*; and Ray and Bapty, *Offa's Dyke*.
29. Fox, *The Personality of Britain*; and Mullin, *A Landscape of Borders*.
30. Dark, *End of the Roman Empire*, 150–192; and White, *Britannia Prima*, 195–207.
31. Davies, *Lordship and Society*; and Stanford, *The Archaeology of the Welsh Marches*, 167–203.
32. Davies, *Lordship and Society*.
33. Belford, "Politics and Heritage," 2–7.
34. Ibid., 7–9.
35. Mullin, *A Landscape of Borders*.
36. Pannett, "Neolithic and Earlier Bronze Age," 16.
37. Walker et al., "Palaeolithic and Mesolithic," 10.
38. Ibid., 7.
39. Myers, "North West Regional Research Framework," 6.

40. Britnell and Silvester, "Hillforts and Defended Enclosures."
41. See note 35 above.
42. Guilbert, *Hillforts in Wales*; and Ritchie, *Iron Age Settlement in Wales*.
43. Davies, *Romano British*, 2–4.
44. Esmonde-Cleary, *Romano-British Period*; and Ray, *Romano-British Period*, 2.
45. Cotton, *Herefordshire*, 1.
46. Stephenson, *Medieval Powys*, 37–52.
47. Webster, *South-West England*.
48. Brennand, *The Archaeology of North West England*; Greig, *Neolithic and Bronze Age*; Pearson, *Later Prehistory*; and Pearson, *Early Post-Medieval*.
49. Caseldine, "Palaeoenvironments."
50. Barter, *Historic Buildings*.
51. See note 25 above.
52. Deacon, *Roman Coins*, 184.
53. Bolton, *Portable Antiquities Scheme*, 2–3.
54. Daubney, 'Floating Culture'; Hardy, 'Analysis of Open-Source Data'.
55. Hardy, 'Analysis of Open-Source Data'.
56. Aitchison and Edwards, *Profiling the Profession*, 47.
57. See note 12 above.
58. Grove and Croft, *South West England*.
59. Martin Ramos, "Review."
60. Cusick, "Creolization," 48–52; and Mullin, "Borders and Borderlands," 100–02.
61. Lightfoot and Martinez, "Frontiers and Boundaries," 475–82; Naum, "Re-Emerging Frontiers," 118–25; and Ylimaunu et al., "Borderlands as Spaces," 250–60.
62. Newman, "Borders and Bordering," 173–8; Radu, "Temporalizing," 422–28; Rumford, "Theorizing Borders," 160–62.
63. Czajlik et al., *Researching Archaeological Landscapes*.
64. Gale, *Later Prehistoric*, 1.
65. See note 10 above.
66. Mike Nevell, *pers. comm.*

Acknowledgments

Some of the ideas in this paper have been discussed with colleagues, in particular Gary Duckers, Ian Grant, Chris Martin, Mike Nevell, Diane Scherzler, Frank Siegmund, Roger White and Andy Wigley. Thoughts were also presented at meetings in Göttingen, Bern and Cardiff, and comments from delegates there have also been incorporated. The author is also grateful to Howard Williams for support and suggestions. Any errors or omissions are entirely the author's responsibility.

Disclosure Statement

No potential conflict of interest was reported by the author.

ORCID

Paul Belford http://orcid.org/0000-0002-9190-9839

Bibliography

Aitchison, K. "Archaeology and the Global Financial Crisis." *Antiquity* 83 (2009): 319.
Aitchison, K., and R. Edwards. *Archaeology Labour Market Intelligence: Profiling the Profession 2007–08*. Reading: Institute of Field Archaeologists, 2008.
Aldred, O., and G. Fairclough. *Historic Landscape Characterisation: Taking Stock of the Method – The National HLC Method Review*. London: English Heritage/Somerset County Council, 2003.
Allen, T. "Legal Principles, Political Processes, and Cultural Property." In *Appropriating the Past: Philosophical Perspectives on the Practice of Archaeology*, edited by G. Scarre and R. Coningham, 239–256. Cambridge: Cambridge University Press, 2012.
Barter, M. 2017. *North West Research Framework: Historic Buildings Resource Assessment Summary* (draft). Accessed February 14, 2020. https://archaeologynorthwest.files.wordpress.com/2017/12/nwrrf_historic_buildings_ra_2017_v3.pdf.
Bayley, J., D. Crossley, and M. Ponting. *Metals and Metalworking: A Research Framework for Archaeometallurgy*. London: Historical Metallurgy Society, 2008.
Belford, P. "Historical Archaeology and Archaeological Practice in Britain." In *Across the North Sea: Later Historical Archaeology in Britain and Denmark*, edited by H. Harnow, M. Høst Madsen, P. Belford, and D. Cranstone, 25–38. Odense: South Denmark University Press, 2012.
Belford, P. "Politics and Heritage: Developments in Historic Environment Policy and Practice in Wales." *The Historic Environment: Policy and Practice* 10, no. 2 (2018): 1–26.
Belford, P. "Some More Equal than Others? Some Issues for Urban Archaeology in the United Kingdom." In *Managing Archaeology in Dynamic Urban Centres*, edited by P. Belford and J. Bouwmeester, 27–41. Leiden: Sidestone, 2020.
Blinkhorn, E. H., and N. Milner. *Developing a Mesolithic Research and Conservation Framework: Resource Assessment*. York: University of York, 2012.
Blinkhorn, E. H., and N. Milner. *Developing a Mesolithic Research and Conservation Framework: Research Agenda*. York: University of York, 2012.
Bolton, A. *The Potential of the Portable Antiquities Scheme and Treasure Finds for Understanding the Iron Age in the West Midlands*. Birmingham: West Midlands Regional Research Framework, 2002. Accessed February 14, 2020. https://archaeologydataservice.ac.uk/archiveDS/archiveDownload?t=arch-2285-1/dissemination/pdf/West_Midlands_Regional_Research_Framework_Late_Prehistoric/AngieBolton_PortableAntiquities.pdf.
Bowler, D. P. *Perth: The Archaeology and Development of a Scottish Burgh*. Perth: Tayside and Fife Archaeological Committee, 2003.
Bradley, R. "Bridging the Two Cultures - Commercial Archaeology and the Study of Prehistoric Britain." *Antiquaries Journal* 86 (2006): 1–13.
Brennand, M., ed. *The Archaeology of North West England. An Archaeological Research Framework for North West England: Volume 1 Resource Assessment*, 8. Manchester: Archaeology North West, 2007.
Britnell, W. J., and R. J. Silvester. "Hillforts and Defended Enclosures of the Welsh Borderland." *Internet Archaeology* 48 (2018). doi:10.11141/ia.48.7.
Brown, N., and J. Glazebrook, eds. "Research and Archaeology: A Framework for the Eastern Counties 2. Research Agenda and Strategy." *East Anglian Archaeology Occasional Papers 8*, 2000.
Caseldine, A. 2017. "Refresh of the Research Framework for the Archaeology of Wales 2011–2016: Palaeoenvironments." *Research Framework for the Archaeology of Wales*. Accessed February 14, 2020. https://www.archaeoleg.org.uk/pdf/review2017/palaeoenvreview2017.pdf
Christie, N., and P. Stamper, eds. *Medieval Rural Settlement: Britain and Ireland, AD 800–1600*. Oxford: Windgather, 2011.
Cooper, N. J., ed. *The Archaeology of the East Midlands: An Archaeological Resource Assessment and Research Agenda*, 13. Leicester: Leicester Archaeology Monograph, 2006.

Cotton, J. *Herefordshire in the Post-Roman to Conquest Period*. Birmingham: West Midlands Regional Research Framework for Archaeology, 2003. Accessed February 14, 2020. https://archaeologydataservice.ac.uk/archiveDS/archiveDownload?t=arch-2285-1/dissemination/pdf/West_Midlands_Regional_Research_Framework_Early_Medieval/JulianCotton_Herefordshire.pdf.

Cusick, J. G. "Creolization and the Borderlands." *Historical Archaeology* 34, no. 3 (2000): 46–55.

Czajlik, Z., M. Črešnar, M. Doneus, M. Fera, A. Hellmuth Kramberger, and M. Mele. *Researching Archaeological Landscapes across Borders. Strategies, Methods and Decisions for the 21st Century*. Budapest: Archaeolingua, 2019.

Dalwood, H. "The Archaeology of Small Towns in Worcestershire." *Transactions of the Worcestershire Archaeological Society* (Third Series) 17, (2000): 215–221.

Dark, K. *Britain and the End of the Roman Empire*. Stroud: History Press, 2002.

Darvill, T. "Research Frameworks for World Heritage Sites and the Conceptualization of Archaeological Knowledge." *World Archaeology* 39, no. 3 (2007): 436–457.

Daubney, A. "Floating Culture: The Unrecorded Antiquities of England and Wales." *International Journal of Heritage Studies* 23 (2017): 785–799.

Davies, J. R. L. 2017. "Refresh of the Research Framework for the Archaeology of Wales 2011–2016: Romano British." *Research Framework for the Archaeology of Wales*. Accessed February 14, 2020. https://www.archaeoleg.org.uk/pdf/review2017/romanreview2017.pdf

Davies, R. R. *Lordship and Society in the March of Wales, 1282–1400*. Oxford: Oxford University Press, 1978.

Deacon, S. "The Distribution of Roman Coins in the West Midlands: A Regional Analysis." In *Clash of Cultures? the Romano-British Period in the West Midlands*, edited by R. White and M. Hodder, 174–186. Oxford: Oxbow Books, 2018.

English Heritage. *Exploring Our Past: Strategies for the Archaeology of England*. London: English Heritage, 1991.

Esmonde Cleary, S. "The Romano-British Period: An Assessment." In *The Archaeology of the West Midlands. A Framework for Research*, edited by S. Watt, 127–147. Oxford: Oxbow Books, 2011.

Fairclough, G., ed. *Historic Landscape Characterisation: The State of the Art*. London: English Heritage, 1999.

Fox, C. *The Personality of Britain: Its Influence on the Inhabitant and Invader in Prehistoric and Early Historic Times*. Cardiff: National Museum of Wales, 1952.

Fox, C. *Offa's Dyke*. London: The British Academy, 1955.

Fulford, M. "The Impact of Commercial Archaeology on the UK Heritage." In *History for the Taking? Perspectives on Material Heritage*, edited by J. Curtis, M. Fulford, A. Harding, and F. Reynolds, 33–53. London: British Academy, 2011.

Fulford, M., and N. Holbrook. "Assessing the Contribution of Commercial Archaeology to the Study of the Roman Period in England, 1990–2004." *Antiquaries Journal* 91 (2011): 323–345.

Gale, F. 2003. "East and Northeast Wales – Later Prehistoric." *Research Framework for the Archaeology of Wales*. Accessed February 14, 2020. https://www.archaeoleg.org.uk/pdf/bronzeandiron/REGIONAL%20SEMINAR%20NE%20WALES%20LATER%20BRONZE%20AGE%20AND%20IRON%20AGE.pdf

Gilmour, S., and E. J. O'Riordan. "Enhancing Understanding: The Future of Research Frameworks in Scotland." *The Archaeologist* 100 (2017): 5–6.

Glazebrook, J., ed. "Research and Archaeology: A Framework for the Eastern Counties 1. Resource Assessment." *East Anglian Archaeology Occasional Papers 3*, 1997.

Greig, J. *Priorities in Neolithic and Bronze Age Environmental Archaeology in the West Midlands Region*. Birmingham: West Midlands Regional Research Framework, 2002. Accessed February 14, 2020. https://archaeologydataservice.ac.uk/archives/view/wmrrf_he_2016/downloads.cfm?part=papers&group=401.

Grove, J., and B. Croft. *The Archaeology of South West England. South West Archaeological Research Framework Research Strategy 2012–2017*. Taunton: Somerset County Council, 2012.

Guilbert, G. "Historical Excavation and Survey of Hillforts in Wales: Some Critical Issues." *Internet Archaeology* 48 (2018). doi:10.11141/ia.48.3.

Hardy, S. A. "Quantitative Analysis of Open-source Data on Metal Detecting for Cultural Property: Estimation of the Scale and Intensity of Metal Detecting and the Quantity of Metal-detected Cultural Goods." *Cogent Social Sciences* 3, no. 1 (2017). doi:10.1080/23311886.2017.1298397.

Hawkes, C., and S. Piggott. *A Survey and Policy of Field Research in the Archaeology of Great Britain*. London: Council for British Archaeology, 1948.

James, S., and M. Millett, eds. *Britons and Romans: Advancing an Archaeological Agenda*. CBA Research Report 125. York: Council for British Archaeology, 2001.

Lieberman, M. "The Medieval 'Marches' of Normandy and Wales." *English Historical Review* 75, no. 517 (2010): 1357–1381.

Lightfoot, K., and A. Martinez. "Frontiers and Boundaries in Archaeological Perspective." *Annual Review of Anthropology* 24 (1995): 471–492.

Mann, B. "Developing Regional Research Frameworks – Is It Worth It?" *The Archaeologist* 91 (2012): 8–10.

Martin Ramos, C. "Review of Westward on the High-Hilled Plains. The Later Prehistory of the West Midlands." *Papers from the Institute of Archaeology* 27, no. 1 (2017).

Marvell, A. "Wales: Can Southport Come to Swansea?" *The Archaeologist* 83 (2012): 10.

Medlycott, M., ed. "Research and Archaeology Revisited: A Revised Framework for the East of England." *East Anglian Archaeology Occasional Papers* 24, 2011.

Mullin, D. "Towards an Archaeology of Borders and Borderlands." In *Places in Between: The Archaeology of Social, Cultural and Geographical Borders and Borderlands*, edited by D. Mullin, 99–104. Oxford: Oxbow Books, 2011.

Mullin, D. *A Landscape of Borders: The Prehistory of the Anglo-Welsh Borderland*. BAR (British Series) 572. Oxford: British Archaeological Reports, 2012.

Murray, J. C. "The Scottish Burgh Survey: A Review." *Proceedings of the Society of Antiquaries of Scotland* 113 (1983): 1–10.

Myers, A. 2017. "North West Regional Research Framework: Prehistory Resource Assessment Update." *Council for British Archaeology North West*. Accessed February 14, 2020. https://archaeologynorthwest.files.wordpress.com/2017/12/nwrrf_prehistoryupdate2017.pdf

Naum, M. "Re-emerging Frontiers: Postcolonial Theory and Historical Archaeology of Borderlands." *Journal of Archaeological Method and Theory* 17, no. 2 (2010): 101–131.

Newman, D. "Borders and Bordering: Towards an Interdisciplinary Dialogue." *European Journal of Social Theory* 9, no. 2 (2006): 171–186.

Olivier, A. *Frameworks for Our Past: A Review of Research Frameworks, Strategies and Perceptions*. London: English Heritage, 1996.

Pannett, A. 2007. "Final Refresh of the Research Agenda for the Neolithic and Earlier Bronze Age." *Research Framework for the Archaeology of Wales*. Accessed February 14, 2020. https://www.archaeoleg.org.uk/pdf/review2017/neolithicreview2017.pdf

Pearson, L. *Cows, Beans and View: Landscape and Farming of the West Midlands in Later Prehistory*. Birmingham: West Midlands Regional Research Framework, 2002. Accessed February 14, 2020. https://archaeologydataservice.ac.uk/archiveDS/archiveDownload?t=arch-2285-1/dissemination/pdf/West_Midlands_Regional_Research_Framework_Late_Prehistoric/LizPearson_LandscapeandFarming.pdf.

Pearson, L. *Environmental Archaeology in the West-Midlands in the Early Post-Medieval Period*. Birmingham: West Midlands Regional Research Framework, 2003. Accessed February 14, 2020. https://archaeologydataservice.ac.uk/archiveDS/archiveDownload?t=arch-2285-1/dissemination/pdf/West_Midlands_Regional_Research_Framework_Early_Post_Medieval/LizPearson_Environmental.pdf.

Perring, D. *Town and Country in England: Frameworks for Archaeological Research*. CBA Research Report 134. York: Council for British Archaeology, 2003.

Radu, C. "Beyond Border-'dwelling': Temporalizing the Border-space through Events." *Anthropological Theory* 10, no. 4 (2010): 409–433.

Rains, M., and D. W. Hall, eds. *Excavations in St Andrews 1980–89: A Decade of Archaeology*. Perth: Tayside and Fife Archaeological Committee, 1997.

Ransley, J., F. Sturt, J. Dix, J. Adams, and L. Blue. *People and the Sea: A Maritime Archaeological Research Agenda for England.* CBA Research Report 171. York: Council for British Archaeology, 2013.
Ray, K. *The Romano-British Period in Herefordshire.* Birmingham: West Midlands Regional Research Framework, 2002. Accessed February 14, 2020. https://archaeologydataservice.ac.uk/archiveDS/archiveDownload?t=arch-2285-1/dissemination/pdf/West_Midlands_Regional_Research_Framework_Roman/KeithRay_Herefordshire.pdf.
Ray, K., and I. Bapty. *Offa's Dyke.* Oxford: Oxbow Books, 2014.
RIA. *Archaeology 2025: Strategic Pathways for Archaeology in Ireland.* Dublin: Royal Irish Academy, 2016.
Ritchie, M. "A Brief Introduction to Iron Age Settlement in Wales." *Internet Archaeology* 48 (2018). doi:10.11141/ia.48.2.
Rumford, C. "Introduction – Theorizing Borders." *European Journal of Social Theory* 9, no. 2 (2006): 155–169.
Southport Group. *Realising the Benefits of Planning-led Investigation into the Historic Environment: A Framework for Delivery.* Reading: Institute for Archaeologists, 2011.
Stanford, S. C. *The Archaeology of the Welsh Marches.* London: Collins, 1980.
Stefánsdóttir, A. "An Introduction to Development-led Archaeology in Europe: Meeting the Needs of Archaeologists, Developers and the Public." *Internet Archaeology* 51 (2019). doi:10.11141/ia.51.9.
Stephenson, D. *Medieval Powys. Kingdom, Principality and Lordships, 1132–1293.* Woodbridge: Boydell and Brewer, 2016.
Tait, P. *Review of Research Frameworks for the Historic Environment Sector in England.* Report for English Heritage. Harrogate: Pye Tait Consulting, 2014.
Thomas, R. M. "Mapping the Towns: English Heritage's Urban Survey and Characterisation Programme." *Landscapes* 7, no. 1 (2006): 68–92.
Walker, E., M. Bates, M. Bell, I. Brooks, A. Caseldine, A. David, R. Dinnis, et al. 2017. "Refresh of the Welsh Research Agenda for Palaeolithic and Mesolithic Archaeology." *Research Framework for the Archaeology of Wales.* Accessed February 14, 2020. https://www.archaeoleg.org.uk/pdf/review2017/palaeolithicreview2017.pdf
Watt, S., ed. *The Archaeology of the West Midlands: A Framework for Research.* Oxford: Oxbow Books, 2011.
Webster, C. J., ed. *The Archaeology of South West England. South West Archaeological Research Framework: Resource Assessment and Research Agenda.* Taunton: Somerset County Council, 2007.
White, P. "Towards a Strategy." *Research Framework for the Archaeology of Wales Supplementary Paper*, 2004. Accessed February 14, 2020. https://www.archaeoleg.org.uk/pdf/Towards%20a%20Strategy.pdf
White, R. *Britannia Prima.* Stroud: Tempus, 2007.
Williams, B. "Archaeology in Northern Ireland." *The Archaeologist* 76 (2010): 14–15.
Woolf, A. "A Dialogue of the Deaf and the Dumb: Archaeology, History and Philology." In *Approaching Interdisciplinarity: Archaeology, History and the Study of Early Medieval Britain, C.400–1100*, edited by Z. L. Devlin and C. N. J. Holas-Clark, 10–23. BAR (British Series 486). Oxford: Archaeopress, 2009.
Ylimaunu, T., S. Lakomäki, T. Kallio-Seppä, R. P. Mullins, R. Nurmi, and M. Kuorilehto. "Borderlands as Spaces: Creating Third Spaces and Fractured Landscapes in Medieval Northern Finland." *Journal of Social Archaeology* 14, no. 2 (2014): 244–267.

Archaeology, Conservation and Enhancement: The Role of Viability in the UK Planning System

Dan Phillips

ABSTRACT

In England, since the publication of the 2012 National Planning Policy Framework, viability has taken an elevated role in the planning process with economic viability becoming an important consideration in the determination of a planning application. In this paper, the author introduces viability as a relatively new formal assessment brought into the UK planning system and explores ways in which it may impact existing provisions in place to protect the historic environment. The article highlights the complexities of adopting the Viability Assessment model and provides cases in which these assessments have been used to mitigate planning obligations in place to conserve and enhance the historic environment. In light of the current application of viability models during the planning process by developers, the author calls on the need for more research in this area as well as the need for further awareness of its use by those working to conserve and enhance the historic environment. Ultimately, the article aims to set Viability Assessment against the broader principles of sustainable development and recommends perusing the concept of a Cultural Capital Valuation for UK heritage.

Introduction

In October 2018 the conference *Engaging with Policy in the UK: Responding to Changes in Planning, Heritage and the Arts* was hosted by Rescue and the AHRC Heritage Priority Area team. It was intended to address issues of engagement related to changing UK policy with the potential to impact the historic environment, as well as addressing the need to seek agreement with other sectors equally affected by changes to 'seemingly disconnected' policy.[1] The resulting cross-sectoral discussion provided the opportunity for Rescue to explore the subject of Viability and its role in planning policy, and how it may impact on the practice of archeology. Rescue – the British Archeological Trust – since its inception in 1971, has endeavoured to highlight shortcomings in policy and practice when handling the protection of the historic environment. In this paper, I address viability as a relatively new assessment brought into the UK planning system and explore ways in which it may impact on provisions already in place to protect the historic environment. I also address the use of viability modelling in the planning system, its economic implications, and the

Viability Assessment process, emphasising the importance of recognising viability as an increasing concern to the historic environment profession.

Legislative Protection of the Historic Environment

The historic environment in England and Wales is well protected under statutory law,[2] yet protection continues to be a controversial issue in the context of development, land use, and the availability of funding. In current practice a planning authority is bound by statute and the policy framework set by government guidance, presently the NPPF, current Development Plan Policy and other material considerations. This legislative protection makes it a criminal offence to intentionally damage or harm some heritage assets, or indeed to proceed with unauthorised development. Historic England's 2012 Final Report on *The extent of crime and anti-social behaviour facing designated heritage assets*[3] suggests that in terms of planning breaches, characterised as unauthorised development, there were 1,858 cases of reported crime. This is the second highest category in terms of heritage crime, falling behind the catch-all 'criminal damage misc'. The report notes that there is a 'significant degree of uncertainty as to the scale of unauthorised development' due to 'policy differences between authorities over prosecutions and issuing of Listed Building Enforcement Notices'.[4] In some instances authorisation may be given to demolish or modify heritage assets, as planning officers exercise their judgment in assessing 'the balance of harm against public benefits, including employment, the provision of housing, heritage gains and new public realm',[5] as well as viability when determining a development's optimum viable use.

Viability in Planning & Practice

Viability in the 2012 National Planning Policy Framework

'Since the publication of the National Planning Policy Framework (NPPF), viability has taken an elevated role in the planning process, both at the plan making and planning decision stages.'[6] Essentially, development viability, in which the economic viability of a development became 'an important consideration in the planning system, both in terms of plan-making and when determining planning applications',[7] can now be used to determine planning applications. Various boroughs across London have produced *Development Viability Supplementary Planning Guidance* (SPG) to explain how policies are applied in relation to development viability, and to 'set out how the council will consider viability in accordance with the National Planning Policy Framework, whilst ensuring that the principles of sustainable development (Figure 1) form the basis of planning decisions'.[8] Their aim is to 'make the viability process more consistent and transparent'.[9]

To ensure viability and deliverability, the 2012 NPPF stated that (my emphasis):[10]

> ... the sites and scale of *development identified in the plan should not be subject to such a scale of obligations and policy burdens that their ability to be developed viably is threatened*. To ensure viability, the costs of any requirements likely to be applied to development, such as requirements for affordable housing, standards, infrastructure contributions or other requirements should, when taking account of the normal cost of development and mitigation,

Figure 1. The domains of sustainable development. (Image: http://www.vidasostenible.org).

> *provide competitive returns* to a willing land owner and willing developer to enable the development to be deliverable.
>
> *The cumulative impacts of standards, obligations and requirements* have to be tested to ensure that they do not put implementation of a development plan at serious risk, and *they should facilitate development throughout the economic cycle.*

Following the publication of the NPPF, several London boroughs and county councils across England revisited their targets to ensure that plans were deliverable.

Sir John Harman, former Chairman of the Environment Agency (2000–2008) in the report on *Viability Testing Local Plans* highlights:

> This important policy document [NPPF] calls for balance between sustainable development which benefits the local community, and realistic returns for land owners and developers such that development is commercially viable.[11]

It is argued that financial viability now takes precedence over sustainable development:

> Sustainable development, though still given prominence in the NPPF, is in practice now subordinated to financial viability. This was informally the case before the NPPF but has now been formalised and given legislative force.[12]

The 2012 NPPF, amalgamated a wealth of planning policy statements and guidance, and was the framework that moved the viability model forward as a material consideration, and placed it at the center of decision-making in the planning process.[13] Since then we have seen the complexity of viability unfold. With Government's increasing reliance on the private sector to achieve developmental objectives, formal planning has been heavily influenced by one driving factor, market forces. Thus, set against the backdrop of an increasingly globalised world operating in a free-market economy, planning had moved towards focusing on economic priorities over the sustainability domains of societal, cultural or environmental needs. More importantly, those economic aspects are prominent in viability assessments. Perhaps inevitably there are conflicting interests between domains (Figure 2), and often mutual exclusivity, which leads to the question of *viability for whom* and *viable for which domain?* Viability, whether a material consideration or not, has always been recognised in

Figure 2. Ensuring viability. While in theory the aim is to achieve the 'Goal' and balance human demand with innovation/technological feasibility, in practice financial viability gets prioritised. Source: www.interation-design.org.

planning in some form or another, the point now is that since 2012, Viability Assessment (VA) has become formalised and largely determined by profits and costs.[14]

Now a recognised model and test for local plans and for decision making, we have seen a prioritisation of financial costs above all other competing interests on space and land.[15] It is potentially such a divisive approach that planners and scholars alike have questioned and criticised the threat to wider public benefits due to VAs, with the conservation and enhancement of the historic environment being no exception.[16]

The guidance document to the NPPF, the *National Planning Practice Guidance (PPG)*, set out how viability should function in relation to plan making, supporting the concept of prioritising economic interests above others.[17] While the guidance suggested that 'viability assessment should not compromise sustainable development', it states that it 'should be used to ensure that policies are realistic'. The 2012 NPPF itself had stated that:

> Pursuing sustainable development requires careful attention to viability and costs in plan-making and decision-taking. Plans should be deliverable. Therefore, the sites and scale of development identified in the plan should not be subject to such a scale of obligations and policy burdens that their ability to be developed viably is threatened. To ensure viability, the costs of any requirements likely to be applied to development, such as requirements for affordable housing, standards, infrastructure contributions or other requirements should, when taking account of the normal cost of development and mitigation, provide competitive returns to a willing land owner and willing developers to enable the development to be deliverable.[18]

The NPPG on Viability further emphasised how:

> In these cases, decisions must be underpinned by an understanding of viability, ensuring realistic decisions are made to support development and promote economic growth. Where the viability of a development is in question, local planning authorities should look to be flexible in applying policy requirements wherever possible.[19]

While the viability test policy could be argued as a major new step within planning,[20] discouraging local authorities from preventing developers' right to profit from their

development investments, critics of the policy suggest it has actually resulted in developers being equipped to challenge planning conditions and obligations imposed on them. As such, the benefits to the wider public have suffered.

In practice viability assessments as set out in the 2012 NPPF, have meant that during the decision-making process any given development should be financially viable to the applicant.

The 2019 Revision of the NPPF, Viability, and Sustainability

The 2012 NPPF's three main targets were intended to streamline previous planning policy statements and guidance to improve efficiency, facilitating house-building, and progressing with sustainable development (SD).[21] Sustainability was now central to many of the Government's agendas, with the UK alongside 192 other states signatories to the *UN 2030 Agenda for Sustainable Development*. But how to embed polices supportive of sustainable development into practice is proving difficult.[22] The 2019 revision of the NPPF appears to move further from balancing the three core domains of sustainability, economy, environment, and society by removing the previous ministerial Foreword. This had explicitly supported sustainable development and placed people and the environment central to planning. The revision, while still supportive of enhancing and protecting both the natural and historic environment, has new subtle additions which favour development over conservation, and continues to add weight to financial viability.[23]

However it should be noted that focus within the revised NPPF has now moved from Viability Assessments at the decision-making stage to the earlier plan-making stage, in that viability is no longer to be considered as a material consideration in determining planning applications.[24] Indeed, although the revised NPPF has sought to play down Viability Assessment, anecdotally planners suggest that viability assessments are still used and requested for planning applications. Viability assessment within planning is still of significant concern and has led to the Royal Institute for Chartered Surveyors publication of guidance in May 2019 on *Financial Viability in Planning*. The guidance sets out the 'mandatory requirements that inform the practitioner on what must be included within financial viability assessments' due to 'dissatisfaction' among stakeholders about the standards to which viability assessments are being produced.[25] In practice, while VAs are no longer a material consideration, they are still in use within planning and can still be used to reduce planning conditions.

Viability Assessment

Viability Assessment is the process by which to determine whether or not a proposed development is financially achievable for both the developer and landowner, when applications involve planning obligations,[26] such as a requirement for social housing. The equation below (Figure 3) sets out the means to determine the economic viability of a proposed scheme by calculating the Residual Land Value (RLV).

The equation calculates whether the final development is profitable or not through the Residual Land Value. First, the total Direct Costs (DC) are calculated. This includes the cost of land purchase, construction costs and planning obligations. This is added to the Direct Profit (DP, or estimated profit) of both the developer and the landowner. Then, the total Direct Revenue (DR) or gross turnover, from the sale of the development, is calculated.

$$RLV = DR - (DC+DP)$$

$$RLV < TLV = \text{unviable}; RLV > TLV = \text{viable}$$

Figure 3. Equation for financial viability.

The Direct Costs plus Direct Profits are then subtracted from the Direct Revenue, leaving a net figure. This is the Residual Land Value (RLV), which is the critical value sought in the equation. The RLV is set against a benchmark figure known as the Threshold Land Value (TLV), an estimated value of the land under its current usage plus any uplift for the landowner. If the RLV is at a level below the TLV, then the proposed development can be considered as financially *unviable*.[27]

An unviable development, however, does not necessarily mean development will not go ahead, rather that in its current shape the proposal would not be implemented. Often in these circumstances a developer will seek to reduce costs through variations to expensive consent conditions. Reductions in planning obligations are an evident target, which can reduce the Direct Costs and increase the potential of financial viability (Figure 4). As discussed above, with the revision of the NPPF in 2019 and subsequent Government guidance favouring financial viability, it is now formally part of the policy process that planning obligations be compromised.[28] Despite the principle objective of planning obligations to benefit society and communities, the removal of such planning conditions is contradictory to keeping people central to planning as well as the ideology behind sustainable development. It is a situation which has led many interest groups and amenity societies, as well as the RICS and some local planning authorities involved in the protection and conservation of the natural and historic environment to question who benefits from planning conditions?

Despite the objective of VAs being impartial and balanced, in practice their use raises a number of concerns. Viability Assessment are based on estimations, known as input values, and aim to consider complexities that become 'saturated with intrinsic uncertainty'.[30] However research suggests that, while VAs are not entirely without merit, they do deal with extremely complex and uncertain measurements and as a result may not be the most appropriate model for delivering planning obligations and planning gain.[31] More importantly the equation completely overlooks the qualitative benefits of planning to communities in its promotion of a financial assessment (Figure 2).

A further concern is related to reasonable returns, and the Threshold Land Value, which lies at the heart of the Viability Assessment:[32] with no defined level of uplift, an estimation of TLV becomes extremely problematic and unquantifiable.

It is also noteworthy that Viability Assessments are produced *by* developers which is seen by some as a clear opportunity to manipulate figures in a developer's interests. The resulting removal of planning obligations can lead to increased profits despite apparently increased costs. As MacAllister has argued, although it is not a developer's task to implement policy, underfunded Local Planning Authorities, rarely have adequate resources to test the veracity of viability assessments, a task which requires specialist input.[33] Most development generates an average return of 12–15%, but in viability modelling margins can be set at a high-end return of 20%.[34] The outcome of such tactics will result in Residual Land Value shrinkage. Further, uncertainty in the TLV, including

DEVELOPMENT VIABILITY APPRAISAL TEMPLATE EXAMPLE

SITE DETAILS

Date of appraisal	January 1st 2017
Developer name and address	Name, address
Developer contact details	Lead officer name, telephone number, e-mail address
Development description	Description (e.g. 5 detached residential units)
Development location	Site address, co-ordinates
Size of development area	Hectares
Total Development Period including securing planning permission.	9 months
When construction starts	Month 4
Construction period	5 months
Sale start period	Month 2

REVENUE

Development Variable	Quantity of development	Income	Notes
Detached units	4 bedroom units x 5	£1,000,000	Anticipated sale value of completed houses. Values are based on comparable evidence from sales in (location) and built by (developer name).
TOTAL		£1,000,000	

DEVELOPMENT COSTS

Development Variable	Further information	Expenditure	Notes
Site cost		£500,000	
Stamp Duty	3.5% interest	£17,500	
Agency Fees	1.25% interest	£6,250	
Legal Fees	0.75% interest	£3,750	
TOTAL		£527,500	
Planning fees		£2000	Standard fees apply
Site investigation works		£2000	This can include Supplier and specialist contractors quotes e.g. contamination
Archaeological mediation works		£1500	This would be for detailed mediation works required and the relevant quotes
Marketing assessment		£2500	This may be necessary depending on the size of the development. Objective assessment of the housing market in the region and relevant quote.
Developer Contributions			Developer Contribution policy and supplementary guidance apply
	Affordable Housing	£25,000	Commuted Sum
	Open space	£7,500	
	Education	£30,000	Nursery, Primary and Secondary School contribution requirement per dwelling
TOTAL		£70,500	
Groundworks		£20,000	
Construction costs including labour		£200,000	This should be broken down to include the detail and costings of the substructure and superstructure, internal finishes, fittings, equipment and services etc.
Infrastructure		£80,000	This should be broken down to include the detail and costings of infrastructure services such as site works, consents, energy suppliers etc.
Contingency allowance	2% interest	£5,400	
Professional Fees	7% interest	£18,900	
TOTAL		£324,300	
Marketing of development		£20,000	This could include advertisement of the development.
House sale legal fees		£5,000	
TOTAL		£25,000	
OVERALL TOTAL		£947,300	

SUMMARY

Revenue	£1,000,000
Development Costs	£947,300
Target Profit %	17.5%
Profit / Loss	Profit of £52,700 (5.27%)

Figure 4. Example template for development viability appraisal. Note the section on 'archaeological mediation works'.[29]

landowner returns, can result in this figure being inflated narrowing the gap between TLV and RLV to the point where TLV is higher than RLV. The result is a development with planning obligations attached which is undeliverable.

Two case studies illustrate this situation. The first example took place in 2012, when the development of 2,760 houses with the provision for a medical center, a community building and a large supermarket received planning permission in Kempston, Bedfordshire.[35] In 2014 the developer was able to successfully argue that the project would have a £10 million deficit and as such was undeliverable. As a result, the planning obligations under the Section 106 agreement were relaxed and neither the medical center nor community building were built, with the supermarket being reduced in size. Since the original proposal was advocated by the developer on the basis and promise of these wider community benefits, new local residents were left feeling short-changed as the development's wider community contributions were cut.[36]

The second example is the Parkes Hotel development in central London, which was subject to appeal in 2009.[37] The developer was able to argue successfully that the project was financially undeliverable should any planning obligations be applied.[38] The case went to appeal, where the developer's team of experts proposed that the development was being undertaken at a financial loss as part of a strategy to generate profit over the long term. In using VA modelling, the developer was able to clearly demonstrate a loss in excess of £7 million, without any social housing. In contrast, the Council's own calculations, suggested that without social housing the Residual Land Value from the development would reach £12 million in surplus.[39]

What these two cases clearly demonstrate is the potential for contradictory outcomes using the VA model, as well as the complexity and intrinsic uncertainties surrounding valuations of individual costs or inputs. The examples also show how obligations or proposals which relate to societal benefits and public services can be removed should financial viability be called into question.

Further, review of planning appeals in England has revealed a large number of cases related to Viability Assessment, some of which are directly related to the historic environment.[40] Many of these cases are in relation to listed buildings or Conservation Areas, which have statutory protection under The Planning (Listed Buildings and Conservations Areas) Act 1990. Viability Assessment here has typically been used to argue that the renovation of listed buildings or buildings within a Conservation Area is economically unviable and that instead demolition is the only reasonable alternative.

This was the situation in the case of Linwood Park Ltd developers of Radcliffe Court, 51 Manor Road, Bournemouth (CO/1987/2015),[41] where planning consent was granted, by Bournemouth Borough Council on 9 March 2015, for demolition of the existing Victorian building and replacement with a new building. The site lay within the East Cliff Conservation Area and the original 2009 planning consent had approved the renovation and retention of the building rather than its demolition. The developer proceeded to challenge the 2009 consent by undertaking a Viability Assessment in which their surveyors, Tangent Chartered Surveyors, found that 'refurbishment was not considered to be a viable proposition due to the condition of the building and the inefficient use of space verses return.'[42] The developer then submitted a new application for demolition supported by its own Viability Assessment. Advice was sought from English Heritage who advised that 'the proposed development in the application would further erode the

special character of the conservation area'.[43] English Heritage was not convinced that the demolition of Radcliffe Court was necessary. Further, advice from the Council's own Heritage Officer supported their conclusions. Based upon the findings of the District Valuation Service (who are used in such instances), the Council concluded that having regard to land and sale values, the developer would suffer a major loss and that the 2009 scheme was therefore not viable. The Council concluded that under paragraph 133 of the NPPF (2012) demolition was justified and so gave planning consent.

Further cases have involved the use of viability to negate Conservation Area protection (e.g. Ulster Architectural Heritage Society V Belfast City Council Planning Department in 2014)[44] and the requirement for Environmental Impact Assessments (e.g. Save Britain's Heritage V Secretary of State for Communities and Local Government in 2012).[45]

Whilst the above examples demonstrate the usage of VA in challenging planning obligations connected with easily identifiable above-ground heritage assets such as listed buildings or Conservation Areas, there is little evidence of the effect on less visible below-ground heritage assets, which are also managed through planning obligations. Information on VA's directly affecting the practice of archeology is scarce. However, precedence has been set and conventional archeological practice is not immune.[46]

The recent development of *Land South of Bray Lake and East of Court Close, Windsor Road, Maidenhead*[47] by the charity Thames Hospice provides a dramatic insight of how conventional archeological practice embedded within the planning framework can be compromised on economic grounds. The construction of a new 28-bedroom hospice, outpatient unit, education center and associated works was granted planning consent by Berkshire County Council in March 2018, subject to a standard archeological condition.[48] Condition 23 of the Council's decision notice read:

> Prior to the commencement of development, including site preparation works, the applicant shall implement a programme of archaeological field evaluation in accordance with a written scheme of investigation, which has first been submitted by the applicant and approved in writing by the Local Planning Authority. The results of the evaluation shall inform the preparation of a mitigation strategy which will be submitted by the applicant and approved in writing by the Local Planning Authority prior to the commencement of the development. The mitigation strategy shall be implemented in accordance with the approved details.
>
> **Reason**: The site is within an area of archaeological potential, as noted on the Berkshire Historic Environment Record. A programme of works is required to mitigate the impact of the development and ensure preservation by record of any surviving remains. Relevant Policies – Paragraph 114 of the NPPF and Local Plan policies ARCH2 and ARCH4.[49]

This standardised text advised by the Council's archeological advisor is familiar to any commercial archeological contractor. Equally so are the reasons behind the proposed archeological condition. In this case the Council Archeological Advisor opted for a measured staged approach in dealing with buried heritage assets.

As required by the condition, investigation was undertaken by means of archeological evaluation in January 2018. The results of which identified buried archeological remains from the prehistoric period, which included pottery and worked flint. These initial findings led the Council Archeologist to advise that the most sensitive portion of the site, which lay

directly under the footprint of the proposed development, should have further archeological investigation to mitigate any potential loss or damage caused by the development.

At this point Thames Hospice decided to challenge the archeological condition in its entirety using financial viability as their key argument. They argued that the cost of any further archeological work, estimated at approximately £30,000, could not be justified in a project which had an estimated total value of approximately £7 million. The charity felt 'unable to justify to its patrons the additional expenditure required for further archaeological investigations'.[50] They appealed to Berkshire County Council to have the condition removed citing the considerable public benefits the project would bring to the community and justified this through sections of the NPPF and other policies. The Council agreed with the applicant and removed the archeological condition. Whilst Thames Hospice did not appear to undertake a formal VA, they nonetheless demonstrated the unviability of their project should any further archeological work be undertaken. The conclusion in their supporting statement sets a dangerous precedent:

> Unlike many other building applications, the funds to build this new facility will come entirely from our supporters in the form of voluntary donations and as such we need to be able to justify every penny we spend. We consider this to be an unacceptable financial cost which will have no impact on the care we offer to our patients and their loved ones and hope the committee support our view.[51]

The examples presented here serve to highlight the importance of considering Viability Assessment to understand the complexities of conservation practice and the protection of the historic environment within the planning system. It has also demonstrated that while the success of VA in mitigating planning obligations is not guaranteed, the evidence shows that it has become part of the developer's 'toolkit' to challenge conditions. More rigorous and in-depth research is needed covering planning appeals using viability over the past six years.

Archeology at Risk: Viability in Development-led Archeology

Within the parameters of planning policy, development can provide the opportunity, or platform, for beneficial growth in a many areas of society, now more generally financed by the private sector.[52] Embedded within this opportunity is the question of whether or not the project or proposal is viable. Indeed, the concept of viability has always played a part in any development process, whether seen from the government's perspective or that of a developer. It has, however, prior to its recent introduction into the planning process, only played a role in the background,[53] though anybody responsible for development or involved in land use planning has tended to weigh in the balance the cost of societal benefits and objectives against costs and revenue. Factors, such as reputational branding, tax incentives and other socio-political value systems can also play a part in a developer's assessment of viable.

In today's development-led archeology, it could be fair to say the sector is – consciously or unconsciously- *involved* in the issue of viability, in particular financial viability, as actors rather than observers in the planning process. The 2011 *Southport Report*, organised by the Southport Group of archeologists, acknowledged that 'pre-planning costs and viability tests, including market tests, could increase significantly at a time when

the business environment is massively unsympathetic'.[54] What the report highlights is that the outcome of archeology's transition into the planning system is not only a material consideration in decision making but a financial cost.

Today the demand for archeologists is at its highest level ever, but as planning obligations are criticised as being too costly for developers, the archeology sector needs to seriously consider at what point obligations in the planning system can be compromised in the name of financial viability. It might also be worth highlighting an observation that prior to the landmark 1990 *Planning Policy Guidance 16: Archeology and Planning* (PPG 16), archeology was very much driven by the principle of 'rescue' rather than compliance. Motivations were not necessarily based on whether an archeological project was viable or not, whereas within today's commercial archeology sector costs and viability play a major role in decision-making.

Benefits of Archeology as a Planning Consideration

Whilst the above section has highlighted the domain in which commercially-led archeological practice operates and its relationship with viability, the principle function of archeology within the planning system is meant to be for the wider public benefit.[55] It is not simply a matter of meeting a planning obligation for its own sake. The reason such conditions are in place in the first instance is fundamentally to identify and record both known and unknown heritage that may be lost in the course of development and the information that may be gained from this process for the benefit of society and future generations.

It is beyond the scope of this paper to continue the ongoing discussion of what commercial archeology is for and why we do it, a subject of intense debate in archeological circles. However, the growth of archeology within the planning system has focussed attention on public participation and outreach, all of which contributes to the wider benefits of archeology in society. Whilst progress may have been slow in realising these wider benefits, there is now clear drive to promote such agendas. However, viability still remains an obstacle to achieving this broader goal in the practice of archeology. Indeed, a 2017 survey by the Association of Local Government Archeological Officers, looking into public outreach within planning found that of 60 respondents, only 16 said they always required public outreach as part of their conditions.[56] It has been argued that archeology contractors feel they are unable to do the archeology justice, as they face time and cost pressures – that is, their work is predominately assessed as to whether it is financially viable.[57]

Archeological Costs and Viability Assessment

Viability Assessment and its validation is now well established in policy, with the potential to reduce or remove planning obligations. It is a situation with which the archeology sector needs to engage; to understand how archeology practiced under compliance may be challenged as it is evident that both the natural and historic environments, are under severe threat.[58] It is also evident that within planning policy, protecting and enhancing these environments are often low on the list of priorities, with obligations such as affordable housing being a key governmental target.[59]

To ensure that that archeology remains a planning consideration places considerable pressure on the need to emphasise public benefit. The profession needs to be aware of how development operates, how viability may be used to challenge planning obligations as well as how viability is calculated and presented to local authorities. To emphasise this, the *2014 Affordable Housing Viability Assessment Procedures* produced by Neath Port Talbot County Borough Council, used to assist with Viability Assessments, has clearly advised archeology should be included in VA calculations to determine viability:[60]

> The applicant will be required to provide site specific evidence (reported cost estimates or invoices) for site infrastructure costs/external works. These costs may include demolition; ecological, geotechnical, archaeological and other site investigations (including those undertaken before site purchase or for planning).

Many archeologists have worked with enthusiastic developers who are keen to collaborate and work together, many too have also experienced what it is like to not be wanted on site, working under severe time and cost restraints. In some instances, developers simply have no interest to engage with archeology beyond satisfying a planning obligation.[61] If we are to consider the long-term implications of viability assessment, the profession needs to acknowledge that an increasing use of viability modelling in financial terms alone approach will compromise the many public benefits that accrue from archeology as a planning obligation. Our sector has yet to explore how we may work more effectively towards a Cultural Capital Valuation, a concept familiar since Bourdieu's work in the 1970s. The risk is that the present model of viability assessment, justifying public benefits in economic terms alone, places to great an emphasis on financial gain. The key issue is ensuring that environmental and social viability is integrated into the VA equation.

Concluding Thoughts

Viability has long been a consideration in planning policy and implementation, but present-day emphasis on financial viability alone to determine value threatens established social and public benefits. This paper has highlighted the financial viability process and the complexities associated such models in determining the viability of a development. The weakness in the established viability equation, its validity, rigidity, financial bias, and acknowledged variables in determining input/output costs can allow it to be self-serving and consequently jeopardise community-centered objectives in local, regional and national development. Today the historic environment sector cannot avoid the emphasis placed on financial value and profit margins in determining viability, yet this places even greater emphasis on the need to quantify the public benefits of cultural heritage. Of course the work of publications such as Historic England's *Heritage Counts* has taken us a long way, but more work must be done on how to develop a Cultural Capital Valuation which will not inappropriately monetise culture to the detriment of its wider benefits. While the impact of financial viability as a general theme needs to be explored further within the context of planning-led archaeology, this paper has highlighted the potential use of VA to mitigate planning obligations and calls for further research to quantify the threat and to explore the use of VA in the context of the historic

environment. This is an important area in the wider study of the impact of planning policy and practice as a whole on the archeological resource and professional practice.

If the unintended consequence of VA is that it enables the reduction, or even removal, of planning obligations, the sector needs to be aware of developers who endeavour to use this mechanism as a loophole to avoid difficult to quantify public benefits. It can, and has, been argued that Viability Assessments can provide structured and sensible approaches to development costs, but its weakness and threat to the historic environment sector is that it is entirely focused on profits and can be (mis)used by those who overlook community values. It fails to take qualitative social and environmental interests into account, despite their inclusion as two of the three domains for achieving sustainable development.

The role of planning must remain beyond private interests, as decades of planning legislation has shown us, and benefit society as a whole. With this in mind, it is essential that environmental organisations as well as local authorities understand the viability concept and Viability Assessments. There is no doubt that Viability Assessments can result in the removal of planning obligations which may be valuable and fundamentally important considerations for the public. If developers continuously argue against building, for example, community infrastructure or social housing, or argue for the destruction of the historic environment on the basis of profits alone, the risk is not only the loss of unrecoverable data but the public benefits which accrue to the historic environment.

The 'successful implementation of the NPPF is entirely reliant on the skills, competence and resources in local government and the development community'.[62] While today local authorities struggle to retain the skills, competence and resources to undertake specialist viability assessment, the current model of measuring viability can easily benefit the few over the many, the economy over the environment and society. If such a situation challenges the independent and objective assessment of Viability Assessment it is legitimate to ask, *'viable to, and for, whom?'*

Notes

1. RESCUE & AHRC Heritage, "Conference Programme 'Engaging with Policy in the UK: Responding to Changes in Planning, Heritage and the Arts'," 2018, https://heritage-research.org/app/uploads/2018/10/Engaging-with-Policy-Programme-Final.pdf.
2. The principal legislative framework for the historic environment is set out in a series of Acts, including the Town and Country Planning Act 1990, the Planning (Listed Buildings and Conservation Areas) Act 1990, the Ancient Monuments and Archeological Areas Act 1979, the Protection of Wrecks Act 1973, and the Historic Buildings and Ancient Monuments Act 1953. Further, of course, are international protections of which the UK is signatory, which include the 1954 European Cultural Convention, the 1972 Convention Concerning the Protection of the World Cultural and Natural Heritage, the 1985 Convention for the Protection of the Architectural Heritage of Europe, the 1992 Convention for the Protection of the Archeological Heritage of Europe and the 2000 European Landscape Convention.
3. Coombes et al., "The Extent of Crime and Anti-Social Behaviour Facing Designated Heritage Assets," *SCCJR* (blog), accessed 26 August 2019, https://www.sccjr.ac.uk/publications/the-extent-of-crime-and-anti-social-behaviour-facing-designated-heritage-assets/. *Newcastle, Center for Urban and Rural Development Studies, Newcastle University. Available*: https://historicengland.org.uk/content/docs/legal/researchpaper-pdf/.
4. Coombes et al. 34 .

5. Planning Court, The Queen and Mayor of London and London Borough of Tower Hamlets and British Land Property Management. Citation Number [2016]EWHC 1006/Case No. CO/5370/2015."Spitalfields Historic Trust Ltd, R (on the Application of) v Mayor of London & Ors [2016] EWHC 1006 (Admin) (10 May 2016)', accessed 26 August 2019, http://www.bailii.org/cgi-bin/format.cgi?doc=/ew/cases/EWHC/Admin/2016/1006.html&query=(%22heritage)+AND+(gain%22).
6. Mayor of London, "Homes for Londoners: Affordable Housing and Viability Supplementary Planning Guidance 2017." 30 August 2017, https://www.housinglin.org.uk/Topics/type/Homes-for-Londoners-Affordable-Housing-and-Viability-Supplementary-Planning-Guidance-2017/. Accessed July 2019.
7. Islington Council, Development Viability, 2016. https://www.islington.gov.uk///~/media/sharepoint-lists/public-records/planningandbuildingcontrol/publicity/publicconsultation/20152016/20160122developmentviabilityspdadoptedjan2016. Accessed July 2019.
8. Islington Council, Development Viability, 2016. https://www.islington.gov.uk///~/media/sharepoint-lists/public-records/planningandbuildingcontrol/publicity/publicconsultation/20152016/20160122developmentviabilityspdadoptedjan2016. Accessed August 2019.
9. London Assembly, 'Affordable Housing and Viability Supplementary Planning Guidance (SPG)', London City Hall, 28 November 2016, https://www.london.gov.uk//what-we-do/planning/implementing-london-plan/planning-guidance-and-practice-notes/affordable-housing-and-viability-supplementary-planning-guidance-spg.g.
10. NPPF 2012. Paragraphs 173/174.
11. Harman, 'Viability Testing Local Plans: Advice for Planning Practitioners', Viability Testing Local Plans, 2012, http://www.nhbc.co.uk/NewsandComment/Documents/filedownload,47339,en.pdf, 13.
12. Colematt, Cochrane, and Field, "The Rise and Rise of Viability Assessment," 11.
13. Ibid., 4.
14. Ibid.
15. Wacher, "Viability: What Does It Mean for the Plan-Led System?," 2015, https://www.rtpi.org.uk/briefing-room/rtpi-blog/viability-what-does-it-mean-for-the-plan-led-system/.
16. Examples of critical articles on viability include Patrick McAllister, Wyatt and Coleman, "Fit for Policy? Some Evidence on the Application of Development Viability Models in the United Kingdom Planning System,", https://doi.10.3828/tpr.2013.26; McAllister, Street, and Wyatt, "Governing Calculative Practices: An Investigation of Development Viability Modelling in the English Planning System,", https://doi.10.1177/0042098015589722; Colematt, Cochrane, and Field, "The Rise and Rise of Viability Assessment"; Harman, "Viability Testing Local Plans: Advice for Planning Practitioners"; Wacher, "Viability: What Does It Mean for the Plan-Led System?"; Lock, "Viability and Planning."
17. MHCLG, 'Viability – GOV.UK', Viability -GOV.UK 2014, 2014, https://webarchive.nationalarchives.gov.uk/20180607114045/https://www.gov.uk/guidance/viability. Accessed August 2019, since revised.
18. Department for Communities and Local Government, 'National Planning Policy Framework', 2012, https://www.gov.uk/government/uploads/system/uploads/attachment_data/file/6077/2116950.pdf. Para. 173. There is no longer an equivalent of Para. 173 in the revised 2019 NPPF.
19. See https://webarchive.nationalarchives.gov.uk/20180607114045/https://www.gov.uk/guidance/viability. Accessed 8 September 2019.
20. McAllister, Wyatt, and Coleman, "Fit for Policy?" 517–40.
21. Harman, "Viability Testing Local Plans: Advice for Planning Practitioners." 7.
22. See UKSSD website, https://www.ukssd.co.uk. Accessed September 2019.
23. Harman, "Viability Testing Local Plans: Advice for Planning Practitioners," 2–38.
24. Great Britain and Communities and Local Government Ministry of Housing, National Planning Policy Framework., 2019. See Para 34 and 58 suggestion VAs may be needed at planning application stage, and clarification that VAs do not need to be submitted if development proposals accord 'with all the relevant policies in an up-to-date development plan'.

25. RICS, "Financial Viability in Planning: Conduct and Reporting," 28 May 2019, 3–21 https://www.rics.org/uk/upholding-professional-standards/sector-standards/building-surveying/financial-viability-in-planning-conduct-and-reporting/.
26. NPPF 2019. Para 76.
27. McAllister, Wyatt, and Coleman, "Fit for Policy?" 522–3.
28. Image found Dumfries & Galloway Council, "Development Viability Appraisals," accessed 6 September 2019, https://www.dumgal.gov.uk/media/19543/Development-Viability-appraisal/pdf/Development_Viability_Appraisal.pdf.
29. Great Britain and Ministry of Housing, *National Planning Policy Framework*. Para 57.
30. Pat McAllister, "The Calculative Turn in Land Value Capture: Lessons from the English Planning System," 122–9, https://doi.10.1016/j.landusepol.2017.01.002.
31. McAllister, Street, and Wyatt, "Governing Calculative Practices."
32. McAllister, "The Calculative Turn in Land Value Capture." 127.
33. Ibid., 123.
34. Colematt, Cochrane, and Field, "The Rise and Rise of Viability Assessment," 5.
35. Lock, "Viability and Planning". Town and Country Planning September (2016), 349.
36. Lock, "Viability and Planning."
37. APP/K5600/A/09/2097458) and Planning Statement, Royal Borough of Kensington and Chelsea. Available: https://www.rbkc.gov.uk/idoxWAM/doc/Other-1406078.pdf?extension=.pdf&id=1406078&location=volume2&contentType=application/pdf&pageCount=1. Accessed September 23, 2019.
38. McAllister, "The Calculative Turn in Land Value Capture." 126.
39. See note 33 above.
40. These cases can be found using word searches on the British and Irish Legal Information Institute database on the www.bailii.org website.
41. "Meyrick, R (On the Application Of) v Bournemouth Borough Council [2015] EWHC 4045 (Admin) (10 December 2015)," accessed 5 September 2019, http://www.bailii.org/cgi-bin/format.cgi?doc=/ew/cases/EWHC/Admin/2015/4045.html&query=(viability)+AND+(heritage)+AND+(conservation)+AND+(cost). Ref: CO/1987/2015.
42. "Meyrick, R (On the Application Of) v Bournemouth Borough Council [2015] EWHC 4045 (Admin) (10 December 2015)."
43. Ibid.
44. 'Ulster Architectural Heritage Society, Re Judicial Review [2014] NIQB 21 (7 February 2014)', accessed 6 September 2019, https://www.bailii.org/cgi-bin/format.cgi?doc=/nie/cases/NIHC/QB/2014/21.html&query=(conservation)+AND+(area)+AND+(viability). Accessed August 2019. Ref: NIQB 21, February 2014.
45. 'Meyrick, R (On the Application Of) v Bournemouth Borough Council [2015] EWHC 4045 (Admin) (10 December 2015)', accessed 5 September 2019, http://www.bailii.org/cgi-bin/format.cgi?doc=/ew/cases/EWHC/Admin/2015/4045.html&query=(viability)+AND+(heritage)+AND+(conservation)+AND+(cost). Accessed August 2019. Ref: CO/2944/2012 November 2012.
46. Planning Ref: 18/02013/VAR.
47. Planning Ref: 17/00798, for details, see https://rbwm.moderngov.co.uk/documents/g7209/Public%20reports%20pack%2029th-Aug-2018%2019.00%20Maidenhead%20Development%20Management%20Panel%20-%20expired%20May%202019.pdf?T=10 .
48. Debbie Raven, "Land South of Bray Lake and East of Court Close, Windsor Road, Maidenhead"(Thames Hospice, July 2018).
49. Raven.
50. Ibid.
51. Ibid.
52. Devereux and Littlefield, "A Literature Review on the Privatisation of Public Space," 3 http://eprints.uwe.ac.uk/31529/1/Grosvenor%20literature%20review%20DL%20MD.pdf.
53. Blundell, "LABOUR'S FLAWED LAND ACTS 1947–1976," 1–9. Accessed August 2019.

54. Southport Group, "Realising the Benefits of Planning-Led Investigations in the Historic Environment: A Framework for Delivery" (Reading: Institute of Field Archeologists, 2011). 9.
55. Moshenska, "Key Concepts in Public Archaeology," accessed September 2019, https://www.uclpress.co.uk/products/84625. Also see Great Britain and Ministry of Housing, *National Planning Policy Framework*. Paragraph 192.
56. ALGAO England, "England Staffing and Service and Planning and Casework Survey 2017," https://www.algao.org.uk/sites/default/files/documents/England%20staffing%20and%20service%20and%20planning%20and%20casework%20survey%202017.pdf. 134. Accessed August 2019.
57. Morel, "Archaeology in Global Cities.".
58. See https://www.ipcc.ch/2019/08/08/land-is-a-critical-resource_srccl/. Accessed August 2019.
59. Homes England, "Homes England Strategic Plan 2018–2023," October 2018, https://assets.publishing.service.gov.uk/government/uploads/system/uploads/attachment_data/file/752686/Homes_England_Strategic_Plan_AW_REV_150dpi_REV.pdf. 2. Accessed August 2019.
60. Neath Port Talbot Borough County Council, 'Affordable Housing Assessment Guidance', March 2014, https://www.npt.gov.uk/pdf/ldp_affordable_housing_assessment_guidance_notes.pdf. 4. Accessed August 2019.
61. Cobb, *Reconsidering Archeological Fieldwork*, 10.
62. Harman, "Viability Testing Local Plans," 7.

Acknowledgments

I would like to thank Hana Morel for her time, energy and input through discussion and review into this article.

Disclosure statement

No potential conflict of interest was reported by the author.

Bibliography

"Meyrick, R. (On the Application of) V Bournemouth Borough Council [2015] EWHC 4045 (Admin) (10 December 2015)." Accessed September 5, 2019. http://www.bailii.org/cgi-bin/format.cgi?doc=/ew/cases/EWHC/Admin/2015/4045.html&query=(viability)+AND+(heritage)+AND+(conservation)+AND+(cost).

ALGAO England. "England Staffing and Service and Planning and Casework Survey 2017." 2017. https://www.algao.org.uk/sites/default/files/documents/England%20staffing%20and%20service%20and%20planning%20and%20casework%20survey%202017.pdf.

Blundell, V. H. *Labour's Flawed Land Acts 1947–1976*, 9. London: Economic and Social Science Research Association, 1993.

British and Irish Legal Information Institute. 2019. *England and Wales High Court (Administrative court) Decisions*. Accessed September 01, 2019. http://www.bailii.org

Cobb, H. L., ed. *Reconsidering Archaeological Fieldwork: Exploring on-Site Relationships between Theory and Practice*. New York: Springer, 2012.

Colematt, R., A. Cochrane, and M. Field. "The Rise and Rise of Viability Assessment." *Town and Country Planning* 84, no. 10 (2015): 453–458.

Coombes, M., D. Bradley, L. Grove, S. Thomas, and C. Young. "The Extent of Crime and Anti-Social Behaviour Facing Designated Heritage Assets." *SCCJR* (blog). Accessed August 26, 2019. https://www.sccjr.ac.uk/publications/the-extent-of-crime-and-anti-social-behaviour-facing-designated-heritage-assets/.

Department for Communities and Local Government. "National Planning Policy Framework." 2012. https://www.gov.uk/government/uploads/system/uploads/attachment_data/file/6077/2116950.pdf.

Devereux, M., and D. Littlefield. "A Literature Review on the Privatisation of Public Space." London: Grosvenor Group Ltd, 2017. http://eprints.uwe.ac.uk/31529/1/Grosvenor%20literature%20review%20DL%20MD.pdf.

Dumfries & Galloway Council. "Development Viability Appraisals." Accessed September 6, 2019. https://www.dumgal.gov.uk/.

Great Britain, and Communities and Local Government Ministry of Housing. *National Planning Policy Framework*. 2019.

Harman, J. 'Viability Testing Local Plans: Advice for Planning Practitioners'. Viability Testing Local Plans, 2012. http://www.nhbc.co.uk/NewsandComment/Documents/filedownload,47339,en.pdf

Homes England. "Homes England Strategic Plan 2018–2023." October 2018. https://assets.publishing.service.gov.uk/government/uploads/system/uploads/attachment_data/file/752686/Homes_England_Strategic_Plan_AW_REV_150dpi_REV.pdf

Lock, D. "Viability and Planning." *Town and Country Planning*, September, 2016, 348–349.

London Assembly. "Affordable Housing and Viability Supplementary Planning Guidance (SPG)." London City Hall, November 28, 2016. https://www.london.gov.uk//what-we-do/planning/implementing-london-plan/planning-guidance-and-practice-notes/affordable-housing-and-viability-supplementary-planning-guidance-spg.

Mayor of London. "Homes for Londoners: Affordable Housing and Viability Supplementary Planning Guidance 2017." August 30, 2017. https://www.housinglin.org.uk/Topics/type/Homes-for-Londoners-Affordable-Housing-and-Viability-Supplementary-Planning-Guidance-2017/

McAllister, P. "The Calculative Turn in Land Value Capture: Lessons from the English Planning System." *Land Use Policy* 63 (April,2017): 122–129. doi:10.1016/j.landusepol.2017.01.002.

McAllister, P., E. Street, and P. Wyatt "Governing Calculative Practices: An Investigation of Development Viability Modelling in the English Planning System." *Urban Studies* 53, no. 11 (August, 2016): 2363–2379. doi:10.1177/0042098015589722.

McAllister, P., P. Wyatt, and C. Coleman "Fit for Policy? Some Evidence on the Application of Development Viability Models in the United Kingdom Planning System." *Town Planning Review* 84, no. 4 (January, 2013): 517–543. doi:10.3828/tpr.2013.26.

MHCLG. "Viability - GOV.UK." Viability -GOV.UK 2014, 2014. https://webarchive.nationalarchives.gov.uk/20180607114045/https://www.gov.uk/guidance/viability

Morel, H. "Archaeology in Global Cities: Exploring the Profession in London and New York City." University College London, 2015. http://discovery.ucl.ac.uk/1474220/. Chapter 5/Pg. 134

Neath Port Talbot Borough County Council. "Affordable Housing Assessment Guidance." March 2014. https://www.npt.gov.uk/pdf/ldp_affordable_housing_assessment_guidance_notes.pdf.

RESCUE & AHRC Heritage. "Conference Programme 'Engaging with Policy in the UK: Responding to Changes in Planning, Heritage and the arts'." 2018. https://heritage-research.org/app/uploads/2018/10/Engaging-with-Policy-Programme-Final.pdf

RICS. "Financial Viability in Planning: Conduct and Reporting." May 28, 2019. https://www.rics.org/uk/upholding-professional-standards/sector-standards/building-surveying/financial-viability-in-planning-conduct-and-reporting/.

"Save Britain's Heritage, R (On the Application Of) V the Secretary of State for Communities and Local Government [2013] EWHC 2268 (Admin) (25 July 2013)." Accessed September 5, 2019; http://www.bailii.org/cgi-bin/format.cgi?doc=/ew/cases/EWHC/Admin/2013/2268.html&query=(viability+OR+heritage+OR+cost+OR+financial)+AND+(archaeolog)

Southport Group. "Realising the Benefits of Planning-Led Investigations in the Historic Environment: A Framework for Delivery." Reading: Institute of Field Archaeologists, 2011.

Spitalfields Historic Trust Ltd, R (on the application of) v Mayor of London & Ors [2016] EWHC 1006 (Admin) (10 May 2016). Accessed August 26, 2019. http://www.bailii.org/cgi-bin/format.cgi?doc=/ew/cases/EWHC/Admin/2016/1006.html&query=(%22heritage)+AND+(gain%22).

"Ulster Architectural Heritage Society, Re Judicial Review [2014] NIQB 21 (7 February 2014)." Accessed September 6, 2019. https://www.bailii.org/cgi-bin/format.cgi?doc=/nie/cases/NIHC/QB/2014/21.html&query=(conservation)+AND+(area)+AND+(viability)

Wacher, J. "Viability: What Does It Mean for the Plan-Led System?" 2015. https://www.rtpi.org.uk/briefing-room/rtpi-blog/viability-what-does-it-mean-for-the-plan-led-system/.

For Everyone?: Finding a Clearer Role for Heritage in Public Policy-making

Georgina Holmes-Skelton

ABSTRACT
The natural environment has enjoyed a recent surge in both public interest and in government policy activity in Westminster. This could in part be attributable to a 'Blue Planet effect', but a bigger change in how the natural world is understood in public policy terms can also be observed, moving the natural environment from a niche conservationist concern, and a perceived resource drain, to a public good which contributes positively to the economy, public health and well-being of the nation as a whole. This paper is interested in what this change can tell us about the importance of public interest and perceptions of public benefit for the historic environment, as another conservationist policy concern. It hypothesises that despite the growing body of evidence about the positive social and economic value of heritage and place, 'heritage' has an association with white, and middle and upper class interests which limits its ability to be perceived as a potential policy solution for delivering wide public benefit, rather than a drain on resource. It concludes that creating a new perspective on heritage as a genuinely shared asset will be key to taking the next step for heritage on the public policy journey.

Declining Fortunes for Heritage in Public Policy

The historic environment could be described as a niche interest in terms of public policy. When you consider the affairs of the state, it likely ranks a long way down the list of government priorities – probably some way behind health, education, transport, business, foreign affairs and defence. In terms of the UK Government, responsibility for heritage specifically is within the portfolio of one junior government minister in one of the smaller departments of Whitehall, with many of the core functions delegated to a medium sized arm's length body. Expenditure on heritage accounted for just 2.7% of the total budget of the Department for Digital, Culture, Media and Sport in 2017/18.[1] And yet, the nature of heritage is that it runs through the fabric of our society. In the words of then Minister for Arts, Heritage and Tourism, John Glen MP in 2017:

> Our heritage is all around us. In our towns and cities, and in our villages and rural areas. In historic buildings, places of worship, inspiring landscapes, ancient ruins and archaeological sites, statues and memorials. In places where great events happened, where famous figures of the past wrote their names in the history books, and where countless ordinary men and women lived and

worked. It speaks to us of who we are and where we have come from, of how we came to be the people and the nation we are today.[2]

So why does something so important to our nation appear to have such a small presence in public policy? If anything, evidence suggests that the degree of priority given to the historic environment has reduced in recent years – as a proportion of DCMS expenditure in 1999/2000 heritage accounted for 15.4%.[3] Indeed, prior to 1997, heritage was given sufficient priority to form part of the name of the Department as the Department for National Heritage before it became the Department for Culture, Media and Sport, and more recently, Digital, Culture Media and Sport. Part of English Heritage was spun off in 2015 to become an independent charity managing the National Collection of heritage buildings and assets previously looked after as part of the machinery of the state (though English Heritage retains ties to government through its governance structures). The remaining non-departmental public body, Historic England, will have seen a 49% real terms cut in Grant in Aid funding between 2010/11 and 2019/20.[4] At the same time, cuts to local authority budgets as a result of central government policy have led to a reduction in resource and staff in historic environment services at a local government level too – staff numbers supporting conservation and archaeology fell 35% between 2006 and 2018.[5]

If reducing priority and resource has been the fate of the historic environment, it has not however been the same story for the natural environment. Environmental policy relating to the natural world seems to have enjoyed an uplift in its level of priority and influence in Whitehall over the last few years and become particularly visible in public discourse – most noticeably since the release of the extremely popular BBC documentary series Blue Planet II in the autumn of 2017. So, what's happening in these two areas of public interest, both relating to the conservation of our physical and cultural environment, that has led to such different fortunes?

The paper seeks to examine the drivers of this change and consider whether the historic environment – and heritage particularly – could find a way to regaining some of its lost profile. I will argue that perceptions of heritage which associate it with dominant historical narratives, and thereby particular class and racial identities, are a barrier to political engagement with heritage as a policy tool. I propose that creating a more inclusive environment for experiencing and accessing heritage, and growing the diversity of the heritage sector itself, could create political space for heritage to play an enhanced, more conscious role in public policy-making.

Shifting Perceptions – Lessons from the Natural World

On 10 December 2017 the final episode of the BBC's second series of Blue Planet II was aired. The series had been dedicated to exploring the world's marine life through spectacular footage and storytelling about the natural world. However, it also portrayed another side of our marine environment: the stark impact of human activity in our oceans, and the devastating proliferation of plastic waste. The series became the most watched programme in 2017, reaching over 37 million people in the UK.[6] The message of the programme, and of its host David Attenborough himself, had immediate impact – both on the public and seemingly on government policy. The phrase 'blue planet' was used in

the House of Commons 57 times between October 2017 and the end of January 2018.[7] The Secretary of State for the Environment, Rt. Hon Michael Gove MP, also spoke publicly about feeling 'haunted' by the programme, and committed to taking further action.[8]

There was certainly a noticeable uptick in the speed and volume of policy changes and proposed interventions relating to plastic waste in the months following the broadcast. The 25 Year Environment Plan published in January 2018 outlined the Government's ambition of 'achieving zero avoidable plastic waste by the end of 2042', backed by a range of proposals to reach this aim.[9] January 2018 also saw a ban on the production of microbeads in cosmetics and cleaning products,[10] which would be followed by a wider ban on the sales of microbead containing products in June 2018.[11] March 2018 saw a call for evidence on using the tax system or charges to tackle single-use plastic waste (which received a record 162,000 responses).[12] This was followed by an announcement of a new tax on produced or imported plastic packaging in the 2018 budget.[13] Further consultations were launched in October 2018 on proposals to ban the distribution and sale of plastic straws, cotton bud stems and drinks stirrers,[14] and in February 2019 on consistency in household and business recycling.[15] There has also been a response from the private sector, with more the 40 private businesses signing up to the collaborative Plastic Pact initiative, led by the charitable organisation WRAP, which aims to make 100% of plastic packaging recyclable, reusable or compostable by 2025. All of this has been achieved from a relatively minimal baseline of regulation around plastic use and waste: although the UK Government had already introduced the plastic bag charge in October 2015,[16] there had been little domestic attempt to reduce or regulate consumer plastic use, and certainly not on this systemic basis.

Explaining the reasons behind public policy decision-making is not a straight-forward task, and certainly there are multiple factors at play in complex political systems. For the purposes of this paper I will look at only a limited number of factors that appear relevant to this comparison between policy areas – there is significant further work that could be done to more systematically explore the wider influences on policy that are at work, particularly relating to heritage. However, for now let us look first to the influence of public attitude on policy making, for which there is significant existing evidence when it comes to the natural environment.

It has been shown that in Europe, shifts in public opinion towards prioritising the environment have had 'a significant and positive effect on the rate of renewable energy policy outputs by governments in Europe'.[17] This is echoed by studies in the United States and elsewhere looking at public opinion and public protests relating to environmental issues, and its impact on public policy.[18] If the impact of Blue Planet II has been significant and created a lasting shift in public opinion it would therefore not be unreasonable to think that it may have helped drive the Government to action. Roger D. Congleton's Median Voter Model suggests that political outcomes can be predicted through the reference to the opinion of the 'median voter'.[19] Perhaps we have indeed seen a shift of the median voter position in relation to natural environment: six months after the series had aired, the BBC claimed that 62% of those surveyed had expressed a desire to make changes to their daily lives to protect the environment.[20] This was backed up by the findings of consumer polling carried out by OnePoll for Waitrose & Partners in November 2017, which found that 88% of those who saw the series say they have changed their behaviour as a direct result.[21] A survey carried out by Ipsos Mori for the environmental charity Keep Britain Tidy in February 2019 also found that 67% of

people said that they tried to use less single-use-plastic following the public debate around plastic waste and TV events such as Blue Planet II.[22]

However, it is impossible to say for certain how much of the action in terms of policy was driven by Blue Planet II alone: wider narratives around the environment certainly created a context for the plastics message to hit home. This includes the increasing sense of crisis in relation to climate: the Intergovernmental Panel on Climate Change (IPCC) report on the impacts of global temperature reaching 1.5C released in October 2018,[23] and the accompanying, well publicised, warning that the world has twelve years to limit climate change has had impact.[24] It is certainly true that climate specifically has become an issue of increasing concern for the public: 2019 has also seen a wave of civil society interest and the growth of climate-related protest movements, particularly notable in climate protests by school children around the world in February and March and the emergence of the Extinction Rebellion climate protest group in the UK. This has also been accompanied by growing media coverage of concerns around declines in global biodiversity[25] and a UN Report in February 2019 on the potential impact of biodiversity loss on food production.[26]

There wider narratives relating to the broader state of the natural environment created a context in which the public were likely to be more receptive to messages about plastic waste. Brexit is another factor, and the prospect of leaving the EU created a pressing need to put in place some alternative policy framework for the environment to substitute the existing EU legal framework. The presence of a Secretary of State with a stated personal commitment to environmental change, has also likely played its part.

This moment also came at a time when longer-term public attitudes towards the environment appear to have already been shifting in the UK, with an upward trend in terms of public concern about the environment. Looking at climate in particular, the UK Government's Public Attitudes Tracking Survey on energy and climate change shows a significant increase in concern between the first survey wave in March 2012, when 65% of respondents said that they were 'very' or 'fairly' concerned about climate change, to Wave 25 in March 2018, when this had increased to 74%.[27]

In the UK longer-term trends in public attitudes have aligned with a significant shift in the approach to policy-making in relation to the environment. The last decade has seen a growing focus on finding ways to understand more accurately and clearly the value of the natural environment to society. In 2009 the Government commissioned a National Ecosystem Assessment (NEA), which was the first attempt to consider the UK's natural environment in terms of the benefits it provides to society, including through an assessment of its economic contribution.[28] The UK Government's 2011 White Paper 'The Natural Choice: securing the value of nature' subsequently outlined a specific ambition to 'mainstream the value of nature across our society'.[29] The development of the concept of natural capital accounting has since arisen as the preferred approach to achieving this ambition – not only in the UK, but around the world.

Natural capital accounting promises a way of assessing the economic value of natural resources to society. To an extent it is a way of attempting to reconcile the drive to ever growing economic growth with the reality that such growth is predicated on resources in the environment which aren't otherwise reflected in the market or captured by traditional economic accounting methods: for example, the value of clean air and access to clean water to sustain human populations, or the value of biodiversity and healthy

ecosystems for food production and broader environmental sustainability. The fiscally-driven framework for making decisions about public spending, and tight economic focus of the HM Treasury do not easily take long term environmental impacts of policy decisions into account, and so this approach seeks to provide a way of incorporating the value generated by natural assets or 'ecosystem services' into the economic methodology that drives decision making and central government policy. It also provides a way of demonstrating that public money spent on protecting and enhancing the environment is not merely money spent without return; it permits a calculation of returns on investment. While for some this approach may feel coldly capitalist and materialistic, for the decision makers in Whitehall seeking to demonstrate value for every public pound spent, this approach creates a much more compelling case for investment than reliance on arguments about inherent value.

The creation in May 2012 of the UK's Natural Capital Committee was a significant first step towards embedding this approach to valuing the natural environment into government policy making, and indeed natural capital has continued to gathered steam in policy thought subsequently. The Government has committed to developing full UK Environmental Accounts by 2020,[30] and the 25 Year Environment Plan (itself instigated by a recommendation of the Natural Capital Committee in 2015),[31] and subsequent Agriculture Green Paper 'Health and Harmony: the future for food, farming and the environment in a Green Brexit',[32] which set out the Government's proposals for an environment-centred replacement to the EU's Common Agricultural Policy, both outlined a commitment to taking a natural capital approach to future environmental policy. As significantly in 2018 natural capital was introduced into the revised HM Treasury Green Book,[33] which provides guidance on decisions involving public money, thus mainstreaming consideration of the public value of the natural environment into the heart of public decision making.

The Blue Planet phenomenon could therefore be seen as a catalyst for speeding up change that was already in action, facilitated both by an increase in public awareness and concern, and a pre-existing shift in the way that environmental policy is positioned within Whitehall as not only relevant to wider policy concerns, but as an active driver of economic and public benefit. However, the rate of change in the journey that the natural environment has made in the public sphere, particularly in the last twelve months, is striking.

Lessons for Heritage

So, what of the historic environment, and in particular, heritage? What can be learned? For those of us who want to drive heritage up the public policy agenda, gain greater support to the protection and management of our heritage assets and increase the profile of heritage as a public good, there is much to consider. Could we spark a similar effect through a similarly well-made and emotionally affecting documentary about the state of the historic environment, that leads to real changes in the way the heritage is treated in public policy?

I have identified two key drivers of change in relation to the natural environment; public opinion and concern about the subject, and a shift in the way that Whitehall values the natural environment. I will explore the latter briefly first from a heritage

perspective, before returning to the former, in the hope of answering that question and proposing a way forward.

Valuing Heritage – beyond Stone and Mortar

As with the natural environment, there has been a lot of work and research over recent years to understand the value that heritage can offer to society. As a result, there is a substantial and growing quantity of evidence already available documenting the public value of heritage beyond the inherent.

From an economic perspective, Historic England estimates that heritage tourism generated £16.9 billion in spending by heritage-related visits and trips in England in 2016 and that for every £1 spent as part of a heritage visit, 32p is spent on site and the remaining 68p is spent in local businesses: restaurants, cafés, hotels and shops.[34] This makes the economic contribution of the heritage sector larger than a number of others which arguably feature more prominently in terms of public policy – such as defence, aerospace, or agriculture.

It's also well documented that heritage supports other sectors such as the construction, film and creative industries. Historic buildings and urban quarters provide desirable locations for commercial businesses, with listed buildings particularly attractive to independent shops, SMEs and creative industry businesses – notably tending to be more productive than businesses not located in listed buildings.[35] Heritage-related construction is estimated to generate £6.6 billion in Gross Value Added to the economy, and support around 94,000 jobs.[36]

Beyond the economic, there is also growing evidence about the social value of heritage and wider benefits for people and communities created by the contribution of the historic environment to wellbeing, sense of place and identity. For example we know that people who regularly visit heritage sites are statistically more likely to have higher measures of happiness and life satisfaction, and lower levels of anxiety.[37] The use of heritage sites for health interventions including social prescribing initiatives is growing,[38] as are projects involving archaeology,[39] gardening[40] and other forms of group activity that can be facilitated by the presence of heritage assets or the historic environment.

The 'Places that Make Us' research by the National Trust and the University of Surrey has found evidence of the physiological impact of place on people and the ability of place to positively impact on our wellbeing.[41] The study identified measurable changes in brain activity in participants who were shown images of places that they had identified as meaningful to them. Meaningful places, it was found, generate a strong emotional response, and participants reported feelings like calmness or joy. While the research didn't look specifically at responses to places with historic features or buildings, and included modern places such as sports venues, stately homes were identified as 'meaningful' by some participants, and the study noted that the features of the places were part of what helped create emotional connection. It seems likely that historic features form part of this sense of place, contributing to its distinctiveness and identity. In addition, a recent scoping review of literature around heritage and wellbeing by What Works Wellbeing highlighted a range of evidence supporting the conclusion that historic places, assets and associate activities and interventions 'can have a wide range of

beneficial impacts on the physical, mental and social wellbeing of individuals and communities.'[42]

While such evidence about the value of heritage is therefore growing, it has not yet generated the sort of shift in the public policy view of heritage assets that natural capital accounting has done for natural resources. There have been some attempts to accommodate some elements of cultural value within the natural capital methodology, and 'cultural services' are included as a category of ecosystem service, but this is not currently able to fully reflect the wider contribution of historic features with ecosystem services, including as a physical asset in the landscape.[43] Historic England continues to progress work in this area seeking to develop a better understanding of how to reflect the role that historic landscape features in supporting ecosystem services,[44] but an effective way of delivering this, or even creating a comparable methodology for assessing the non-market economic benefits generated by heritage assets (such as the social value described above) appears to still be some way off. That said, there are signs that some recognition of the contribution of the historic environment is beginning to filter into wider public policy decision making – albeit not always specifically with heritage protection as its core philosophy or driver. For example, the role of place in supportive economic regeneration and productivity is creeping more and more into the language of policy-makers. DCMS commissioned research in 2016 which led to the 'CASE Place Shaping Report – The role of culture, sport and heritage in place shaping', which sought to create an evidence base for the role of these factors in supportive positive economic and social outcomes in local areas.[45] A range of government funding streams and programmes seek to support place-making to drive economy and productivity have subsequently been launched, including the Cultural Development Fund, launched on the back of the Creative Industries Sector Deal in 2018.[46]

There is also growing interest in wellbeing as a form of social value, and there have been similar drives to build consideration of wellbeing impacts into the public policy decision making process as those seen for the natural environment. Indeed, in addition to the natural capital references, a further change in the Treasury Green Book update in 2018 was to include explicit references to wellbeing. Given the growing evidence connecting heritage to wellbeing this appears to be a potential back door for working heritage into policy decisions, albeit not in its own right.

Overall there is clearly is some potential for change in the way that public policy perceives heritage – a growing understanding that money spent on protecting, maintaining or restoring heritage assets is not necessarily without return for the public purse. However, this has not yet led to substantial changes in decision-making or sort of acceleration of policy and regulatory interventions that centre heritage itself as a public good, in the way that we have arguably seen at least start to happen in the natural world. I'm going to make what might be a bold assertion and propose that this is down to the second factor that I identified as a driver of change: perception.

Who Is Heritage For?

94.2% of people agree that it is important to look after heritage buildings and places, and 74.8% of adults visited a heritage site in 2016/17.[47] On the face of it, therefore, heritage appears to enjoy substantial public support. However, these figures need unpacking and examining against the bigger picture, and there are questions first to

address regarding what 'heritage' really means in terms of public understanding and political perception, and the role it plays in the emotional life of both individuals and the nation as a whole.

Qualitative research carried out by the Heritage Lottery Fund in 2015 involving residents of twelve places around the UK found that the primary 'top of mind' associations related to physical heritage, and in particular museums, monuments and old buildings.[48] This is perhaps unsurprising – in the UK the most visible monuments of history – those buildings and assets that are most famous, most visited, and most held up as examples of British history, tend to be in this category. Among the top 10 most visited paid attractions in England in 2017 the heritage sites included the Tower of London, Stonehenge, St Paul's Cathedral, Westminster Abbey, Royal Botanical Gardens, Kew, Roman Baths and Pump Room, and RHS Wisley.[49] The most visited National Trust properties (setting aside Giants' Causeway) tend to be the stately homes and estates – the top ten pay for entry sites by visitor number includes Clumber Park, Cliveden, Attingham Park, Belton House, Waddesdon and Fountains Abbey Estate.[50]

A theme emerges. These are places that are largely associated with ruling class, white histories. And this is important, because unlike 'natural environment', which speaks to a global concept, relatively free of class or racial association (though some argue less so when attention is directed to specific sites, locations or individual connectedness – Dorceta E. Taylor's analysis of racial and ethnic differences in connectedness to nature is of interest[51]), history is a minefield in terms of association, narrative and meaning – particularly when it comes to state involvement.

Nietzsche talked about the perils of the study of history and the dangers associated with approaches to history that limit or distort our ability to learn from them, and which do not serve to enhance contemporary life.[52] Much has subsequently been written of the role of heritage in both establishing and reinforcing our collective sense of community or national identity, and the way that the presence and interpretation of heritage assets and collections can be used to preserve or promote dominant narratives of history, and therefore also police narratives of identity, nation and belonging.

Laurajane Smith identified the impact of 'Authorised Heritage Discourse' in shaping collective perceptions of legitimacy around what is 'heritage' and what is not.[53] The preserving of particular sites, artefacts and cultural practices, to ensure their continued existence for the next generation takes place in the context of prevailing narratives around history and attitudes towards what is valuable. Choices are made about what should be preserved, and which stories connected to them should be told. By its very nature, therefore, a state's projection of its 'heritage' is not something that exists in a vacuum; it is not an impartial guide to historic truth, but rather a reflection of the way that those who have control of the narrative chose to portray their nation.

It is unsurprising therefore that public policy for heritage protection in the past, particularly for the built environment, has favoured the protection of sites associated with the ruling classes: wealthy white families and the history of aristocracy. Measures such as the Acceptance in Lieu Scheme have helped protect stately homes and country houses and their associated collections, by enabling these assets considered to be of national significance to be transferred to institutions such as the National Trust in lieu of inheritance tax. The same was not historically true of sites associated with histories of the working class or those from other ethnic backgrounds. As a result of this and other

policy interventions, many of the heritage sites and historic collections held by major institutions such as the National Trust or English Heritage are of this nature – and in a sense the very names of these institutions continue to reiterate the status of these assets as representative of our 'national heritage'.

That the predominance of particular class and racial interests continues today is perhaps demonstrated also in the disparity in who is engaging with these sites. While overall levels of engagement with heritage among adults in the UK are high, this is not consistent across all demographics. Government data shows that people from Asian, Black and other ethnic groups have significantly lower levels of engagement and are less likely to visit heritage sites in general.[54] There is also a gap in terms of socio-economic status – with around a 20-percentage point gap between the number of those who had visited a heritage site in the upper and lower socio-economic groups. Perhaps tellingly, a recent YouGov poll asked adults in the UK, in the aftermath of the Notre Dame fire, 'do you feel an emotion connection to certain historic, important or special buildings in your area?'. While 51% of ABC1 respondents said yes, only 42% of C2DE said the same.[55]

This disparity is visible also in the professions that make up the heritage sector. Workforce data about socio-economic background is not readily available across the sector, but there is a great deal of evidence of the lack of ethnic diversity. For example, research in 2013 showed that 99% working archaeologists were white, reflected also in students taking archaeology as a first degree.[56] The Royal Historical Society has also highlighted a prominent underrepresentation of Black and minority ethnic students and staff in UK university history programmes, with only 11% of students coming from these backgrounds, while 96.1% of UK-national staff are white.[57] There is also underrepresentation in organisations such as Historic England where only 4.3% of staff come from Black, Asian and minority ethnic backgrounds, and in the museum sector where only 5% of staff in Arts Council Major Partner Museums are from these backgrounds.[58] This underrepresentation is particularly noticeable among leadership roles, which is especially relevant when considering public policy, because it is these leaders who often lead discussions and engagement with government. It is surely not irrelevant that, at the time of writing, all of the sector organisations represented at the Heritage Council – the group set up by the Government to act as a formal link between the heritage sector and central government, and chaired by the Minister for Arts, Heritage and Tourism – have white Chief Executives or Director Generals, and therefore the representation of the whole of the heritage sector in that key forum is likely to be entirely white.

It seems unlikely that people from Black and minority ethnic backgrounds are fundamentally less likely to be interested in history or heritage than those of white background – indeed there is evidence that people from these backgrounds are more likely than others to engage with local archives libraries or local collections, which may indicate that these groups are simply engaging with heritage more selectively.[59] In terms of historic buildings, and heritage sites however, this is a clear indication that representation matters: it doesn't feel a great leap to suggest that where certain types of asset or building are those permitted to be labelled 'heritage' – or perhaps as in the YouGov Poll, permitted to carry the label of 'historic, important or special', those that value other forms of heritage or feel alienated by the narratives they associate with these sorts of heritage, will potentially disengage from the mainstream heritage sector.

The underlying class and racial associations, and real-life gap in terms of engagement and representation are both, I believe, problematic in terms of the position of heritage as a public policy issue: if heritage is primarily perceived as being for white, middle class people, then it is natural to assume that investment in it also benefits those audiences – which are low priority audiences for funding in today's political context. Despite the growing availability of evidence about the wider public value of heritage assets, this continued association creates a political disincentive which is hard to overcome, particularly in times of austerity (or even post-austerity economic uncertainty).

This problem is made more entrenched by the nature of modern public policy intervention for heritage, which remains predominantly in the realm of protection and restoration – laws regulating what people should do or not do with their own heritage assets or those on their property, how the historic environment should be treated in the planning system, and how to allocate grants or make best use of public money to protect, restore or renovate the buildings and assets that we have. Policy relating to the natural environment has long been connected in the mind of Whitehall with wider public policy concerns such as agriculture, food, flood protection, and water and air quality – even if some of these interests have in recent history dominated in terms of priority, to the cost of nature and biodiversity. The exploration of natural capital and the wider role of the natural environment has created a structure for reflecting the interconnectedness of these issues in policy development. Heritage policy is less concerned with broader visions about how to use heritage for wider public benefit beyond merely its continued existence. As discussed, the evidence base for the potential in this space is growing, and there are signs that this could change, but this is still at the early stages, and as things stand spending on heritage can still equate to (and be politically framed as) spending money on buildings or assets that are perceived to predominantly benefit those who may be less in need than others – particularly where the spending may be to support private owners of historic buildings, for example.

Stuart Hall's seminal work on 'Un-Settling "the Heritage"' explored the challenge of re-imagining our vision of national heritage to be inclusive of a wider range of perspectives on our history. Hall noted that these sorts of assumptions about heritage are not fixed in perpetuity:

> The Heritage inevitably reflects the governing assumptions of its time ad context. It is always inflected by the power and authority of those who have colonised the past, whose versions of history matter. These assumptions and co-ordinates of power are inhabited as natural – given, timeless, true and inevitable. But it takes only the passage of time, the shift of circumstances, or the reversal of history, to reveal those assumptions as time- and context-bound, historically specific, and thus open to contestation, re-negotiation, and revision.[60]

Time has passed since Hall's comments, and while much has changed in those twenty years, it is clear from my analysis that the job of widening the discourse around heritage to a more culturally inclusive one has not yet been achieved. But public and political interest in promoting equality and inclusion has grown more mainstream, particularly since the introduction of the Equality Act 2010 and other socially progressive measures such as the Marriage (Same Sex Couples) Act 2013. As such we have not been relying solely on the passage of time. There are some signs that at least some progress has been

made, and perhaps some of the 'building blocks' that Hall discussed are closer to being seen in reality.

In early 2019 the ongoing political drama of Brexit focused for a brief moment on the historic legacy of Winston Churchill. Shadow Chancellor John McDonnell was asked his view of Churchill during an interview and replied 'Tonypandy. Villain.' This statement led to a widely publicised public row over whether Churchill, who had in 2002 been named 'Greatest ever Briton' in a BBC poll, was instead a 'villain', with commentators in the media highlighting claims that Churchill was a white supremacist, against others defending his wartime historical role. As with all such public rows, no conclusion was ultimately reached, but that such a row occurred is evidence of a growing awareness and willingness to discuss the differences in perception that exist. Perhaps this will lead to a more public debate about his legacy, and reflection on the idea that while for some his statue in Parliament Square is a reminder of a great man (and to some degree a wider manifestation of their perception of Britain at its best) for others the statue sparks a different reaction and holds much darker, more negative associations.

There has also been an increase in the willingness of the major heritage institutions to widen their engagement with more diverse stories and forms of heritage, and break through the authorised narratives associated with our 'national heritage'. For example, the National Trust explored LGBTQ+ histories in their national 'Prejudice and Pride' programme in 2017, and is embracing approaches to curation, programming and visitor experience which allow more stories to be told and seeking to tackle some of the more contested or challenging aspects of history represented in their places and collections. Historic England has used public events to debate some of the issues involved – sparking significant controversy in April 2018 when they used an animation of Nelson's column being knocked down by a wrecking ball in a tweet advertising a public debate about what to do with controversial statues and memorials.[61] Greater prominence and focus on promoting diversity is also being given in the approaches of funders such as the National Heritage Lottery Fund and Arts Council. Beyond organisational action, individual and local activism has also been important in this process. The Rhodes Must Fall campaign originally began in South Africa in 2015, and successfully campaigned for the removal of a statue of Cecil Rhodes from the University of Cape Town. This lead to a wider campaign around the decolonialisation of physical spaces, reform of academic curricula and reassessment of traditional historical narratives – not just in South Africa, but around the world. In the UK the Rhodes Must Fall in Oxford campaign called for a statue of Rhodes to be removed from Oriel College and received significant media coverage and interest, including some strong criticism of the students demands.[62]

That these issues are being aired and debated are positive. However, it's worth acknowledging the strength of emotion that can be generated in response – and the reaction to the Rhodes Must Fall in Oxford is an example of this in practice. We're in the realm of personal identity; where new narratives are aired that challenge existing interpretations of heritage which holds emotional connection for people, we shouldn't be surprised when people take personal affront. Just as creating and reinforcing dominant historical narratives through heritage is as much a process through time as a state of affairs, so reassessing and widening narratives will also be a process which some people will find uncomfortable, and which does need to be handled with sympathy and respect for all perspectives if it is to have positive outcomes for society as a whole.

Ultimately I see the central challenge for heritage in public policy terms as being the need to find to a new identify for 'heritage', as not merely a collection of physical buildings, assets and artefacts that need to be protected against the march of time for their own sake, or for a narrow audience to enjoy, but as a more multifaceted public good – a driver of economic growth that can be used as a tool for increasing productivity and financial benefit, and an asset that contributes positively to place and well-being. However, heritage occupies a complex space in society. It carries baggage and associations that the natural environment as a cause does not – at least not with the same immediacy and potency. A greater and more public recognition of these complexities, and of the fact that history, and its artefacts do not – and cannot – have a fixed interpretation or meaning, is needed.

The mainstream heritage sector must continue to grow its confidence in facing up to this complexity and historical baggage. It must become more representative in its workforce and leadership, continue to grow audiences and demonstrate benefit to people of all backgrounds, help more communities feel involved in and a sense of ownership of their local heritage and quality of place, and help create genuinely shared understandings of history. The sector needs to create the space for policy-makers and politicians to see heritage as part of the solution rather than a luxury, or even worse a problematic call on public money. Otherwise, our heritage may be as close to 'forever' as we can make it, but will not truly be 'for everyone'.

Notes

1. National Audit Office, *Departmental Overview: Department for Digital, Culture, Media and Sport, 2017–18*, 6.
2. Department of Digital, Culture, Media and Sport, *Heritage Statement 2017*, 4.
3. HM Treasury, *Main Supply Estimates 1999–2000*, 142–147.
4. Historic England, *Historic England Corporate Plan 2018–21*, 18.
5. Lloyd-James, *Tenth report on Local Authority Staff Resources*.
6. See https://www.bbc.co.uk/mediacentre/latestnews/2018/plastics-watch.
7. House of Commons Official Report, Hansard Online using search term "Blue Planet," 1 September 2017–31 January 2018.
8. Gove, Twitter post, 20 November 2017, 6:37pm. https://twitter.com/michaelgove/status/932,679,274,812,854,273.
9. Department for Environment, Food and Rural Affairs, *25 Year Plan to Improve the Environment*, 13.
10. Department for Environment, Food and Rural Affairs, "World-leading microbeads ban takes effect."
11. Department for Environment, Food and Rural Affairs, "World leading microbeads ban comes into force."
12. Department for Environment, Food and Rural Affairs, *Consultation on Plastic Packaging Tax*.
13. Department for Environment, Food and Rural Affairs, *Single-use plastics: Budget 2018 brief*.
14. Department for Environment, Food and Rural Affairs, *Consultation on proposals to ban the distribution and/or sale of plastic straws*.
15. Department for Environment, Food and Rural Affairs, *Consultation on Consistency in Household*.
16. Department for Environment, Food and Rural Affairs, "Charges for single-use plastic carrier bags."
17. Anderson, Böhmelt, and Ward, "Public opinion and environmental policy output," 3.

18. For e.g. Agnone. "Amplifying public opinion: the policy impact of the US environmental movement," and Shum, "Can attitudes predict outcomes? Public opinion, democratic institutions and environmental policy."
19. Congleton, "The Median Voter Model."
20. BBC, "BBC announces major initiative 'Plastics Watch' following the global impact of Blue Planet II".
21. Waitrose & Partners, *Food & Drink Report 2018–19.*
22. Ipsos MORI, "New research reveals the power of Blue Planet II and how it's changed attitudes and behaviour."
23. IPCC, *IPCC Special Report on the impacts of global warming of 1.5°C above pre-industrial levels.*
24. See for e.g. Watts, 2018, "We have 12 years to limit climate change catastrophe, warns UN" https://www.theguardian.com/environment/2018/oct/08/global-warming-must-not-exceed-15c-warns-landmark-un-report.
25. See for e.g. Webster, 2019, "UN: Western lifestyles must change to avoid catastrophe, says UN," https://www.thetimes.co.uk/article/rich-countries-must-halt-consumption-un-extinction-report-warns-gdvkdbzs2.
26. FAO, "The State of the World's Biodiversity for Food and Agriculture."
27. Department for Business, Energy and the Industrial Strategy, "Energy and Climate Change Public Attitudes Tracker: Wave 25."
28. UK National Ecosystem Assessment, *The UK National Ecosystem Assessment: Technical Report.*
29. Department for Environment, Food and Rural Affairs, *The Natural Choice: securing the value of nature.*
30. Ibid., 36.
31. Department for Environment, Food and Rural Affairs, *25 Year Plan to Improve the Environment.*
32. Department for Environment, Food and Rural Affairs, *Health and harmony: the future for food, farming and the environment in a Green Brexit.*
33. HMT, *The Green Book.*
34. Historic England, *Heritage Counts: Heritage and the Economy.*
35. National Lottery Heritage Fund, *New Ideas Need Old Buildings.*
36. Historic England, *Heritage Counts: Heritage and the Economy*, 28.
37. Department for Digital, Culture, Media and Sport, "Taking Part Focus on: Wellbeing."
38. See for e.g. "Farming Memories", a joint project between Care Network Cambridgeshire and the National Trust at Wimpole Home Farm – http://fenedge.co.uk/farming-memories-wimpole-home-farm/.
39. See for e.g. Operation Nightingale – https://www.wessexarch.co.uk/our-work/operation-nightingale.
40. See for e.g. Growing Space at Tredegar House – http://www.growingspace.org.uk/about.html.
41. National Trust, *Places that Make Us.*
42. What Works Wellbeing, *Heritage and wellbeing: the impact of historic places and assets on community wellbeing – a scoping review.*
43. Fluck and Holyoak, "Natural Capital, Ecosystem Services and the Historic Environment."
44. See for e.g. CCRI, *Heritage, natural capital and ecosystem services: Historic Buildings and Boundaries.*
45. Department for Digital, Culture, Media and Sport, *The Role of Culture, Sport and Heritage in place shaping.*
46. Department for Digital, Culture, Media and Sport, "£20 million government boost for culture and creative industries in England."
47. Department for Digital, Culture, Media and Sport, "Taking Part Focus on: Heritage."
48. National Lottery Heritage Fund, *20 years in 12 Places*, 25.
49. Visit Britain, "2017 Most Visited 20 Paid Attractions."
50. National Trust, *Annual Report 2017/18*, 71.
51. Taylor, "Racial and Ethnic Differences in Connectedness to Nature and Landscape Preferences Among College Students."

52. Nietzsche, *The Use and Abuse of History for Life*.
53. Smith, "Class, Heritage and the Negotiation of Place."
54. See note 47 above.
55. YouGov, "Should Notre-Dame be rebuilt exactly as before? Plus, emotional connection to buildings, and inverted snobbery results."
56. Aitchison and Rocks-Macqueen, *Archaeology Labour Market Intelligence: Profiling the Profession 2012–13*.
57. Atkinson et al, *Race, Ethnicity & Equality in UK History: A Report and Resource for Change*.
58. Arts Council, *Equality, Diversity and the Creative Case: A Data Report, 2017–2018*.
59. National Lottery Heritage Fund, *20 Years in 12 Places*, 32.
60. Hall, "Whose Heritage?: Un-settling 'The Heritage', re-imagining the Post-nation."
61. Historic England, Twitter post, 15 April 2018, 10:05 am https://twitter.com/HistoricEngland/status/985443884653268992.
62. See for e.g. Mount, 2015, "It's time to say No to our pampered student emperors"; and Robinson, 2016, "Oxford's Cecil Rhodes statue must fall – it stands in the way of inclusivity."

Disclosure statement

No potential conflict of interest was reported by the author.

Bibliography

Agnone, J. "Amplifying Public Opinion: The Policy Impact of the US Environmental Movement." *Social Forces* 85, no. 4 (2007): 1593–1620. doi:10.1353/sof.2007.0059.

Aitchison, K., and D. Rocks-Macqueen. *Archaeology Labour Market Intelligence: Profiling the Profession 2012–13*. Sheffield: Landward Research, 2013.

Anderson, B., T. Böhmelt, and H. Ward. "Public Opinion and Environmental Policy Output: A Cross-national Analysis of Energy Policies in Europe." *Environment Research Letters* 12 (2017): 114011: 3. Accessed May 19, 2019. https://iopscience.iop.org/article/10.1088/1748-9326/aa8f80/meta

Arts Council. "Equality, Diversity and the Creative Case: A Data Report, 2017-2018." 2018.

Atkinson, H., S. Bardgett, A. Budd, M. Finn, C. Kissane, S. Qureshi, J. Saha, J. Siblon, and S. Sivasundaram. "Race, Ethnicity & Equality in UK History: A Report and Resource for Change." Royal Historical Society, 2018.

BBC. "BBC Announces Major Initiative "plastics Watch" following the Global Impact of Blue Planet II." BBC Media Centre. June 23, 2018. Accessed April 17, 2019. https://www.bbc.co.uk/mediacentre/latestnews/2018/plastics-watch

BBC Pulse Survey, as reported by BBC. "BBC Announces Major Initiative 'plastics Watch' following the Global Impact of Blue Planet II." BBC Media Centre. June 23, 2018. Accessed April 17, 2019. https://www.bbc.co.uk/mediacentre/latestnews/2018/plastics-watch

CCRI. "Heritage, Natural Capital and Ecosystem Services: Historic Buildings and Boundaries." Accessed May 10, 2019. http://www.ccri.ac.uk/heritage-natural-capital-and-ecosystem-services-historic-buildings-and-boundaries/

Congleton, R. "The Median Voter Model." In *The Encyclopedia of Public Choice*, edited by C. K. Rowley and F. Schneider, 707-712. Boston, MA: Springer US, 2004.

Department for Business, Energy and the Industrial Strategy. "Energy and Climate Change Public Attitudes Tracker: Wave 25." BEIS Public Attitudes Tracker. April 26, 2018. Accessed May 19, 2019. https://www.gov.uk/government/statistics/energy-and-climate-change-public-attitudes-tracker-wave-25

Department for Digital, Culture, Media and Sport. "Focus On: Wellbeing." Taking Part 2014/15: "Focus On.." reports. 2015. Accessed May 19, 2019. https://www.gov.uk/government/statistics/taking-part-201415-focus-on-reports

Department for Digital, Culture, Media and Sport. "The Role of Culture, Sport and Heritage in Place Shaping." Trends Business Research Ltd, NEF Consulting Ltd and Middlesex University. 2016.

Department for Digital, Culture, Media and Sport. "Taking Part Focus On: Heritage." Taking Part October 2017: "Focus On…" Reports. 2017. Accessed May 18, 2019. https://www.gov.uk/government/statistics/taking-part-october-2017-focus-on-reports

Department for Digital, Culture, Media and Sport. "£20 Million Government Boost for Culture and Creative Industries in England." June 21, 2018. Accessed May 10, 2019. https://www.gov.uk/government/news/20-million-government-boost-for-culture-and-creative-industries-in-england

Department for Environment, Food and Rural Affairs. "World Leading Microbeads Ban Comes into Force." June 19, 2018. Accessed May 18, 2019. https://www.gov.uk/government/news/world-leading-microbeads-ban-comes-into-force.

Department for Environment, Food and Rural Affairs. *The Natural Choice: Securing the Value of Nature*. London: TSO, 2011. Accessed May 10, 2019. https://www.gov.uk/government/uploads/system/uploads/attachment_data/file/228842/8082.pdf

Department for Environment, Food and Rural Affairs. "Charges for Single-use Plastic Carrier Bags." July 21, 2015. Accessed April 19, 2019. https://www.gov.uk/government/collections/carrier-bags

Department for Environment, Food and Rural Affairs. "A Green Future: Our 25 Year Plan to Improve the Environment." 2018. Accessed April 17, 2019. https://www.gov.uk/government/publications/25-year-environment-plan

Department for Environment, Food and Rural Affairs. "Health and Harmony: The Future for Food, Farming and the Environment in a Green Brexit." 2018. Accessed May 18, 2019. https://www.gov.uk/government/consultations/the-future-for-food-farming-and-the-environment

Department for Environment, Food and Rural Affairs. "Single-use Plastics: Budget 2018 Brief." October 29, 2018. Accessed April 19, 2019. https://www.gov.uk/government/publications/single-use-plastics-budget-2018-brief

Department for Environment, Food and Rural Affairs. "World-leading Microbeads Ban Takes Effect." January 9, 2018. Accessed April 17, 2019. https://www.gov.uk/government/news/world-leading-microbeads-ban-takes-effect

Department for Environment, Food and Rural Affairs. "Consultation on Consistency in Household and Business Recycling Collections in England." February 18, 2019. Accessed April 19, 2019. https://consult.defra.gov.uk/environmental-quality/consultation-on-consistency-in-household-and-busin/

Department for Environment, Food and Rural Affairs. "Consultation on Plastic Packaging Tax." February 18, 2019. Accessed April 19, 2019. https://consult.defra.gov.uk/environmental-quality/plastic-packaging-tax/

Department for Environment, Food and Rural Affairs. "Consultation on Proposals to Ban the Distribution And/or Sale of Plastic Straws, Plastic - Stemmed Cotton Buds and Plastic Drink

Stirrers in England." October 22, 2019. Accessed April 19, 2019. https://consult.defra.gov.uk/waste-and-recycling/plastic-straws-stirrers-and-buds/

Department of Digital, Culture, Media and Sport. "Heritage Statement 2017." December 4, 2017. Accessed April 17, 2019. https://www.gov.uk/government/publications/the-heritage-statement-2017

FAO, J. Bélanger and D. Pilling, eds. *The State of the World's Biodiversity for Food and Agriculture*. Rome: FAO Commission on Genetic Resources for Food and Agriculture Assessments, 2019. Accessed May 14, 2019. http://www.fao.org/3/CA3129EN/CA3129EN.pdf

Fluck, H. and V. Holyoak. "Natural Capital, Ecosystem Services and the Historic Environment." Historic England Research Report Series 19/2017, 2017.

Gove, M. "Twitter Post." 6:37pm. November 20, 2017. Accessed April 17, 2019. https://twitter.com/michaelgove/status/932679274812854273

Hall, S. "Whose Heritage?: Un-settling 'The Heritage', Re-imagining the Post-nation." *Third Text* 49, Winter (1999-2000): 6.

Heritage Lottery Fund. "New Ideas Need Old Buildings." 2013. Accessed May 10, 2019. https://www.heritagefund.org.uk/publications/new-ideas-need-old-buildings

Historic England. "Heritage Counts: Heritage and the Economy." 2018. Accessed May 10, 2019. https://historicengland.org.uk/research/heritage-counts/heritage-and-economy/

Historic England. "Historic England Corporate Plan 2018-21." 18, 2018. Accessed April 17, 2019. https://historicengland.org.uk/images-books/publications/he-corp-plan-2018-21/

Historic England. "Twitter Post." 10:05 am. April 15, 2018. Accessed April 17, 2019. https://twitter.com/HistoricEngland/status/985443884653268992

HM Treasury. "Main Supply Estimates 1999-2000." 142–147. London: HMSO, 1999. Accessed April 17, 2019. https://webarchive.nationalarchives.gov.uk/20130402195912/http://www.hm-treasury.gov.uk/main_supply_estimates_9900.htm

HM Treasury. "The Green Book: Appraisal and Evaluation in Central Government." 2018. Accessed May 18, 2019. https://www.gov.uk/government/publications/the-green-book-appraisal-and-evaluation-in-central-governent

House of Commons. "Hansard Online, Search Using Term "Blue Planet" 1st Sept 2017 – 1st February 2018." Accessed May 18, 2019. https://hansard.parliament.uk/search?startDate=2017-09-01&endDate=2018-02-01&searchTerm=%22blue%20planet%22&partial=False

IPCC. "Global Warming of 1.5°C. An IPCC Special Report on the Impacts of Global Warming of 1.5°C above Pre-industrial Levels and Related Global Greenhouse Gas Emission Pathways, in the Context of Strengthening the Global Response to the Threat of Climate Change, Sustainable Development, and Efforts to Eradicate Poverty." Geneva, Switzerland: World Meteorological Organization, 2018. Accessed May 19, 2019. https://www.ipcc.ch/sr15/

Lloyd-James, O. "The Tenth Report on Local Authority Staff Resources." Historic England. 2018. accessed April 17, 2019. https://historicengland.org.uk/images-books/publications/tenth-report-la-staff-resources/

Mount, H. "It's Time to Say No to Our Pampered Student Emperors." The Telegraph. December 29, 2015. Accessed May 18, 2019. https://www.telegraph.co.uk/education/educationopinion/12073349/Its-time-to-say-No-to-our-pampered-student-emperors.html

National Audit Office. "Departmental Overview: Department for Digital, Culture, Media and Sport, 2017-18." 2018. (Accessed April 17, 2019. https://www.nao.org.uk/report/departmental-overview-department-for-digital-culture-media-and-sport-2017-18/

National Lottery Heritage Fund. "20 Years in 12 Places." 25. 2015.

National Trust. "Annual Report 2017/18." 71. 2018.

National Trust. "Places that Make Us." 2018. Accessed May 18, 2019. https://www.nationaltrust.org.uk/stories/why-do-places-mean-so-much

Nietzsche, F. "The Use and Abuse of History for Life." 1874.

Page, B. "New Research Reveals the Power of Blue Planet II and How It's Changed Attitudes and Behaviour." Ipsos MORI. February 6, 2019. Accessed May 18, 2019. https://www.ipsos.com/ipsos-mori/en-uk/new-research-reveals-power-blue-planet-ii-and-how-its-changed-attitudes-and-behaviour

Robinson, Y. "Oxford's Cecil Rhodes Statue Must Fall – It Stands in the Way of Inclusivity." The Guardian. January 19, 2016. Accessed May 18, 2019. https://www.theguardian.com/commentisfree/2016/jan/19/rhodes-fall-oxford-university-inclusivity-black-students

Shum, R. "Can Attitudes Predict Outcomes? Public Opinion, Democratic Institutions and Environmental Policy." (2009): 281–295. doi:10.1002/eet.518.

Smith, L. "Class, Heritage and the Negotiation of Place." Conference: Missing Out on Heritage: Socio-Economic Status and Heritage Participation, at English Heritage, London, March, 2009.

Taylor, D. E. "Racial and Ethnic Differences in Connectedness to Nature and Landscape Preferences among College Students." *Environmental Justice* 11, no. 3 (2018): 118–136. doi:10.1089/env.2017.0040.

UK National Ecosystem Assessment. "The UK National Ecosystem Assessment: Technical Report." UNEP-WCMC. Cambridge, 2011.

Visit Britain. "2017 Most Visited 20 Paid Attractions." Annual Survey of Visits to Visitor Attractions. 2017. Accessed May 18, 2019. https://www.visitbritain.org/annual-survey-visits-visitor-attractions-latest-results.

Waitrose & Partners, Food & Drink Report 2018-19. November, 2018. Accessed May 19, 2019. https://waitrose.pressarea.com/pressrelease/details/78/NEWS_13/10259

Watts, J. "We Have 12 Years to Limit Climate Change Catastrophe, Warns UN." The Guardian. October 8, 2018. Accessed May 10, 2019. https://www.theguardian.com/environment/2018/oct/08/global-warming-must-not-exceed-15c-warns-landmark-un-report

Webster, B. "UN: Western Lifestyles Must Change to Avoid Catastrophe, Says UN." The Times. May 7, 2019. Accessed May 10, 2019. https://www.thetimes.co.uk/article/rich-countries-must-halt-consumption-un-extinction-report-warns-gdvkdbzs2

What Works Wellbeing. "Heritage and Wellbeing: The Impact of Historic Places and Assets on Community Wellbeing – A Scoping Review." Quotation from blog post accompanying publication. 2019. Accessed May 19, 2019. https://whatworkswellbeing.org/blog/heritage-and-wellbeing/?mc_cid=16ce68eedd&mc_eid=9a31f69150

YouGov. "Should Notre-Dame Be Rebuilt Exactly as Before? Plus, Emotional Connection to Buildings, and Inverted Snobbery Results." Survey Results. April 16, 2019. Accessed May 18, 2019. https://yougov.co.uk/opi/surveys/results#/survey/8d5c1ec9-602d-11e9-a559-57f9c67f2c8a/question/e83ac0b9-602d-11e9-88a5-3f19d4e08dae/social

Always on the Receiving End? Reflections on Archaeology, Museums and Policy

Gail Boyle

ABSTRACT

The Society for Museum Archaeology (SMA) is a Subject Specialist Network for British Archaeology in the UK. Founded in 1975, it was originally formed because of a perceived need for a political voice at a time of evolutionary change in the role for museums relative to the archaeological profession. Since then the role of museum archaeologists has been transformed by policies and other agendas not of their own making. As a consequence, the profession faces multiple challenges requiring new strategies to be formulated and there have been fundamental changes in the way that museums participate in a more professionalised yet compartmentalised fieldwork process. In particular museums have had to deal with the results of changing attitudes towards the preservation and recording of archaeological sites and the introduction of new planning policy. As a result, new standards have evolved, professional groupings formed and resources stretched to breaking point. SMA has been working collaboratively towards finding solutions to the shared challenges the profession faces as a result of policy. Observations on the response to some of these challenges are illustrated here using SMA's newsletters and other publications and commentary provided on recent approaches that have been taken to resolving them.

Finding a Voice

The role of museums within the wider archaeological process has always been one of constant evolution. The Society for Museum Archaeology (SMA) membership newsletter, 'The Museum Archaeologist' (latterly 'Museum Archaeologists News'), is an invaluable source of social commentary on this evolutionary process. Significantly, the less formal nature of this publication may have afforded its contributors the opportunity to provide more candid views than would have otherwise been the case. It is possible therefore, for readers of the newsletter's back catalogue to gain contemporary insight in to the development of sector-wide policy, its relationship to museum archaeological practice and to understand the historic context for the situation that prevails today.

The first edition of The Museum Archaeologist enabled the Society's then Chairman, Kenneth Barton, to explain why a museum archaeologists group needed to exist at all:

... we are forced by circumstances to meet to defend our professional status. We are under threat from field archaeologists who are setting up conservation and display units ... ' and that 'This unfortunate chain of events has been brought about by the rapid development of Archaeological Rescue Units ... '[1]

An Uneasy Relationship

The origin of the uneasy relationship that existed at that time, between museum-based archaeologists and 'Independent Units' (IUs), was explored in a paper produced and read to the Society by Thomas Hassall in 1977.[2] The Standing Conference of Unit Managers had been established the previous year and of its 80 or so members, approximately 30 were 'independent', i.e. not affiliated to pre-existing organisations such as museums. Hassall identified three areas of difficulty in the relationship between IUs and museums: policy-making, implementation and data storage, of which the latter was deemed to be the most critical, 'The interrelationship between IUs, which for the most part do not claim long-term curatorial responsibility for their archives and museums is obviously of fundamental importance both to the IUs themselves and museums.'[3]

Professional existential concern over the role that museum archaeologists played within the archaeological process continued to be articulated and protested in the following years. In 1979, Gareth Davies, then Director and Keeper at St Albans Museums and an SMA committee member, wrote:

> Is the museum archaeologist merely the caretaker of a warehouse? Why do archaeologists draw up important policy statements without mentioning the possible contribution of museums? Clearly, if museums are to regain in British archaeology the role they lost by failing to respond to the "rescue crisis", they must adopt much more positive attitudes to collection policies (particularly with rescue excavation material and treasure hunting) and must acquire a firmer voice in local planning decisions.[4]

Museum archaeologists would hope that by now most people would appreciate them being rather more than 'caretakers', but nevertheless it is true that they still have much more to do to demonstrate what they do professionally. One way this has been addressed recently was by the development of a 'specialist competence matrix'.[5] This was primarily written to support applicants who work in museum archaeology when applying for accreditation by the Chartered Institute for Archaeologists (CIfA). Nevertheless, although the matrix provides insight into the types of work museum archaeologists do and the experience, knowledge and skills they might demonstrate, it does not explain their role relative to the overall archaeological profession.

Rescue and Museums

With regard to the 'rescue crisis' referenced by Davies, rescue excavations paid for by central government, 'became a recognised policy before the 1939–45 war' and accounted for approximately 1000 excavations between 1938 and 1972.[6] Museums continue to house the products of these excavations, which were often undertaken entirely independently of them. Since then the role of museum-based archaeologists in the practical delivery of fieldwork has become increasingly more remote. The development control system that exists today places archaeological investigation firmly within

the planning process and most fieldwork is undertaken by commercial units in response to it. This means that with very few exceptions, museum archaeologists are the curators of archives produced by others rather than being their creators. Similarly, the role of the amateur excavator has also become increasingly marginalised. Bristol's experience may be taken as an example to illustrate this. The first excavation undertaken on behalf of the city with the direct involvement of the Bristol Museum Committee took place as early as 1899, when the site of a Roman villa was discovered in Brislington.[7] In the late 1940s it was the Museum Committee that took responsibility for the acquisition and preservation of Kings Weston Roman Villa, revealed during the construction of a post-war housing estate and excavated by students.[8] By the late 1960s and until 1992, Bristol Museum & Art Gallery hosted the city's field archaeology unit and after this Bristol & Regional Archaeological Service (BaRAS) as a self-financing arm of the museum.[9] Sadly all fieldwork undertaken by BaRAS ceased in 2016 when the unit was decommissioned. Since the mid-1980s, however, the curatorial team charged with the care of Bristol's archaeological collections, has had no direct practical involvement with fieldwork activity. Nevertheless, it is still responsible for collecting and curating archives produced by others within the museum's agreed collecting area. With only one or two exceptions, none of the archives that have been collected in the last 25 years have been produced by amateur groups. To put this into context the museum has agreed to collect on average 75 archives per year for the last 10 years.

Adapting to Change

The consequences of rescue archaeology and issues arising from the growth in fieldwork activity dominate the topics of conversation in SMA's earlier newsletters. The sad fact is that many of these contributions read as if they were written in the recent past rather than decades ago, which is perhaps indicative of the lack of progress being made in some areas. Dealing with the product of so many projects of variable size and quality necessarily required the development of, and improvements to, standards in recording, curation and interpretation. In 1986 the SMA newsletter editor reported that:

> 'SMA was recently at a meeting of SCAUM (Standing Conference of Archaeological Unit Managers) to discuss the possibility of preparing (in association with SMA and UKIC) a series of criteria for excavation units on the preparation of excavation archives for deposit in approved museums.' [10]

Two years later the draft paper relating to these proposed criteria was discussed and 'concern was expressed over the lack of consultation with museums inherent throughout the document.'[11] By this time, however, the winds of change had seriously begun to blow, 'It has become clear that the government and its agencies, using a language of 'competition', 'privatisation', and 'marketing' wish to divest themselves of responsibility for funding many public services and want to make them pay for themselves."[12]

The need to adapt to change and its response to 'circumstances beyond the control of the profession' were the focus of SMA's annual conference in 1991.[13] Those circumstances included the introduction of government policies relating to compulsory competitive tendering and the effect of economic recession. On the one hand museum archaeologists and others were trying to put their houses in order by professionalising

their practice and on the other, having to navigate major changes in the public sector within which they operated.

Introducing Standards

With regard to the need to professionalise practice, one of the most important challenges that faced both units and museums related to the effective compilation and curation of archives. Clearly there was a need to ensure that the products of archaeological investigations. i.e. archives, were compiled in such a way that they might provide appropriate and detailed records of sites that would essentially be destroyed by excavation, and so that record could be re-examined in the future. Similarly challenging, was the practical deposition process by which archives were transferred to museum stores in ways that enabled them to be curated in the most efficient way, as well as providing access to them. By the early 1990s a long list of advisory notes, reports and guidelines had begun to be produced by a wide variety of organisations. These included those that reflected growth in standardisation of the management of archaeological archives in museums, for example, 'Standards in the Museum Care of Collections' produced by the Museums and Galleries Commission in 1992 and which contained a whole section on the preparation and transfer of archaeological archives.[14] SMA also published 'Selection, Retention and Dispersal of Archaeological Collections' in 1993, which particularly referenced, 'The lack of a unified framework for museums and archaeology at either local or national level ... '[15]

The role of the county, field and museum archaeologists, as well as the requirement to formulate sector-wide standards and guidance, continued to be explored by SMA and others. However, it was not until 2007 that a guide to best practice in creation, compilation, transfer and curation was produced by Duncan H. Brown, who had 'for many years championed standards for archaeological archives in Southampton' and on behalf of SMA.[16] Building upon previous work, this guide represented a major step forward both for those producing archives and for those receiving them. It is worth noting here that a European standard has now been produced, which aims 'to make archaeological data, information and knowledge available, stable, consistent and accessible for present and future generations.'[17] The impact of this work can be demonstrated by results from SMA's most recent survey of museums collecting archaeological archives, which showed that of those institutions that continue to collect archives, 86% do so in accordance with an agreed set of deposition guidelines.[18] Unfortunately, as yet, there is no standard format for these guidelines, in part because they usually refer to individual organisational need, custom and practice but also because they have grown organically in response to changes in the way that archaeological projects are managed and delivered through the planning process. More recently, some museums, for example those in Gloucestershire, have started to create 'countywide' standards for deposition although it is acknowledged that 'a completely uniform approach to the preparation and deposition of Archaeological Archives in Gloucestershire is not entirely possible as individual Museums have some site-specific arrangements.'[19]

Development-led Archaeology

Whilst the consequences of rescue archaeology had initiated both challenges and change in the delivery of archaeological projects, this was nothing in comparison to

those that museums and the archaeology profession faced as a result of changes to the planning system. *'Planning Policy Guidance 16: Archaeology and Planning'* (PPG16) was a document published in November 1990 that 'set out the Secretary of State's policy on archaeological remains on land, and how they should be preserved or recorded both in an urban setting and in the countryside'.[20] This was produced in response to growing concerns and evidence which demonstrated that important archaeological and heritage sites were not only being discovered but also destroyed by urban development. In short, PPG16 enabled archaeology to become integral to the planning process and 'this arrangement became known as development led'.[21] Although PPG16 was cancelled in 2010, its principles have been carried forward in to the current planning framework. Now, more often than not, archaeological investigation takes place as a condition tied to planning permission, with the work being undertaken by commercial excavation units and paid for by the developer.

Museums and PPG16

Three months after PPG16 was published, Mark Davies (Colchester Museums) presented a paper on behalf of SMA at a seminar organised by the Institute of Field Archaeologists' finds group on storage and curation of archives.[22] Davies noted 'whatever other players are involved in the game; museum-based archaeologists always have to catch the ball at some point and do something constructive with it, even if they did not start the ball-rolling in the first place.' The ball which started rolling with regard to PPG16 and the preservation of sites by record has yet to stop.

The most serious omission of the policy was that it made no mention of preserving the archaeological record that would be produced as its result. The sheer scale of the record amassed over the 20-years of PPG16 is enormous. The Archaeological Investigations Project showed that there were more than 80,000 archaeological projects undertaken in England between 1990 and 2010 including over a 1000 excavations per year, and that '90% of recorded archaeological investigations resulted from the planning process or the determination of consent works in protected places.'[23] Although PPG16 was cancelled it was replaced by *'Planning Policy Statement 5: Planning for the Historic Environment'* (PPS5), which in turn was superseded by the National Planning Policy Framework (NPPF) and its subsequent revision, which 'sets out the Government's planning policies for England and how these should be applied.'[24] Paragraph 199 of the latter requires that evidence from archaeological investigations resulting from the development process, and any archive generated by them, should be made publicly accessible. In particular it is required that 'Copies of evidence should be deposited with the relevant historic environment record, and any archives with a local museum or other public depository.'[25] Irrespective of the provisions made for archaeological recording by these policies, there is no corresponding statutory requirement for museums, or any other organisation, to be responsible for collecting archives, yet collect they did and not without consequence.

Strain on Resources

Museums had long protested about the pressure on storage space resulting from rescue excavations and continued to do so after PPG16 was introduced. An editorial piece

published in SMA's newsletter in 1992 said 'Now, most museum stores are strained to bursting point and substantial resources would be needed to acquire the storage space required to house the material that will be offered to them in the future.'[26] Other concerns that were raised in the editorial included the lack of overall funding for the results of the development-led process and whether or not it was appropriate for museum funding bodies to have to pick up the bill. It is worth noting here that research undertaken by Rachel Edwards on behalf of SMA in 2012 showed that the majority of museums which currently collect, or have collected archaeological archives in the past, were either 'fully-funded or part-funded by local authorities'.[27] Herein another major flaw in the system: there is no statutory responsibility for local authorities to provide a museum, which means that provision for archaeological collecting is highly vulnerable to economic circumstance and varying political agendas. The results of SMA's annual surveys undertaken 2016–18 also confirmed that approximately half of all the museums that have archaeological collections continue to be provided by local authorities.[28] While there are clearly a number of factors at play, the reason cited most often for ceasing to collect was lack of space, followed by shortage of staff resource and then staff expertise.

It is likely that local authority funding cuts to museum provision have had, and will continue to have, a direct effect on museums' ability to continue to accept archaeological archives. The Museums Association's annual Museums Survey 2018 suggests no sign of improvement as there is 'continued pressure on local authority museum funding' and that 'local authority museums were much more likely to have made staffing cuts.'[29] Cumulatively data collected by Edwards, SMA and the Federation of Archaeological Managers and Employees makes stark reading since there are thousands of archives being held by units in England rather than in publicly accessible repositories.[30] Similarly, approximately two-thirds of those museums that currently collect archives have reported that their stores will be full in five years or less at their current rate of collecting.[31] The system whereby museums take responsibility for collecting archives resulting from the development process would appear to be at breaking point.

Sector Wide Consequences

In 2015 Historic England published *'Building the Future, Transforming our Past: Celebrating development-led archaeology in England, 1990–2015'*, which was produced to mark the 25th anniversary of the publication of PPG16 and to celebrate 'the contribution development-led archaeology is making to the cultural life of England.'[32] PPG16 was described as ' ... imaginative, pioneering and a great success.'[33] Since this was intended to be a celebratory account it is understandable that some of the challenges the policy brought with it in terms of delivery were not explored. It is without doubt that archaeological knowledge and professional practice have reaped rewards from development-led archaeology, but the system that currently exists due to planning policy is still proving to be unsustainable for museums and others.

Museums are not alone in experiencing shortfalls in capacity to deal with development-led archaeology. In 2014, SMA submitted evidence at the invitation of John Howell MP and Lord Redesdale as part of an inquiry into the future of local government archaeology services in England, which was commissioned by the then Minister for Culture, Communications and the Creative Industries, Ed Vaizey.[34] The review was

prompted by concerns that local authority archaeology and historic environment services in some areas of the country were failing to meet an adequate level of service provision relative to the planning system. Service levels were being reduced as a consequence of financial pressures bought about by the economic climate. Since, as referenced above, many museums that collect archaeological archives are provided by local authorities, SMA felt it appropriate to respond. It was one of at least 20 national organisations that submitted both written and oral evidence and many submissions referred to issues relating to deposition and long-term provision of care for archives. The report which resulted from the review was not published until September 2016. It acknowledged that the 'current situation was too burdensome for museums' and recommended that 'English Heritage engages further with the Arts Council England and the museum sector to pursue further strategies for selecting, retaining, housing and promoting access to archaeological archives which reduces the amount to be kept.'[35] This concurs with recommendations made in the Edwards report which said that a 'national strategy for the storage and curation of archaeological archives should be developed' and that accessibility of the resource required attention to be paid to storage, selection and retention as well as rationalisation of older collections.[36]

Accessibility and Expertise

One of the most important tenets of development-led archaeology is that the evidence which is produced as the result of investigation is made publicly accessible, as expressed in the National Planning Policy Framework. The lack of storage space in museums means units are unable to deposit archives and this renders increasingly larger parts of the archaeological record publicly inaccessible. Providing a solution to the storage problem is only one part of the accessibility equation. In order to ensure that archives are publicly accessible they should be managed by people who have the ability to unlock their potential for a wide variety of audiences and not just for those who are archaeologists. Safeguarding these collections and realising the greatest public benefit from them, requires more than a catalogue of their contents and a secure location with the correct environment. It requires curators with professional expertise appropriate to their care, display and interpretation, who are also capable of disseminating accumulated knowledge about them as well as delivering inspirational engagement opportunities. Museum closures and reduction in staffing due to austerity measures are regularly being reported in the press and in some cases curatorial posts are being replaced with those that have a learning or community engagement focus.[37] However, the need for retention of specialist collection knowledge and skills was recognised in the *'Character Matters: Attitudes, behaviours and skills in the UK Museum Workforce'* report published in 2016, which said 'There are challenges to future skills development particularly around retaining and protecting specialist knowledge and heritage-specific skills while broadening roles and encouraging collaboration.'[38] Sadly data from SMA's annual surveys suggests that there are many museums with archaeological collections that no longer have this type of expertise.[39] Respondents to the surveys reported a drop in the number of staff engaged in the care of archaeological materials of between 29–36% since 2010 and only about 50% employ a curator with expertise. For those that do not have expertise, the capacity to maintain public accessibility of the archives they care for will either be non-existent or challenging at best.

A Fragmented Profession

It is clear that over time museum archaeologists and the wider archaeology sector bodies have been more than able to identify specific challenges they face as the result of changes to policy but they have yet to find overarching solutions. This has not been helped by professional fragmentation within the sector itself, with a wide variety of constituent practitioner bodies and authorities, each with their own policies and agendas. There is no single overarching body that speaks for, or represents all. Although the Chartered Institute for Archaeologists, for example, represents itself as the 'leading professional body representing archaeologists working in the UK and overseas', its membership and activities still largely reflect its beginnings as the Institute of Field Archaeologists.[40] Archaeologists with development control, historic environment or conservation roles working in local authorities and national parks are represented by the Association of Local Government Officers (ALGAO), and The Federation of Archaeological Managers and Employers (FAME) represents archaeological businesses, commercial consultancies, universities, local authorities and charitable trusts. Then there is Historic England, English Heritage, the Council for British Archaeology, the National Trust and so on and so forth: the list is seemingly endless. The need for a 'single authoritative voice for the discipline' was articulated in the British Academy report *'Reflections on Archaeology'* published in 2017.[41] This report, which resulted from three round table sessions held at the Academy the previous year, noted that 'urgent action is required to ensure that the UK's fragile archaeological resource continues to be protected and promoted for research, education and public enjoyment'.[42] It is entirely possible that the planning policy which sought to protect, preserve and promote the archaeological resource, and which has done so in many cases, will contribute to and may ultimately be responsible for breaking the system that manages the long-term curatorial care of the archives it produces.

Providing Guidance

SMA has continually responded to and participated in initiatives that have attempted to assess problems and to find solutions and it is obvious from its newsletters that it has used as many platforms as it possibly can to do this. The key to finding answers to sector-wide problems will be in part to work collaboratively with other organisations, but also for SMA to continue gathering the data it needs to inform change and to produce guidance on best practice. With regard to the latter, the Society has recently published practical guidance on the rationalisation of archives since this has been suggested as one way of alleviating the storage problem.[43] The work that was undertaken to inform the guidance proved to be an effective way of testing the potential impact of rationalisation and in this respect it was found to be a time, resource and cost heavy process. Furthermore, the results of each of the five case-studies, upon which the guidance was based, showed that rationalisation was not an effective way of releasing enough storage space for the continued long-term acquisition of archives.[44]

Working Together Better: Regionally

In terms of collaborative work, the baseline data SMA has collated relating to the current state of collecting in museums has begun to inform many discussions on the future of museum archaeology collections and the resolution of the problem of un-deposited

archaeological archives. Activity has been taking place at both a regional and national level and it is clear that opinions and real-world experience of museum archaeologists are now being both sought and absorbed. At a regional level, archaeologists across South West England came together in 2016 to begin to discuss what could be done to formulate, and then implement, a consistent methodology for the deposition of archive material from sites across the region. The aim was to examine the process from each practitioner group perspective, from development control through to deposition. The initial discussion resulted in the 'Seeing the Light of Day' project funded by Arts Council England (ACE), which aimed 'to develop sustainable solutions for archaeological archives.'[45] Aside from the recommendations that resulted from the project, the most important outcome was that it provided a platform for communication between many of the practitioners that had not really existed before. It will be difficult for archaeologists to find solutions if they continue to fail to break free from working in the professional silos that began to evolve more than forty years ago.

Working Together Better: Nationally

From a national perspective there have been a number of recent initiatives that may provide breakthroughs. In 2017, a series of workshops were organised by the Chartered Institute for Archaeologists, in partnership with and funded by Historic England as part of the '21st-century Challenges for Archaeology' project, which had 'its origins in the aftermath of the celebration of the 25-year anniversary of Planning Policy Guidance 16 ... '[46] Significantly 'The order of the discussions was determined in part by the then impending government review of museums and the need to engage early with the topic of archaeological archives in order to input to this review.'[47] The first workshop 'New models for archive creation, deposition, storage, access and research' addressed what the sector could do to redefine the archaeological archive and realise its public value and the discussion was informed by SMA's survey data throughout. The impending museum review was due to be undertaken in response to the Culture White Paper of 2016. Subsequently *The Mendoza Review: an independent review of museums in England'* outlined key recommendations relating to government support for the museums sector in England.[48] Importantly one of its recommendations was for Historic England to 'Work with key stakeholders to produce recommendations for DCMS early in 2018, which will improve the long-term sustainability of the archaeological archives generated by developer-funded excavations'.[49]

The fact that archaeological archives had been referenced at all was testament to the responses which were submitted to inform the report by a wide variety of archaeology and heritage bodies. While the sector may not have a single authoritative body that speaks on its behalf, its constituent bodies are now beginning to advocate for each other with consistent messaging. SMA's data had in part informed these submissions and was then used again to inform Historic England's response to the requirement that had also been placed upon it.[50] The 'task and finish' group that was convened to support Historic England in delivering its response included representatives from a wide number of bodies. This approach ensured consensus on the sector-wide problems and shared priorities which needed to be addressed. It also took full account of the museum archaeological perspective in a way that had not happened so readily when SMA was first formed.

A Brighter Future?

It is likely that Historic England's response to the museum review, and the Minister's full acceptance of it, will have far-reaching and positive effects. The fact that government has endorsed its content provides momentum for change to occur in many areas and for deficiencies in policy and practice to be addressed. The response presented six key recommendations and an action plan produced collaboratively by Historic England, ACE, SMA and others. Some of the actions have already been completed. Others are being monitored for progress and further intelligence gathering has begun to help inform the business case for change that will need to be implemented.

Clearly one of the most important priorities is to find a strategic and economically viable approach to the provision of additional storage. In 2012 Edwards said, 'Possible solutions have been put forward, including the establishment of archaeological resource centres; regional storage facilities shared between different institutions, and/or more rigorous selection strategies.'[51] One of these solutions, in the form of 'resource centres', had been advocated by the Southport Group in a report published the previous year.[52] This group was formed at the Chartered Institute for Archaeologists conference in Southport in 2010 and consisted of a number of individuals representing a wide variety of professional organisations involved in the development-led process. Produced as a response to perceived opportunities presented by PPS5 principles, it presented a vision for the future that included 'a network of resource centres, related to existing museum structures and supporting appropriate expertise, that curate archaeology collections (records and material) and provide access to all types of information on the historic environment for a wide variety of users.'[53] PPS5 was unfortunately to be short-lived and a recent report by Taryn Nixon has shown that although progress was made against many of the Southport Group's recommendations, 'its overall vision has not been reached.'[54] Nevertheless, the possibility still exists for some of its aspirations to be realised, although perhaps not in the way they were originally articulated. For example, Recommendation 2 of Historic England's response to the Mendoza Review was to request that the Department of Digital, Culture, Media and Sport ask ACE and others to work together to deliver a feasibility study.[55] The study is required to look at models for establishing additional strategic storage capacity for archaeological archives, which might act in support of existing museum provision. It is unlikely that the study will be able to provide a 'one-size fits all solution' but it will focus on looking at how extra capacity might be delivered regionally and/or nationally in publicly accessible repositories. It is not hard to imagine that these may, if they come to fruition, take the form of the archaeological resource centres aspired to by the Southport Group.

One important aspect to note here is that Historic England made a direct link between the feasibility study and SMA's recently adopted definition of a publicly accessible repository, which emphasises that such repositories should be 'capable of providing physical and intellectual access to stored collections and their associated data to a wide and diverse range of audiences.'[56] Although the NPPF makes reference to such repositories, there has been no guidance as to what characteristics such a facility would have. SMA sought to produce a definition that encapsulated standards, management, development and public benefit as follows:

> An accredited repository for the collection, curation and safe-guarding of archaeological archive material which is pro-actively managed and developed by staff qualified to ensure continued public engagement with, and the best possible access to the archaeological resource, for the purposes of enquiry, exhibition, learning, research, inspiration, enjoyment and general interest.

Commercial storage models will also be examined as part of the feasibility study and whilst they may be able to provide additional resource these, and the other models, will be tested against the SMA's definition relative to public benefit and accessibility.

Significantly the definition does not describe these repositories as museums. This is because SMA acknowledges that there are already other models for the management and care of this type of collection. For example, there are archive stores that are not managed by museums but which act as the primary archaeological archive repository for their area such as that provided by Cambridgeshire County Council Historic Environment Team. The definition also does not preclude the use of commercial 'deep- storage' type facilities to provide additional capacity, so long as the material stored within them is managed pro-actively and professionally for the purposes described, and that the material is publicly accessible. The skillsets and expertise required to do this accord well with those expressed in the matrix of competence referenced above. In this respect there may be a future where individuals with museum archaeological skills take responsibility for managing archaeological archives but not necessarily within a museum setting.

A Shared Responsibility

There is clear evidence therefore that in recent years the responsibility for finding a solution to dealing with the product of development-led archaeology has started to become a shared one. There equally appears to be a growing desire for all practitioners within this process to support each other in promoting positive change and to embrace different ways of working together. The professional silo mentality is beginning to break down. SMA's need to find a political voice more than forty years ago enabled it to be heard in some quarters, but now it is one of many that finally appear to be coming together as a much larger collective professional voice. Acting in partnership with other organisations, and particularly through the auspices of The Archaeology Forum, has enabled SMA's data and comments to be made available to, for example, members of the All Party Parliamentary Archaeology Group and for those issues to be raised at a government level and in parliamentary debate.[57] Since many of the issues outlined above have arisen because of changes to planning policy, it is incumbent on the profession to continue to make its voice heard amongst those that have the power to revise those policies, or at least enable them to understand the consequences. In April 2019, ALGAO produced a report which had been prompted by a raft of other initiatives including the CIfA Twenty First Century Challenges for Archaeology Project and the Mendoza Review. The *'Planning for Archives: Opportunities and Omissions'* project aimed to 'understand the relationship between the National Planning Policy Framework (locally interpreted and applied) and supporting documentation, and the creation and management of archaeological archives.'[58] Amongst other findings, the report highlights the fact that neither the NPPF nor its associated guidance provides definitions of what

an 'archaeological archive' is or what 'publicly accessible' means.[59] The report goes on to suggest that all organisations who represent the sector should lobby for these definitions to be added to the guidance when it is revised and that one of the definitions which should be adopted is that produced by SMA with reference to publicly accessible repositories. Although the revision date for guidance has not yet been published, the call to arms has been issued. It will be for all those with an interest in archaeology and museums to engage with policy with one voice, for after all they are all archaeologists with a shared vested interest in the outcome.

Notes

1. Barton, "Chairman's Comments," 2.
2. Hassall, "Museums and Field Archaeology," 2–10.
3. Ibid., 3.
4. Davies, "Museums and Archaeology," 123–5.
5. Society for Museum Archaeology, "Specialist Competence Matrix".
6. Butcher and Garwood, *Rescue Excavation*, 7.
7. Barker, "Remains of a Roman Villa," 78–97.
8. Boon, "The Roman villa in Kingsweston Park," 5–58.
9. Jones, "Bristol," 190.
10. Society of Museum Archaeologists, "SCAUM," 1.
11. Society of Museum Archaeologists, "News from Committee," 2.
12. Society of Museum Archaeologists, "Editorial," 1.
13. Southworth, "Foreword," paragraph 2.
14. Museums and Galleries Commission, *Standards for preparation*, 15–18.
15. Society of Museum Archaeologists, *Selection, Retention and Dispersal*, 3.
16. Brown, *Archaeological Archives*, 3.
17. Perrin et al, *Standard and Guide*, 11.
18. Booth, Boyle and Rawden, "Museums Collecting Archaeology," 27–29.
19. Paul, "Gloucestershire Archaeological Archive Standards," 1.
20. DCLG, *Planning Policy Guidance 16*, 3.
21. Nichols, *Building the Future*, 1.
22. Davies, "Excavation Archives," 8.
23. Darvill et al, *Archaeology in the PPG16 Era*, summary.
24. MHCLG, "National Planning Policy Framework," 4.
25. Ibid., Footnote 64.
26. Society for Museum Archaeologists, "Editorial: Standards, Archives & Collections," 1.
27. Edwards, *Archaeological Archives & Museums*, 20.
28. Booth, Boyle and Rawden, "Museums Collecting Archaeology," 3.
29. Museums Association, "Museums in the UK: 2018," 5.
30. Edwards, *Archaeological Archives & Museums*, 8.
31. Booth, Boyle and Rawden, "Museums Collecting Archaeology," 3.
32. Nichols, *Building the Future*, 1.
33. Ibid., 4.
34. CIfA, "The Future of Local Government Archaeology," 94.
35. APPAG, "Future of Local Government Archaeological Services," 11.
36. Edwards, *Archaeological Archives & Museums*, 9.
37. Kendall Adams, "Subject Expertise and Public Engagement," 12–13.
38. BOP Consulting, *Character Matters*, 1.
39. Booth, Boyle and Rawden, "Museums Collecting Archaeology," 3.
40. CIfA, "Brief History," 1.
41. British Academy, *Reflections on Archaeology*, 43.

42. Ibid.,43.
43. Baxter, Boyle and Creighton, "Guidance on Rationalisation," 3.
44. Ibid., 35.
45. Fernie, McNulty and Dawson, "Seeing the Light of Day," 1.
46. Wills, "The World after PPG16," 4.
47. Ibid., 6.
48. Mendoza, *The Mendoza Review*, 12–18.
49. Ibid., 16.
50. Historic England, "Mendoza Review," 8.
51. Edwards, *Archaeological Archives & Museums*, 12.
52. Southport Group, "Realising the Benefits," 19.
53. Ibid., 19.
54. Nixon, "What about Southport," 2.
55. Historic England, "Mendoza Review," 2.
56. Society for Museum Archaeology, "Publicly accessible repositories," 1.
57. Hansard, HL Deb vol. 782, col.53GC.
58. Donnelly-Symes, "Planning for Archives," 5.
59. Ibid., 8.

Disclosure statement

No potential conflict of interest was reported by the author.

Bibliography

All Party Parliamentary Archaeology Group (APPAG). "The Future of Local Government Archaeology Services." 2014. http://www.appag.org.uk/future_arch_services_report_2014.pdf
Barker, W. R. "Remains of a Roman Villa Discovered at Bristol, December 1899." *Proceedings of the Clifton Antiquarian Club* V (1900–1903): 78–97.
Barton, K. J. "Chairman's Comments." *The Museum Archaeologist* 1 (1977): 2.
Baxter, K., G. Boyle, and L. Creighton "Guidance on the Rationalisation of Museum Archaeology Collections." Society for Museum Archaeology. 2018. http://socmusarch.org.uk/projects/guidance-on-the-rationalisation-of-museum-archaeology-collections/
Boon, G. C. "The Roman Villa in Kingsweston Park (lawrence Weston Estate) Gloucestershire." *Transactions of the Bristol & Gloucestershire Archaeology Society* 69 (1950): 5–58.

Booth, N., G. Boyle, and A. Rawden "Museums Collecting Archaeology (England) Report Year 3: November 2018." Society for Museum Archaeology. 2018. http://socmusarch.org.uk/socmusarch/gailmark/wordpress/wp-content/uploads/2019/04/HE-SURVEY-2018-TEMPLATE-FINAL.pdf

BOP Consulting & The Museum Consultancy. *Character Matters: Attitudes, behaviours and skills in the UK Museum Workforce*. Arts Council England, Museums Galleries Scotland, Museums Association and Association of Independent Museums, 2016. https://www.artscouncil.org.uk/sites/default/files/download-file/Character_Matters_UK_Museum_Workforce_full_report.pdf

British Academy. *Reflections on Archaeology*. London: British Academy, 2017. https://www.thebritishacademy.ac.uk/sites/default/files/Reflections%20on%20Archaeology%20report.pdf.

Brown, D. H. *Archaeological Archives: A Guide to Best Practice in Creation, Compilation, Transfer and Curation*. Institute for Field Archaeologists, 2007. https://archaeologydataservice.ac.uk/archiveDS/archiveDownload?t=arch-799-1/dissemination/pdf/Archives_Best_Practice.pdf.

Butcher, S., and P. Garwood. *Rescue Excavation 1938 to 1972*. English Heritage, 1994. https://archaeologydataservice.ac.uk/archiveDS/archiveDownload?t=arch-1416-1/dissemination/pdf/9781848021792_ALL.pdf.

Chartered Institute for Archaeologists (CIfA). "The Future of Local Government Archaeology Services: Collated Written Evidence (from National Bodies)." Chartered Institute for Archaeologists. 2017. http://www.archaeologyuk.org/archforum/NATIONAL%20BODIES%20EVIDENCE%20with%20cover%20note.pdf

Chartered Institute for Archaeologists (CIfA). "A Brief History of the Chartered Institute for Archaeologists." Chartered Institute for Archaeologists. Accessed May 18, 2019. https://www.archaeologists.net/sites/default/files/A%20brief%20history%20of%20CIfA.pdf

Darvill, T., K. Barrass, V. Constant, E. Milner, and B. Russell. *Archaeology in the PPG16 Era: Investigations in England 1990–2010*. Oxford: Oxbow Books, 2019.

Davies, D. G. "Museums and Archaeology - a Lost Cause?" *Museums.Journal* 78 (1978): 123–125.

Davies, M. "Excavation Archives – A Museum Perspective." *Museum Archaeologists News* 13 (1991): 8–11.

Department of Communities and Local Government (DCLG). *Planning Policy Guidance 16: Archaeology and Planning*. The Stationery Office, 1990. https://webarchive.nationalarchives.gov.uk/20120906045433/http://www.communities.gov.uk/documents/planningandbuilding/pdf/156777.pdf.

Donnelly-Symes, B., "Planning for Archives: Opportunities & Omissions." Historic England. 2019. https://historicengland.org.uk/images-books/publications/planning-for-archives/planning-for-archives/

Edwards, R., *Archaeological Archives & Museums 2012*. Society of Museum Archaeologists, 2013. http://socmusarch.org.uk/socmusarch/gailmark/wordpress/wp-content/uploads/2016/07/Archaeological-archives-and-museums-2012.pdf

Fernie, K., P. McNulty., and D. Dawson, "Seeing the Light of Day: Securing a Sustainable Future for Archaeological Archives. Summary Report." 2017. https://seeingthelightofday.files.wordpress.com/2017/10/summary-report-seeing-the-light-of-day-2017-10-26.pdf

Hansard, H. L. Deb. vol.782 col.53GC, 30 March 2017 (Online). Accessed May 18, 2019. https://hansard.parliament.uk/lords/2017-03-30/debates/37940467-E73D-4E6F-AF67-073061D65DEA/LocalArtsAndCulturalServices

Hassall, T. G. "Museums and Field Archaeology: The View of an 'independent' Unit Director." *The Museum Archaeologist* 2 (1977): 2–10. http://socmusarch.org.uk/socmusarch/gailmark/wordpress/wp-content/uploads/2016/07/The-Museum-Archaeologist-No.-2.pdf.

Historic England. "Mendoza Review: Historic England's Recommendations to DCMS on the Future of Archaeological Archives, March 2018." Historic England. 2018. https://historicengland.org.uk/content/docs/consultations/he-response-to-dcms-mendoza-review-mar18-pdf/

Jones, R. H. "Bristol." In *Twenty-Five Years of Archaeology in Gloucestershire. A Review of New Discoveries and New Thinking in Gloucestershire South Gloucestershire and Bristol 1979–2004*, edited by N. Holbrook and J. Jurica, 189–209. Cotswold Archaeology, 2013. https://cotswoldarchaeology.co.uk/wp-content/uploads/2011/07/Bristol-Gloucestershire-Archaeological-Report-No.-3r_part-5.pdf.

Kendall Adams, G. "Subject Expertise and Public Engagement Have to Co-exist." *Museums Journal* (May 2019). 119: 12–13.

Mendoza, N. *The Mendoza Review: An Independent Review of Museums in England*. Department for Digital, Culture, Media & Sport, 2017. https://assets.publishing.service.gov.uk/government/uploads/system/uploads/attachment_data/file/673935/The_Mendoza_Review_an_independent_review_of_museums_in_England.pdf.

Ministry of Housing, Communities and Local Government (MHCLG). *National Planning Policy Framework*. Her Majesty's Stationery Office, 2019. https://assets.publishing.service.gov.uk/government/uploads/system/uploads/attachment_data/file/779764/NPPF_Feb_2019_web.pdf.

Museums and Galleries Commission. *Standards in the Museum Care of Archaeological Collections*. Museums & Galleries Commission, 1992. https://326gtd123dbk1xdkdm489u1q-wpengine.netdna-ssl.com/wp-content/uploads/2016/11/Standards-in-the-museum-care-of-archaeological-collections.pdf.

Museums Association. "Museums in the UK: 2018 Report." Museums Association. 2018. https://www.museumsassociation.org/download?id=1244881

Nichols, L., ed. *Building the Future, Transforming Our Past: Celebrating Development-led Archaeology in England, 1990–2015*. Historic England, 2015. https://historicengland.org.uk/images-books/publications/building-the-future-transforming-our-past/building-future-transforming-past/.

Nixon, T., "What about Southport". Chartered Institute for Archaeologists. 2017. https://www.archaeologists.net/sites/default/files/What%20about%20Southport%20A%20report%20to%20CIfA%20against%20the%20vision%20and%20recommendations%20of%20the%20Southport%20report%202017_0.pdf

Paul, S., ed. *Gloucestershire Archaeological Archive Standards*. South West Museum Development Programme, 2017. https://www.archaeologists.net/sites/default/files/Gloucestershire%20Archaeological%20Archive%20Standards%20Version%201a%20January%202017.pdf.

Perrin, K., D. H. Brown, G. Lange, D. Bibby, A. Carlsson, A. Degraeve, M. Kuna et al. "A Standard and Guide to Best Practice for Archaeological Archiving in Europe: EAC Guidelines 1." Europae Archaeologiae Consilium. 2013. https://archaeologydataservice.ac.uk/arches/attach/The%20Standard%20and%20Guide%20to%20Best%20Practice%20in%20Archaeological%20Archiving%20in%20Europe/ARCHES_V1_GB.pdf

Society for Museum Archaeology. "Publicly Accessible Repositories & Archaeological Archives." Society for Museum Archaeology. 2017. http://socmusarch.org.uk/socmusarch/gailmark/wordpress/wp-content/uploads/2018/04/Publically-accessible-repositories.pdf

Society for Museum Archaeology. "Specialist Competence Matrix " Society for Museum Archaeology. Accessed May 18, 2019. https://www.archaeologists.net/sites/default/files/Museum%20Archaeology%20specialist%20competence%20matrix_final.pdf

Society of Museum Archaeologists. "SCAUM." *Museum Archaeologists News* no. 3 (1986): 1.

Society of Museum Archaeologists. "News from Committee." *Museum Archaeologists News* no.8 (1998): 2.

Society of Museum Archaeologists. "Editorial." *Museum Archaeologists News* no. 9 (1989): 1.

Society of Museum Archaeologists. "Editorial: Standards, Archives & Collections." *Museum Archaeologists News* no.15 (1992): 1.

Society of Museum Archaeologists. *Selection, Retention and Dispersal of Archaeological Collections*. London: Society of Museum Archaeologists, 1993.

Southport Group, "Realising the Benefits of Planning-Led Investigation in the Historic Environment: A Framework for Delivery." The Southport Group. 2011. https://www.archaeologists.net/sites/default/files/SouthportreportA4.pdf

Southworth, E., ed. "Foreword." *The Museum Archaeologist Volume 18, Conference Proceedings Sheffield, 1991*. Society of Museum Archaeologists, 1993. http://socmusarch.org.uk/socmusarch/gailmark/wordpress/wp-content/uploads/2016/07/Vol.-18-Picking-up-the-Pieces_-Adapting-to-change-in-museums-and-archaeology.pdf

Wills. "The World after PPG16: 21st-century Challenges for Archaeology." Chartered Institute of Archaeologists. 2018. https://www.archaeologists.net/sites/default/files/21st-century%20Challenges%20for%20Archaeology%20project%20report%20October%202018.pdf

Historic Environment Policy: The View from a Planning Department

Chris Patrick

ABSTRACT
The responsibility for the management of much of Britain's historic environment lies in the hands of the nation's numerous local authorities; on one hand they administer the planning system whilst on the other they own large expanses of land containing archaeological sites along with museums and thousands of historic buildings. The last 10 years have seen significant changes in the landscape of local government which has impacted on their management of the historic environment. This is both in terms of changes in planning policy with the move from Planning Policy Guides 15 & 16 to 2010's Planning Policy Statement to 2012/2018's National Planning Policy Frameworks, but also in the pressures brought by declining government funding and the quest for associated efficiencies. This paper will draw on the personal experiences of myself and historic environment colleagues, principally in the West Midlands region, over the past decade to look at what has changed and what maybe the opportunities and threats to the future management of the historic environment in local government.

Local Historic Environment Services

Many non-specialists are generally surprised to learn that the protection of the vast majority of the nation's historic places and archaeological sites, is not the role of Historic England nor the National Trust but the responsibility of England's numerous local authorities. Local government has played an active and major role in managing the country's historic environment, either through the implementation of planning policy in relation to historic sites and buildings or through the management of land and buildings in their ownership, for more than half a century.

In contemporary Britain the local government is delivered in a variety of different forms; principally through a two-tier system or unitary authority. In a two-tier system, a County Council like Worcestershire is responsible for strategic functions such as highways and social care while District Councils, such as Malvern Hills, is responsible for a narrower range of services. In single-tier authorities, for example, cities like Birmingham or Coventry or counties like Shropshire or Cornwall, historic environment services sit within the unitary authority. The structures of the system were not planned in a single event, but have evolved since the 1960s when councils first began to employ

archaeologists and conservation officers.[1] As a general rule a unitary authority will often have a more compact structure with archaeologists, conservation officers and the historic environment record (HER) grouped together within a single department. County Councils in the two-tier system may have an archaeology service supported by an HER with conservation officers employed by the districts. There are variations where an archaeological service is based in the local museum or archive service.[2] In some situations a local planning authority (LPA) may receive their advice from an external body. For example, the Greater London Archaeological Advisory Service advises many London boroughs. The critical issue is that specialists who provide heritage planning advice should not be organisationally divorced from Planning departments where decisions can have important repercussions for the way the historic environment is managed.

A typical historic environment service will provide the local planning authority with advice on heritage assets that may be affected by development. It will work closely with an HER in a cyclical process in which evidence it holds is used to inform the planning process and from which new information generated as a result, can be fed back into the Record. Concurrently there is now a higher degree of collaboration between the archaeological and conservation disciplines, although advice on listed buildings, locally listed buildings, conservation areas and the built environment is still generally provided by conservation officers.

In addition to their development control casework the officers responsible for heritage issues, both archaeology and built heritage, also provide input into local planning documents, such as Local Plans, Supplementary Planning Guidance, Minerals Plans and other development plan documents to ensure that the historic environment is fully represented in local policy. Archaeology and conservation officers will also assist colleagues working in enforcement teams to pursue cases where planning breaches occur, ensuring that appropriate action is taken whether it involves reinstatement, damage limitation or repair. Advice can also be provided in respect to property management, the maintenance of historic places, parks, buildings and streets to ensure that local character and historic interest are maintained. Such advice must be consistent in the face of the diverse challenges and the competing priorities in local government and throughout specialised advice can contribute to the successful management of the historic environment that benefits placemaking, the economy and well-being.[3]

One of the most important roles of the local archaeologist, HER officer or conservation officer is that of ambassador for the historic environment. In many situations where local government services are now hidden behind call centres, officers involved with heritage remain outward looking, able to engage with local communities. Experienced officers with a deep understanding of a town or landscape, often gained by long tenure, can be viewed as the sympathetic and approachable face of many planning departments.

The Importance of Policy

In 1990 the publication of *Planning Policy Guidance Note 16* (PPG16) was a watershed moment in British archaeology that established it within the planning process. From that point on it was a requirement for developers to undertake and fund archaeological investigation where the resource was threaten by development. It was followed in 2010 by its replacement, the short-lived *Planning Policy Statement 5* (PPS 5)

subsequently replaced by the *National Planning Policy Framework* (NPPF) in 2012. The NPPF was the 2010–2015 Conservative–Liberal Democrat coalition government's move to streamline the planning process which had been criticised for being too unwieldy and slowing development, particularly house building. At the time the historic environment sector feared the weakening of planning policy and the loss of many of the hard-won heritage protections of the previous two decades. The reality was that things continued much as before and that local planning authorities retained the means to protect heritage.[4]

The prediction by some heritage groups and archaeological colleagues that the NPPF created ambiguities particularly around the significance of heritage assets and the assessment of the levels of harm is evident. For some this was seen as being a 'lawyers heaven' though in my opinion it has not been quite that extreme but it has resulted in greater analysis and debate on issues like the setting of heritage assets.[5] Assessments becoming far more methodical and rigorous than before with a greater use of heritage consultants by developers to produce an appropriate level of information. When submitting an application, developers are required to consult the HER as a minimum to check whether the proposals affect a heritage asset and then submit a heritage statement or archaeological desk-based assessment which is proportional to the significance of the asset affected.[6] Applicants are encouraged to engage with the LPA at an early stage when proposals are first being formulated to ensure that issues like archaeology are being considered.[7] With this information the local planning authority will make a judgement on the acceptability of the proposal. The local authority planner should give 'great weight'[8] in the decision-making process to the conservation of the heritage asset and to the 'desirability of sustaining and enhancing significance'[9] and any proposal which is judged harmful will require 'clear and convincing justification'.[10]

The whole process is underpinned by the local authority's HER which is crucial when identifying heritage assets, predicting archaeology and assessing significance. The NPPF requires that the LPA must have access to 'up to date evidence'[11] on the historic environment and that this information must be publicly accessible. The NPPF requires local authorities to set out 'a positive strategy' for managing the historic environment and for its 'enjoyment' by the public. This underlines the importance of the local policy formulated by the LPA and the role of the HER underpinning it. Whilst the designation of statutory protection such as the listing of buildings and the scheduling of archaeological sites is carried out nationally by Historic England, the designation of conservation areas, the identification of non-scheduled archaeological sites, the local listing of buildings and the identification of non-designated heritage assets are carried out by the local authority. Non-designated assets are viewed by some planners as the poor relation of nationally designated assets but they are a vitally important component of the historic environment of most towns and districts. The high-bar that is rightfully set for statutory listing and scheduling means that the majority of elements which make up the historic environment in many towns would fall outside their listing criteria. It would leave much of what is truly characteristic and unique in many places unprotected.[12] For example, the watchmaking and car building heritage of a city like Coventry would have been totally lost if it were not for the efforts of the local authority using the tools of local listing alongside the designation of conservation areas.[13] Similarly, the identification and excavation of non-designated archaeological remains using the HER has allowed Birmingham to reclaim its long-lost medieval origins.

In the author's experience Local Listing, in particular, is often poorly regarded amongst planning officers. Firstly it is felt to have little weight in the eyes of the Planning Inspectorate and that the LPA would lose any appeal which involved local listing. Secondly was there any point in refusing an application when a building could be demolished under Permitted Development rights (PD rights) anyway? Such views are not acceptable and the tools are now available for an LPA to retain buildings if they are brave and determined enough to use them.[14] In Coventry, the LPA created a list of criteria for designation of locally listed buildings and an online form for the public to nominate buildings and sites that would then be taken to planning committee with a recommendation for approval or otherwise.[15] On several occasions locally listed buildings were threatened with demolition under Permitted Development rights granted under the *Town and Country (General Permitted Development) Order 2015* and the LPA responded by making what are known as Article 4 Directions[16] to remove the PD rights and require planning permission for demolition. This brought such cases fully into the realms of the planning system where significance could be assessed, levels of harm ascertained and public benefits balanced. Planning permission for demolition and redevelopment was refused on several occasions and the subsequent appeals were dismissed by the Planning Inspectorate who supported the council's stance.[17] Fears of sizeable compensation claims which frequently discourage Councils from using their powers in relation to heritage were unfounded. No financial loss had been made by the applicant aside from minor abortive expenditure in relation to Council Tax that was repaid by the LPA.

Whilst the NPPF alongside strong, locally specific local planning policy[18] does give LPAs the tools to successfully manage the historic environment, the last 10 years have been tough in local government with historic environment services suffering from cuts in many areas and disproportionately high in some regions.[19] With hindsight the early 2000s was the high-water mark for the historic environment services in many councils; PPG 15 and 16 had bedded in as an accepted part of the planning system, the expansion in services allowed the creation of new posts for a more comprehensive coverage along with improved pay and conditions in a maturing archaeological profession.[20] The financial crisis of 2008 and the government's austerity policy hit all council budgets hard and the drive to reduce staff resulted in many highly experienced conservation and archaeology staff in the later years of their careers being offered early retirement or redundancy.[21] The result was that hundreds of knowledgeable, expert staff left, resulting in a loss of knowledge and manpower that has never been replaced. The national figures gathered by Historic England, the Association of Local Government Archaeological Officers (ALGAO) and by the Institute for Historic Building Conservation (IHBC) for the *Tenth Report on Local Authority Staff Resources* show a 35% decrease in archaeological and conservation posts in local government since 2006 across England. Whilst the national picture is bleak the situation is far worse in some regions. In the West Midlands conurbation from Wolverhampton, Walsall, Dudley, Sandwell, Birmingham, Solihull and Coventry the cut in officers is actually nearer 67% almost double the national figures.[22] Birmingham's team of 10 officers is now reduced to three conservation officers, Sandwell's team of three is now one conservation officer whilst at the time of writing Coventry City Council currently have no permanent archaeological or conservation officers or HER staff, where once there was a team of four. None of the West Midland conurbation authorities have a dedicated archaeological officer dealing solely with development control anymore.

The current condition of HERs in the region is a particular concern. Aside from Solihull which has a service level agreement with Warwickshire County Council, Wolverhampton is the only authority which currently has an experienced HER specialist in post. However, the time that she can devote to the HER is limited as the post is part-time and the postholder has to perform the duties of a planning archaeologist. In addition, several hours each week is spent providing archaeology advice and HER cover to neighbouring Walsall Council. Elsewhere, the HERs have been left in the hands of conservation officers. Many are already fully occupied by work in their own specialism without taking on an extra specialist role with which they are not overly familiar with. The result is that the 'up to date' evidence base required by the NPPF which underpins so much of the heritage guidance, is not being maintained as it should be. This has given rise to the phenomena that is referred to by some members of the region's ALGAO HER Forum as 'Zombie HERs'. The HER exists but is not a living, developing data set.[23] The decline in HER provision is often a result of management misconceptions leading to poor decision-making, HERs are wrongly thought of as 'back of house' or as comprehensive, finished entities that do not require updating. This perception is not helped by the often lower profile of HER officers in comparison to the more prominent conservation and archaeology officer colleagues who may attract greater attention by appearing, from time to time, in front of planning committee.

Some local authorities also lack access to specialist archaeological advice, either because unitary authorities, like Sandwell, have cut posts or by district councils removing themselves from long-standing advisory arrangements with county councils. Stratford-on-Avon District Council, which is the largest district and busiest planning authority in Warwickshire, no longer takes specialist advice from the county archaeological service. Many county councils have service level agreements to provide advice to district councils, but as budgets have become tighter some districts have looked to save money by leaving these arrangements. For a senior officer in a cash-strapped authority the money being paid to another council for what they consider to be a non-statutory service (despite the clear historic environment requirements of the NPPF) and which they perhaps view as being invisible to local residents is unfortunately an attractive target. Issues in two-tier authorities have also occurred where no service level agreements for advice are in place and the county archaeological service has looked to recover costs by introducing a charging regime for consultations. The result is that the number of consultations from some districts fell dramatically with them only seeking advice on certain cases whilst the majority were, presumably, decided without specialist input. Where an LPA is not receiving specialist advice planning officers, who in many cases will have little experience of archaeology, are forced to work from basic constraint maps derived from the HER data which highlight areas of potential. Constraint maps are a useful tool on a GIS system for alerting planners to potential archaeological implications, but they are meant as a trigger for them to seek specialist advice, they are not meant as a substitute for expert input. In such circumstances, typically a planner will ask the applicant to provide a desk-based assessment and from then on, find themselves very much in the hands of the developer and/or consultant and their recommendations. This approach can work but without the scrutiny that a local authority's own archaeologist could have provided, the system is open to abuse. Pressure from the client could, for instance, lead to percentage samples for trial trenching evaluations being lower than is usually considered appropriate and if remains are found the mitigation/excavation ahead of development might not be as

comprehensive as it should be. The reverse situation could also be true where planning authorities without specialist advice may request work that is actually excessive or unnecessary in relation to the significance of the evidence. For example, Birmingham had been without an archaeological officer for several years and this seems to have resulted in a constraints-map lead approach where conditions for 'archaeological observation' were applied to permissions often resulting in watching briefs that were an inappropriate archaeological response to a site type which had little chance of returning useful results.

However, despite the criticisms and the scenarios highlighted above, at least the LPAs were acknowledging archaeological issues and trying to do something. Nevertheless, it remains highly likely that development sites with archaeological potential are being missed on a regular basis. There is no quantification, regionally or nationally, of the number of sites being missed as discoveries are rarely recognised and reported. Staff working on a development site are unlikely to recognise significant archaeology and if they do, it is unlikely to be reported by the developer due to the potential for delays and increased costs. The exceptions to this are sites where the archaeology is instantly recognisable. From my experience those working on-site will notify the relevant authorities if, say, human remains are found, but this is usually motivated more by concerns over environmental health or whether it is a crime scene, than by concerns over the loss of archaeological evidence.[24]

In short the local authority archaeologist does more than alert the LPA as to where the archaeological resource might occur, they also police the system by monitoring fieldwork, advise on post-excavation requirements, critically review reports and publications and at the end of the process ensure the deposition of the archive in a museum, ensuring that the standards, regulations and guidelines of the profession are followed.[25]

A similar range of issues applies to LPAs without conservation officers where non-specialist staff may have to provide in-house scrutiny of proposed changes to the historic built environment. Design and access statements or heritage statements cannot be taken at face value. All too often these simply explain that the quality of the development will be high and the level of harm is low or zero. If consent is granted it is essential that specialist staff are available to check that the implementation is complied with. The message from this unsatisfactory situation is that access to local specialist archaeological or conservation advice and an up to date HER has added value for an LPA. Expert scrutiny ensures that the correct research questions are addressed and that the appropriate methodology engaged. Policy implementation should not be a box-ticking exercise.

In 2014 the *Vaizey Report* recommended LPAs have access to joint arrangements and share expertise. However, whilst there are limited areas where perhaps this could work or where HERs could be merged, such arrangements often result in officers' time being spread more evenly, but inevitably more thinly. As many services are already struggling to find the time to do all the tasks required of them this does not seem a sensible long-term solution. In some instances, LPAs have employed private sector consultants to provide advice instead of having their own in-house staff, but these arrangements can be expensive, time-limited and restricted to specific or core tasks. Almost inevitably outsourcing in this way results in a less comprehensive service'.[26] Where the outsourcing of heritage advice has occurred, it has rarely produced a satisfactory outcome. Anticipated savings and streamlining have failed to materialise and for many private consultancies,

the rates are too low. An overarching issue is that successful historic environment services benefit from team integration with archaeologists, conservation officers and the HER firmly embedded in the planning serviceable to both share information with colleagues and respond comprehensively in a way that outsourcing cannot.

Who Is Making the Decisions?

Government policy in recent years has been to boost economic growth. As a result, there are growing concerns in the heritage sector that this drive, and the decline of specialist advice, is leading to a situation where the NPPF polices intended to protect the historic environment not being implemented by the LPA. A recent report commissioned by Historic England; *Heritage in Planning Decisions: The NPPF and Designated Heritage Assets*, analysed the decision-making process in 318 planning applications affecting designated assets and found a worrying picture of LPAs failing to follow the historic environment policy in the NPPF. In making their recommendations just 24% of case officers were assessed as having given 'great weight' to the conservation of heritage assets, though it was notable that planners with access to local heritage advice were far more likely to give heritage the appropriate weighting.

Decision making on planning applications is made either by the case officer exercising delegated powers or by a planning committee made up of elected members. Cases usually go to committee if they are of a certain size or importance, if there are objections from the community, or if a councillor makes a specific request. Planning officers recommendations to their committee take the form of an officer's report and indicate whether the application should be approved or not. Generally, councillors will follow an officer recommendation.[27] However, my experience is that few councillors who sit on planning committees have a background in planning, and the majority have been delegated to the role by their political group. Most will learn what they know 'on the job' with little training. Councillors who spend many years on a committee may develop an expertise and some councillors will be interested in heritage but it is rare to have a councillor who may be regarded as an expert. If committee members are not equipped to scrutinise applications on heritage issues and ask the right questions, despite their role in the decision-making process, it places considerable emphasis on the experience and skills of a planning officer or archaeologist. It is their responsibility to advise on development control and to represent historic environment policy, ensuring it is correctly applied.

Things can start to go wrong early in the planning process if historic environment implications are not flagged up and considered at an early stage. The Historic England report, *Heritage in Planning Decisions* ... also found that only 63% of the applications in the sample had consulted the HER. Yet this is a basic requirement of the NPPF. In Birmingham, we receive around 100 requests a year for HER searches which suggests that the take up is actually far lower considering the 1000 or so applications we comment upon each year. No doubt some applicants make use of information freely available from Council and Historic England websites and heritage statements that are submitted with applications vary greatly in quality. Many are produced by specialist heritage consultants and adhere to the appropriate standards[28] whilst those by non-specialists tend to be minimal, giving little more than a title and a brief description; in the case of listed buildings often just the list description. The issue here is one of quality

control at the application registration stage. However, difficult it is for a non-specialist administrative assistant who deals with this stage to know what a proper or proportionate assessment is, it is not appropriate to accept a report simply because it is entitled 'heritage statement'. The situation is not helped by the lack of advice available to applicants on what a heritage statement should include. Often in my authority by the time poor quality assessments are discovered a development has been fully designed, a planning application registered and the consultation has begun. A potential collision course has been set.

An appropriate heritage statement will assess the significance of heritage assets and the potential for them to be affected by development. Ideally, the applicants will have engaged specialist advice at an early stage and designed a scheme which, where possible, avoids harm and sustains significance. Problems occur when the heritage considerations are an afterthought and an assessment has to be retro-fitted to a largely finalised but evidently harmful scheme. In such cases, there is a tendency for significances to be downplayed and for a conclusion to be reached that the degree of harm is 'less than substantial'. That the harm is then outweighed by the public benefits of the scheme. In this example the LPA's conservation officer may provide advice on whether the level of harm can be justified or suggest ways of mitigating the harm. A planning officer is not bound to accept such advice and may accept the applicant's argument that the harm is outweighed by the public benefits. Whilst some schemes do undoubtedly have substantial public benefits, whether these are jobs, homes, transport improvements or housing, other applications with debateable benefits are approved with the planning decision siding with the harmful development rather than with the heritage.[29]

It is rather depressing that the historic environment is still perceived amongst some council officers and politicians as being a hindrance to growth and progress. This is often a false opposition and there is a considerable body of evidence to suggest that heritage can be harnessed to drive regeneration and provide characterful and locally distinctive places.[30] In some authorities policy is specifically linked to heritage-led regeneration.[31] Similarly, archaeology is still sometimes viewed as a hindrance despite the evidence of the economic and social benefits which can accrue to it in the context of development.[32] There is now a well-established profession that is integrated with the planning system and the development industry with the capacity to exploit such potential.[33] This situation however, has not been helped by the recent economic circumstances. In many areas of the country, like the West Midlands, desperate for investment even substandard and harmful schemes may give the appearance that something is happening. In these situations, it is not altogether surprising that planning officers may feel the pressure not to be overly rigorous in assessing developments affecting heritage assets.[34] Sadly, it seems that there is still work to be done to convince some decision-makers of the benefits offered by the historical environment in the planning system.

Who are We Doing This For?

Paragraph 184 of the NPPF states that heritage assets should be conserved so that they can be *'enjoyed for their contribution to the quality of life of existing and future generations'*. This is current policy serving the present generation and their enjoyment of the historic environment. I believe that public benefits are inherently present across a wide range of

work that is undertaken in the sector, some of it is proactive community engagement which attracts attention while the majority of conservation work goes quietly under the radar and only attracts attention when things go wrong, when something is damaged or disappears or causes a public outcry. Yet archaeological work which has been carried out through the planning system since 1990 has transformed our understanding of many places and periods in this country.

From my perspective the integration archaeology into the planning system has been a remarkable success story and it seems incredible today that it was ever anything different. However, as the profession has matured it has moved away from its roots in local archaeological societies and civic societies which campaigned to record and preserve our history in the face of development threats. It now feels like a process that is becoming more distant from the public. Archaeological work often takes place behind hoardings and can be seen as comparable to an exercise in remediating contamination rather than a journey of discovery. Tight development programmes and health and safety requirements make it hard to organise open days and involve local communities and it is often difficult to compel developers to engage with and fund outreach. This is particularly evident in areas where development viabilities are marginal already.[35] The cuts to local council historic environment services mean that officers and HERs no longer have the resources to engage the public and assist with community projects and can no longer support outreach posts. Many of these are disappearing. In Coventry, this was an important aspect of the reciprocal relationship with the community. Volunteers from the local archaeological society were able to walk fields in the search for artefacts, discoveries which were then entered into the HER. It was evidence of this type which was eventually used to inform the green belt elements of the local plan.[36] The concern is that we will find ourselves in a vicious circle where cuts in services lead to a decline in public awareness of and support for archaeology. In turn, this has the potential to lead to further budgetary cuts and changes in policy. At present the profession cannot take developer funding in archaeology for granted; in reality, it is a recent invention and could be vulnerable to ministerial whim in the face of vigorous lobbying about its fitness for purpose.

The paragraph above largely concerns archaeology but conservation is in a similar situation. IHBC (the Institute of Historic Building Conservation) the professional body of Conservation Practice has just launched the IHBC Creative Conservation Fund[37] to co-ordinate continuing support for the widest public benefit and to add new capacity highlighting how progressive and creative conservation practice has become. There is no doubt that the profession needs to extoll the public benefits of their work whether this is in historic places, contributes to the quality of life for local residents or leads to environmental and economic benefits. The work of organisations like Civic Voice and their 'Big Conservation Conversation'[38] campaign to highlight the value of conservation areas to local communities and the threats to them is to be applauded. Such a campaign should raise greater awareness of the issues facing the historic environment as well as harnessing public support.

So, What Can Be Done?

The last decade has seen a marked decline in the number of local authority historic environment posts; the near compete coverage that once existed now has gaps with more authorities today without conservation or archaeological advice or an HER which is not being maintained.

The consequences are hard to quantify in the absence of collected data. However, from cases reported anecdotally at regional ALGAO and Conservation Officers Group meetings it is apparent that harmful works are being approved and carried out to heritage assets due to lack of advice or because specialist advice is not being followed. In some examples, archaeological recommendations are absent or not enforced, with the potential that sites are destroyed without record. Furthermore, information is not being recorded by or disseminated from HERs and links to the public and research institutions are being lost.

Firstly there is no doubt than many of the issues raised in this paper stem from the reduced funding of local government and shows how the whole planning system needs to be properly resourced. In some areas historic environment services have instituted charging regimes for pre-application advice, providing briefs or site visits but many are still heavily reliant on core funding from the LPA to survive. Protection of the historic environment is a statutory obligation and the present situation suggests it is time for LPAs to ring-fence support for historic environment services.[39]

Secondly, steps towards statutory status for HERS have been made with the requirements of the NPPF 209 (para 189) and this urgently needs to be revisited although it is hard to see this happening in the current political climate. Currently, historic environment services are too often undervalued or viewed as optional by some authorities.

Thirdly the profession needs to promote a wider critical awareness of the issues amongst decision-makers. Planning officers, senior managers and politicians who are portfolio holders as well as planning committee members need support. Historic Environment officers embedded within the authority would be best placed to provide this support. Historic England initiatives like 'Heritage Champions'[40] has had successes but the 'Champion' is most effective if they are in a senior position, a Cabinet or planning committee member.

A further area in which the historic environment appears deficient is in relation to advocacy. Few heritage professionals, often with high levels of transferable skills, rise to senior management roles in local government. This may be due to a reluctance to leave behind specialist practice rather than lack of talent, but I believe that senior managers with a heritage expertise could be hugely beneficial to the profession.

Finally, the profession needs to seize opportunities to display our work to the wider world. My perception is that we are far too modest about our achievements. Despite acute time pressures, the profession must continue to maintain relationships and linkages with the public whether through specific amenity groups or the wider community. Archaeologists in particular need to communicate better the benefits to the places we manage. Archaeology must not become merely an exercise in decontamination for developers. The sector has come a long way but how we display archaeology, how we synthesise results of investigations and make the information accessible can all be improved. The links that have been lost between local university archaeology departments and the profession need to be re-established,[41] and the profession needs to continue to reach out to local archaeological societies encouraging meaningful engagement with the management of the historic environment.

The present system has been a huge success story and although in recent years development control and management of the historic environment has been a victim of wider economic and political circumstances, the profession must continue to promote its achievements to avoid any weakening of future heritage protection.

Notes

1. The post-war period was one of rapid change and growth in Britain with the new developments and highway infrastructure causing the loss of historic buildings and archaeological remains in the centres of many historic towns and cities. Concern at the scale of losses led to the growth of the conservation movement through the 1960s and 1970s. Conservation officer posts appeared in local authorities from the late 1960s primarily as a result of the 1967 Civic Amenities Act that established the concept of conservation areas. At around the same time, many local authorities also began to employ archaeology officers and organise teams of archaeologists to carry out rescue excavations on development sites. For further reading see Elain Harwood and Alan Powers (Ed), *The Heroic Period of Conservation*, Twentieth Century Architecture 7, 2004 and John Hunter and Ian Ralston (Ed) *Archaeological Resource Management in the UK, an Introduction*, Sutton, 2001.
2. A list of historic environment services including HERs can be found on the website of the Association of Local Government Archaeological Officers www.algao.org.uk/.
3. See Sarah Reilly, Claire Nolan & Linda Monckton, Wellbeing and the Historic Environment; Threats, Issues and Opportunities for the Historic Environment, Historic England, 2018 www.historicengland.org.uk/images-books/publications/wellbeing-and-the-historic-environment/wellbeing-and-historic-environment/, Historic England's Heritage Counts audits www.historicengland.org.uk/research/heritage-counts/ and Doug Rocks-Macqueen, Ben Lewis, Archaeology in Development Management; Its contribution in England, Scotland and Wales, Landward Research Ltd 2019 www.algao.org.uk/archaeology-development-management.
4. Many of the concerns related to the potential loss of protection for the historic environment stemmed from the brevity of the NPPF Conserving and Enhancing the Historic Environment where the over 100 pages of guidance in both PPGs was condensed into 18 pages of Planning Policy Statement 5, which were then in turn condensed into 4 pages of the NPPF. However, these 4 pages are supported by numerous national and local guidance documents with the overriding principle that significance is assessed, potential harm identified and balanced against the benefits.
5. See Goatley and Pindham this vol.
6. NPPF paragraph 89.
7. With almost all developments archaeology is one of the first activities that will happen on a site. Failure to identify archaeological potential, significance and impact at an early stage can lead to problems with costs and programming for the developer and early assessment is important for managing this risk. Early assessment also gives the potential for the archaeological remains to enhance the development proposals by incorporating historic elements into the layout of the scheme or by displaying remains.
8. NPPF paragraph 193.
9. NPPF paragraph 192.
10. NPPF paragraph 194.
11. NPPF paragraph 187.
12. Historic England's listing selection documents can be found on their website https://historicengland.org.uk/listing/selection-criteria/.
13. Spon End and Nauls Mill Area of Local Distinctiveness Area Character Statement and Design Guidelines and Designation of Two Conservation Areas, SPG 2003.
14. In March 2011 SAVE Britain's Heritage won an important case at the Court of Appeal against the Secretary of State which ruled that demolition did fall within the scope of the European Impact Assessment Directive and that demolition was a project that was not exempt from planning control. https://www.savebritainsheritage.org/news/item/182/SAVE-Secures-Landmark-Ruling-on-Demolition Demolition is now a permitted development under Part 11, Class B of the Town and Country Planning (General Permitted Development) Order (England) 2019. http://www.legislation.gov.uk/uksi/2015/596/schedule/2/made.
15. See Coventry City Council website https://www.coventry.gov.uk/info/269/heritage_ecology_and_trees/453/listed_buildings/6.

16. An Article 4 Direction is made by a local planning authority where is it felt that carrying out the development under permitted development rights, i.e., without the need for planning permission, would have an undesirable effect on amenity of an area. https://historicengland.org.uk/advice/hpg/historic-environment/article4directions/.
17. See Coventry City Council applications; FUL/2013/0274 The Black Horse, Spon End; FUL/2016/0680/PA No 6 The Firs and FUL/2015/1424 United Reformed Church, Hawkes Mill Lane.
18. For example, the Coventry Local Plan 2016 Policy HE2 specifically identifies significant elements of the City's Historic Environment that are to be conserved. https://www.coventry.gov.uk/localplan.
19. See the Historic England, Institute for Historic Building Conservation and Association of Local Government Archaeological Officers annual staffing surveys https://historicengland.org.uk/images-books/publications/tenth-report-la-staff-resources/.
20. See the Chartered Institute for Archaeology's Profiling the Profession survey reports https://cifa-uat.opencloudcrm.co.uk/profession/profiling.
21. See IHBC Research Note 2013/1 http://www.ihbc.org.uk/resources/Research-Note-2013-1—Loss-of-senior-staff-in-England-2011-12.pdf.
22. A survey recently undertaken on behalf of ALGAO and Historic England by Dr Jill Collens identified a comparable 64% reduction in Archaeological Services in the north-west region of England. Dr Jill Collens, *North West Local Government Archaeology Services; Analysis and models for future provision*, Historic England Project No 7808, May 2019.
23. See ALGAO website for details of regional HER Forums and committees https://algao.org.uk/subject/her.
24. Examples of where lack of archaeological advice in LPAs have resulted in sites not receiving the appropriate archaeological response can be found in the Archaeological and Planning Case Studies Project Report, September 2019, published on the Historic England website. http://historicengland.org.uk/research/current/planning-research/.
25. The Regulations, Standards and Guidelines of the CIFA can be found at https://cifa-uat.opencloudcrm.co.uk/codes/cifa.
26. In the West Midlands, this has occurred in Walsall and in Coventry.
27. House of Commons Library Briefing Paper Number 01030, 30 August 2019 'Must planning committees follow officers' advice in reaching decisions?' G Garton Grimwood www.parliament.uk/commons-library | intranet.parliament.uk/commons-library | papers@parliament.uk | @commonslibrary Accessed 24/10/19.
28. See Chartered Institute for Archaeologists (CIfA) Standard and Guidance for Historic Environment Desk-Based Assessment 2014.
29. See Heritage in Planning Decisions: The NPPF and Designated Heritage Assets. For Historic England by Green Balance. February 2018. https://historicengland.org.uk/content/docs/planning/7559-heritage-in-planning-decisions-green-balance-v2-pdf/.
30. Such as *Heritage Counts 2017* Heritage and the Economy 2 Heritage and Regeneration, 6; *British Property Federation* review (see https://www.allsop.co.uk/media/heritage-led-regeneration-looking-back-look-forward/) Accessed 23/10/19.
31. For example *Plan for London*, 2016, Chap 7, London's Living Spaces and Places. Policy 7.9 Heritage Led Regeneration.
32. https://www.archaeologists.net/find/clientguide/benefits Accessed 22/10/19.
33. See Robin Skeates, Carol McDavid, and John Carman (eds) 2012 The Public Benefits of Archaeology.
34. Recent research published in *Archaeology and Development Management, its contribution to England and Wales*, showed that only 55 of the 525,000 planning applications submitted in the UK were refused on archaeological grounds.
35. Phillips this volume.
36. Coventry City Local Plan, Adopted 6 December 2017, Section 7 Green Belt and Green Environment 105.
37. "Heraclitus and Parminides in the world of Trump," Context 161, Sept 2019, 57.
38. See Civic Voice website and Campaigns area http://www.civicvoice.org.uk/campaigns/.

39. It should be remembered that the lack of specialist heritage advice could leave LPAs vulnerable to Judicial Review proceedings if they fail to follow due process https://historicengland.org.uk/advice/hpg/consent/challenging/.
40. 'A Heritage Champion is normally a local councillor who has been nominated by their authority to promote all aspects of the historic environment in their area. It is up to the local authority to decide how to nominate their Heritage Champion ... At a strategic level, Champions can make sure that local plans and strategies capture the contribution that the local historic environment can make to the success of an area ... ' quote taken from https://historicengland.org.uk/advice/planning/local-heritage/heritage-champions/what-is-a-heritage-champion/ accessed 25/10/19.
41. The University of Birmingham closed its long-established archaeology department and its field unit in 2011 which has left a large gap in the West Midlands region that remains to be filled for academic research and commercial archaeology services.

Disclosure statement

No potential conflict of interest was reported by the author.

Bibliography

The Future of Local Government Archaeology Services. An exploratory report commissioned by Ed Vaizey, Minister for Culture, Communications and Creative Industries, and conducted by John Howell MP and Lord Redesdale. May, 2014.
Historic England. *The Tenth report on Local Authority Staff Resources*. produced by HE, ALGAO and IHBC. October, 2018.
Historic England. *Heritage in Planning Decisions; The NPPF and Designated Heritage Assets*. For Historic England by Green Balance. February, 2018.
HM Government. *Draft Heritage Protection Bill*. 2008. London: Department of Culture, Media and Sport.
HM Government. *Town and Country (General Permitted Development) Order (England)*. 2015. London: Majesty's Stationery Office (HMSO).
MCLG. *National Planning Policy Framework*. 2019. London: Ministry of Communities and Local Government.
Ministry of Housing, Communities & Local Government. *National Planning Policy Framework*. London, 2019. London: Her Majesty's Stationery Office
ODPM. *Planning Policy Guidance Note 16: Archaeology and Planning*. 1990. London: Deputy Prime Minister, Her Majesty's Stationary Office.
ODPM. *Planning Policy Guidance Note 15: Planning and the Historic Environment*. 1994. London: Stationary Office.

The Heritage-creation Process and Attempts to Protect Buildings of the Recent Past: The Case of Birmingham Central Library

Matt Belcher, Michael Short and Mark Tewdwr-Jones

ABSTRACT
The successful conservation of our built heritage relies upon multi-scalar negotiation between a wide array of stakeholders and agents in the planning process. This negotiation reflects both the values that we ascribe to particular structures and landscapes, and choices about what to retain in response to social, commercial and aesthetic opportunities, preferences and aspirations. We are particularly interested in how redevelopment and regeneration processes often result in the removal of buildings from the recent past – Brutalist buildings from the 1960s, in particular – even though coalitions are built which seek their active protection and conservation. Using the case of Birmingham Central Library (demolished 2015–16) we explore how conservation of the most recent past challenges us – how can buildings of the recent past be deemed heritage, how can they be meaningfully conserved and how are different interests mediated? This paper seeks to uncover the conflicts inherent within the conservation of such buildings, drawing conclusions about the heritage-creation process.

Introduction

Throughout history, humans have responded to the needs and desires of society by creating, adapting and reshaping the environment around them. Indeed this environment 'is continually rebuilt to reflect changing motives, attitudes and tastes as societies evolve politically, economically and technically'.[1] Over the past 150 years, however, the erasure of particular elements of the historic urban environment has encouraged both expert- and citizen-led movements to conserve, in some form, these 'relics of the past'.[2] Conservation planning is a multi-dimensional, multi-objective forum for the management of change in the built, historic and natural environment that is both regulatory, in the sense that it is enshrined within a statutory system, and visionary, in the sense that future visions are promoted and implemented through it.[3] It is within this context that selected buildings are protected from inappropriate change.

Given that redevelopment and economic growth in large cities often results in the eradication of relatively recent urban layers,[4] it is generally accepted that the conservation of the historic environment should be an important goal of public policy.[5] Politicians, the

public and development professionals increasingly find themselves at a critical point in deciding how the heritage assets of the 20th century are to be identified, represented or conserved. Making these decisions often results in a series of conservation conflicts over the meaning and value of buildings of the recent past. Where the role of time and rarity as primary selectors is being challenged, the judgement onus is placed on particular conceptual and policy debates. In the context of rapid socio-economic transformations and interest clashes within society, resolution of these debates often proves to be a challenge.

It is within this context that this paper examines a number of elements. First, we reflect upon the heritage-creation process drawing upon theory to establish a frame for considering post-war heritage. Secondly, we explore the purpose and circumstances of protection (listing) in England in order to establish how different heritages are produced by the competent authorities. Thirdly, the potential tensions and complementarities[6] between the politics of redevelopment and that of the conservation of recent buildings will be analysed using the case study of the attempts to list Birmingham's Central Library. Finally, we will reflect upon 20th century heritage conservation perspectives and then identify further research possibilities and recommendations.

The Heritage-creation Process

Decisions about what heritage survives, and why, often revolve around statutory protective regimes and the input advocacy groups bring into the process.[7] In effect, the preservation movement originally perceived itself to be somewhat of a rescue operation,[8] heroically and unselfishly salvaging architectural riches of the distant past, selected according to supposedly objective criteria, such as age or beauty, or a link to a particular reading of the past.[9] The emergence of conservation (as opposed to preservation) in the post-war period widened the object of attention to ensembles of buildings. Finally, a more recent shift reveals history as a product selected according to the criteria of consumer demand and managed through the intervention of the market. In effect, the concept of heritage embraces a consideration of the active use of what is conserved, that is 'the process of evaluation, selection and interpretation – perhaps even exploitation – of things of the past'.[10]

This final stage of the increasing commodification of the built heritage, or evolution of a 'heritage product', has seen the justification for heritage protection shift to a consumerist orientation where the relics of history become a product in the market to satisfy consumption.[11] Much of the UK, for example, is 'neatly packaged into heritage products, carefully denoted by the brown signs marking entrances to "Shakespeare's Country", "Lawrence's Country" and many more'.[12]

Conservation planning in general, and local conservation regimes in particular, reflect a number of common elements. First, conservation planning is a largely political and multiscaled activity; it must gain legitimacy for its decisions at the local as well as national level.[13] At the local level heritage governance is complex, characterised by the interconnection of a variety of organisations and interests.[14] It is in the political and policy exchanges between these groups that decisions about development are reached. Secondly, conservation planning is a technical activity which uses a wide range of tools during the assessment of proposals to 'ensure that decisions are taken in line with ... prevailing rationalities'.[15] These tools are also politicised in that they reflect the interconnectedness of organisations and interests in their content and are, therefore, rarely objective or value-neutral. Thirdly, it

attempts to manage space through the selective protection of elements of the townscape. According to Hobson,[16] it can only do this through harnessing other development processes that lie outside its core competencies. In this sense, conservation planning is dependent on a number of externalities that it has little direct control over.

Finally, one other crucial element in local conservation regimes is their criticism by what might be called 'pro-development interests'. While[17] argues that, whilst the principles of conservation planning are supported in general terms, it is periodically criticised by pro-development interests owing to the direct costs it imposes (which might include the repair and maintenance of protected buildings, and/or opportunity costs of alternative development).

One type of conservation planning has come to epitomise the problems of accommodating retention and change for various conservation organisations, municipal government and the development industry. Modernist buildings of the 1960s and 1970s in Britain promised a better, fairer future amid a scene of societal post-war optimism.[18] Many British cities saw radical rebuilding programmes as part of the welfare state, often led by municipal authorities, which strove to improve quality of life for all through mass public housing programmes, education and community facilities, and the rise of office developments. Employing significant use of concrete, plate glass and systems building, Modernist architecture pushed the boundaries of technological achievement, but often created urban landscapes that appeared to be too 'Brutalist' or 'raw' for citizen appeal.[19] Brutalist is derived from the French 'béton brut' meaning 'raw concrete'. By the end of the twentieth-century, the Modernist ideals were perceived largely as having failed and the building stock condemned as inappropriate for contemporary needs. Many post-war buildings now face an uncertain future as redevelopment pressures mount for their demolition.

Post-war buildings provoke extreme opinions and recent debates regarding their future have been mired in controversy and conflict. Although the majority of people seem to dislike the buildings and brand them 'concrete monoliths',[20] there is a significant and growing minority who believe their conservation is important. Extensive debates have thus occurred over threatened structures as conflicting opinions and desires fight over the heritage-worth of the nation's built environment. While many of the most obvious examples have already been granted listed status,[21] the conservation agenda has recently focused on more contentious cases in an effort to determine exactly which buildings, and in what form, are worthy of protection. Recent examples include prominent debates concerning the future of Trinity Square Car Park, Gateshead (now demolished), the Tricorn Centre Portsmouth (also demolished), and Preston Bus Station (conservation and development proposals pending). Before going on to highlight a case study of another development, Birmingham's Central Library, we turn attention to consideration of the formal conservation planning process in its treatment of Modernist buildings.

Conceptualising Conservation and Policy Approaches

At present, buildings possessing 'special architectural or historic interest' (Planning (Listed Buildings and Conservation Areas) Act 1990: c.1/1)[22] are granted formal recognition through the statutory listing process which 'enables the planning system to protect them'.[23] Proposals for protection for all buildings are considered under a generic policy framework, with overall accountability for decisions attributed to the Secretary of State

(for Digital, Culture, Media and Sport). Any building in England older than 30 years can be awarded Grade I, II* or II listed status if it possesses sufficient 'special' architectural or historic interest. To be of special architectural interest a building must be of 'importance in its design, decoration or craftsmanship',[24] such as particularly significant examples of building types or techniques, and significant plan forms. For buildings of the more recent past in particular, the 'functioning of the building (to the extent that this reflects on its original design and planned use, where known)'[25] should also be a consideration. This criterion has usually been 'fairly straightforward'[26] in the sense that it is often the external appearance that people judge that special interest. To be of historic interest, a building must 'illustrate important aspects of the nation's history and/or have closely substantiated historical associations with nationally important individuals, groups or events'.[27] Significantly, the national listing framework suggests there should be 'some quality of interest in the *physical fabric* of the building itself to justify the statutory protection afforded in listing'.[28] However, special interest under either of these criterion may not always be reflected in visual or physical quality.[29] Indeed, buildings put forward for listing for reasons of technological innovation, or illustrating particular points or characters in history, may have little visual or physical value.[30]

The academic response to this framework in relation to post-war buildings has been notably varied. Although defended by a minority – Cherry deems it to be 'an inherently flexible system'[31] – opposing critiques questioning the appropriateness of an essentially artistic listing process are more numerous. Hubbard, for example, suggests that the assessment of architecture cannot be reduced to the same process as that applied to paintings as 'the built environment is not merely art, but a setting for everyday life'[32] and thus the consideration of functional elements is crucial to any full evaluation. This is particularly pertinent for post-war Modernist buildings, as it is the use of and relationship between space(s) which is as much a defining feature as the physical fabric of materials and craftsmanship.[33]

This clash in listing ideology between substance and essence is commonly discussed[34] with a consensus that the former's precedence in the statutory process creates barriers to the consideration of issues beyond the conventional art-history approach. Tait and While's[35] 'black box' concept attempts to provide a theoretical depth to this critique, arguing that the traditional statutory procedure attempts to reduce buildings to a stable entity of clearly defined inputs (the architect) and outputs (the contribution to a particular style) that ignores the reality of myriad individuals and networks. While the 'black box' approach simplifies listing merits to ease decision-making, it also 'den[ies] hybridity and compromise' as an input, while 'view[ing] buildings as static in value and form' in output.[36] As a result, the existing statutory framework is theorised as being too simplistically formulaic in methodology, accommodating the conservation only of 'star' buildings which are then perpetually 'locked' with an output determined in an 'elitist nature'.[37]

A range of alternative conceptions and understandings of post-war conservation have also been proposed, which highlight the variety of often conflicting positions from which the academic field is operating. For instance, an economically grounded understanding of heritage's value as a commodity for popular consumption is proposed by Larkham.[38] Perhaps attributable as a precursor to the actor-network approach of Tait and While,[39] the author rejects any notion that the conservation process is equitable or necessarily based on historical accuracy, instead identifying the concept of 'heritage' not as history or place

but instead as 'a process of selection and presentation of both, for popular consumption'.[40] This understanding is interesting in that it encompasses the realities of capitalism and relates to the operation of growth-machines (see below), but crucially also represents a diametrically opposing conceptualisation of the process compared to the traditional 'art-history' approach.

An alternative economic approach for post-war buildings relates to the more practical considerations of re-use and economic viability. Delafons recognises the need for any conservation framework to conserve the best of 'heritage' but 'without imposing unsupportable costs'.[41] The economic reality of a duality between the state's desire for conservation and the willingness and ability of the private sector to pay for it is thus highlighted, although the implications of exactly what 'heritage' constitutes in this context remain tacit. Furthermore, while 'Sustainable conservation' is proposed as an idealised operational compromise to effect a 'rational balance between conservation and change',[42] this approach fails to address the degree of ethical compromise that either currently occurs or should occur to achieve this.

While each of the conservation conceptions differ significantly, all possess an implicit assumption of the necessity of a statutory listing process and a physical conservation outcome. However, it has been suggested that neither of these approaches are necessarily required or justifiable for post-war buildings. Saint, for instance, discusses a Darwinian approach to conservation that encourages the survival only of the 'fittest and luckiest' without any state support of the 'weaklings or obsolescent specimens that stand in the way of younger, thrusting new species'.[43] This approach is, after all, the one which has left civilisation with its most ancient buildings, albeit operating within socio-economic contexts of much slower cycles of (re)production.

If it is the essence of post-war Modernism, the ideology from which the library was designed, that is deemed important to preserve as well as the myriad socio-spatial relationships which ensued in its operational form, then a purely conceptualist approach to conservation could be applied. One for which 'a record of the idea is enough, whether in the form of pictures, drawings, models or "virtual reality"'.[44] In complete contrast to the present statutory approach, it could be that, where sufficient archive material exists, there is no longer a requirement to conserve any fabric whatsoever.[45]

Distinctly separate academic strands have been developed regarding broader considerations of post-war conservation than simply the statutory and ethical debates. A significant strand worthy of consideration is that of the impact of growth-machines, which while not formally incorporated within any statutory framework are nonetheless intrinsic in shaping the built environment. The selectivity of 'heritagisation' relates to growth-machines, a coalition of partners who attempt to image city landscapes to attract investment and regeneration. This process can place particular pressures on the post-war landscape due to their weathered concrete representing the 'failures of utopian planning'[46] while their physical presence 'restrict[s] development options or impose[s] extra costs on developers, renters and landowners'.[47]

At one level the very idea of conservation is antithetical to capitalism, hence one of the founding principles of government intervention being 'to oppose the blind onrush of commercially driven modernisation'.[48] However, conservation policies can also bring economic benefit[49] to a city where the heritage helps generate a desirable, marketable image. The significance of growth-machines is in perpetuating 'authorised'[50] heritage

discourses, as achieved through the 'layering of policy statements, statutory protection, place marketing, press articles'.[51] This can operate in a constructive sense, through strategies like *Plymouth: 20th Century City*, though in other instances unwanted heritage associations can be marginalised to suit the desires for perceived socio-economic prosperity.[52] Although largely an economic issue, an ethical undercurrent is present as a particular heritagisation of a building or city may 'overlap, conflict with, or even deny its cultural role'[53] and question the real motivation for conservation decisions.

Of course, the vision of a growth-machine does not necessarily mirror that of the wider public, with different layers of understandings and values throughout society.[54] While has argued that whilst populist opposition to post-war conservation often emanates from 'dirty concrete', deeper associations of the failure of modernist ideals imposed by autocratic planners of the post-war era are also important considerations.[55] Alternatively, the desire for change could be viewed as a repetition of the city reconstruction processes following World War II, whereby successive waves of capital accumulation fuelled a desire for improved urban forms in a perpetual quest for modernity.[56] The mid-twentieth century saw the demolition of many fine Victorian buildings, just as the Victorians had demolished Georgian masterpieces. It is, therefore, plausible that the current popular distaste for post-war architecture simply represents the present incarnation of a generational attack of the 'nearly-new' built environment.[57]

A 'U-shaped' process of high popular satisfaction upon completion followed by a dip in which an architectural era is threatened by distaste, only to once again become appealing 30 plus years later as fashionable 'heritage', has been suggested by Saint.[58] It is this dilemma that underpins the kind of fractious listing cases that this research is based on, and yet surprisingly little attempt has been made to better understand the rationale that drives the perceptions of and relationships between the public, cultural elites, decision makers and the statutory process.

For instance, very little recognition is made of the different perceptions and associations existing within distinct cohorts of society, nor between the high-, middle- and low-level spatial scales of built environment communication identified by Rapoport.[59] A building might, for example, have a different resonance to an architectural historian interested in the contribution of a building or architect to a particular style (national, high-level) to a societal cohort who lived through the building's construction and completion (mid-level) or an individual who has unique memories and experiences of a structure (local, low-level). For the latter, the concept of ontological security may be of relevance to local perceptions, as local, everyday surroundings play an under-acknowledged role in the creation of personal identities,[60] and the loss of particular structures can impact significantly on communities as myriad memories of heritage are lost. These differing perceptions of architectural heritage are now discussed in the next section through a case study analysis.

In order to investigate how heritage might be created, we utilise a combination of semi-structured interviews and analysis of policy documents, popular-press articles and social media archives; and a qualitative 'thick description' of the processes of listing relating to Birmingham Central Library. The primary material informing this research is based upon grounded-theory. It utilises semi-structured interviews with both sets of actors directly involved in the Central Library listing debate and others and undertaken in 2009–10 at a critical stage of the story. These included representatives of national, local, statutory and non-statutory heritage bodies and civic societies, conservation 'guerrilla'

groups and Central Library management. Discussions with members of the public were conducted informally, predominantly taking place in the library, Chamberlain Square and Centenary Square (adjacent to Central Library).

Birmingham Central Library

A more detailed architectural history of Central Library is provided elsewhere,[61] but an overview of its design, evolution and the listing efforts is useful to contextualise the following research. Designed from 1964–66 by the Birmingham-based John Madin Design Group and completed in 1974, Central Library consisted of a seven-storey cantilevered inverted ziggurat that housed a reference library and an adjoining curving three-storey wing accommodating a lending library (Figures 1 and 2). The library was an example of the Brutalist architectural aesthetic and represents the pinnacle of the post-war Modernist ideology as Birmingham progressively attempted a social and practical revolution of its core. It was the largest civic library in Europe on completion,[62] and was well patronised throughout its existence, attracting 1.35 million visits per year.[63] Furthermore, even though the scope and level of destruction during the bombing of the Second World War was extensive, and the rebuilding was largely comprehensive and Modernist, there was, in fact, no official plan for the city, much less the city centre.[64]

At ground level, a public concourse provided the only pedestrian link between Chamberlain and Centenary Square. This was originally an open courtyard envisaged as a

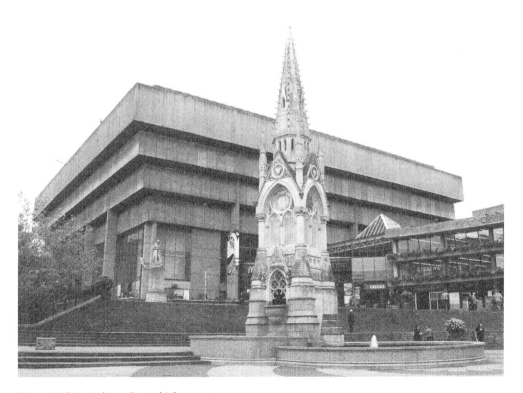

Figure 1. Birmingham Central Library.

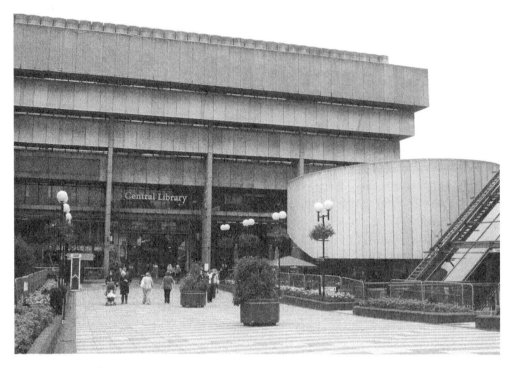

Figure 2. Birmingham Central Library.

social node offering access to a planned municipal bus station below, but it was later named 'Paradise Forum' and took the form of a covered retail arcade. The entire structure sat atop the A41 arterial route, significant at the time like so many urban transport schemes as part of an inner ring-road envisioned to facilitate a motor-dominated society.[65] While the bus station never came to fruition, the ideological impetus of the design is nonetheless representative of the planning thought-processes of the time. Furthermore, the library – unusually for the time – pioneered a system of displaying less popular books alongside reading rooms, rather than storing them in peripheral areas,[66] 'making for ready access and easy flexibility'[67] in the use of the library.

Budgetary constraints during construction resulted in the changing of certain design features. Of particular note was the use of pre-cast concrete as a cladding material, deemed substantially more affordable than the specified stone, and the non-materialisation of landscaped gardens intended to soften the building's aesthetic (Figure 3). The retail units adorning Paradise Forum were added in 1989 following the enclosure of the internal court with a glazed roof, but the building became increasingly dilapidated by the 1990s and 2000s with little investment provided for its upkeep or improvement. Large chunks of concrete were missing from numerous cladding panels, while various wings of the complex lay empty and abandoned.

Birmingham as a city has a history of continual redevelopment. Indeed, it was this process that saw the Victorian library building demolished in the 1970s for replacement by the subsequent structure. Madin's library was also deemed incompatible with attempts

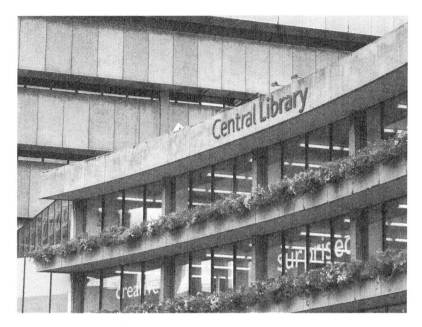

Figure 3. Birmingham Central Library.

to re-image the city. Since the early 2000s many post-war buildings have been demolished, including the original Bull Ring shopping centre, and with a new Library of Birmingham completed in 2014, pressures for the redevelopment of the Madin library site grew since its acquisition by the developer Argent Group PLC in 2004.

The conservation debate over the building was launched in 2003 when an initial application for the building to be listed at Grade II status was endorsed by English Heritage (later Historic England) but rejected by the then Local Government Minister Kay Andrews. The conflict reached a new pinnacle in 2009 following the City Council's request for a Certificate of Immunity from listing (CoI) and another Grade II listing recommendation by English Heritage. In November 2009 Margaret Hodge, then Minister for Culture, announced the issuing of a CoI and the building's future seemed bleak. Madin's Central Library closed in 2013 and was eventually demolished in 2015–16 (Figure 4).

The Library Story: Heritage Bodies and Birmingham City Council

Any dominant rationale for conservation has the potential to influence the processes through which listing decisions are made. As such, it is useful to gain an appreciation of the understandings employed by the numerous interest groups involved with Central Library in order to contextualise the decision-making framework. A notable variety in the conception of conservation was immediately apparent in Birmingham between the heritage bodies operating at the local and national scales. These often proved contradictory and inevitably fuelled contestation over the listing potential of Central Library.

Historic England's formal conceptualisation of conservation followed the present statutory guidance of assessment of architectural and historical significance. However, whereas the DCMS[68] requests a 'special' architectural or historic interest to define a building worthy

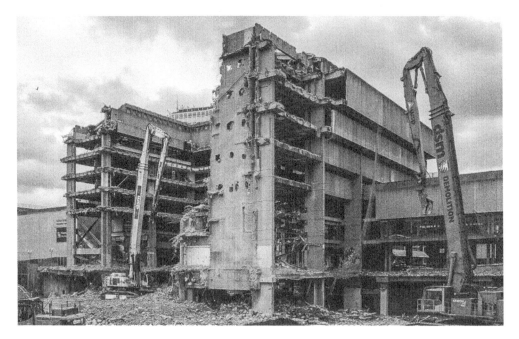

Figure 4. The Central Library under demolition.

of listing, in the Central Library case English Heritage specified that consideration was given to 'whether it fulfilled its brief; whether it was a particularly good example of a public library; how well it survives; how it compares to other listed buildings of a similar type; and how influential the building has been'.[69] It is also important to note that, although English Heritage recommended Central Library for listing at Grade II, given the open-minded attitude to the reuse of post-war buildings elsewhere, under their 'constructive conservation' approach[70] – notably with Birmingham's Rotunda[71] and Sheffield's Park Hill – in this case the organisation was less concerned with fabric, than with the perpetuation of a building's physical and ideological presence. As such, deemed most significant was Central Library's 'boldly confident exterior [that] defines an era of Birmingham's recent history'.[72]

The Twentieth Century Society took a subtly different stance, deeming Central Library 'historically and architecturally significant' and that 'it is capable of being adapted for the needs of 21st century Birmingham' but where its use as a library is maintained.[73] However, even the latter consideration was of secondary significance to the Society, which argued that listing decisions should be made 'purely on the basis of architectural or historic interest'.[74] Consequently, the conception of conservation underpinning their campaign for Central Library's listing was significantly narrower than that of English Heritage.

Both Birmingham City Council and Birmingham Civic Society opposed the conservation of the library and actively supported an application for a Certificate of Immunity to facilitate demolition. The City Council had seemingly little regard for post-war heritage and instead actively opposed the conservation rationale on which English Heritage based its listing recommendation. In a letter to the Minister Margaret Hodge, the leader of the council[75] criticised the detailed rationale provided by English Heritage in an undisclosed document, critiquing the architectural quality of the building and the significance of the

building in Birmingham's history. Whilst a similar methodological approach was taken, a subjectively opposing stance was taken to that of English Heritage in which existing functional attributes were prioritised above architectural consideration, to the extent that a Council spokesperson stated that, 'even if the Central Library is listed, we'll still knock it down'.[76]

In its Unitary Development Plan 2005, the City Council's dominant rationale in the City Centre was to create space for (re)development given 'that the supply of vacant land available for immediate new development is severely limited'.[77] Any value, or not, that the library might exhibit is not explored in this document. The decision notice granting consent for the redevelopment to Argent Group PLC, dated 8 February 2013, makes no mention of the library or any desire to have the building recorded.[78] Indeed, 'the applicants were not required to consider the merits of retaining the library in any redevelopment'.[79]

Birmingham Civic Society operated from a more considered position in which Central Library might be deemed worthy of conservation 'in the absence of any other consideration', but that in reality consideration of other socio-economic elements 'outweigh' the building's architectural merit.[80] A rationale of a 'degree of fit' was employed, in which the aesthetics of the building were considered in relation to its surroundings, the quality of materials used in construction, public accessibility, and the potential benefits any redevelopment could bring. To this end it was conceded by one council member that 'I would have been interested in retaining it if you could move it about half a mile away', but that any conservation rationale based on viewing the building in isolation was insufficient.[81]

Despite sharing the same anti-listing sentiment, the ethical perspectives of key decision makers in the Council and Civic Society were contradictory. Whilst one Council employee stated that any approach to accommodate new uses within the building would be 'more disrespectful than knocking it down' because of an intrinsic need to view buildings holistically 'with both the exterior and the interior complementing one another'[82], an individual from the Civic Society stated 'I don't mind a bit of messing around on the inside because sometimes you have to do that simply to make the building useable'.[83] In developing a theoretical scenario, this suggests that if the economic realities were more favourable the Civic Society would have had no ethical objection to re-purposing the building, whilst the Council would have continued to resist any re-use.

Offering yet another conceptual perspective was the local action group, Friends of Central Library (FoCL), whose primary consideration was the continued use of a relatively young building for both economic and environmental reasons. Consequently, the conceptual positioning of FoCL was far more ethically liberal to the extent that one respondent stated: 'I wouldn't mind if they covered it in PV panels or whatever. I know that goes against the Brutalist aesthetic, but so what? ... I don't mind it being adapted if it continues to have a useful life'.[84]

What is obvious from an analysis of only the key players in the formal debate surrounding Central Library is the wide array of conceptualisations, rationales and ethical stances in operation. The contradictory positions of the pro- and anti- conservation parties presented an obvious source of conflict which the processes of post-war listing must accommodate, but of equal significance were the more subtle variations within each camp. However, one factor on which formal actors agreed was the continued importance of a physical architectural record. A representative view was provided by an employee of the Council:[85]

'I think the sheer physicality of architecture and buildings means that we need to try and preserve the physical record. Whenever you see images – whether still or moving – of buildings that are not there anymore, somehow it doesn't do it any longer because you don't capture the sheer four-dimensional reality – including time – of the presence that they have in their environment.'

A consensus rejecting the prospect of a comprehensive archival record, replacing the preservation of actual buildings as suggested by Saint,[86] thus provided the only stable grounding.

The Library Story: The Public

The general public are the 'end-users' of Birmingham city centre and their conceptions of Central Library's potential listing were equally varied. The topic solicited vociferous responses in both support and antagonism to the building's conservation, although the majority of conservation conceptions were opposed to its listing. Clashing conceptions of what even represented 'heritage' were frequently apparent. For instance, while some recognised the significance of post-war buildings as part of England's national history, a diametrically opposing conception was proposed by many, as illustrated by one respondent's reaction:

> 'Listing should be for old manor houses with beautifully maintained grounds covered in ivy winding up the sides, not a concrete block which looks like it was taken straight out of the concrete mixer and dumped in the city'.[87]

A prioritisation of aesthetics beyond any appreciation of architectural or historical merit was common. Another idiosyncrasy existed where several individuals acknowledged the library as a potential heritage asset, but supported its demolition based on a personal distaste for its appearance. Highly emotionalised descriptions of the building included 'concrete monstrosity', 'ghastly' and 'hideous', but one individual switched the conception around: 'it might look horrible, but it's important to keep a record of that era'.[88] The significance of conceptions of ontological security on conservation rationale was also recognisable, though again, in often contradictory forms that support Upton's[89] assertion of structures having multiple imaginings within the public. Anti-conservation sentiments were expressed by those who felt the library to be 'oppressive', 'dominating' and generally undesirable 'compared to traditional landscapes'[90] perhaps representative of a feeling of the Modernist townscape being 'unfaithful' in contrast to the more ontologically secure architectural vernacular of the neighbouring 1879 classical Council House.[91] For others, however, conservation-worth was grounded upon experiential associations of having grown up using the building and because it was now a familiar, if still largely unloved, part of the streetscape. Although numerous interviewees had concerns about a perceived negative image Central Library cast over the entire city, one individual viewed the building as an icon representing an era of civic pride.[92]

Processes of Post-War Listing and the Statutory Conservation Framework

Determining listing outcomes are numerous operational inputs and influences that collectively represent the processes of listing. Their roles in the Central Library case are

worth considering to gain an insight into the realities and suitability of the statutory conservation framework in accommodating the post-war listing debate. This can be achieved, it is suggested, through an evaluation using four themes: architectural-historical or fitness for purpose; image, growth and power; accountability and transparency; and participation and democracy.

Architectural-historical or fitness for purpose: The current DCMS framework stipulates only an architectural-historical perspective to warrant a building being listed. However, in reality much broader considerations appear to have influenced the Central Library case. While English Heritage stated that their recommendation for listing was based upon the building successfully meeting their architectural-history criteria,[93] the DCMS issued no formal statement on the criteria used in reaching their decision to announce the issuing of a CoI in November 2009. However, Margaret Hodge did make numerous comments to the media suggesting that criteria other than architectural-history had been considered, for example: 'The escalators that I went up and down [are] pretty narrow and that might not have been the architect's fault. But does that make it a fit-for-purpose building for the 21st Century?'.[94]

The fitness for purpose issue adds a new dimension to post-war listing not formally considered in the existing statutory framework, and yet one which Hodge went on to state as a significant consideration.[95] Birmingham City Council and the Civic Society both supported the inclusion of such criteria in the listing debate and based much of their anti-listing campaign on highlighting the building's functional shortcomings. Indeed, one interviewee insisted that 'the future of a building should not be determined simply according to a subjective view of its architecture'[96] before highlighting the failure of construction materials, a lack of accessibility to the library, and a constriction of pedestrian movement at ground level as reasons why the building should not receive listed status.

This unofficial expansion of listing considerations subsequently shaped the participation in the debate of pro-conservation groups. The FoCL admitted that the basis of their campaign became one not so much of arguing for the building's architectural or historic significance, but of 'knocking down all their reasons why the library is not fit for purpose':

> 'We know very well that many other things have got into the process underneath the official reasoning and we felt we couldn't just let it happen; we had to join the debate and review the arguments about fitness for purpose, the structure, the cost. We knew full well it wasn't supposed to be – we wrote letters to the Minister saying 'we know these things are not considered, but we know the City Council have been saying all these things in public'.[97]

Throughout the listing debate FoCL were therefore highly active in presenting evidence to disprove the statements made by the Council and Civic Society about the building's lack of fitness for purpose. Significantly and in contrast, the Twentieth Century Society's pro-listing campaign was specifically tailored to argue only on the architectural-historical route, with an unwillingness to support the fitness-for-purpose element of FoCLs campaign.[98] While pursuing the architectural-historical approach was legally the legitimate course, in reality it splintered the pro-listing campaign approach and left FoCL alone to fight against the Council-Civic Society partnership.

Image, growth and power: As a city, Birmingham has a historic tradition of perpetual redevelopment and, as a result, an 'assemblage of architecture and planning interventions over time'.[99] In this regard it appears that the growth-machine incorporating the Council and Civic Society may have been influential in determining a negative 'heritagisation' of the

library, with these 'authorised' decision makers perpetuating associations of the building which purposely denigrated any wider desire for the building to be conserved. For instance, the then chairman of the Civic Society provided high-profile interviews in which he expressed opinions such as:

> 'It's an example of the worst kind of architecture. Brutalist architecture had its place perhaps in post-revolutionary Russia. It doesn't have its place in a Victorian square in Birmingham'.[100]

The close 'critically constructive' partnership between the Council and the Civic Society, in which joint opinions were formed prior to formal action,[101] disseminated and perpetuated an 'authorised' perspective that the building was inappropriate for the city, and even played on negative associations between Modernist aesthetics and failures of socialism.[102] If viewed via a derivative of Tait and While's[103] 'black box' theory, an attempt was made to stabilise the 'negative' heritage-worth and deny the possibility of other more positive perceptions. Instead, the potential of the site for commercial redevelopment was highlighted and the great significance of this for the future economic prosperity of Birmingham:

> 'That is the premier development site in the whole city, you might even argue in the country. There's huge potential on that site to create a new magnet that will draw people to the city and improve the image of the city internationally'.[104]

The importance of image is palpable to a Civic Society who desire 'photogenic' buildings that attract inward investment.[105] For those historic buildings not (yet) perceived picturesque, their economic heritage-worth is negligible or even negative and thus efforts are made to resist their safeguarding through listing. A present distaste for the Brutalist aesthetic in accord with Saint's[106] U-shaped fashion trend model therefore left the Central Library vulnerable.

The pro-conservation groups were particularly critical of this element of the listing debate, with one interviewee feeling the Council had 'bullied' the decision-making Minister by overplaying the claimed 'catastrophic' implications that would ensue should the building have been listed, while exploiting the unpopularity of Brutalism and 'using it as a kind of expletive' to sway opinion.[107] For FoCL, a reluctant acceptance was made of the economic potential that a prime redevelopment site offers and so a perception that 'however brilliant this library is or was would have made very little difference' to any listing decision.[108] In respect of this, a conception of the listing process such as Glendinning's[109] being in place to oppose purely commercially driven modernisation requires re-evaluating given the seemingly powerful influence the growth-machine played in supporting the processes of capitalism.

Accountability and transparency: When Margaret Hodge announced her intention to award a Certificate of Immunity to Central Library rather than confirm listed status, she announced on a regional news programme:

> 'I had representations from nearly a hundred bodies and organisations. More felt it shouldn't be listed than it should, and in the end I had to exercise my judgment'.[110]

In reaching this decision, the Minster had overturned a recommendation for listing from English Heritage as well as the support of the statutory consultee The Twentieth Century Society. There was a feeling among the pro-conservation groups that ministerial accountability had been severely compromised in the Central Library case, with an accusation that

Hodge was 'able to hoist her own prejudices onto the system'.[111] A dichotomy exists within the present system whereby listing decisions are theoretically based upon heritage expertise but within an inherently politicised climate. Consequently, one interviewee summarised the Central Library process as having 'English Heritage, the experts, advising a Minister who decides to ignore their advice because she's a politician who needs to get votes'.[112]

Despite the contrasting opinions and campaigns of the various actors involved with the case, a recurring theme of a lack of understanding of the decision-making process undertaken by the DCMS, or indeed a full rationale for its decision, was present among the Birmingham-based groups. Interviewees from FoCL and the Civic Society similarly conceded a total lack of knowledge of what rationale the Minister employed in reaching her decision, having not been allowed access to the report produced by civil servants at the DCMS.

An ongoing failure of the DCMS to meet deadlines for decision making was also commonly highlighted among each of the local interest groups as a hindrance to transparency, with a drawn-out formal process spanning from November 2007 to November 2009. However, seemingly unknown to the conservation groups, and certainly unpublished in the public domain, was the revelation from a City Council employee that the CoI had yet to be formally issued:

###'In November 2007 we submitted an application for immunity from listing. As at the present moment [11 August 2010] there has been no official response to that. We had a visit from Margaret Hodge – the responsible Minister – and she wrote us a letter which stated it was her intention to grant us a CoI. But before she was able to do that a General Election was called and that certificate has never actually been issued, so we remain in a state of uncertainty'.[113]

Significantly, the CoI issue also illustrates a definite hierarchy of 'transparency' throughout the listing framework (see Figure 5). Although the positions of English Heritage and the entieth Century Society remain unknown in this respect – and indeed their lack of input into this research is in itself illustrative of a lack of transparency in the process – it would appear that the Council did not, unsurprisingly, share this development with opposing heritage groups, but seemingly neither with the Civic Society nor the general public either.

Guerrilla groups like FoCL appeared to be at the bottom of the transparency hierarchy, resorting to Freedom of Information (FoI) requests to gain information from the Council. That much of the FoCL campaign required FoI requests in order to view documents the Council were basing their anti-listing campaign upon has transparency implications in itself, but there were also cases of the Council requesting a fee to enable the researching and release of information.[114] Arguably, a 'privatisation' of the listing process occurred both in this regard, but also on occasions where the Council refused to disclose information to FoCL on the grounds of commercial confidentiality. While this position might be justifiable were the redevelopment of the site subject to ongoing developer negotiations, the reality here is of the developer Argent having had an exclusivity agreement since 2004 and hence no reason for non-disclosure.

Participation and democracy: The transparency issues illustrate the barriers to participation that faced various 'formal' Central Library interest groups, but this case also shows often the views of the public are often forgotten in listing debates. Every individual interviewed about the Central Library had strong opinions on the building and its heritage-worth, suggesting a definite public interest at some level in the future of the

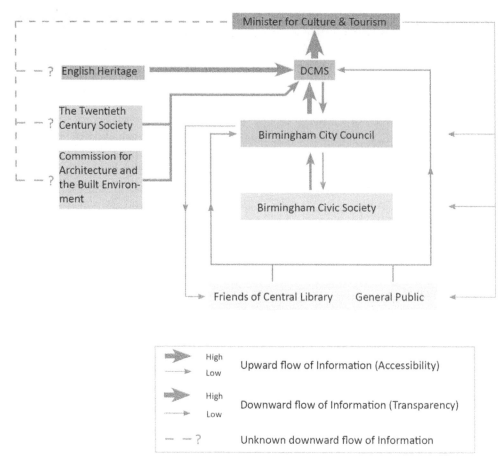

Figure 5. Hierarchy of access and transparency inequalities among Central Library actors as identified in interviews. *(Source: Authors derived from Interviews A, B & C, 2010).*

building. As part of the existing statutory listing process, individuals could write letters to the DCMS expressing their opinions, although it remains unknown to what extent these views were considered. The Library Services also held extensive consultation exercises with 'over 10,000 people'[115] (although primarily in regard to the building's fitness for purpose as a library).

The attitudes towards public participation universally expressed by the 'formal' groups were interesting in their concern that a lack of applied architectural or historical knowledge among the public could result in inappropriate listing decisions being made. For instance, one pro-conservation interviewee stated: 'you don't want too many ordinary people having their say because look what they might decide' given that 'these particular buildings are not yet considered heritage in the general public's mind'.[116] Given this, it is important to note that the majority of public opinions – both for and against – were based purely on aesthetic or functional opinions rather than on any academic basis.[117]

While public opinions are in part related to ontological security, there is also an inevitable perception-forming relationship between the press and the public. Significantly, the language used in press coverage relating to Central Library – in both local and national, tabloid

and broadsheet – was often sensationalised and typically presented shallow attacks on the aesthetics of Brutalism. Numerous articles[118] gave great prominence to the infamous quote by Prince Charles in which Central Library was likened to being 'a place where books are incinerated, not kept!'[119] while others attacked its 'brusque insensitivity'.[120] Although *The Independent's* architectural critic defended Central Library and Brutalism as a genre,[121] this supportive stance is rare and it is tempting to draw linkages between this and the knowledge-perspective predominant among the public.

Also significant is a lack of educational material on Central Library published either by English Heritage or the Twentieth Century Society. Exhaustive web and archival searches up to the decision to issue a CoI produced only two meaningful explanations of the building in specialist architectural publications and as such a superficiality of public knowledge is hardly surprising. Knowledge of the library's architect, John Madin, was equally sparse at the time despite his significant role in shaping post-war Birmingham and has only been addressed subsequently by a book reviewing his life and work.[122]

Conclusions

This paper has demonstrated an obvious need for significant transparency improvements in the conservation listing process. While it is important for any state-led process to be visible to, and understood by, the population in the name of democracy and accountability, the listing decisions for post-war buildings are of particular significance to society given their impact on the lives of city-users. Transparency issues obviously also exist lower down the decision-influencing hierarchy, with particular interest groups – Birmingham City Council in this instance – having the power to withhold information on the legal status of particular buildings, even if they too are left in a state of uncertainty over the lack of definitive progress from government.

Perhaps requiring more thoughtful debate is the relationship between the DCMS, English Heritage (now Historic England) and planning. If listing is, as historically and legally has been the case, primarily an issue of conserving the best of the nation's built heritage, the future role of professional organisations in advising decision making is going to be problematic. With an apparent broadening of assessment criteria to incorporate 'fitness-for-purpose' and economic concerns, the judiciary boundaries of the process become blurred to incorporate topics conventionally considered by planners and architects. Larkham and Adams[123] suggest that a review of the way in which buildings are assessed for heritage purposes might be wise, as a result.

The actions of Historic England and, as a statutory consultee, the Twentieth Century Society must also be critically re-evaluated given the shift away from the architectural-historical designation approach. Historic England has a significant role to play in increasing the transparency of the listing processes through openly publishing the representations they make to the DCMS, but the potential also exists for both organisations to fulfil a far greater educational role. It is surprising that so little information is available either to built environment professionals or the general public on the very buildings that campaigns are trying to save from demolition. If it is accepted that 'with education comes appreciation'[124] then heritage bodies may need to significantly increase their publication of accessible and appropriate educational material in order to reduce ignorance of post-war buildings and increase their likelihood of survival.

Overall, the conflicts dominating post-war listing debates can be traced back to an inherent unease of a process that attempts – seemingly incoherently – to apply a policy framework to what are ultimately a series of subjective ethical decisions. Such a policy framework is, of course, a compromise mechanism necessary to reach any sort of justifiable decision, but it is also important to note that the current statutory framework is based on the same basic ideals conceived in the nineteenth-century. Undeniably the post-war listing debate presents a different scenario to that for buildings of previous generations and it is only reasonable that the policy framework evolves to contemporary needs. Fundamentally though, there is a need for a more holistic, interdisciplinary process; countless opinions, objectives and influences collectively shape contentious listing cases, and consequently a more holistic understanding of heritage issues would prove highly beneficial to both future research and practice.

Notes

1. Kain, *Planning for Conservation*, 2.
2. Tung, *Preserving the World's Great Cities*, 3.
3. Heath et al., *Public Places*, 3.
4. While and Short, "Place Narrative and Heritage Management," 4.
5. Pendlebury, *Conservation in the Age of Consensus*, 2.
6. While, "Modernism v Urban Renaissance," 2415.
7. For example: Hobson, *Conservation and Planning*; and While, *The State and Controversial Demands of CBH*.
8. Ashworth, "Conservation as Preservation or as Heritage," 93.
9. SPAB, *The SPAB Manifesto*, 1.
10. Larkham, "Preservation, Conservation and Heritage," 105.
11. Ashworth and Larkham, *Building A New Heritage*.
12. Cullingworth and Nadin, *Town and Country Planning in the UK*, 289.
13. Tewdwr-Jones, "Development Control and the Legitimacy of Planning Decisions,"
14. Strange and Whitney, "The Changing Roles and Purposes of Heritage in the UK."
15. Murdoch, "Space Against Time," 4.
16. Hobson, *Conservation and Planning* .
17. While, "Modernism v Urban Renaissance," 2407.
18. Harwood, *Space, Hope and Brutalism*, 3.
19. Calder, *Raw Concrete*, 7.
20. Beanland and Meades, *Concrete Concept*, 7.
21. See for example: Harwood (2003).
22. *Planning (Listed Buildings and Conservation Areas) Act 1990*.
23. DCMS, *Principles of Selection for Listed Buildings*, 4.
24. Ibid., 5.
25. DCMS, 2018, 5.
26. Mynors and Hewitson, *Listed Buildings and Other Heritage Assets*, 66.
27. See note 5 above.
28. Ibid., 6.
29. Mynors and Hewitson, *Listed Buildings and Other Heritage Assets*, 67.
30. Ibid.
31. Cherry, "Listing Twentieth Century Buildings, "7.
32. Hubbard, "The Value of Conservation," 369.
33. Powers, "Style or Substance," 5.
34. See for example: Turnpenny, *Cultural Heritage, an Ill-defined Concept*; Goss, "The Built Environment and Social Theory."

35. Tait and While, "Ontology and the Conservation of Built Heritage," 726.
36. Ibid., 734.
37. Ibid., 722.
38. Larkham, "Preservation, Conservation and Heritage," 108.
39. See note 35 above.
40. Larkham, "Preservation, Conservation and Heritage," 115.
41. Delafons, *Politics and Preservation*, 177.
42. Ibid.
43. Saint, "Philosophical Principles of Modern Conservation," 17.
44. Ibid., 21.
45. Larkham, "Preservation, Conservation and Heritage," 109.
46. Parker and Long, "The Mistakes of the Past?" 40.
47. See note 6 above.
48. Glendinning, "The Conservation Movement," 361.
49. Historic England, *Heritage Counts*, 14.
50. Smith, *Uses of Heritage*, 4.
51. While and Short, "Place Narrative and Heritage Management," 2.
52. See for example While and Short, "Place narratives and heritage management," 7.
53. Graham et al., *A Geography of Heritage: Power, Culture and Economy*, 3.
54. Hubbard, "The Value of Conservation," 369.
55. While, *The State and Controversial Demands of CBH*, 649.
56. Harvey, *The Limits to Capital*, xiv.
57. Green, "Introduction," 2.
58. See note 43 above.
59. Rapaport, *The Meaning of the Built Environment*, 37.
60. Greenville, "Conservation As Psychology," 448.
61. See for example: Clawley, *John Madin*; and Foster, *Pevsner Architectural Guides: Birmingham*.
62. Clawley, *John Madin*.
63. CIPFA, "Norfolk Library is most popular in the UK."
64. Larkham and Adams, "The Un-necessary Monument?" 100.
65. Bianconi and Tewdwr-Jones, "The Form and Organisation of Urban Areas," 314.
66. Historic England, *The English Public Library 1945–85*, 7.
67. Clawley, *John Madin*, 112.
68. DCMS, *Principles of Selection for Listing Buildings*, 4.
69. English Heritage, "Birmingham Central Library," 3.
70. English Heritage, *Constructive Conservation in Practice*, 7.
71. Bansal D (2008), "The Rotunda, Birmingham," 37.
72. Please see http://www.english-heritage.org.uk/about/news/birmingham-library/.
73. Wright, please see https://c20society.org.uk/news/ministers-refusal-to-list-birmingham-central-library/.
74. Ibid.
75. Whitby, please see http://www.scribd.com/doc/3940170/Mike-Whitbys-Letter-to-DCMS-Re-Central-Library.
76. Merrick, please see http://www.independent.co.uk/arts-entertainment/architecture/battle-to-save-britains-brutalist-buildings-from-the-bulldozer-1890905.html.
77. Birmingham City Council, *UDP 2005*, 15.6.
78. Birmingham City Council, *Decision Notice*.
79. Birmingham City Council, "Committee Report," 6.28.
80. Interview A, 2010.
81. Ibid.
82. Interview B, 2010.
83. Interview A, 2010.
84.. Interview C, 2010.
85. Interview B, 2010.

86. Saint, "Philosophical Principles of Modern Conservation," 18.
87. Interview B,, 2010.
88. Interview C, 2010.
89. Upton, "Architectural history or landscape history?" 196.
90. Interviews, 2010.
91. Larkham and Lilley, "Plans, Planners and City Images."
92. Interviews 2010.
93. English Heritage, "Birmingham Central Library."
94. BBC, "No listed status for main library."
95. Bury, "Now that's what Margaret Hodge calls architecture."
96. Interview A, 2010.
97. Interview C, 2010.
98. Ibid.
99. Larkham and Adams, *The Un-necessary Monument?* 118.
100. Gick, please see http://www.bbc.co.uk/blogs/theoneshow/onepassions/2008/09/birmingham-central-library-ugl.html.
101. Interview A, 2010.
102. Ibid.
103. See note 35 above.
104. Interview A, 2010.
105. Gick, "Architectural Bravery," 19.
106. Saint, *Philosophical Principles of Modern Conservation*.
107. Interview D, 2010.
108. Interview C, 2010.
109. Glendinning, *The Conservation Movement*.
110. BBC, please see http://news.bbc.co.uk/1/hi/england/west_midlands/8374348.stm.
111. Interview D, 2010.
112. Interview C 2010.
113. Interview B, 2010.
114. Interview C, 2010.
115. Interview B, 2010.
116. Interview D, 2010.
117. Interviews, 2010.
118. See for example: Dolan, 2008; The Telegraph, 2008; BBC, 2008.
119. HRH Prince Charles, *A Vision of Britain*, 4.
120. Grimley, see https://www.business-live.co.uk/lifestyle/brums-central-library—should-3959522.
121. See note 76 above.
122. See note 62 above.
123. Larkham and Adams, "The Un-necessary Monument?" 118.
124. Twentieth Century Society, see http://www.c20society.org.uk/about.html.

Disclosure statement

No potential conflict of interest was reported by the authors.

Bibliography

Ashworth, G. "Conservation as Preservation or as Heritage: Two Paradigms and Two Answers." *Built Environment* 23, no. 2 (1997): 92–110.

Ashworth, G., and P. Larkham. *Building a New Heritage: Tourism, Culture, and Identity in the New Europe.* London and New York: Routledge, 1994.

Bansal, D. "The Rotunda, Birmingham." *Conservation Bulletin* 59 (2008): 36–38.

BBC. "Dutch Designer Chosen for Library." Accessed September 11, 2019. http://news.bbc.co.uk/1/hi/england/west_midlands/7543147.stm

BBC. "No Listed Status for Main Library." Accessed September 11, 2019. http://news.bbc.co.uk/1/hi/england/west_midlands/8374348.stm

Beanland, C., and J. Meades. *Concrete Concept: Brutalist Buildings around the World.* London: Frances Lincoln, 2016.

Bianconi, M., and M. Mark Tewdwr-Jones. "The Form and Organization of Urban Areas: Colin Buchanan and Traffic in Towns 50 Years On." *Town Planning Review* 84, no. 3 (2013): 313–336. doi:10.3828/tpr.2013.18.

Birmingham City Council. *Unitary Development Plan.* Birmingham: BCC, 2005.

Birmingham City Council. "Committee Report: Land at and Bounded by Paradise Circus Queensway and Surroundings Including Chamberlain Square, Parade and Paradise Street, Birmingham, B3 3HJ." BCC: Birmingham. 20, 2012.doi: 10.1094/PDIS-11-11-0999-PDN.

Birmingham City Council. *Decision Notice; APPLICATION NUMBER: 2012/05116/PA.* Birmingham: BCC, 2013.

Bury, L. "Now That's What Margaret Hodge Calls Architecture." Accessed September 11, 2019. http://www.bdonline.co.uk/news/now-that's-what-margaret-hodge-calls-architecture/3109322.article

Calder, B. *Raw Concrete: The Beauty of Brutalism.* London: Heinemann, 2016.

Cherry, M. "Listing Twentieth-Century Buildings: The Present Situation." In *Modern Matters: Principles & Practice in Conserving Recent Architecture*, edited by S. Macdonald and G. Ostergren, 5–14. Shaftesbury: Donhead, 1996.

CIPFA. "Norfolk Library Is Most Popular in UK for Eighth Year Running." Accessed September 11, 2019. https://www.cipfa.org/about-cipfa/press-office/archived-press-releases/2014-press-releases/norwich-library-most-popular-in-uk-for-eighth-year-running

Clawley, A. *John Madin.* London: RIBA Publishing, 2011.

Cullingworth, B., and V. Nadin. *Town and Country Planning in the UK.* Abingdon: Routledge, 2006.

DCMS (Department of Culture, Media and Sport). *Principles of Selection for Listing Buildings.* London: Department for Culture, Media and Sport, 2018.

Delafons, J. *Politics and Preservation: A Policy History of the Built Heritage 1882–1996.* London: E&FN Spon, 1997.

Dolan, A. "UK's Ugliest Building Set to Be Given Listed Status." Accessed September 11, 2019. http://www.dailymail.co.uk/news/article-1028753/UKs-ugliest-building-set-given-listed-status.html

English Heritage. *Constructive Conservation in Practice.* London: English Heritage, 2008.

English Heritage. "Birmingham Central Library." Accessed August 16, 2019. http://www.english-heritage.org.uk/about/news/birmingham-library/

Forester, J. *Critical Theory, Public Policy and Practice.* Albany, NY: State University of New York Press, 1993.

Foster, A. *Pevsner Architectural Guides: Birmingham*. London: Yale University Press, 2005.
Gick, F. "Architectural Bravery." *Birmingham Perspectives*. 5, 2009. Spring – Summer.
Gick, F. "The One Show." Accessed on September 11, 2019. http://www.bbc.co.uk/blogs/theone show/onepassions/2008/09/birmingham-central-library-ugl.html
Glendinning, M. "The Conservation Movement: A Cult of the Modern Age." *Transactions of the RHS* 13 (2003): 359–376.
Goss, J. "The Built Environment and Social Theory: Towards an Architectural Geography." *Professional Geographer* 40, no. 4 (1998): 392–403. doi:10.1111/j.0033-0124.1988.00392.x.
Graham, B., G. Ashworth, and J. Tunbridge. *A Geography of Heritage: Power, Culture and Economy*. London: Arnold, 2000.
Green, C. "Introduction." In *Modern Matters: Principles & Practice in Conserving Recent Architecture*, edited by S. Macdonald, 1–2. Shaftesbury: Donhead, 1996.
Greenville, J. "Conservation as Psychology: Ontological Security and the Built Environment." *International Journal of Heritage Studies* 13, no. 6 (2007): 447–461. doi:10.1080/13527250701570614.
Grimley, T. "Brum's Central Library – Should It Stay or Should It Go?" Accessed September 11, 2019. https://www.business-live.co.uk/lifestyle/brums-central-library—should-3959522
Harvey, D. *The Limits to Capital*. Oxford: Blackwell, 1982.
Harwood, E. *England: A Guide to Post-War Listing Buildings*. London: Batsford, 2003.
Harwood, E. *Space, Hope and Brutalism: English Architecture 1945–1975*. London: Yale University Press, 2015.
Healey, P. *Collaborative Planning: Shaping Places in Fragmented Societies*. London: Macmillan Press, 1997.
Heath, T., T. Oc, and S. Tiesdell. *Public Places - Urban Spaces: The Dimensions of Urban Design*. London, London: Routledge, 2011.
Historic England. *The English Public Library 1945–85: Introductions to Heritage Assets*. London: Historic England, 2016.
Historic England. *Heritage Counts*. London: Historic England, 2018.
Hobson, E. *Conservation and Planning: Changing Values in Policy and Practice*. New York: Spon Press, 2004.
Hubbard, P. "The Value of Conservation: A Critical Review of Behavioural Research." *Town Planning Review* 64, no. 4 (1993): 359–373. doi:10.3828/tpr.64.4.v758731671422276.
Kain, R. *Planning for Conservation: An International Perspective*. Oxford and London: Mansell, 1981.
Larkham, P. *Conservation and the City*. London: Routledge, 1996.
Larkham, P. "Preservation, Conservation and Heritage: Developing Concepts and Applications." In *British Planning: 50 Years of Urban and Regional Policy*, edited by B. Cullingworth, 105–122. London: Athlone Press, 1999.
Larkham, P., and D. Adams. "The Un-necessary Monument? the Origins, Impact and Potential Conservation of Birmingham Central Library." *Transactions of the Ancient Monuments Society* 60 (2016): 94–127.
Larkham, P., and K. Lilley. "Plans, Planners and City Images: Place Promotion and Civic Boosterism in British Reconstruction Planning." *Urban History* 30, no. 1 (2003): 183–205. doi:10.1017/S0963926803001123.
Merrick, J. "Battle to Save Britain's Brutalist Buildings from the Bulldozer." Accessed September 10, 2019. http://www.independent.co.uk/arts-entertainment/architecture/battle-to-save-britains-bru talist-buildings-from-the-bulldozer-1890905.html
Murdoch, J. "Space against Time: Competing Rationalities in Planning for Housing." *Transactions of the Institute of British Geographers* 25 (2000): 503–519. doi:10.1111/tran.2000.25.issue-4.
Mynors, C., and N. Hewitson. *Listed Buildings and Other Heritage Assets*. Fifth ed. London: Sweet & Maxwell, 2017.
Parker, D., and P. Long. "The Mistakes of the Past? Visual Narratives of Urban Decline and Regeneration." *Visual Culture in Britain* 59, no. 1 (2004): 37–58.
Pendlebury, J. "The Conservation of Historic Areas in the UK: A Case Study of Grainger Town, Newcastle-upon-Tyne." *Cities* 16, no. 6 (1999): 423–433. doi:10.1016/S0264-2751(99)00040-2.
Pendlebury, J. *Conservation in the Age of Consensus*. London: Routledge, 2009.
Planning (listed Buildings and Conservation Areas) Act 1990; C.1. London: Houses of Parliament.

Powers, A. "Style or Substance? What are We Trying to Conserve?." In *Modern Matters: Principles & Practice in Conserving Recent Architecture*, edited by S. Macdonald and G. Ostergren, 3–11. Shaftesbury: Donhead, 1996.

Prince Charles, H. R. H. *A Vision of Britain: A Personal View of Architecture*. London: Doubleday, 1989.

Probert, S. "Govt Rejects Calls to Save Birmingham Central Library." Accessed September 11, 2019. http://www.birminghampost.net/news/west-midlands-news/2009/11/16/govt-rejects-calls-to-save-birmingham-central-library-65233-25182063/

Rapoport, A. *The Meaning of the Built Environment*. Beverley Hills: Sage, 1982.

Saint, A. "Philosophical Principles of Modern Conservation." In *Modern Matters: Principles & Practice in Conserving Recent Architecture*, edited by S. Macdonald and G. Ostergren, 15–28. Shaftesbury: Donhead, 1996.

SPAB (Society for the Protection of Ancient Buildings). *SPAB Manifesto*. London: SPAB, 1877.

Strange, I., and D. Whitney. "The Changing Roles and Purposes of Heritage Conservation in the UK." *Planning, Practice & Research* 18, no. 2–3 (2003): 219–229. doi:10.1080/0269745032000168278.

Strauss, A., and J. Corbin. *Basics of Qualitative Research: Techniques and Procedures for Developing Grounded Theory*. Thousand Oaks: Sage, 1998.

Tait, M., and A. While. "Ontology and the Conservation of Built Heritage." *Environment and Planning D: Society and Space* 27 (2009): 721–737. doi:10.1068/d11008.

The Telegraph. "Birmingham's Ugly Library Gets Protected." Accessed September 11, 2019. https://www.telegraph.co.uk/news/uknews/2184733/Birminghams-ugly-library-gets-protected.html

Tewdwr-Jones, M. "Development Control and the Legitimacy of Planning Decisions." *Town Planning Review* 66, no. 2 (1995): 163–181. doi:10.3828/tpr.66.2.9824933563413608.

Tung, A. M. *Preserving the World's Great Cities: The Destruction and Renewal of the Historic Metropolis*. New York: Clarkson Potter, 2001.

Turnpenny, M. "Cultural Heritage, an Ill-defined concept?A Call for Joined-up Policy." *International Journal of Heritage Studies* 10, no. 3 (2004): 295–307. doi:10.1080/1352725042000234460.

Twentieth Century Society. "About the Society." Accessed September 11, 2019 http://www.c20society.org.uk/about.html

Upton, D. "Architectural History or Landscape History?" *Journal of Architectural Education* 44, no. 4 (1984): 195–199. doi:10.1080/10464883.1991.11102694.

While, A. "Modernism Vs Urban Renaissance: Negotiating Post-war Heritage in English City Centres." *Urban Studies* 43, no. 13 (2006): 2399–2419. doi:10.1080/00420980601038206.

While, A. "The State and the Controversial Demands of Cultural Built Heritage: Modernism, Dirty Concrete, and Postwar Listing in England." *Environment and Planning B: Planning and Design* 34, no. 4 (2007): 645–663.

While, A., and M. Short. "Place Narrative and Heritage Management: The Modernist Legacy in Manchester." *Area* 43, no. 1 (2011): 4–13.

Whitby, M. "Birmingham Central Library – Certificate of Immunity from Listing." Accessed September 11, 2019. http://www.scribd.com/doc/3940170/Mike-Whitbys-Letter-to-DCMS-Re-Central-Library

Wright, J. "Minster's Refusal to List Birmingham Central Library." Accessed September 11, 2019. https://c20society.org.uk/news/ministers-refusal-to-list-birmingham-central-library/

Pathways to Engagement: The Natural and Historic Environment in England

Hana Morel and Victoria Bankes Price

ABSTRACT
This article sets out to address what lessons can be learnt from conservation and management efforts across both the natural and cultural heritage environments by highlighting how approaches which separate the two environments are worked into policies and bureaucracies of activities. The authors discuss issues related to the natural and historic environment, the complexities in English legislation, and the organisational structures which make it difficult to work towards an integrated approach which enhances, protects and conserves both the natural and cultural heritage. These complexities are looked at through the 2018 revision of the National Planning Policy Framework, the introduction of the Environment Bill and the Net Gain concept. The authors suggest that working coordination and cooperation across the sectors may result in more effective lobbying and more substantive improvements.

Introduction

In 1864, George Perkins Marsh suggested 'Man has too long forgotten that the earth was given to him for usufruct alone, not for consumption, still less for profligate waste'.[1] At around this time, there was a rise in the protection of both nature and culture across the United States and Europe – with many who fought that battle often stewards of both heritages.[2] Indeed, cultural and natural heritage were viewed as interconnected and indivisible, with similar traits of being both non-renewable and a limited resource. Yet in management, we seem to treat these two legacies differently, or at least separately, despite a clear 'ethic shared among nature conservationists, social scientists, and cultural advocates' on the 'importance of diversity and the processes that create it'[3] as well as the need to pass both nature and culture down to future generations.

However, the 'opposition between nature (the non-human) and culture (the human)' is increasingly being seen as 'untenable',[4] particularly as we accept that 'no aspect of nature is unimpacted by human agency' and 'no artefact devoid of environmental impress'.[5] With the idea of nature and culture as separate domains increasingly viewed as an artificial divide, it is timely to question what lessons can be learnt from conservation and management efforts across both the natural and cultural heritage environments.

The fluctuating relationship between both culture and nature can be seen through the changes within UNESCO declarations and practices, as well as through revisions of its definitions.[6] UNESCO's effort to recognise and reflect the complexities of the relationships

between nature, culture and multiple world perspectives is increasingly becoming apparent in resolutions to the World Heritage Convention. How these interdependencies are reflected across the practices and policies worldwide is yet another hurdle. It has been suggested for many years, if not decades, that an integrated approach or framework needs to be explored: how these approaches are worked into policies and the bureaucracies of activities is yet another challenge.[7] This paper addresses the relationship between the two environments, and explores overlaps between the two sectors when working towards policy advocacy.

Overlaps and Gaps

The discussion and debate that continues over the interrelationship – or symbiosis – between culture and nature, as well as how the two may be linked in heritage conservation strategies may be seen as a consequence of a Eurocentric understanding of (or lack thereof) nature and culture. From this perspective, in simple terms, nature is understood as not human-made and in that respect rather distinct from what we understand as culture, despite being profoundly shaped by human activity as well as being constructed by human intellect's understanding and valuing of nature. It is the unique perspective that each culture (or group of cultures) has on nature, culture and their own interrelationship with nature and culture which lends itself to decisions made on the management and conservation of the two. The 'self-understanding of human beings in relationship to the wider world is evidenced by differing concepts of nature', Dailoo and Pannekoek argue, and in that 'nature is a key part of humanised, culturally defined places'.[8] And although there may be different views on what comprises heritage across peoples and time, the attachments and values reflected on heritage are 'universal'.[9]

Natural and cultural spaces can be described as a 'meeting place of nature and people, of past and present, and of tangible and intangible values',[10] and existing conservation strategies equally are acts of human – or cultural – intervention, further supporting a dependency between the culture-nature domain. Cultures have, over millennia, integrated closely as human communities with the local environment – modifying it, understanding it, using it, and managing it for their own purposes.[11] In turn, nature has provided the base and source for all human activity. The overlap is clear: while there is no natural environment devoid of humans or human footprints, equally there is no human activity devoid of nature. Yet, generally a Eurocentric perception, 'people are not often treated or regarded as part of the biosphere; certainly not as part of biodiversity'.[12] Eurocentric values continue to 'remain uncomfortably ambivalent as to the status of humans with respect to nature'[13] in which we separate ourselves from biodiversity within ecosystems, although this approach is slowly starting to shift.[14]

Looking at UNESCO: Approaches to Reconciling the Nature-culture Domain

The reconciliation of the nature-culture divide is certainly dependent on influencers and agendas of key stakeholders involved with environmental policymaking. Initiatives, such as sustainable development, come from a political objective to reconcile ongoing development with environmental integrity.[15] These political objectives – driven from prevailing values, shared beliefs or cultural practices- may be influenced or shaped over time by changing understandings through advances in science or technology, although science

and technology do not always shape the final decisions and actions. Indeed, as is more visible in today's socio-political landscape, 'at any given moment [...] values and beliefs may be more important in the shaping of public policy than the results of the latest scientific research'.[16] This cannot be overstated: mindsets and practices often trump scientific research which might question normalised behaviours.

While overall there is a recognition of the importance of acting against environmental degradation, we often remove human agency from the formula. To exemplify this further, global agreements that are most supported and are evident through higher signatories address environmental degradation directly as an issue. However, the global conventions that are relevant to environmental degradation – the Convention on Biological Diversity (CBD), the Convention to Combat Desertification, or the Convention on International Trade in Endangered Species of Wild Fauna and Flora, for example, tend to ignore culture as an aspect of resource management.[17] In many instances it is often easier to deal with *material* issues rather than open up the scope of considerations to include culture and its practices. This, however, is now changing to some degree. The artificial barrier between culture and nature is increasingly disappearing in Western discourse: not only is there more uncertainty about the division between the two environments, but there is an increased level of interest from stakeholders that is influencing various organisations, including UNESCO and UNEP, to pursue work joining the two. For example, the *2003 UNEP Governing Council Resolution on environment and cultural diversity* referred to the importance of further examining this issue in cooperation with UNESCO, with particular attention to its implications for human well-being.'[18] These interrelationships are not uncommon, seen through a plethora of research now exploring the links and interplay between cultural heritage and the natural environment.[19] This ongoing effort of the interplay between culture and nature is actually reflected in, for example, the UNESCO 1972 Convention for the Protection of the World Cultural and Natural Heritage, the 2001 Convention on the Protection of the Underwater Cultural Heritage, the 2001 Universal Declaration on Cultural Diversity, and 2003 Convention for the Safeguarding of the Intangible Cultural Heritage.[20] More particularly is the attention brought to cultural landscapes through the World Heritage Convention Management Guidelines for Cultural Landscapes, which has played a significant role in revising World Heritage concepts of culture and nature. Indeed, the entanglement between the cultural and natural is difficult, at best, to separate. 'With constant deepening in the knowledge and understanding to this value, especially the aggravated damage to the natural and cultural heritages caused by natural disasters and unsustainable economic growth, the world heritage protection and heritage site development have become one of the hotspots attracting the worldwide attention'.[21] The nature-culture connectivity, however, has been more apparent within conservation efforts of indigenous peoples who recognise a clear relationship between their identity and culture, shared values and nature itself.

Policy in the UK

The heritage of nature and culture in UK policy is complex. Parliament passes literally thousands of statutory instruments each year, and so in many instances, it is difficult to pin down how to effectively secure strong relationships between both nature and culture. Are there the resources necessary to revisit decades of legislation and rethink (then

UK Primary Legislation Search for 'the Environment'
Pollution
Control of Pollution Act 1974
Environmental Protection Act 1990
Wildlife
Wildlife and Countryside Act 1981
Weeds Act 1959
Badgers Act 1991
Protection of Badgers Act 1992
Hunting Act 2004
Conservation
Planning (Listed Buildings and Conservation Areas) Act 1990
National Parks and Access to the Countryside Act 1949
National parks of England and Wales and National parks of Scotland
Ancient Monuments and Archaeological Areas Act 1979
Countryside and Rights of Way Act 2000
Climate Change
Climate Change Act 2008
Planning and Energy Act 2008
Energy Act 2008, 2010, 2011

Figure 1. UK primary legislation search for 'environment'.

implement) them embedding this new paradigm of entangled heritages? Looking at UK legislation that protects the environment, there are over 300 statutory instruments ranging from access to the countryside to carbon budgets. The scope is almost endless, whether the focus is on pollution or conservation or community wellbeing or climate change.[22] Figure 1 below is a table of some UK primary legislation that relates to the 'environment', to demonstrate the range of topics covered.[23]

By taking a broad definition of 'the environment', we can see a range of Acts that clearly relate to *both* the natural and historic/cultural environment. It is also clear that the Acts separate nature and culture through their focus. This separation is also reflected within governmental departments: for example, Historic England sits within the Department of Digital, Culture, Media and Sport (DCMS)[24] whereas nature-focused organisations, such as Natural England or the Environment Agency, sit within the Department of Environment, Food and Rural Affairs (Defra). This separation is not just technical, but political. A 'distinguishing feature of the environmental policy-making is the potential for conflict between the many competing interests involved'[25] – and of course, as the environment is the basis of all activities we do, interests are plenty, particularly those concerning land use. The scope of competing issues can be cross-national, with environmental issues increasingly seen as a global crisis, yet management solutions tend to be more localised and address particular regions and their interests. Although government needs to address and resolve competing interests, as a political system its very nature reflects the power dynamics and conflict of interests embedded across a huge range of issues and activities. 'Environmental issues cross cut a huge variety of governmental activities – transport, agriculture, trade and so on – and these separate policy arenas

tend to provide a great deal of influence for development-oriented interests.'[26] It is in these instances it becomes easier to see the similarities between both natural and historic environments, when faced with destruction or habitat loss through land use, conversion impact, and development activities. It could be suggested that land use and development act as catalysts for the rise of the environment as a political issue, largely due to the public becoming more attentive and expressing strong concern for and interest in their environments. New waves of environmental concerns tend to form at times of rapid environmental transformation. Whether such effects are caused by adverse economic and land use practices or as the result of natural disasters, this is one of the intersections where the protection and conservation of natural and cultural 'ecosystems' become fundamental to the 'sustainable development' discourse. It is a discourse characterised recently by the efforts of individuals in the heritage sector to create bridges between the nature-culture sectors.[27]

England's National Planning Policy Framework

The UK's revision of its National Planning Policy Framework (NPPF) in 2019, is a telling example of how the nature and culture sectors work independently to challenge common potential impacts to the environment. The NPPF, originally published in 2012, is the consolidation of many of the UK's previous Planning Policy Statements (PPS) and Guidance Notes (PPG), covering all national planning issues from housing to design (Figure 2). The UK Government published the Framework as a 'dramatic simplification of planning guidance to encourage sustainable growth' that 'safeguards the environment'.[28] A presumption in favour of sustainable development was introduced, suggesting that 'proposals should be approved promptly unless they would compromise the key sustainable development principles set out in the draft Framework'.[29] Yet despite

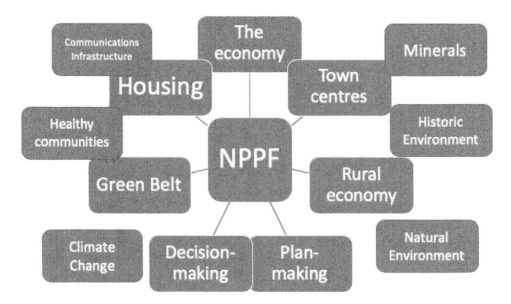

Figure 2. Areas covered in the NPPF.

Type of consultation respondent

Personal view	1,726
Local authority[1]	336
Neighbourhood planning body, parish or town council	204
Private sector organisation[2]	290
Interest group or voluntary organisation[3]	442
Other	224
Total	**3,222**

We also received responses in the form of a number of campaigns on specific issues. The table below provides a breakdown of the overall number of responses including campaigns and general submissions.

Campaigns

Woodland Trust campaign	8,095
General Aviation	4,530
Local Wildlife Sites campaign	13,020
National Parks campaign	357
General submissions	3,222
Total	**29,224**

Figure 3. Type of consultation respondents/campaigns for the NPPF revision. Credit: MHCLG, 2018.

these statements, concerns from both the natural and historic environment sector continue to be raised.

In July 2018, the UK's Ministry of Housing, Communities and Local Government (MHCLG) published the revised NPPF for technical consultation, after which the updated version was available from February 2019.[30] According to MHCLG's *Government response to the draft revised NPPF consultation* which includes a summary of consultation responses, a total of 3,222 consultations were received (see Figure 3 for details). Of the campaigns, there was a total of 29,224 submissions with some 74% of those coming from natural environment organisation campaigns with no explicit historic environment campaign mentioned. While there was not an historic environment campaign similar to the natural environment, a range of historic environment and heritage organisations – from local authorities to private archaeological contractors – submitted consultations. These included Historic England, the Institute of Historic Building Conservation, the Chartered Institute for Archaeologists, the Heritage Alliance, Rescue, the Ancient Monuments Society, the Association of Local Government Archaeological Officers, the Society of Antiquities London, and many more.

Heritage Environment Legislation, Policy and Guidance

Overall, the response from both the natural and historic environment sectors has demonstrated that the NPPF revision clearly raises a set of concerns. Below are some of main concerns highlighted from those involved and interested in protecting and conserving the environment, defined as both natural and cultural, in the 2018 consultation for the revision of the NPPF.[31]

To contextualise, in many instances the further simplification of the UK planning process means that the relationship between environmental legislation, policy and guidance may not be explicitly mentioned within policies, such as the National Planning Policy Framework.[32] In some instances, much of the associations between legislation and policy are made in footnotes or simply removed. For example, Paragraph 9 of the earlier 2012 NPPF aimed at the 'pursuit of seeking positive improvements to the quality of the built, natural and historic environment' with reference to the Natural Environment White Paper of 2011: this paragraph is now removed in the revised NPPF along with its reference. The revised policy cuts the use of the terms 'natural environment' and 'historic environment' from mention within the current NPPF from 38 to 24 times.[33]

In recent years the European Union (EU) has been profoundly influential on the United Kingdom's environmental policy sector and a significant question is how the UK will emerge post-Brexit. The UK government has indicated its promising ambition to support the environment with its 25 Year Environment Plan, but lacks detail and at present covers England alone acknowledging 'coordination challenges associated with devolved policies'.[34]

The lack of strong domestic policy and issues of accountability aside, much of the UK's environmental policies are rooted in either United Nations (UN) or EU policy. The UK is signatory of some 40 international agreements, but additionally there are international agreements entered into by the EU alone, meaning that 'unless and until the UK itself ratifies EU-only international environment agreements' the UK can lose these protections.[35] According to a 2017 National Audit Office's Report, for example, 'approximately 80% of Defra's areas of responsibility are currently framed by EU legislation and 25% of EU laws apply to its sectors'.[36] There remain ongoing issues and challenges of enforcement for many of these EU and international environment agreements, which are reliant on full and proper implementation as well as availability and effectiveness of UK enforcement mechanisms.

These examples frame the UK's position in effectively handling ongoing issues and challenges facing the environment, however while further simplification may enable some interests into action, it will disable others.

Revisions Impacting Community Relationships with the Natural and Historic Environment

Similar concerns towards the NPPF revisions that were identified by both the natural and historic/cultural environment sectors are evident in the consultation responses. One of the most obvious points was the apparent disconnect between associating the natural and historic environment with 'positive growth', understood as 'making economic, environmental and social progress for this and future generations'.[37] This disconnection is reinforced by the removal of the 2012 NPPF Ministerial Foreword by the Rt Hon MP Greg Clark (Minister of State in DCLG, 2010–2012) who had provided an insightful start to the policy document by clearly defining the terms 'sustainable' and 'development', and the intention of sustainable development as being about 'change for the better, and not only in our built environment'.[38]

The disconnect continues through the removal of the 2012 Introduction, which highlighted an explicit connection to local people, framed as 'local people and their

accountable councils can produce their own distinctive local and neighbourhood plans, which reflect the needs and priorities of their communities'.[39] The revision also removed an introductory paragraph of UN Resolution 42/187 on the broad principles of sustainable development as well as a paragraph stating the interrelationship between the economy, society and the environment as 'mutually dependent' and 'not [to] be undertaken in isolation'.[40] The clear connection between sustainable development and communities in the 2012 version, with the communities' association alongside the UK planning system seen through a statement referring to people and communities being 'allowed' back into planning, disappeared from the revision.

Today the 2019 NPPF explicitly removes communities from the heart of environmental protection, and has extinguished the relationship between what it means to be truly sustainable by empowered communities able to recognise and value their own environment, or further enrich and enhance their lives.[41] The revision also suggests that the three key domains of sustainability – that is, the economy, social, environmental- are 'not criteria against which every decision should be judged', working against the initial 2012 statement in which sustainability was a 'golden thread running through both plan-making and decision-taking'.[42]

What is important here is that both the natural and historic/cultural heritage sectors rely heavily on communities, their involvement, and relationship with planning to enable protection of the environment. The symbiotic relationship between communities and environments enables us to value the benefits afforded to us through the protection of natural and cultural heritages. The 2019 revision does not mention the significant contributions heritage (e.g. historic buildings, places and landscapes) provides to our national and local communities and economies.

Plan-making and Decision-making

More importantly, there is an increasing threat to resources, whether that is in-depth local knowledge or appropriate evidence, required to help deliver evidence-based decisions of a higher standard.[43] This is particularly evident in the proposed removal of the requirement that local planning authorities should have access to 'up-to-date evidence about the historic environment' in order to 'assess the significance of heritage assets and the contribution they make to their environment'.[44] While the outcry against this revision resulted in this principle paragraph remaining within the current NPPF at paragraph 169, that its removal was even considered is indicative of the current climate. At present, historic environment records (HER) across England are suffering tremendously as a consequence of cuts to local government.[45] In reality, if these records are not properly resourced nor funded efficiently, the system for assessment prior to development will not work even if it is embedded into policy frameworks.[46]

The motivations, or drive, to speed up the decision-making process of the planning process in order to build a 'strong, competitive economy', combined with a reduction in resources, have jeopardised proper assessment and management of natural and historic environments. These motivations and interests are predominantly held by stakeholders who see regulatory obligations as red tape. An example of this is seen in the current progress of the 'Green Belt (Protection) Bill 2017-19' making its way through UK Parliament.[47] The Green Belt, which was originally conceived as a ring

of countryside around London, was first raised as an idea by the Greater London Regional Planning Committee in 1935 as a means to prevent urban sprawl through an urban containment policy. A decade later in the Town and Country Planning Act 1947, the concept was picked up and extended to other local authorities which were then allowed to include such proposals in their own development plans. According to research by Natural England and the Campaign to Protect Rural England,[48] England's 14 Green Belts now cover more than a tenth (12.4%) of the country and are accessible to 30 million people. Despite being much prized worldwide, the Green Belt has been criticised by international organisations, such as the Organisation for Economic Cooperation and Development (OECD), which has surprisingly recommended the UK start building on the Green Belt. Their view is that restrictions (for example, planning conditions) placed on housebuilding are responsible for the booming property market, raising prices some 7.6 times higher than the average annual salary.[49] In this approach, the provision of housing without question trumps the preservation of the Green Belt. Whether this is a legitimate argument or not, the contested nature of what is viable or profitable once again highlights areas of conflicting interests.[50]

It is such conflict of interests that highlight fundamental concerns of how decision-making relevant to the environment and its use are made. Despite the recurring narrative that people are and should be at the heart of planning, local opposition to development can often be labelled and dismissed as NIMBYism (*Not In Back Yard*), implying 'citizens have illegitimate or irrational selfish (or narrow) reasons for opposing facilities', rather than discussing the nuances and 'complexities of public opinion'.[51] These dynamics and the absence of stakeholders central to decision-making often leads to issues of trust between planning authorities, developers and residents, which acts as a key barrier to any progression.[52]

Conserving and Enhancing the 'Environments'

Competing motivations, interests and agendas behind development are key factors in winning support for development. Land value and private property assets are rarely detached from decisions on development, and are rooted in many discussions in which power dynamics emerge. For example, civil design and planning specialist Sturzaker suggests that the 'rural elite' prevent 'much-needed new housing' being built in the countryside, and that people with 'local connections' enable exclusionary and discriminatory behaviour towards those in need of housing.[53] The identification of such motivations behind the conservation and enhancement of natural and historic environments is important in its suggestion that the pursuit of environmental protection may inadvertently be entangled with sustaining existing power dynamics. It also raises issues of accessibility, and questions who is excluded from the benefits of environmental conservation and enhancement.

Natural and cultural heritage assets are irreplaceable resources that contribute to wider social, cultural, environmental *and* economic benefits through effective conservation.[54] Wider changes and challenges – from the need for industry, infrastructure, and housing to increasing populations and climatic challenges – require both thoughtful and flexible approaches for effective management and positive strategy.[55] However in order to have that flexible and effective approach for management, we need to start thinking fluidly across boundaries. There are instances in which guidance and reports demonstrate an entanglement between the two environments/heritages (e.g. see Figure 4), or indeed

Figure 4. Natural England provides a 'technical information note' to offer guidance on historic environment features when considering the management of woodlands.

Local Plans reference the protection of both natural and historic environment under a single heading, but more needs to be done to open the doors of collaboration between the two sectors. Anecdotally, practitioners tend to see the grass greener in the other sector, envying what are considered 'successes' by the other sector. For example the current goal from the historic environment sector to create a Cultural Capital Valuation mirrors the Natural Capital Valuation; meanwhile the natural environment sector sees the creation of a new cross-departmental Heritage Council in UK parliament, and the NPPF (para 194 (b)), stating destruction of designated assets as 'wholly exceptional', as 'wins'.

'Years of Campaigning Pay Off': The Woodland Trust and the NPPF

An indication of how advocacy from the natural environment perspective played out during the NPPF revision is the Woodland Trust campaign. The example also highlights the importance of advocacy and engaging in the consultation process.

One of the criticisms of the 2012 NPPF is that it had an opportunity to improve protections that were embedded in previous planning policy protections, such as the

'Planning Policy Statement 9: Biodiversity and Geological Conservation'[56] (for the natural environment) or the 'Planning Policy Guidance 16: Planning and Archaeology'[57] (for the historic environment). Instead previous PPSs or PPGs were either replicated or diluted with little apparent effort to improve the link between nature and culture. The disconnect was picked up by the Woodland Trust, the UK's largest woodland conservation charity, who used the chasm as a basis of their 2017 campaign to improve the protection of ancient woods and trees in the English planning system.[58] The Trust would highlight in their campaigning, lobbying and technical submissions the imbalance between the protection and value placed on England's irreplaceable natural heritage versus its historic heritage.

This discrepancy can be seen in the 2012 Framework. For example, in consideration of nature, Paragraph 118 states (italics added):

> Planning permission should be refused for development resulting in the loss or deterioration of *irreplaceable* habitats, including ancient woodland and the loss of aged or veteran trees found outside ancient woodland, *unless the need for, and benefits of, the development in that location clearly outweigh the loss* ...

However, in relation to the 'irreplaceable' environment of heritage assets, we see loss as 'wholly exceptional' rather than an issue of 'outweighing the loss', as seen in Paragraph 132 states (italics added):

> As heritage assets are *irreplaceable*, any harm or loss should require clear and convincing justification. Substantial harm to or loss of a grade II listed building, park or garden should be exceptional. Substantial harm to or loss of designated heritage assets of the highest significance, notably scheduled monuments, protected wreck sites, battlefields, grade I and II* listed buildings, grade I and II* registered parks and gardens, and World Heritage Sites, *should be wholly exceptional*.

For the cultural heritage/historic environment sector, the lack of protection was challenged and despite the addition being diluted from previous guidance and statements, the case was won. Some heritage practitioners, however, at the time were frustrated by the introduction of the term 'asset' rather than resources, suggesting a commodification of heritage, despite its earlier use in the draft 2009 Heritage Protection Bill.[59] The inconsistency raised by the Trust's campaign, nevertheless, shows the gap between values placed on nature and culture by decision-makers working in policy production. More relevant, the campaign strategy also pointed to a gap in how both the natural and historic environment sectors fail to communicate effectively. It is often the case that each sector acknowledges the successes and benefits of the other, but rarely work together to push for the 'environment' as a whole.

The success of the Woodland Trust's campaign saw Government documents begin to address the imbalances in protections towards the natural environment, finally referring to woodlands as 'living cultural heritage', notably within Defra's 2014 publication *'Keepers of Time, A Statement of Policy for England's Ancient and Native Woodland'* (italics added):[60]

> England's ancient woodlands and trees represent a *living cultural heritage, a natural equivalent* to our great churches and castles. They are also our richest wildlife habitat and are highly valued by people as places of tranquillity and inspiration.

Ultimately the benefits of the Trust's concerted campaign would see the 2019 NPPF revise protections, seen in Paragraph 175c:[61]

> development resulting in the loss or deterioration of irreplaceable habitats (such as ancient woodland and ancient or veteran trees) *should be refused, unless there are wholly exceptional reasons* and a suitable compensation strategy exists ...

The phrase 'exceptional reasons' is linked to footnote 58 of the 2019 NPPF, which includes infrastructure projects 'where the public benefit would clearly outweigh the loss or deterioration of habitat'. This again lends itself to how we value or balance, or indeed judge, what 'clearly' outweighs the destruction of natural and historic environments. In pursuit of any development, the natural (and potentially historic) environment *will be* modified or destroyed, the question is to what extent, and for what end? In the end, nothing has *ultimate* protection, and as the planning system is increasingly liberalised, the endeavour to find a positive planning balance continues.

The Environment Bill

The Environment Bill currently making its way through Parliament at time of writing is yet another example of the divergence between the two environment sectors, in which the historic environment sector has been left behind.

The context is important. In 2008 the *Heritage Protection Bill for England and Wales* was intended as the first legislation after 30 years which would cover heritage.[62] It followed the 2004 Green Paper *Review of Heritage Protection: The Way Forward* and the feedback received from the White Paper *Heritage Protection for the 21st Century*. The Bill was set to replace the *Historic Buildings and Ancient Monuments Act 1953*, the *Ancient Monuments and Archaeological Areas Act 1979*, and *Planning Act 1990*. At the time, the then Culture Secretary Andy Burnham had said:

> Heritage protection is as important as anything else we do in this Department [DCMS]. But nobody can sit in an office in London and decide what is heritage or not. Local communities have strong feelings about their own heritage and it is important that those voices are heard.
>
> By unifying the protection regimes, encouraging wider participation, and making the system more transparent we aim to make heritage protection easier to understand and manage, and help it become an integral part of public life.

Culture Minister Margaret Hodge agreed:

> This draft Bill is a really important step along the way to making our system of heritage protection more democratic and, where necessary, more effective. It has been many years in preparation and will make a real difference to the way that ordinary people all over the country engage with our built environment.

Despite cross-party support, the Bill was dropped for the second time by 2009, with the Council of British Archaeology Director Mike Heyworth commenting that the 'lack of Government commitment to these uncontroversial and widely supported reforms is deplorable'.[63]

Fast forward to 2018 and the Conservative Government announced a policy paper, *A Green Future: Our 25 Year Plan to Improve the Environment*,[64] which builds on both the

Industrial Strategy (to transform productivity) and a Clean Growth Strategy (to drive green innovation). Potentially triggered by an aim to deliver a Green Brexit, the UK Government published a consultation on *Environmental Principles and Governance* which ran from May to August 2018, receiving some 177,000 responses.[65] The historic environment sector was adamant that cultural and historic concerns be included in the *Environment Bill*, with calls to define the environment as:

> ... the totality of all the external conditions affecting the life, development and survival of an organism, including the naturally, socially and culturally produced physical surroundings on which humanity is entirely dependent in all its activities. The environment can be divided into physical, biological, social and cultural factors, any or all of which can influence health status in populations.[66]

However, these efforts to include cultural heritage in *The Environment Bill* have so far failed. The current draft at time of writing states:

> Conversely, legislation concerning the following matters, for example, would not normally constitute environmental law as defined here, and therefore the majority of legislation within these areas would be outside the scope of the OEP [Office for Environmental Protection]: cultural heritage.[67]

Heritage organisations such as Historic England have raised concern over this explicit omission, again highlighting the division of roles between government departments. Defra is simply not equipped to deal with heritage-related concerns, which may well be why cultural heritage is explicitly not included in this monumental bill. Ultimately this situation makes it more difficult to implement much-needed change in the separation of the two environments/heritages.

Net Gain

Net gain is understood as development that leaves resources in a better state than before. It goes beyond outweighing losses with gains to actually doing everything possible to avoid loss while simultaneously making gains valuable locally.[68] The UK's Defra opened the consultation on Net Gain in December 2018 to February 2019 to 'improve the planning system in England to protect the environment (biodiversity net gain) and build places to live and work'.[69] Within the *25 Year Environment Plan*, the policy towards using and managing land sustainably is by 'embedding an "environmental net gain" principle for development, including housing and infrastructure',[70] with the ambition to 'expand the net gain approaches used for biodiversity to include wider natural capital benefits, such as food protection, recreation and improved water and air quality'.[71] To evaluate net gain, Government hopes to 'robustly value everything we wish to in economic terms', recognising 'wildlife [as] a particular challenge'.[72] The Plan states 'initiatives to protect and improve the natural world and cultural heritage ... are economically sensible'.

The urgency of tacking the threat to biodiversity cannot be stressed more, reiterated by the landmark report by the Intergovernmental Science-Policy Platform on Biodiversity and Ecosystem Services (IPBES) earlier this year which announced that without action 'there will be a further acceleration in the global rate of species extinction, which is already at least tens to hundreds of times higher than it has averaged over the past 10

million years'.[73] The message is that the protection placed on the ecosystem needs to be prioritised despite strict cost-benefit calculations favouring development over protection, which may have net economic costs. Yet biodiversity nevertheless continues to sit within an ecosystem of habitats and environments which, as discussed earlier, are part of a mix of interests and agendas, including key global and national (societal) priorities. Meeting the needs of conserving, restoring and sustainably living with and off nature (and biodiversity) is a complex issue.

Market mechanisms and priorities rarely ensure the protection and conservation of ecosystems and their services, yet it is clear through the successes of the Natural Capital Valuation and the work of the Natural Capital Committee that the next step for the cultural heritage sector is to work towards a Cultural Capital Valuation to highlight cultural net gain. 'By costing nature [and culture], you ensure that it commands the investment and protection that other forms of capital attract'.[74] It is certain that there will be an upcoming investment in cultural capital value in the coming years, which – in many instances – may be easier to value than nature itself. As a note of caution, it is worth highlighting that 'markets are often unable to address important intra- and intergenerational equity issues associated with managing ecosystems for this and future generations, given that some changes in ecosystem services are irreversible'.[75]

Bridging Gaps

'The world has witnessed in recent decades not just dramatic changes to ecosystems but equally profound changes to social systems that shape both the pressures on ecosystems and the opportunities to respond'.[76] In 2005, the major assessment of the human impact on the environment commissioned by the United Nations was published as *Ecosystems and Human Well-being: A Framework for Assessment* by the Millennium Ecosystem Assessment (MA), to explore the relationship between ecosystems and human well-being, integrating economic, environmental, social and cultural aspirations with information from both the natural and social sciences. The report successfully demonstrated the relationship between nature and culture through its simple starting point of defining 'ecosystem':

> ... humans, with their cultural diversity, are an integral part of ecosystems' which itself is a 'dynamic complex of plant, animal and microorganism communities and the non-living environment interacting as a functional unit'.[77]

It further examined ecosystem services as benefits people obtain from ecosystems (Figure 5).

Around the same time as the MA report, Natural England on behalf of Defra delivered the *Environmental Stewardship* (ES) scheme. In the scheme farmers and land managers are paid to protect and enhance the environment and wildlife of their land through effective management. The aim of the ES scheme is to conserve wildlife (biodiversity); maintain and enhance the quality and character of the landscape; protect the historic environment; protect natural resources; promote public access to and understanding of the countryside; conserve rare breeds; manage flood risk, and; mitigate and adapt to climate change. In a 2008 report on the environmental benefits of the scheme *Provision of Ecosystem Services through the Environmental Stewardship Scheme*, it was stated that:

Figure 5. The relationship between ecosystem services and well-being. Direct image from *Ecosystems and Human Well-being: A Framework for Assessment*, Pg 5.

The natural environment and ecosystems provide a wide range of valuable services that benefit people (ecosystem services). Reflecting the Millennium Ecosystem Assessment framework these services can be classified as the supporting services essential to life (such as photosynthesis and soil formation); the provisioning services (such as the provision of food, fibre and fuel); the regulating services (from climate regulation to the regulation of air, soil, water and pollination); to the cultural services associated with human well-being (including cultural heritage, sense of place and recreation). The conservation of biodiversity for its own sake is also often considered as a separate and discrete service in its own right.[78]

There is little evidence to suggest the environment, or ecosystem, can or should be understood as anything other than an entangled entity. Management and policy change impact an ecosystem in multiple ways. Health, access to basic resources, security (as opposed to conflict), social relations and empowerment are all related to changes in ecosystem services, and are impacted by heritage management and policy changes. Decisions of these and more areas are made by a range of decision-makers that work at local, municipal, provincial, national and international levels – making the decision-making process 'complex and multidimensional'.[79] How human activities affect the ecosystem as a whole is undeniable, yet all economies are completely dependent on the ecosystem itself. Practical mechanisms for protecting both natural and cultural environments need to include, rather than exclude, the needs of local communities as well as their knowledge and cultural values.

In this paper we have highlighted some of the issues related to the natural and historic environment, the complexities in English legislation and the organisational structures which make it difficult to work towards an integrated approach which enhances, protects and conserves both the natural and cultural heritage. In hindsight, it is worth recognising that we both look to each other's accomplishments and how each sector is represented in policy, but tend not to speak to each other as much as we should nor explore lessons learnt so to develop more nuanced approaches. It is worth considering that while working intimately across the silos and sectors may require more time, effort, resources and understanding, the benefits will make it worthwhile. Working together and facilitating engagement between the two sectors was a key objective of the 2018 Conference *Engaging with Policy in the UK: Responding to Changes in Planning, Heritage and the Arts*.[80] It is unassailable that there is a need for greater understanding and wider examination of the factors which divide the sectors, and the impact this has on conservation and enhancement of the environment as a whole. It is important to considering how closer working coordination and cooperation across the sectors may result in more effective lobbying and more substantive improvements.

Notes

1. Marsh, *Man and Nature*, 36.
2. Lowenthal, "Natural and Cultural Heritage," 84.
3. Harmon, "A Bridge over the Chasm," 386.
4. Harrison, "Beyond "Natural" and "Cultural" Heritage,"and ibid., 27, 30.
5. Lowenthal, "Natural and Cultural Heritage," 81.
6. Dailoo and Pannekoek, "Nature and Culture," 25.
7. See this volume: 'Power of Place – heritage policy at the start of the new millennium', *The Historic Environment: Policy & Practice* (2019). and Georgina Holmes-Skelton's article *'For everyone?: finding a clearer role for heritage in public policy-making'*, *The Historic Environment: Policy & Practice* (2019).
8. Dailoo and Pannekoek, "Nature and Culture," 27.
9. See note 5 above.
10. Phillips, "Why Lived-in Landscapes Matter to Nature Conservation."
11. Bridgewater, Arico, and Scott, "Biological Diversity and Cultural Diversity," 407.
12. Ibid.
13. Ibid.

14. For further reading, see scholars such as Latour, Haraway, Morton, and Descola who explore the Anthropocene.
15. Cormier-Salem and Bassett, "Nature as Local Heritage in Africa," 10.
16. Bridgewater, Arico, and Scott, "Biological Diversity and Cultural Diversity," 408.
17. Ibid., 406.
18. Ibid., 408.
19. For example, see Harrison; Brown and Murtha, "Integrating Natural and Cultural Resources in North American Large-Landscape Conservation."
20. See note 11 above.
21. Qing-wen, Wen-hua and Ye-hong, "Discussion on the Scientific Research of Natural and Cultural Heritage," http://en.cnki.com.cn/Article_en/CJFDTotal-DLYJ200604000.htm.
22. We should, however, be careful when exploring UK Acts as the devolved governments of Scotland, Wales and Northern Ireland often progress independently with their own legislation (e.g. Northern Ireland's 2011 *Wildlife and Natural Environment Act;* Scotland's 2011 *Wildlife and Natural Environment Act* and *Historic Environment Scotland Act 2014;* Wales' 2016 *Environment Act* and *Historic Environment Act*).
23. See UK Environmental Law, https://en.wikipedia.org/wiki/United_Kingdom_environmental_law.
24. Previously the Department for Culture, Media and Sport.
25. Garner, *Environmental Politics*, 9.
26. Ibid.
27. Particular historic environment individuals are known within the nature sector and are known for their work and efforts to bridge the chasm between the nature-culture divide. Additionally, there has been extensive efforts to embed cultural heritage into environmental policy and practice from the early 1990s. See Trow, "Archaeology and the State We're In."
28. MHCLG, "Dramatic Simplification of Planning Guidance to Encourage Sustainable Growth," GOV.UK, https://www.gov.uk/government/news/dramatic-simplification-of-planning-guidance-to-encourage-sustainable-growth–3.
29. Ibid.
30. See UK Government, *Changes to planning policy and guidance including the standard method for assessing local housing need* (London: MHCLG) .
31. Note that the reference to the '2018 consultation of the NPPF' refers to the *Draft* that was put under consultation, not that which was finally published in February 2019.
32. See this volume: Hewitson, "The Disconnect between Heritage Law and Policy."
33. The NPPF 2012 mentioned the natural environment 14 times and historic environment 24 times, whereas the current NPPF mentions the terms 6 and 18 times respectively.
34. Burns, Gravey, and Jordan, *UK Environmental Policy Post-Brexit*.
35. UKELA, *Brexit and Environmental Law*, 3.
36. National Audit Office, *Implementing the UK's Exit from the European Union*, 5.
37. DCLG, "National Planning Policy Framework," i.
38. Ibid.
39. Ibid., 1.
40. DCLG, "National Planning Policy Framework," 8. Paragraph 8.
41. See AMS *Defending Historic Buildings* Response.
42. Draft NPPF. Paragraph 9, 5; NPPF, 2012. Paragraph 14, 4.
43. We see the section on 'Using an appropriate evidence base' removed (for example, see paragraphs 169 and 170).
44. DCLG. Paragraph 169, 41.
45. Local government deals with 95% of the historic environment that falls outside the responsibilities of Historic England. See https://www.archaeology.co.uk/articles/features/after-the-cuts-scorched-earth-or-clean-slate.htmAlso see https://www.bbc.com/news/uk-england-46443700 (accessed September 2019) to demonstrate that spending on culture has fallen by 43%.

46. See this volume: Chris Patrick, "Historic Environment Policy: the view from a planning department," *The Historic Environment: Policy & Practice* (2019).
47. See https://researchbriefings.parliament.uk/ResearchBriefing/Summary/SN00934.
48. Green Belts: A Greener Future; A report by Natural England and the Campaign to Protect Rural England, January 2010 https://www.cpre.org.uk/resources/housing-and-planning/green-belts/item/1956-green-belts-a-greener-future.
49. Office for National Statistic, "Housing Affordability in England and Wales 2017," (April 2018).
50. See this volume: Daniel Phillips, *"The role of viability in the UK planning system and how it can influence the conservation and enhancement of archaeology," The Historic Environment: Policy & Practice* (2019) for exploring viability and viability assessments in planning.
51. Hunter and Leyden, "Beyond Nimby: Explaining Opposition to Hazardous Waste Facilities," 602.
52. Sims and Bosetti, *Stopped: Why People Oppose Residential Development in Their Back Yard*, 24.
53. Sturzaker, "The Exercise of Power to Limit the Development of New Housing in the English Countryside.".
54. For historic environment, see Historic England's *Heritage Counts* report; for natural environment, see the *State of Nature* Report.
55. Gov.uk, *Guidance: Conserving and Enhancing the Historic Environment*.
56. Planning Policy Statement 9: Biodiversity and Geological Conservation 16 August 2005, https://webarchive.nationalarchives.gov.uk/20120919230238/http://www.communities.gov.uk/archived/publications/planningandbuilding/pps9 .
57. Department for Communities and Local Government, "Planning Policy Guidance 16: Archaeology and Planning." Also note that PPG16 along with PPG15 was replaced by PPS5: Planning for the Historic Environment in 2010.
58. Woodland Trust response to Housing White Paper, May 2017, https://www.woodlandtrust.org.uk/mediafile/100819242/cr-wt-110717-fixing-our-broken-housing-market.pdf?cb=e16da36444734846a5120fb4c8b7cc26.
59. DCMS, "Draft Heritage Protection Bill."
60. DEFRA and the Forestry Commission, February 2014, Keepers of Time, A Statement of Policy for England's Ancient and Native Woodland, https://assets.publishing.service.gov.uk/government/uploads/system/uploads/attachment_data/file/778106/KeepersofTimeanw-policy.pdf.
61. MHCLG, "National Planning Policy Framework."
62. DCMS.
63. Culture24, "Government Drops Heritage Bill Again," https://www.culture24.org.uk/history-and-heritage/art70059.
64. Defra, "Policy Paper: 25 Year Environment Plan," https://www.gov.uk/government/publications/25-year-environment-plan.
65. Defra, "Consultation Outcome: Environment: Developing Environmental Principles and Accountability," https://www.gov.uk/government/consultations/environment-developing-environmental-principles-and-accountability.
66. Rescue, "Rescue Responds to Environmental Principles and Governance Consultation," http://rescue-archaeology.org.uk/2018/08/06/rescue-responds-to-environmental-principles-and-governance-consultation/.
67. Defra, "Policy Paper: 25 Year Environment Plan," Paragraph 212, 67.
68. Baker and Beatty, *Biodiversity Net Gain*, 1.
69. Defra, "Net Gain Consultation," https://consult.defra.gov.uk/land-use/net-gain/.
70. Defra, "Policy Paper: 25 Year Environment Plan," 32.
71. Ibid., 33.
72. Ibid., 135.
73. IPBES, *The Global Assessment Report on Biodiversity and Ecosystem Services*, 3.
74. Monbiot, "The Uk Government Wants to Put a Price on Nature – but That Will Destroy I."
75. Millennium Ecosystem Report, "Ecosystems and Human Well-Being," 44.
76. Ibid., 7.

77. Ibid., 4 and 52. The definition of the ecosystem here is adopted from the Convention of Biological Diversity (1992: Article 2).
78. Defra, 2004. *Provision of Ecosystem Services through the Environmental Stewardship Scheme*. Pg. 2 Available from: http://sciencesearch.defra.gov.uk/Default.aspx?Menu=Menu&Module=More&Location=None&Completed=0&ProjectID=15901.
79. Ibid., 15.
80. AHRC Heritage/RESCUE, *Engaging with Policy in the UK: Responding to Changes in Planing, Heritage and the Arts*.

Disclosure statement

No potential conflict of interest was reported by the authors.

Bibliography

Baker, J., and B. Beatty. *Biodiversity Net Gain: Good Practice Principles for Development*. CIEEM, CIRIA and IEMA: CIEEM. Winchester: CIEEM, 2016. https://cieem.net/wp-content/uploads/2019/02/Biodiversity-Net-Gain-Principles.pdf.

Bridgewater, P., S. Arico, and J. Scott. "Biological Diversity and Cultural Diversity: The Heritage of Nature and Culture through the Looking Glass1of Multilateral Agreements." *International Journal of Heritage Studies* 13, no. 4–5 (2007): 405–419. doi:10.1080/13527250701351130.

Brown, M., and T. Murtha. "Integrating Natural and Cultural Resources in North American Large-Landscape Conservation." *Environmental Practice* 21, no. 2 (2019): 57–68. doi:10.1080/14660466.2019.1601935.

Burns, C., V. Gravey, and A. Jordan. *UK Environmental Policy Post-Brexit: A Risk Analysis*. London: Friends of the Earth, 2018.

Cormier-Salem, M.-C., and T. J. Bassett. "Nature as Local Heritage in Africa: Longstanding Concerns, New Challenges." *Africa* 77, no. 01 (2011): 1–17. doi:10.3366/afr.2007.77.1.1.

Culture24. "Government Drops Heritage Bill Again." Culture24. https://www.culture24.org.uk/history-and-heritage/art70059.

Dailoo, S. I., and F. Pannekoek. "Nature and Culture: A New World Heritage Context." *International Journal of Cultural Property* 15, no. 01 (2008). doi:10.1017/S0940739108080077.

DCLG. "National Planning Policy Framework." In *Department for Communities and Local Government*, edited by. London, UK: The Crown, 2012.
DCMS. "Draft Heritage Protection Bill." In *Media and Sport Department of Culture*, edited by. London: Her Majesty's Stationary Office, 2008.
Defra. "Provisions of Ecosystem Services through the Environmental Stewardship Scheme" http://sciencesearch.defra.gov.uk/Default.aspx?Menu=Menu&Module=More&Location=None&Completed=0&ProjectID=15901.
Defra. "Consultation Outcome: Environment: Developing Environmental Principles and Accountability." Defra. https://www.gov.uk/government/consultations/environment-developing-environmental-principles-and-accountability.
Defra. "Net Gain Consultation." Defra. https://consult.defra.gov.uk/land-use/net-gain/.
Defra. "Policy Paper: 25 Year Environment Plan." Defra. https://www.gov.uk/government/publications/25-year-environment-plan.
Garner, R. *Environmental Politics: Britain, Europe, and the Global Environment*. New York: St Martin's Press Inc, 2000.
Gov.uk. *Guidance: Conserving and Enhancing the Historic Environment*. Department for Communities and Local Government, 2014. https://consult.environment-agency.gov.uk/engagement/boston-barriertwao/results/c.1.10—nppg—conserving-and-enhancing-the-historic-environment.pdf.
Department for Communities and Local Government. "Planning Policy Guidance 16: Archaeology and Planning." London: The Crown, 2006.
Harmon, D. "A Bridge over the Chasm: Finding Ways to Achieve Integrated Natural and Cultural Heritage Conservation." *International Journal of Heritage Studies* 13, no. 4–5 (2007): 380–392. doi:10.1080/13527250701351098.
Harrison, R. "Beyond "natural" and "cultural" Heritage: Toward an Ontological Politics of Heritage in the Age of Anthropocene." *Heritage & Society* 8, no. 1 (2015): 24–42. doi:10.1179/2159032X15Z.00000000036.
Heritage/RESCUE, AHRC. *Engaging with Policy in the UK: Responding to Changes in Planning, Heritage and the Arts*. London, 2018. https://heritage-research.org/events/engaging-policy-uk-responding-changes-planning-heritage-arts/.
Hewitson, N. "The Disconnect between Heritage Law and Policy: How Did We Get Here and Where are We Going?" *The Historic Environment: Policy & Practice* (2019): 1–8. doi:10.1080/17567505.2019.1645760.
Hunter, S., and K. M. Leyden. "Beyond Nimby: Explaining Opposition to Hazardous Waste Facilities." *Policy Studies Journal* 23, no. 4 (1995): 18. doi:10.1111/j.1541-0072.1995.tb00537.x.
IPBES. *The Global Assessment Report on Biodiversity and Ecosystem Services*. IPBES, 2019. https://www.ipbes.net/global-assessment-report-biodiversity-ecosystem-services.
Lowenthal, D. "Natural and Cultural Heritage." *International Journal of Heritage Studies* 11, no. 1 (2005): 81–92. doi:10.1080/13527250500037088.
Marsh, G. P. *Man and Nature*. New York: John F Trow, 1864.
MHCLG. "National Planning Policy Framework." London, UK: The Crown, 2019.
MHCLG. "Dramatic Simplification of Planning Guidance to Encourage Sustainable Growth." https://www.gov.uk/government/news/dramatic-simplification-of-planning-guidance-to-encourage-sustainable-growth-3.
Monbiot, G. 2018. "The UK Government Wants to Put a Price on Nature - but that Will Destroy It." *The Guardian*.
National Audit Office. *Implementing the UK's Exit from the European Union: The Department for Environment, Food & Rural Affairs*. London: Defra, 2017.
Phillips, A. "Why Lived-in Landscapes Matter to Nature Conservation." *APT Bulletin: the Journal of Preservation Technology Association for Preservation Technology International (APT)* 34 (2003): 1. doi:10.2307/1504846.
Millennium Ecosystem Assessment. 2005. "Ecosystems and Human Well-Being: A Framework for Assessment."

Rescue. "Rescue Responds to Environmental Principles and Governance Consultation." Rescue: The British Archaeological Trust. http://rescue-archaeology.org.uk/2018/08/06/rescue-responds-to-environmental-principles-and-governance-consultation/.

Sims, S., and N. Bosetti. *Stopped: Why People Oppose Residential Development in Their Back Yard*. London: Centre for London, 2016. July.

Office for National Statistics. 2018. "Housing Affordability in England and Wales 2017."

Sturzaker, J. "The Exercise of Power to Limit the Development of New Housing in the English Countryside." *Environment and Planning A: Economy and Space* 42, no. 4 (2010): 1001–1016. doi:10.1068/a42297.

Trow, S. "Archaeology and the State We're In: Defining a Role for Historic England in the Archaeological Practice of the Twenty-First Century." *The Historic Environment: Policy & Practice* 9, no. 2 (2018): 83–101. doi:10.1080/17567505.2018.1456718.

UKELA. *Brexit and Environmental Law: The UK and International Environmental Law after Brexit*. Bristol: UKELA, 2017. https://www.ukela.org/content/doclib/320.pdf.

Wen-hua, L. I., M. I. N. Qing-wen, and S. U. N. Ye-hong. "Discussion on the Scientific Research of Natural and Cultural Heritage." http://en.cnki.com.cn/Article_en/CJFDTotal-DLYJ200604000.htm.

Index

Notes: This has the reference of figures as "Italics" and tables as "Bold".

Acceptance in Lieu Scheme 149
accountability 189, 199, 200–1, 216
actor-network approach 190–1
administration: local 24; post-Roman Anglo-Saxon 108
AHRC Heritage/Rescue conference 1, 38, 124, 136n1
Aldous, Simon 3, 8n13
ALGAO *see* Association of Local Government Archaeological Officers (ALGAO)
Ancient Monuments and Archaeological Areas Act 1979 57, **213**, 221
AONBs *see* Areas of Outstanding Natural Beauty (AONBs)
archaeology/archaeological/archaeological research: approaches 114–15; architectural-historical approach 199; cycle *94*; desk-based assessment 176; destination approach 203; frameworks 102–4; investigations project 163; organisations 91
The Archaeology Forum (TAF) 4
Areas of Outstanding Natural Beauty (AONBs) 109–11
Association of Local Government Archaeological Officers (ALGAO) 105, 166

Badgers Act 1991 **213**
Barton, Kenneth 159–60
Belcher, Matt 7
Big Conservation Conversation campaign 182
Birmingham Central Library 193–5
Blackpool City Council 43
border landscape *112*
Bournemouth Borough Council 131
Boyle, Gail 6
bridging gaps 223–5
Bristol Museum Committee 161
Brown, Duncan H. 162
Burnham, Andy 221

Campaign to Protect Rural England 218
CBD *see* Convention on Biological Diversity (CBD)

Central Library 198–203
character-based thinking trend 25
charitable organisation 144
Chartered Institute for Archaeologists (CIfA) 4, 107, 160, 168, 169
Chitty, Gill 5
CIfA *see* Chartered Institute for Archaeologists (CIfA)
Civic Amenities Act of 1967 25, 39, 184n1
Clark, Greg 216
Clark, Kate 5, 40, 45, 52n11
Clean Growth strategy 222
climate change 5, 15, 111, 145, *213*, 223, 226n22
Climate Change Act 2008 **213**
conceptualisation of conservation/policy approaches 189–93
conservate/conservation 187
Conservation Areas Partnerships scheme of 1995 31n62, **35**
constraints-map lead approach 179
constructive conservation approach 25, 196
contractors sector 107
Control of Pollution Act 1974 **213**
conventional art-history approach 190
Convention on Biological Diversity (CBD) 212
Convention on International Trade in Endangered Species of Wild Fauna and Flora 212
Convention to Combat Desertification 212
Council's Planning Committee 69
Countryside and Rights of Way Act 2000 **213**
cross-sectoral approaches 7
cross-Whitehall approach 23
culturally diverse approach 19
Cultural Property (Armed Conflicts) Act 4
cultural spaces 211
culture; *see also* heritage: artificial barrier 212; black environment network 13; building 2; CASE Place Shaping Report 148; ecosystem 223; minority 15; nature domain 211–12; protection 210; in UK policy 212
Culture, Media and Sport Committee Session 1998-99 12

Darwinian approach 191
DCLG *see* Department for Communities and Local Government (DCLG)
DCMS *see* Department for Culture, Media and Sport (DCMS)
DEFRA *see* Department for Environment, Food and Rural Affairs (DEFRA)
Delafons, J. 39
democratic governance process 2
Department for Communities and Local Government (DCLG) 137n18, 227n57
Department for Culture, Media and Sport (DCMS) 12, 213
Department for Environment, Food and Rural Affairs (DEFRA) 23, 213
Department for Transport, Local Government and the Regions (DTLR) 12
Department of National Heritage (DNH) 12
designated heritage 43, 57, 60, 64
Destination Management approach 25
developer-funded planning-based archaeology 101
development-driven approaches 105
development-led archaeology 84, 89, 162–3
Development Viability Supplementary Planning Guidance 125
diffusionist models 39
1995 Disability Discrimination Act 17
DNH *see* Department of National Heritage (DNH)
DTLR *see* Department for Transport, Local Government and the Regions (DTLR)

ecosystem/ecology; *see also* heritage: eco structures 105–7; food production and sustainability 146; habitats and environments 223; natural assets 146; professional *115*; research frameworks 113
EDCSP 79
Ellis, Michael 3, 4, 7n1
Enabling Development and the Conservation of Significant Places (EDCSP) 79
Energy Act 2008, 2010, 2011 **213**
Engaging with Policy 4–5, 8n5, 124, 136n1
England's national planning policy framework 214–15
English Heritage 12–15, 23–7, 29n3 n. 3–7, 45, 58, 79, 81, 102, 109, 143, 195–6, 199; annual report **37**; archaeology **34**; grants **35**; historic buildings **35**; policy and legislation 39; work **34**
Environmental Protection Act 1990 **213**
Environmental Stewardship (ES) scheme 223
Environment Bill 221–2
ES scheme 223
evidence-based publication 2

Fairclough, Graham 14, 23
Federation of Archaeological Managers and Employers (FAME) 166
financial viability *129*
FoCL campaign 201
A Force for our Future 22–4

Glen, John 3, 7n1
Goatley, Peter 5
Government policy Circulars 39–40
Greater London Regional Planning Committee 218

Hague Convention 3, 4
Hall, Stuart 151
Harman, John 126
Hassall, Thomas 160
Heathrow Terminal 5, 92–3
heritage: assets 100, 218–19; consent 26; conservation 19, 211; creation process 188–9; designated 43, 57, 60, 64; environment legislation, policy and guidance 215–16; management system 18; natural and cultural assets 218–19; non-designated 43, 60, 176; organisations 4, 19, 222; public policy 142–3; statement 176
Heritage Alliance 1, 4, 215
Heritage Council 3, 150, 219
Heritage Counts 24, 31n57, 43–3, 135
Heritage Economic Regeneration scheme 25
Heritage Lottery Fund 25, 27–8
Heritage Monitor 24
Heritage Protection Bill 58, 221
Heritage Statement 3, 176, 179–81
heritagisation 191
HERs *see* Historic Environment Records (HERs)
Hewison, Robert 2
Hewitson, Nigel 5
Historic Buildings and Ancient Monuments Act 1953 56, 67, 136n2
Historic Environment Records (HERs) 107
Hodge, Margaret 200, 221
Holmes-Skelton, Georgina 6, 225n7
Hunting Act 2004 **213**
hypothetico-deductive approaches 86

IHBC *see* Institute of Historic Building Conservation (IHBC)
inevitable perception-forming relationship 202–3
Informed Conservation Principles 45–6
Institute of Historic Building Conservation (IHBC) 182
institutional agency 2
interdisciplinary approaches 7
interpretations: assets and collections 149; *Conservation Principles* approach 43; historic environment 15; national engagement 1; statutory tests 69–75

intertextual complexity 41
Iron-Age-Danube project 116

Jenrick, Robert 1
Joint Nautical Archaeology Policy Committee (JNAPC) 4
juggling act of policy development 29

land-use planning system 13, 22
Leasehold Reform, Housing and Urban Development Act 1993 67
Legal Aid, Sentencing and Punishment of Offenders Act 2012 81n3
legislative protection of historic environment 125
Library Services 202
listed buildings 65
local authorities planning 42–3, **46**; terms **48**
local government/local governance: administration 24; association 3–4; communities 1, 65
local planning authority (LPA) 175
LPA see local planning authority (LPA)

Marcher Lordships 108–9
Marsh, George Perkins 210
Median Voter model 144
Medway's strategy 46
Millennium Ecosystem Assessment framework 224
mitigation 88, 91, 116
municipal authorities 189
museum review 3, 167–8

narrative coherence 114
narrative-led heritage approaches 14–15
national administration 24
National Lottery Heritage Fund 25, 27–8
National Parks and Access to the Countryside Act 1949 **213**
National Planning Policy Framework (NPPF) 3, 7, 8n6, 56–7, 64, 84, 90–1, 163, 165, 169, 176, 214–15, 219–25; approach 59–60, 81; comparison 47–8; practice 91–2; revision 128; types of campaigns *215*; viability 125–31
Natural Capital Valuation committee 6–7, 146, 223
Neighbourhood Planning Bill 3
net gain 222–3
neutral recording 88
Nietzsche, F. 149
non-designated heritage 43, 60, 176
non-professionals sector 105–6
Nottingham's heritage strategy 43
NPPF see National Planning Policy Framework (NPPF)

Organisation for Economic Cooperation and Development (OECD) 218

Parliamentary Under-Secretary of State for the Arts 7n1
PAS see Portable Antiquities Scheme (PAS)
Patrick, Chris 6
PD rights 176
Permitted Development rights (PD rights) 176
Phillips, Dan 6
Pindham, Nina 5
Planned statutory reform 40
Planning (Listed Buildings and Conservation Areas) Act 47, 56–7, 64, 72, 80, 82n9, 136n2, 189, **213**, 221
Planning and Compulsory Purchase Act 2004 67, 80
Planning and Energy Act 2008 **213**
planning authorities 106–7
Planning Policy Statement 5 (PPS 5) 40, 90–1
Policy Action Plan 10 12, 19
polluter pays approaches 101, 105
Portable Antiquities Scheme (PAS) 113
post-Brexit migration restrictions 4
Power of Place 20–4, 26
PPG 16, 87–8, 163
practical deposition process 162
professional 'ecosystems' *115*
Protecting our Heritage 12, 22
Protection of Badgers Act 1992 **213**
Protection of Wrecks Act 1973 63n1, 136n2
publicly-funded organisations 87
public policy intervention 151

quasi-autonomous non-government organisation 12

Raynsford Review on Planning 3
RCHME see Royal Commission on the Historical Monuments of England (RCHME)
RDAs see Regional Development Agencies (RDAs)
regional administration 24
Regional Development Agencies (RDAs) 25
Residual Land Value (RLV) 129
Rhodes Must Fall campaign 152
RLV see Residual Land Value (RLV)
Royal Commission on the Historical Monuments of England (RCHME) 109

Save Britain's Heritage 74, 184n14
Scottish Archaeological Research Framework (ScARF) 103
Scottish Urban Archaeological Trust (SUAT) 103
SD see sustainable development (SD)
Secretary of State for Housing 1
Secretary of State under section 1 of the 1990 Act 65
Short, Michael 7
SMA see Society for Museum Archaeology (SMA)
Smith, Claire 5
Smith, Laurajane 149
Society for Museum Archaeology (SMA) 159

Standing Conference of Unit Managers 160
state heritage bodies 106
statutory conservation framework 198–203
2002 Strategic Plan 27
Stroud's heritage strategy 43, 45
SUAT 103
sustainable conservation 191
sustainable development (SD); *see also* culture/heritage: approaches 13; domains 126; strategy 12

TAF *see* The Archaeology Forum (TAF)
Tewdwr-Jones, Mark 7
Thomas, Roger 5–6
Thompson, Matt 7
Threshold Land Value (TLV) 129
Tintern Abbey 12
TLV *see* Threshold Land Value (TLV)
topography 108
Town and Country Planning Act: 1947 218; 1990 136n2
Treasure Act 3, 7n2
Twentieth Century Society's pro-listing campaign 199

UNESCO Convention on Underwater Heritage 4
Unitary Development Plan 2005 209

United Nations Conference on Environment and Development 29n5
urban/urbanization *see* culture: transport schemes 194
U-shaped fashion trend model 200

values-based approaches 40–1
viability: assessment 128–33, 134–5; development-led archeology 133–4; model 126, 129, 135; revision 128
Victorian buildings 192
voluntary campaigning body 24, 30n18

Weeds Act 1959 **213**
whole historic environment approach 25
WHS *see* World Heritage Sites (WHS)
wiki style approach 117
Wildlife and Countryside Act 1981 **213**
Willis Corroon buildings 12
Woodland Trust's Campaign 7, 219–25
Woolf L. J. 73
World Heritage Sites (WHS) 104
Written Schemes of Investigation (WSIs) 91–2

Years of Campaigning Pay Off 219–25
Young Roots programme 28